New York
Waterfalls

Your boots want to go out
and play - listen to them.

Enjoy!

0 11557 00586 8

New York Waterfalls

A Guide for Hikers & Photographers

Scott E. Brown

STACKPOLE
BOOKS

Published by
STACKPOLE BOOKS
5067 Ritter Road
Mechanicsburg, PA 17055
www.stackpolebooks.com

Printed in China

10 9 8 7 6 5 4 3 2 1

FIRST EDITION

Cover design by Caroline Stover

Cover: Lower Falls of the Genesee River, Letchworth State Park
Back cover: Upper Falls of the Willowemoc Creek, Sullivan County

Library of Congress Cataloging-in-Publication Data

Brown, Scott E., 1962–
 New York waterfalls : a guide for hikers & photographers / Scott E. Brown.
 p. cm.
 ISBN-13: 978-0-8117-0586-8 (pbk.)
 ISBN-10: 0-8117-0586-2 (pbk.)
 1. Hiking—New York (State)—Guidebooks. 2. Photography of water—New York (State)—Guidebooks. 3. New York (State)—Guidebooks. I. Title.
GV199.42.N7B76 2010
917.47'0444—dc22
 2010012926

To the women and men of the New York Department
of Environmental Conservation and the
Office of Parks who make all the lovely gorges
and glens safe for the rest of us to enjoy.
Also, to the various land conservation groups who purchase,
preserve, and maintain the wildlands in New York.
Many thanks to you all.

Contents

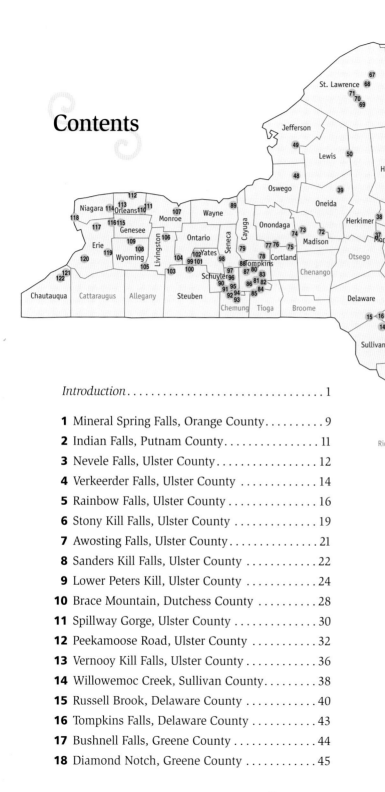

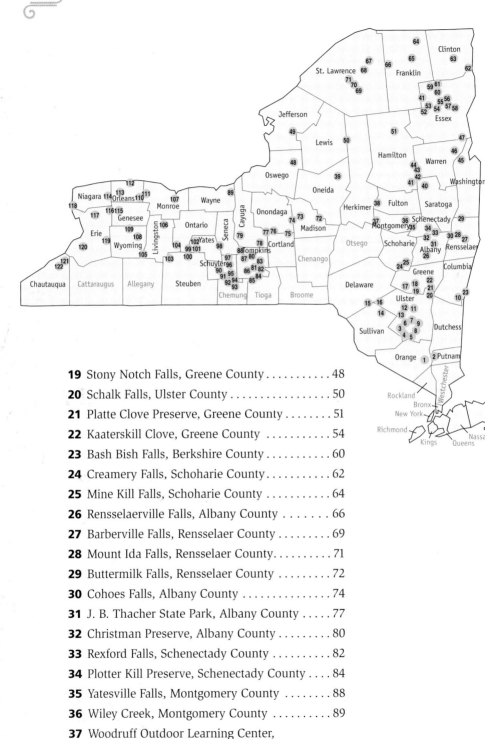

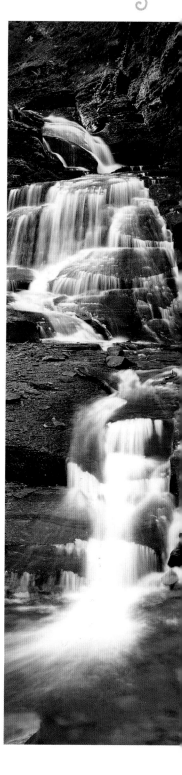

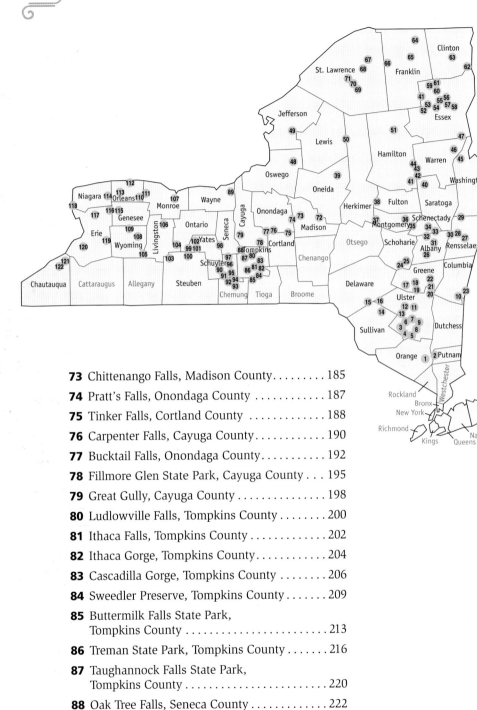

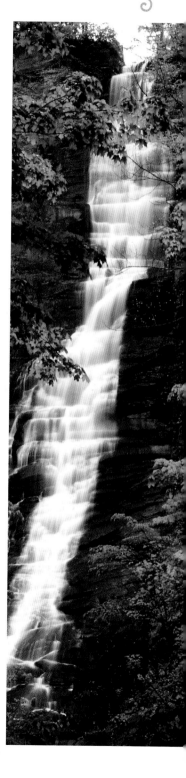

Introduction

The reason we seek waterfalls is different for each of us, but I think for many the draw is their ethereal beauty. Falling water cradled within a vibrant green landscape is pleasing to the eye, and the sound is comforting to the ear. Waterfalls are food for the hungry soul; we love to look at them, stand under them, photograph them, be photographed near them, listen to them, or simply stand in awe of them. Waterfalls are nature's animated invitation to enter a magical realm.

Nature doesn't care if you can only muster a short walk or whether you're able to ramble 20 miles with a full pack. I've encountered every form of humanity in the woods, from the hard-core backpacker to the accidental tourist, and we all share a common purpose that isn't based on miles trekked. We seek only "to be" in nature's wonderland.

New York is blessed with an incredible beauty born from the forces of plate tectonics and the grinding power of glaciers. From the rolling terrain of the western Finger Lakes to the craggy High Peaks of the Adirondacks to the southern Ridge and Valley, New York has possibly the largest number of waterfalls of any state east of the Mississippi. I don't know the total, because I stopped counting at around one thousand.

I ask that you consider these words as you travel: Of all the roads you travel in life, make sure a few of them are dirt. So please join me for time on the road less taken; I guarantee it will make all the difference. Now go out and play.

Safety

I would be remiss if I didn't begin by talking about safety with this stern warning: You are solely responsible for your own safety. If that doesn't say it well enough, the picture on page 2 should demonstrate it clearly. "Risk of serious injury or death" is no hyperbole; it is the plain-spoken truth of hiking in a dangerous vertical environment. There are five common words used on maps to describe waterfall-containing stream systems: gorge, gulf, glen, gully, and gulch. All describe what amount to sheer-walled canyons. It doesn't matter if

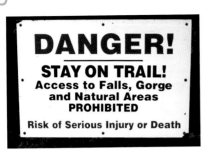

DANGER!

STAY ON TRAIL!
Access to Falls, Gorge
and Natural Areas
PROHIBITED

Risk of Serious Injury or Death

they're 20 feet deep or 400 feet deep, if you don't have specialized climbing gear, training, or support, then you're not going to get into them. I hike into remote locations all the time and I'm comfortable around heights and scrambling up and down steep slopes. So when you read about a location in this book and I say it's not safe to explore further, or don't attempt to do thus-and-such, please believe that it's too dangerous!

Consider this: the town of Naples, south of Canandaigua Lake in Ontario County, is quite proud of its EMS Gorge Rescue Team. As one of their members told me, "We get way more practice than we'd like. It's just that people are stupid, which keeps us real busy." Sage words from a professional.

Waterfalls are tall, moss-and-algae-covered cliffs with water plunging down them. They are as slick as ice and less forgiving. When standing at the head of a 20-foot-tall-fall it's important to remember that you're standing atop a three-meter, ice-covered diving board looking down into the deep end of a swimming pool *with no water in it.* Shooting streams and waterfalls requires that you take extreme care with your footing. Quite a few falls in this guide are in undeveloped places with few improved (meaning graded) trails, poor cell phone service, and no easy way to get out or self-rescue if injured.

Slipping and falling isn't the only problem. Of greater danger is falling rock or becoming what's called "ledged out." Most New York fall systems cut through rock formations made of thin shale lamina—like slate-roof shingles, only softer. Gorges and glens are often overhung with this weak material, which will give way without warning and squash you like a bug. This is such a safety issue that there is a group of state Department of Environmental Conservation (DEC) safety crews dedicated to scaling cliffs and clearing loose rock. All it takes is one small rock dropping a hundred feet to ruin your day. Also, glen walls can subside and sweep you over like a huge stack of collapsing newspapers.

In approaching a fall from above you might be tempted to scramble down this weak material. You may then find yourself in a position where you're clinging to "rocks" with the consistency of dead leaves and not having sufficient traction to retreat. With no way to move up or down you've become "ledged out." When muscle fatigue sets in a few minutes later you're in for a fatal lesson in Newton's Law of Universal Gravitation. Whether you're ascending or descending a steep section, always make sure to test getting back down or up before you complete the pitch. This is especially true during wet weather.

Hiking directions, fording notes, and difficulties noted here are based on spring runoff and high-water approaches. In summer most falls are simple creek walks; however, care and caution dictate a different process during

high flow. In some cases fording can be an unnerving affair due to slick stream bottoms or steep channels, even in ankle-deep water. Never underestimate how little water it takes to push you downstream once you slip and begin sliding. Water weighs 64 pounds per cubic foot, and when combined with a current moving at a jogger's pace, it creates an incredible amount of force to overcome. Also, fording in swift, choppy water can induce vertigo. Don't look at your feet when this happens; lock onto a fixed target such as a boulder and turn your feet upstream until the feeling passes.

New York is a popular winter destination and many falls are used by ice climbers. Ascending many of the locations in this guide takes special training and equipment whenever ice is present. For level creek hikes you can usually get to at least one fall using snowshoes, crampons, or hiking studs. Many pages could be spent discussing the ins and outs of working frozen stream systems. Talk to experienced outfitters like the people at The Mountaineer in Keene Valley; describe in detail what you want to do, and have them explain the particulars to you. There's no need to be nervous about winter hiking. You just need to be prudent. Good-quality gear is also important.

The overzealous, overconfident, and the ignorant keep Naples' EMS teams busy, so please do the following:

- Consider your fitness, experience, and time available before starting out.

- Never walk to the precipice of any waterfall.

- Always carry ample water (at least one quart per person) and never drink from streams.

- Always hike with a partner whenever possible.

- Always let someone know where you're going and when you expect to be back. If you're at a campsite tell the campground supervisor; when at a hotel tell the desk clerk. When you come back from your trek, don't forget to check back in.

- Dress warmly in layers, and have rain gear available.

- Wear appropriate footgear.

- Never hike in high water or swift-moving water above the knee.

- Bring a map, a flashlight, and a snack.

- Check the weather report and always keep an eye towards the sky.

- Always be aware of the clock. If you have to descend to a fall remember it will take longer to climb back up than down—typically twice as long. Never, ever try to hike unimproved stream trails in the dark.

- Some waterfalls are on state lands open to hunting. Everyone, not just hunters, should wear 100 square inches of blaze orange above the waist year-round. For a list of hunting seasons check the DEC Web site.

- Choose hikes that fit your time, fitness level, and experience, and you'll be able to show your family and friends some amazing photographs. Use care, caution, and common sense to experience the landscape, not become part of it.

Ethics and Etiquette

Time and again I've seen amateur photographers come to a location and try to bully their way to a good spot. Some photographers tend to be very intolerant of non-photographers. Respect and common courtesy go a long way towards getting what you want. Words like "please," "thank you," and "may I," work wonders—use them.

Consider becoming a member of the North American Nature Photography Association. NANPA is a strong proponent of ethical behavior among nature photographers and their ethics principle states as follows:

> Every place, plant, and animal, whether above or below water, is unique, and cumulative impacts occur over time. Therefore one must always exercise good individual judgment. It is NANPA's belief that these principles will encourage all who participate in the enjoyment of nature to do so in a way that best promotes good stewardship of the resource.

To paraphrase some of the NANPA guidelines as they apply to photographing waterfalls, please do the following:

- Stay on trails that are intended to lessen impact.
- When appropriate, inform resource managers or authorities of your presence and purpose.
- Learn the rules and laws of the location. In the absence of management authority, use good judgment.
- Prepare yourself and your equipment for unexpected events.
- Treat others courteously.
- Tactfully inform others if you observe them engaging in inappropriate or harmful behavior. Report inappropriate behavior. Don't argue with those that don't care—report them.
- Be a good role model, both as a photographer and citizen. Don't interfere with the enjoyment of others.

A great many falls that don't appear in this guide are clearly visible from roads and bridges but you must cross posted land to get to them. Posted is not a mere notification that the land is privately owned, it is a stern warning to stay off the land. It doesn't matter what you see other people doing; unless you have specific permission to go onto private land you are in violation of the law and subject to arrest. Respect all private land markers and postings.

DEC land markers will be either yellow signs or yellow paint blobs. White and/or blue typically mark private land boundaries. In cases where DEC or

other organizations such as The Nature Conservancy (TNC) have access easements there will be signage stating so. There are many who believe that all streams are public land and that if you travel up a creek you're not trespassing. This is a myth. Posted means posted—period.

How to Use This Guide

This guide divides the state into regions and within each region it groups waterfalls geographically. These groupings are designed to provide a central starting point for your trip(s). Driving distances are provided in miles and road names are given along with the state or county route number, or just the route number when there is no name. The best map to have when using this guide is DeLorme's *New York Gazetteer*. The state forest service does not have public-use maps so it's a good idea to have a topographic map of any such areas you intend to visit. National Geographic has excellent waterproof map sets for the Adirondacks and the Catskills. Also, AAA provides a set of regional maps (Western New York, Finger Lakes, Adirondacks, Central and Southern New York) that are easy to read. I used mine so much they fell apart.

GPS coordinates for parking areas and waterfalls are given in degrees, minutes, seconds format. In many cases the coordinates are from the U.S. Geological Survey Geospatial Information System database, known as GIS. National Geographic's *TOPO! State* series CD-ROM maps were used to get

What's in a Name?

What exactly is a waterfall? According to the U.S. Geological Survey there are sixty-three accepted topographic names that could be used to define a waterfall, including fall, ledge, slide, cataract, rapid, riffle, chute, plunge, and drop. As can be seen by this small sample of names, not every fall is a vertical drop from a ledge or overhang as might be expected. Many are tumbles down heavily terraced faces, nearly vertical slides, cataracts, or flume-like chutes. In lieu of a clear USGS definition, the naming criteria for this guide are defined as follows:

Fall—Water plunging from a ledge or precipice that is vertical and/or undercut.

Cascade—A vertical to nearly vertical terraced face where water tumbles down it and is too steep to climb without special climbing gear.

Slide—Near-vertical to less-than-vertical smooth surface, or nearly smooth surface, that is wider than the stream going over it and is too steep to climb without special climbing gear.

Chute—A narrow slide or cataractlike feature that confines the stream flow and is too steep to climb without special climbing gear.

These definitions all have one thing in common: Waterfalls are generally impassable obstructions unless special equipment is used.

this information. These GIS coordinates are ground-verified using a Garmin E-Trex handheld GPS. For falls that have no GIS location the E-Trex was used to mark the location. Even though a handheld GPS unit might indicate twelve feet positioning accuracy, in reality the number is as much as plus or minus 100 feet depending on the GPS unit's view of the sky. A GPS unit will you get you close to a fall; finding it is typically done by ear. Bear this fact in mind where I note GPS coordinates for bushwhacks and trail junctions.

Round-trip hiking distances are in miles. Times are given as well. Please note that hiking times do not include the time needed to set up, compose, shoot, and break down camera equipment. When planning a hike, consider how long you may take to photograph based on past experience. Always be aware of the clock so as not to be caught by darkness.

Elevation changes are given in feet from the parking area and are the total elevation gain/loss for the route provided. If you go up 800 feet and then descend 200 feet the elevation gain will be given as 1,000 feet.

Hike difficulties are rated as easy, moderate, difficult, and strenuous. This is a subjective rating system that combines elevation gain, steepness, and trail conditions into a general statement of what to expect. Hike difficulties are rated on the conservative side.

The "hand" of stream sides, banks, and edges, such as left-hand and right-hand, is given from the perspective of looking downstream. For example, when I say, "Cross to the left-hand side of the creek at any convenient point," I mean the left side as viewed when looking downstream. Words like opposite, turn, and return are from the perspective of the hiker. For example, when I say, "Turn right and look for an enormous boulder," I mean turn towards your right. In many cases I use redundant notations to make sure there's no ambiguity. For example, "From this point turn left (upstream) and walk 2 miles."

Most New York waterfalls are somewhat seasonal and so their power and character will vary from spring's snowmelt to summer's heat. Also, their photographability changes from week to week and even day to day due to rainfall. Generally speaking, the best seasons are spring, during the early portion of leaf-out, and autumn after a good soaking rain. However, any time a big front moves through and soaks an area, be prepared to shoot.

Footgear

First, recognize this important fact: At some point you're going to get wet. Although you can get most anywhere with a good pair of sneakers I don't recommend them. Ankle and arch support is very important when hiking along uneven creek banks, and boots that cover the ankle area are important. A twisted ankle is a common hiking injury, and as my own orthopedic surgeon will attest, you can break an ankle anywhere, at anytime. Stout hightop boots are a must. When working in water use quality waders or heavy outdoor sandals, and don't forget that mountain streams are ice cold.

Camera Equipment and Shooting Tips

Toting around thirty to fifty pounds of camera equipment is not always easy. I carry my gear in Lowepro camera backpacks. With a lighter complement of gear, use a waist pack or a big fanny pack. In any case, the object is to keep your hands free when walking on uneven terrain. Amazing photographs can be made with even the simplest of cameras. What camera equipment to use is beyond the scope of this guide; however, here are a few things to consider when choosing equipment and when shooting waterfalls:

- Use a camera with a manual exposure setting capability and meter everything in the scene to be photographed *except* the whitewater in the fall itself.

- For digital, use the histogram to check exposures. For the best post-processing opportunity have the histogram touch the left edge to keep shadow detail. "Blinkies" are inevitable; try to keep them to a minimum.

- Lenses in the 17mm to 50mm range, especially those wider than 35mm, will be used more often than any other.

- Put a polarizer on the camera and leave it on, and don't bother with a Skylight or UV filter—they're worthless.

- Use warming filters or "cloudy" settings very sparingly.

- Exposures between one and fifteen seconds will be the norm, so a sturdy tripod that places the camera at eye level without extending the center post works best.

- Do some gardening. Gardening means cleaning up the scene to make it look tidy. This does not mean removing plants or picking flowers. Never, ever remove plants. Rather, clear the clutter from the scene, such as plastic cups, trash, piles of dead leaves, tree bark, sticks, and twigs. Don't be afraid to walk into the scene and remove or hide these pieces of flotsam.

- Check the edges of the viewfinder. Run your eye around the perimeter of the viewfinder in both directions and look closely for twigs, leaves, or anything that juts into the edge of the frame. These are called sneakers and they are enormously frustrating. Don't let anything jut into the edge of the frame if you can avoid it.

- Look for merges and apparitions. These are trees that don't appear to go anywhere or rocks that appear to be sitting on top of one another. Since we have binocular vision we can tell what object is in front of another. A photograph has no depth, so depth must be created. Take a cluster of three trees in the middle of the scene where the trunks overlap and move the camera around until three distinct trees are seen. The difference between a good photo and great photo is this attention to detail.

- Move your feet! We all have a tendency to drop our tripod legs and shoot from just one spot. Move around, even just a few feet, to know that you've picked a good spot to work from.

- Be comfortable behind the camera. Streamside rocks are slick, wobbly, and can be uncomfortable to balance on. There's only one thing worse than hurting yourself and that's knocking over a tripod and destroying your equipment. Do yourself a favor: If you're not comfortable, shoot from another spot.

- Pray for rain, fog, or mist. Shooting waterfalls in bright sunlight is almost impossible, even when merging images digitally using a process called High Dynamic Image Range Merge (HDIRM). Overcast and flat lighting work best.

- Splash water on dry surfaces. Even when it's overcast, dry rocks near a fall will render overly bright. Splash them with water to make them look better.

Have fun! Making good photographs is hard work and the tendency is to get lost in all the knobs, dials, and technical minutia. Stop, look around, and enjoy your surroundings. The camera is just an empty box—the image comes from the heart!

Hike 1 Mineral Spring Falls, Orange County

Type: Slide	**Height:** 63 feet
Rating: 4	**GPS:** 41° 22.865'N, 74° 3.790'W
Stream: Mineral Spring Brook	**Distance:** .8 mile
Difficulty: Easy	**Elevation Change:** 160 feet
Time: 30 minutes	**Lenses:** 17mm to 90mm

Directions: From I-87 exit 16 (Harriman State Park), take NY 17 west before making an immediate right onto NY 32. Follow signs for Central Valley and head north toward Highland Mills. In 4.8 miles turn right onto Trout Brook Road, just after passing under I-87. In .9 mile turn left onto CR 9 (Mineral Spring Road) and follow it 1.3 miles, bearing right onto Old Mineral Spring Road. Park between some signs near a large gate. GPS coordinates: 41° 23.059'N, 74° 3.898'W. If the lot is full you'll have to park in an alternate location downhill along CR 9 near where you turned.

Proceed up an old woods road called West Point Military Reserve Way. The road leads into the United States Military Academy. You probably observed a number of U.S. government "No Trespassing" signs along CR 9. There are many locations all along CR 9 where cadets go on maneuvers, so if you see a bunch of youngsters coming down trail loaded for bear don't worry—they're on our side.

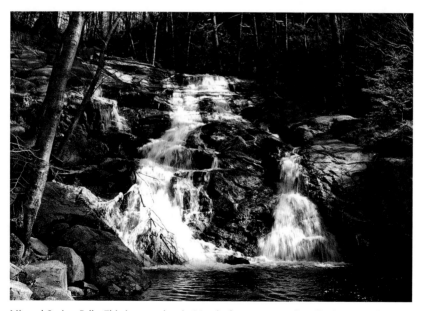

Mineral Spring Falls. This image, shot in March, features some ice clinging to rock edges and tree roots. You can make nice images of falls even when hand holding on a sunny day. Just make sure that there are few shadows and try hard to keep highlights out of frame. The bright rocks in the lower left are on the edge of becoming a distraction. *Canon EOS Digital Rebel, Tokina 20–35, Polarizer, ISO100 setting, f/5.6 @ 1/20 sec.*

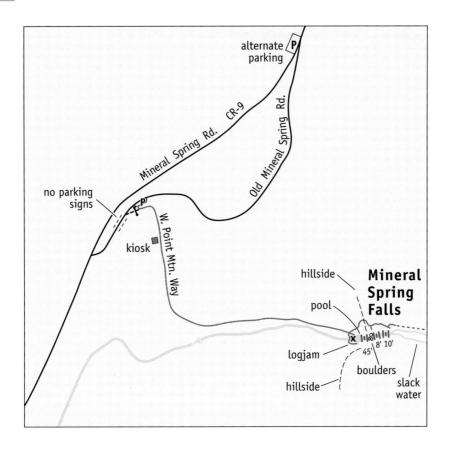

Register at the kiosk and follow the road, which is blazed with green diamonds and white squares. In a quick .4 mile you arrive at the large slide, which is visible from about 100 yards away. From the plunge pool you can see only the 45-foot slide and not the upper drops. The smallish plunge pool is created by a logjam that may be gone by the time you arrive. Shooting the fall and using the pool as a foreground anchor requires the use of an extremely wide lens. When working from farther away, the logjam's dead trees separate the tailwater from the pool, creating an unbalanced image. I worked from in front of the logjam.

By following a path up and left you will top out perhaps 60 feet above the fall's base; here is an eight-foot fall headed by a ten-foot cascade. Between the upper and lower sections the creek is a boulder-choked flume, and there are some nice macro setups within the flume shooting various ripples and riffles or mossy ledges. Don't forget to work the creek above and below the falls. The trail continues well up the creek but I only went another hundred yards. This is a great starter hike for kids since it's short and well-graded. In spring look for the occasional red trillium nuzzled against the many hemlocks found in the creek's wide ravine.

Hike 2 Indian Falls, Putnam County

Type: Cascade	**Height:** 20 feet
Rating: 4	**GPS:** 41° 24.291'N, 73° 55.790'W
Stream: Indian Brook	**Distance:** .5 mile
Difficulty: Easy	**Elevation Change:** 90 feet
Time: 30 minutes	**Lenses:** 17mm to 90mm

Directions: From the intersection of SR 9D (Chestnut St.–Bear Mountain Beacon Highway) and NY 301 (Main Street) in the town of Cold Spring, take NY 9D south 1.4 miles and bear right onto Indian Brook Road. Indian Brook Road twists and turns; in .6 mile park under the tall NY 9D bridge in a signed parking area for the Audubon Constitution Marsh. GPS coordinates: 41° 24.288'N, 73° 55.905'W.

Follow a wide, green-blazed carriage road downhill toward Indian Brook, which will be on the right, and cross an old stone bridge that can make an attractive image. Now turn left and follow a prominent footpath to the fall's base. The fall will be partly visible from the bridge; as you approach, stick with the creek's left-hand side (the side you're on). You may find an arrow pointing left—don't follow it, as this drops into the creek. This left turn may be okay in summer when the seasonal brook is easily passable, but in spring flow, which is best for shooting, a rock outcrop juts into the creek and makes a water approach problematic. I was here in March during decent snow runoff and had to contend with quite a few pale tree limbs in the fall's tailwater. Since I didn't have waders, and water shoes would have exposed me to hypothermia, I couldn't do my normal gardening and just

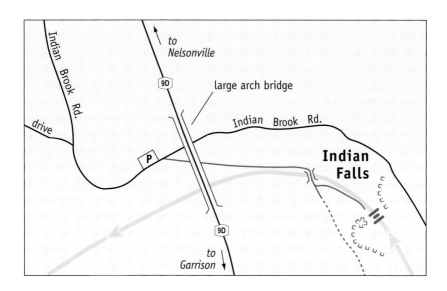

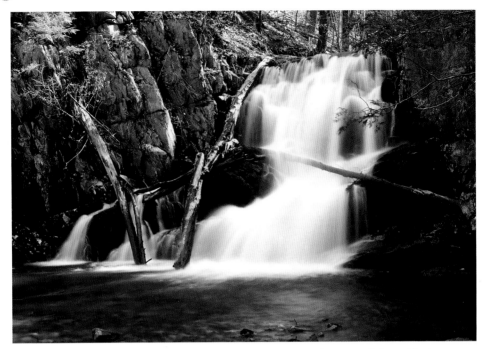

Indian Falls. I shot verticals and horizontals from far away to close-up and chose this close portrait from the bunch. Shooting several dozen frames gave me the option of selecting the best composition. Always shoot more than you think you'll need. *Canon EOS Digital Rebel, Tokina 20–35, Polarizer, ISO100 setting, f/16 @ 1.3 sec.*

had to deal with these distractions. There are other trails running uphill along the creek that I didn't explore. I recommend you do so since I heard about nice wildflowers that bloom in mid-May.

Hike 3 Nevele Falls, Ulster County

Type: Chute	**Height:** 45 feet
Rating: 4	**GPS:** 41° 42.482'N, 74° 23.069'W
Stream: North Gully	**Distance:** 50 yards
Difficulty: Easy	**Elevation Change:** None
Time: 10 minutes	**Lenses:** 35mm to 90mm

Directions: From the intersection of US 209 (Main Street) and NY 52 (Center Street) in the town of Ellenville, take NY 52 east through town .9 mile. After crossing a bridge with a waterfall on the left, make an immediate right onto Chapel Street and park under some electrical transformers on the right. There is a dirt area under the transformers with room for two cars. GPS coordinates: 41° 42.494'N, 74° 23.115'W.

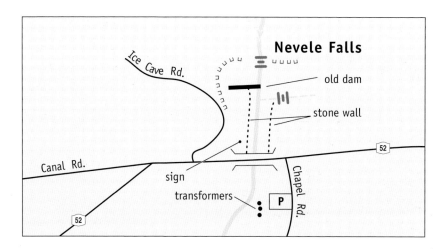

Nevele Falls

old dam

stone wall

Ice Cave Rd.

Canal Rd.

sign

transformers

P

Chapel Rd.

52

52

Carefully cross Center Street and hop the guardrail behind a large sign welcoming you to Ellenville. The fall is tucked into a narrow fault or fracture in the cliffs about 60 yards ahead of you. The creek is not posted. The flume-like character of the creek can make a water approach difficult since the remains of an old dam stand about halfway between you and the fall. An old stone wall makes a convenient shooting perch and allows you to get close enough to make lovely images.

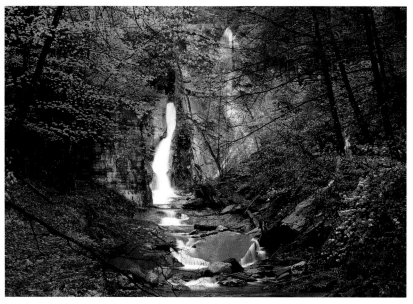

Nevele Falls. Normally this would be a vertical shot; however, with the small horsetail running well due to heavy rain and with water running in from the right, I opted for a different perspective. Note the remains of a large dam on the left where the leafy trail ends. *Canon EOS Digital Rebel, Tamron 28–200, Polarizer, ISO100 setting, f/22 @ 1.6 sec.*

Hike 4 | Verkeerder Kill Falls, Ulster County

Type: Fall	**Height:** 72 feet
Rating: 5+	**GPS:** 41° 41.094'N, 74° 19.698'W
Stream: Verkeerder Kill	**Distance:** 6 mile
Difficulty: Easy; moderate below the falls	**Elevation Change:** 770 feet
Time: 2 hours, 30 minutes	**Lenses:** 17mm to 70mm

Directions: From the intersection of US 209 (Main Street) and NY 52 (Center Street) take NY 52 east 1.2 miles, passing Nevele Falls, and turn left onto Mount Meenagha Road. In .8 mile Meenagha joins South Gully Road. You then make a quick right to stay with South Gully. Turn left onto Sam's Point Road in 2.2 miles. When you get to the odd-shaped intersection with Laurel Mountain Road in .8 mile, bear left one last time and enter the Nature Conservancy's Sam's Point Preserve and park in the large lot. GPS coordinates: 41° 40.202'N, 74° 21.732'W.

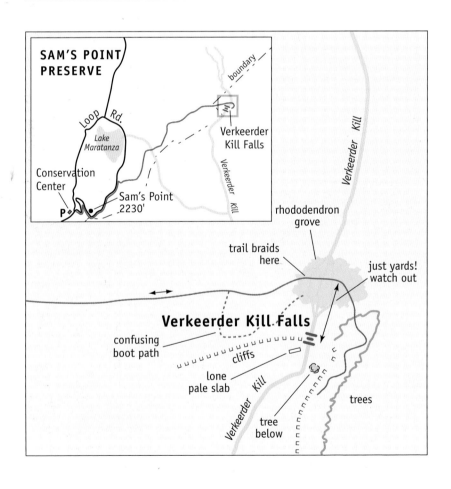

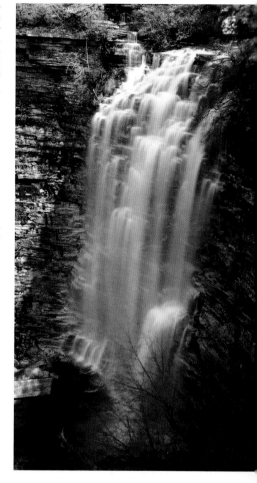

Verkeerder Kill Falls. This was shot in high winds from a sheer cliff and I had to set my tripod low to keep from being blown off the ledge. In order to compensate for the sunny conditions I under-exposed slightly and then did some light burning of the lit cliff face in Photoshop. I tried a high dynamic range image merge process but none of the trees or branches lined up due to the winds. *Canon EOS Digital Rebel, Tokina 20–35, Polarizer, ISO100 setting, f/22 @ 0.8 sec.*

Sam's Point Preserve is a 5,400-acre par-cel preserving one of the largest stands of red dwarf pine in the United States. Located on the southwest tip of the Sha-wangunks, this preserve begins a trail net-work that runs into Minnewaska State Park and on to the famed Mohonk Preserve. If you have the time to explore the "Gunks" you will not be disappointed by the vast array of cliff-edge views and more than forty rare plant and animal species. In fact, any of the views along the scarp of the Shawangunks is a prime spot to view the fall raptor migration.

Stop at the nice visitor center, pay the $7 fee, and then head along a road past a white wood-frame building. Follow signs and green blazes for Ice Caves and Ver-keerder Kill Falls. After climbing quickly 240 feet in .6 mile, the trail has a long, level section before beginning a decep-tively slow descent of 530 feet to the falls. This is why the net elevation gain is listed as 770 feet. After the steady .6-mile climb you arrive at exposed cliffs atop the scarp overlooking the parking area. It's a wonderful view.

At 1.0 miles you arrive at a signed turn for Verkeerder Kill Falls and the Ice Caves. Turn right and in about 100 yards turn left off the wide gravel road onto a rocky trail heading to the falls. After scrambling over rocks, boulders, and more rocks along a snake-like trail you come to a Y at 1.98 miles, blazed as a right turn. An unmarked trail on the left heads into the brush. Turn right instead. Cross into private land at 2.54 miles. Until I got here I assumed the falls was on Nature Conservancy property; it's not, so please behave accordingly. If the falls is running with any power you'll be able to hear it from this point. If, like me, you encounter standing water along the trail, take it as a good sign.

As you approach the fall near 2.9 miles you'll cross a braided creek through a confusing rhododendron patch; just keep an eye for blazes and

whatever you do, don't work right to get through the tangle. The fall's head is a few scant yards away and slick wet rock shows no mercy to the unwary. Once across the little creek, bear right and follow a cliff edge to a perch overlooking the falls' left-hand side. A trail continues along the cliff and provides stunning views of the Wallkill River and Hudson River valleys near Newburgh. Although the Hudson is hidden by low hills the river's course is evident. To the southeast, some 27 miles away, you can make out Storm King Mountain, which guards West Point.

The wide fall, situated in a large amphitheater, is surrounded by pale tan cliffs more than 90 feet tall. On my first trip here my walk was in a delightful mix of light rain and fog. I had shot about ten frames when both lifted, leaving the fall's right-hand side in bright sun. This created an impossible dilemma that was remedied by stitching together different exposures in Photoshop.

To return to your car, reverse your route, making the long 530-foot climb back to the gravel road and arriving at your car at 6.0 miles.

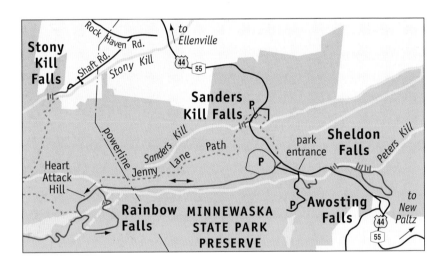

Hike 5 Rainbow Falls, Minnewaska State Park, Ulster County

Type: Fall	**Height:** 60 feet
Rating: 2–3	**GPS:** 41° 42.859'N, 74° 16.612'W
Stream: Tributary to Peters Kill	**Distance:** 7.4 miles
Difficulty: Difficult	**Elevation Change:** 850 feet
Time: 3 hours, 45 minutes	**Lenses:** 20mm to 70mm

Directions: From I-87, take exit 18 for New Paltz and NY 299. Take NY 299 west through New Paltz for 7.5 miles to a T intersection with US 44/NY 55. Turn right onto US 44 west and begin a long climb up a massive cliff. In 4.5 miles, turn left into Minnewaska State Park and pay the $9 parking fee. Then turn right and park in the lower parking area. GPS coordinates: 41° 44.062'N, 74° 14.686'W.

There are two steep climbs on this hike, one a road section climbing more than 100 feet and the other a hand-over-hand, root-assisted cliff climb of around 70 feet. Neither is a big deal, but when combined with a seven-mile hike they can be a tad much for some, so plan accordingly.

Head out along a wide gravel carriage road leaving the large lower parking area. This road is a pleasant, fast-paced jaunt through pines and with sporadic views of some well-preserved glacial features. At 1 mile there are a number of exposed and unusually smooth white sandstone slabs protruding from the ground. The white sandstone is called Tuscarora sandstone and is quite hard. You'll notice many parallel grooves running away from the road. These grooves, which are called striations, are formed by glaciers cutting the stones like an old-style record. All the rocks along the road have striations running in the general direction of New York City. Now consider that the massive cliff you climbed up on US 44 had a glacier pouring over it that was more than a mile thick.

At 2.0 miles you arrive at a trail junction. A blue-blazed footpath heading right, called the Jenny Path, leaves the road. This path crosses US 44 near Sanders Kill Falls (Hike 8, see page 22) about 1.5 miles away. Left is the Blueberry Path, which runs more or less along Peters Kill. Stay on the carriage road. Now climbing slightly but steadily, the road clings to a large open area on the right that dips steeply away. I actually found some cactus among the dwarf red pines here. When you pass under power lines at 2.5 miles you'll get a decent view of Peters Kill Valley on the left. From here the kill is audible when running full. Continuing steadily upward, at 3.0 miles you arrive at a sharp left where an old, less-used stone road heads straight and the better gravel carriage road goes left. Turn left and begin a climb up Heart Attack Hill, a steep climb to Lake Awosting. Having read about this "daunting climb," I found the name much worse than the fact. As you climb you'll pass a wood post on the left with green blazes; this marks your return route.

Continue up the road and pass below a nice cliff rising above on your right. The road tops out at 3.36 miles at a T junction facing Lake Awosting. Keeping the lake on your right, follow the road left as it sweeps away from the lake and begins a slight downgrade. Near 4.2 miles look for a signed green blaze that drops steeply left; this is the Rainbow Falls trail. Turn left and descend into a pine-filled valley. In 2008, ice storms wrecked a large number of trees and the Minnewaska staff was working hard to clear all the blowdowns. As a result

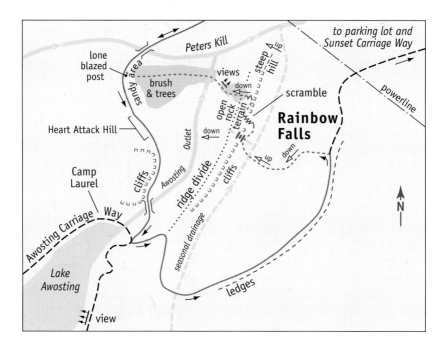

some blazes may be missing, so keep a sharp eye for green. At 4.44 miles, scramble up a boulder slide below the cliff-edge drop of Rainbow Falls.

This weakly running seasonal fall is actually two drops: a larger one on the left and another smaller one about 30 yards away on the right. Even in mid-April both still had large icebergs sitting at their base, which speaks to the winter shooting possibilities. However, by May both falls will be dry and as such this spot is not a fall color option. A view coming up on the return is, however.

To start the return leg, stand with your back to the fall looking for green blazes that head downhill and slightly left. Follow these, and within about 75 yards the blazes lead left up to a cliff. At first look the route appears to be a dead end but it isn't. The trail climbs up a rocky cleft; by using a couple tree roots you'll top out in a few minutes. Once atop the tree-lined cliff, turn left to follow the trail away from it. Shortly the trail becomes a bit more difficult to follow as dense trees give way to more bare rock exposures and blazes become sporadic; look for blazes on trees and at your feet on rocks. This is where you'll find a series of nice views looking northwest toward the Catskills. Carefully follow the green blazes down and ever so slightly left across open stretches of rock. Then inexplicably make a sharp left to cross a weak stream at 4.75 miles. It all happens quickly, so keep looking ahead *and* behind for blazes and don't be afraid to backtrack to keep the correct trail.

After a bit of confusion, rejoin the carriage road at the foot of Heart Attack Hill at 4.95 miles. Now turn right and follow the wide road, arriving back at your car at 7.4 miles. All in all, this is a nice long walk in the woods with just enough challenge to keep your interest up.

Hike 6 Stony Kill Falls, Minnewaska State Park, Ulster County

Type: Fall		**Height:** 90 feet	
Rating: 5		**GPS:** 41° 44.379'N, 74° 15.539'W	
Stream: Sanders Kill		**Distance:** 1.2 miles	
Difficulty: Easy		**Elevation Change:** 100 feet	
Time: 40 minutes		**Lenses:** 35mm to 90mm	

Directions: From I-87 exit 18 (New Paltz and NY-299), take NY 299 west through New Paltz 7.5 miles to a T intersection with US 44/NY 55. Turn right onto US 44 west and begin a long climb up a massive cliff. In 9.9 miles, after passing over and through Minnewaska, turn left onto the poorly signed Minnewaska Trail–Rock Haven Road and then make an immediate left onto Rock Haven. There will be an old hotel billboard marking the turn. In 1.9 miles turn left onto the gravel Shaft 2A Road and park at the road's end without blocking the gate or a nearby lane. A new parking area and fee station was under construction at the time of writing. GPS coordinates: 41° 44.045'N, 74° 17.760'W.

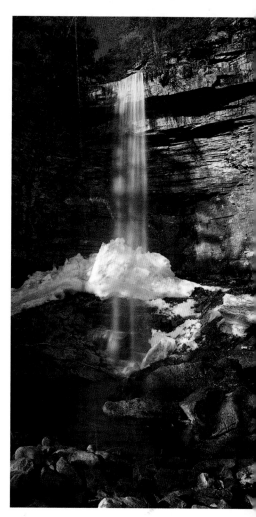

Walk down the wide road into what appears to be a vast mining area, passing a service shaft for a New York City aqueduct. In .4 mile you arrive at the narrow Stony Kill; turn right onto a bootpath that climbs up and right of a small check dam. The clarity of the path comes and goes, but as long as the creek is audible on the left you'll be fine. At .6 mile you arrive at a massive headwall and boulder choke below an impressive 90-foot fall.

Stony Kill Falls. Tricky lighting is no longer an issue with a careful digital exposure. I had shot this fall under "traditional" cloudy skies with much greater stream flow and had horrible problems with spray. Knowing the next day was to be sunny, I arrived just around dawn but still the sun cast significant shadows. With Photoshop I was able to dodge the dark side of the frame and burn the bright side to get an even result. If that's your intention, make sure the histogram touches the left edge of the scale with minimal "blinkies" and you should be okay. *Canon EOS 5D MkII, Tokina 20–35, Polarizer, ISO100 setting, f/22 @ 0.3 sec.*

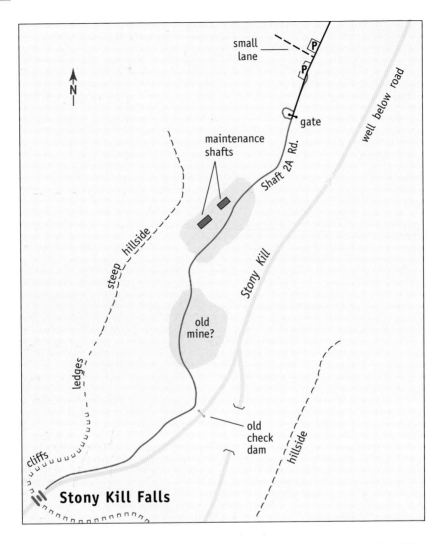

By climbing up through the rocks to your right you can shoot the fall's ballistic arc in profile. It's a very pleasing shape. From the tailwater you get a good view of this tall plunge's horsetail character. There is no plunge pool to use as an anchoring foreground and the boulders strewn about have gnarly little trees growing among them. There is a good view from the left, but I recommend the right-side view. In morning the plunging water will be backlit, providing an interesting effect. Facing more or less northeast the plunge will be brightly lit until well into the afternoon. If the fall is in shadow during a blue-sky day, try a graduated filter to even out the exposure, or else shoot a couple exposures and combine them in Photoshop.

Hike 7 Awosting Falls, Minnewaska State Park, Ulster County

Type: Fall	Height: 70 feet
Rating: 5	GPS: 41° 44.032'N, 74° 14.237'W
Stream: Peters Kill	Distance: 1.2 miles
Difficulty: Easy	Elevation Change: 60 feet
Time: 30 minutes	Lenses: 35mm to 90mm

Directions: Follow the directions and GPS coordinates for Hike 5 (see page 16).

This straightforward walk along wide carriage roads brings you to quite a large fall. Running powerfully mostly during snowmelt and after large spring storms, Awosting Falls is easy to shoot. The only major issue with this location can be potential large crowds. Minnewaska is only a couple hours from New York City and during fall color, or any nice weekend, the place is mobbed. I once sat on US 44 for fifteen minutes just to get in and then had to troll both parking lots for a spot. It was simply not fun. When I finally shot Awosting I did it in March during rain and ice when the steep carriage road down was only navigable using hiking studs.

From the lower parking area, walk up a wide carriage road running parallel to US 44, returning to the entrance hut in .3 mile. Then turn right onto

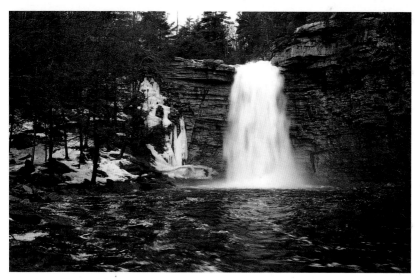

Awosting Falls. The fall was just blasting with snowmelt in March. An exposure of a 1/2 second left the watercourse white with no detail. The best option was to trade shutter speed for aperture and shoot a faster exposure, which left detail in the water. The steep, ice-covered trail required hiking studs. *Canon EOS Digital Rebel, Tokina 20–35, Polarizer, ISO100 setting, f/10 @ 1/6 sec.*

the paved road and then left onto a signed road down to Awosting Falls. Arrive at the fall's base at .6 mile. From close in along the trail the fall is hidden by some young pines, so move downstream and work from a stone retaining wall lining the creek. You can move into the creek some, but there is a strict prohibition against wading.

Hike 8 Sanders Kill Falls, Minnewaska State Park, Ulster County

Type: Fall over fall	**Height:** 12 feet
Rating: 3	**GPS:** 41° 44.379'N, 74° 15.539'W
Stream: Sanders Kill	**Distance:** .6 mile
Difficulty: Easy	**Elevation Change:** 35 feet
Time: 30 minutes	**Lenses:** 35mm to 90mm

Directions: From I-87 exit 18 (New Paltz and NY 299), take NY 299 west through New Paltz 7.5 miles to a T intersection with US 44/NY 55. Turn right onto US 44 west and begin a long climb up a massive cliff. In 5.6 miles, park along the road on the right at the Jenny Lane trailhead. You will probably spot the fall on the left about .2 mile from the parking area. GPS coordinates: 41° 44.561'N, 74° 15.262'W.

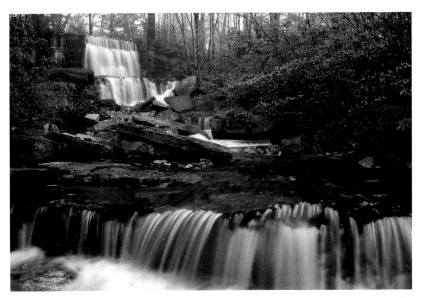

Sanders Kill Falls. You can stand next to this small fall or work from below, looking for anchoring foregrounds such as this little ledge. What's hard to see is the extent of the burn in the surrounding forest created by a 2008 forest fire. The fog helped to hide the crownless dead trees above. *Canon EOS Digital Rebel, Tokina 20–35, Polarizer, ISO100 setting, f/22 @ 2.5 sec.*

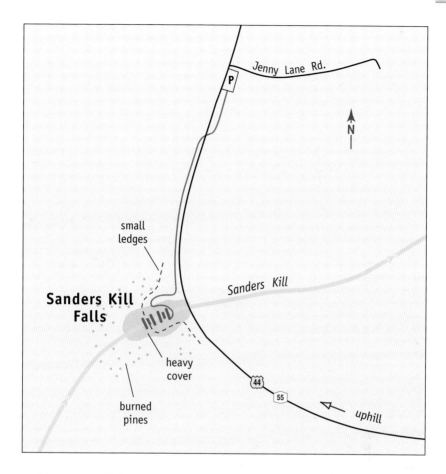

This two-tiered drop is interesting and easy to shoot. Getting through the rhododendrons is a bit of a problem though. After leaving the parking area, cross the road and walk east along US 44, sticking to the far side of the guardrail. Yes, this places you with the traffic flow; however, westbound traffic tends to hug the shoulder as it climbs.

In .25 mile turn right into the woods along a prominent bootpath and climb slightly. Very quickly turn left and arrive at the fall's top at an overgrown ledge. Next, follow a series of bootpaths down to the fall's tailwater and start shooting. The surrounding woods bear significant scarring from a large forest fire that burned a couple thousand acres in 2008.

Hike 9 Lower Peters Kill, Minnewaska State Park, Ulster County

Saw Mill

Type: Cascade over cascade	Height: 18 feet
Rating: 4	GPS: 41° 44.441'N, 74° 13.537'W

Sheldon

Type: Chute and cascade	Height: 53 feet
Rating: 5	GPS: 41° 44.346'N, 74° 13.834'W
Stream: Peters Kill	Distance: 1.6 miles
Difficulty: Easy	Elevation Change: 310 feet descent
Time: 1 hour	Lenses: 28mm to 100mm

Directions: From I-87 exit 18 (New Paltz and NY 299), take NY 299 west through New Paltz 7.5 miles to a T intersection with US 44/NY 55. Turn right onto US 44 west and begin a long climb up the face of a massive cliff. In 3.8 miles turn right into a parking lot for Minnewaska State Park's main office. GPS coordinates: 41° 44.439'N, 74° 13.539'W.

Before you begin this hike, check in at the main office to see if the trail from Saw Mill Falls to Sheldon Falls is officially open. The park staff was in the process of formally establishing a route between the two falls using an existing unblazed trail but had not gotten very far when the recession hit and halted public funding. The park's concern is not access to the fall, but instead in preserving a historically significant power plant nearby. So please ask permission to access Sheldon Falls before heading out. If the staff says no then that's the end of the conversation. If they say yes, apply the highest principles of ethical field practice by taking only pictures and leaving only footprints.

To begin, follow a path of woodchips from the large parking loop toward the bouldering and climbing area; an information kiosk will be on the left. In short order you cross a yellow-blazed climbing trail that meanders among ledges and a massive jumble of boulders. Your trail ahead is now blazed red and climbs slightly while following a stony road. You'll come to a small sign announcing the red-blazed Peters Kill Path. Follow this red blaze steeply downhill, arriving at the flume-like Peters Kill at .4 mile on the right-hand side.

The kill flows swiftly in early spring, but runs weakly by mid-to-late May before becoming a trickle by mid-June. This long, flume-like creek section has very nice shooting possibilities, particularly if the kill is running when the rhododendrons bloom in late June. Follow the kill upstream along a wide, meandering trail. Eventually the red-blazed trail makes a hard left steeply up and away from the creek along a wide expanse of exposed rock at

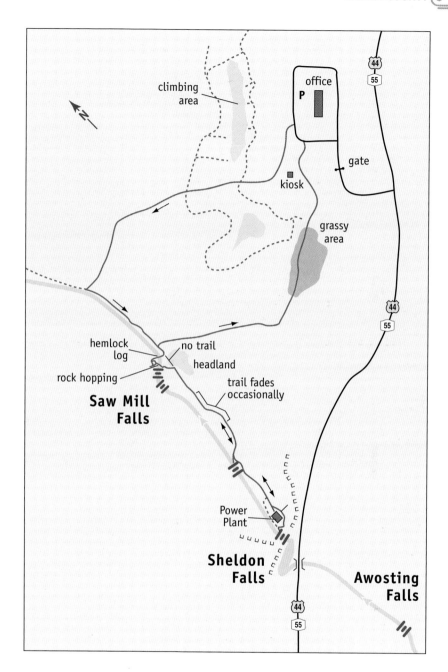

around .5 mile. This will be your return route. For now, continue straight along the creek and follow an unblazed bootpath.

A short distance ahead, the route is blocked by a headland where the kill makes a sharp ninety-degree turn from heading toward you to run parallel with the trail. Look to your right and find a large hemlock that bridges the

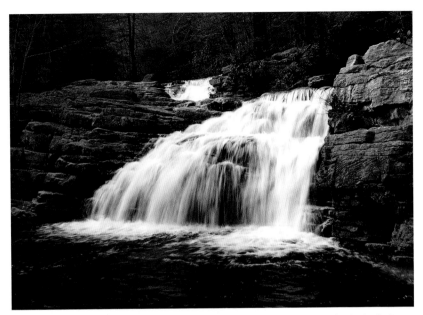

Saw Mill Falls. By setting up on a ledge on the left-hand side you can easily see both drops. In early spring, leafless trees above create a daunting monochrome scene, so compose tightly. In autumn go wide and have fun. *Canon EOS Digital Rebel, Tokina 20–35, Polarizer, ISO100 setting, f/8 @ 1/4 sec.*

creek. In low flow you can rock-hop the creek; in high you must carefully use the hemlock like a balance beam to bridge the creek. This move is not for the faint of heart.

Once across (and now on the left-hand side), work upstream along the creek and arrive at the tandem drop of Saw Mill Falls at .53 mile. The lower plunge is headed by a small cascade and the tailwater is filled with massive blocks of conglomerate. Rock-hop to a nice position and shoot away; don't forget to work from both banks. I liked a rocky perch on the fall's left-hand side that gave enough height to include both drops.

When you're done here, rock-hop to the right-hand side, where you'll find a slightly open pine forest and a number of "no swimming" signs among the trees. Now head slightly left away from the creek on a prominent unblazed trail. In about 100 yards the trail makes a hard left away from the creek, where it fades somewhat before going right again to become very distinct again as it runs creekside once more. Hop into the stone-bottomed creek, keeping to the dry edges, and head upstream to a nice little five-foot ledge at .68 mile (GPS coordinates: 41° 44.417'N, 74° 13.715'W). Linger a while and enjoy the lush green background, and then backtrack to the path you left several yards back.

Continue along the unblazed path that parallels the kill. It will fade briefly a couple of times, so keep a sharp eye out for trail sign such as ground-up

leaf litter. Also, the creek will be in sight on the right the entire way. On my first trip I was so intent on keeping the trail I almost bumped into the stairs leading to the old power plant, which you reach at .78 mile. Inside there are two complete dynamos, the remains of a back-up diesel generator, old power panels, and simply fascinating stonework. What a wonderful place to shoot black and white! I used to work on historic steam locomotives when I was younger and this old plant brought back quite a few memories.

Head left of the building and find Sheldon Falls at .8 mile. This large fall is two distinct drops melded into one. Right is a steep chute and left is a wispy cascade. In low flow only right will run and in high flow both will run, with the left side running weakly. After its 53-foot tumble, the water slides along steeply pitching smooth stone. Leaf litter closest to the right-hand bank (the side you're on) will be quite slick. Shooting options abound but a blank sky above will fill the frame's upper left. There's no avoiding this unless you set up well left and shoot the fall edge-on. I spent about two hours shooting here and then about another hour just hanging out enjoying a nice wet April day.

Above Sheldon Falls and close to US 44 is another drop of about fifteen feet, which you saw from the car on your way to the other falls in Minnewaska State Park. This upper section defines the lower drop's head wall and it's absolutely inaccessible.

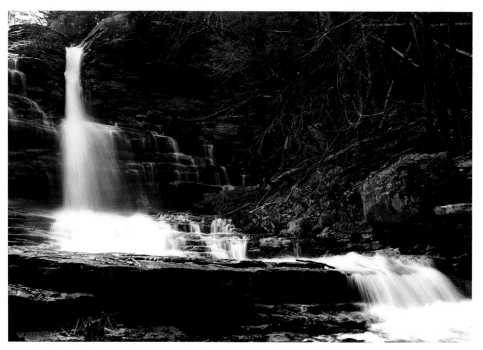

Sheldon Falls. From downstream the frame's upper left will be a blank white triangle. Move close and left to eliminate this, even if you miss some of the cascade. *Canon EOS Digital Rebel, Tokina 20–35, Polarizer, ISO100 setting, f/8 @ 1/4 sec.*

Reverse your route and head back to the red blaze that climbed up the steep stone exposure, now at 1.2 miles. Turn right and head steeply uphill, keeping a careful eye out for blazes. Some will be on trees, some at your feet on the stone, and all will be faded. You will not cross the yellow trail on the way out as you might expect; instead you will top out when you enter a field. Here the now-grassy trail swings left, returning to the parking lot near an information kiosk you saw earlier. Before you pack up, do me a favor— thank the park staff for their work. It takes a great deal of effort to manage a park this size and they do take some grief from rude and impatient people.

Hike 10 Brace Mountain, Dutchess County

Type: Cascade	**Height:** 63 feet
Rating: 4	**GPS:** 42° 1.863'N, 73° 29.797'W
Stream: High Falls Creek	**Distance:** 1.1 miles
Difficulty: Difficult	**Elevation Change:** 640 feet
Time: 40 minutes	**Lenses:** 17mm to 70mm plus macro

Directions: From the center of Copake Falls, take NY 22 south 7.0 miles and turn left onto White House Crossing Road. Climb a hill and enter a nice housing development. In .7 mile turn left onto CR 63 (Boston Corners Road) and then in .2 mile make a quick right onto Deer Run Road. In .5 mile turn left onto Quarry Hill Road (which may be signed as Deer Run), and then in .5 mile park on the left opposite houses number 102 and 100 in a tight two-car-wide parking area signed Taconic State Park. GPS coordinates: 42° 1.950'N, 73° 30.334'W.

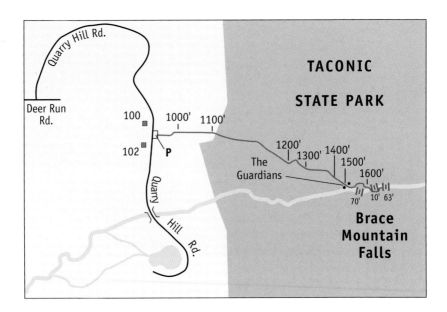

Brace Mountain Falls. Take care to remove whatever birch branches you can reach before shooting. The pale white bark will stand out in stark, distracting relief against the dark stone. This attention to detail is critical to obtaining a publishable image. *Canon EOS Digital Rebel, Tokina 20–35, Polarizer, ISO100 setting, f/20 @ 3.2 sec.*

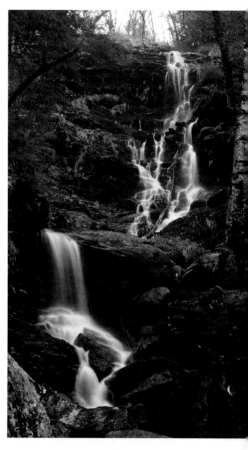

"**U**p!" is the best description I can give for this steep trail that ends at a nice seasonal cascade. Follow a white-blazed footpath out of the parking area and away from the road. For about 100 yards the path follows a field edge before turning left and entering the woods. The next .5 mile is a relentless 600-foot climb; the last 50 yards is brutal but which I found kind of fun. As you work uphill the trail will swing right along a level line near .4 mile and appear to end at the creek. Look up and left for two massive boulders with a steep ladder-like footpath passing between them. These rocks are called the Guardians; turn left to head steeply uphill between them and zigzag hand-over-hand past a 70-foot-tall slide. Once above the slide turn right and drop into the creek near the head of a 10-foot cascade. This is your spot to shoot while looking up at the 63-foot cascade. I tried to get a shot of the big slide below but couldn't find a position with enough of a foreground to make a nice image. It's a big slide but something about it left me saying "meh." During my first trip in mid-May the fall was running powerfully for its size and numerous red trilliums could be found along the creekshed quite a ways down from the fall.

Hike 11 Spillway Gorge, Ulster County

Type: Flume	**Height:** 35 feet
Rating: 4	**GPS:** 41° 55.949'N, 74° 10.127'W
Stream: Spillway Channel	**Distance:** 100 yards
Difficulty: Easy	**Elevation Change:** None
Time: 10 minutes	**Lenses:** 20mm to 70mm

Directions: From I-87, take exit 19 at Kingston. Merge onto NY 28 west and make your way around the traffic circle to stay with NY 28. In 3.0 miles turn left onto CR 50/NY 28A west, and then in 3.2 miles make a slight left to follow CR 50 (Spillway Road) Shortly after, bear right away from Dug Hill Road to keep with CR 50. When you come to a Y-shaped intersection with Beaver Kill Road and Ashokan Road a large bridge will be on the right. Turn right and park at any convenient point that doesn't block the intersection. GPS coordinates: 41° 55.937'N, 74° 10.108'W.

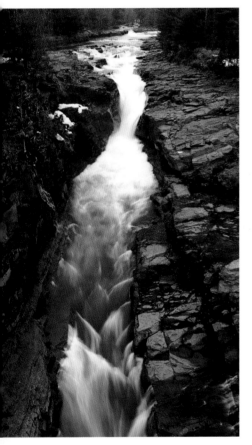

Walk to the bridge's mid-span and shoot the large cataract upstream. During spring snowmelt the flume will be running violently to the point that smooth water fills the narrow channel hiding the drop. In low flow the flume has a much more distinct edge to it. The shape of the channel makes this purely a vertical shot. Traffic on the bridge will cause camera vibration, so wait for long traffic gaps before squeezing the shutter, and work quickly since you are in an exposed position even though the bridge is quite wide.

Ashokan Spillway. Believe it or not, this image was shot with a level on the camera. The subtle tilt of the rock strata and high perspective from the bridge makes the image look like it has quite a tilt. Although expensive, a bubble level that fits your camera's hot-shoe is a critical tool. *Canon EOS Digital Rebel, Tokina 20–35, Polarizer, ISO100 setting, f/8 @ 0.6 sec.*

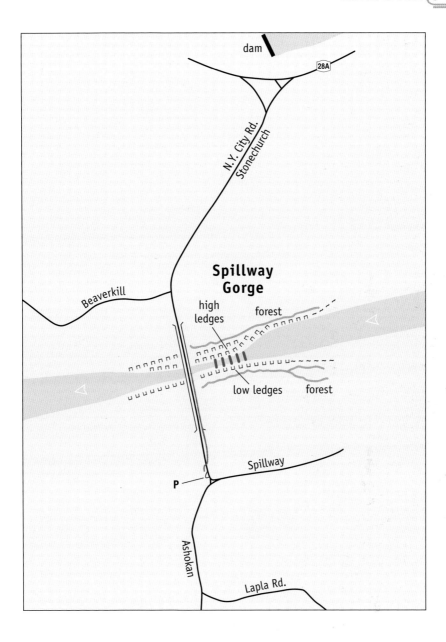

dam

28A

N.Y. City Rd.

Stonechurch

Spillway Gorge

Beaverkill

high ledges

forest

low ledges

forest

Spillway

P

Ashokan

Lapla Rd.

Hike 12 **Peekamoose Road, Ulster County**

Buttermilk Falls

Type: Cascade	**Height:** 46 feet
Rating: 5	**GPS:** 41° 55.443'N, 74° 24.808'W
Fall 2	
Type: Chute over slide	**Height:** 54 feet
Rating: 3	**GPS:** 41° 55.416'N, 74° 24.183'W
Fall 3	
Type: Cascade	**Height:** 65 feet
Rating: 5	**GPS:** 41° 55.446'N, 74° 23.597'W
Fall 4	
Type: Cascade	**Height:** 100 feet
Rating: 5	**GPS:** 41° 55.443'N, 74° 24.808'W
Fall 5	
Type: Cascade	**Height:** ~90 feet
Rating: 3	**GPS:** 41° 55.432'N, 74° 21.651'W
Fall 6	
Type: Cascade	**Height:** ~90 feet
Rating: 5	**GPS:** 41° 55.392'N, 74° 22.039'W
Stream: Buttermilk Falls Brook	**Distance:** No walk is more than 200 yards
Difficulty: Easy	**Elevation Change:** No walk more than 30 feet
Time: 1 hour, 20 minutes	**Lenses:** 20mm to 80mm

Directions: From the intersection of US 209 (Main Street) and NY 52 (Center Street) in Ellenville, take US 209 north 17.7 miles to the town of Stone Ridge. Turn left onto NY 213 (Cooper Street). In 1.0 miles NY 213 makes a sharp right. Join NY 28A in 7.5 miles by bearing left along the west shore of Ashokan Reservoir. In 5.5 miles you arrive at the village of West Shokan at the intersection of Watson Hollow Road and NY 28A. GPS coordinates: 41° 58.147'N, 74° 16.614'W.

This combination of driving and quick walks covers nearly ten miles of Peekamoose Road, which some have labeled the "Waterfall Highway." I agree with that label. I have structured this drive to take you to the farthest fall (Buttermilk) first so you can scout the route and then shoot on the return leg. Thus, all road mileages begin from the small parking area at Buttermilk Falls. I did this because if you are driving solo all the landmarks you need are on the passenger's side of the vehicle, making them tough to see

when heading west. By making a scouting run you get a lay of the road and then have the important landmarks on the driver's side when it matters.

Please note there are very few places to turn around along the narrow road, much of which is vigorously signed for no parking. If you miss a parking area or simply blow by a nice fall you will most likely need to turn around at either a state campground west of Buttermilk Falls or at a logyard between falls 3 and 4. That's okay; I did it more times than I care to count. It helps to have another pair of eyes keeping track of parking spots while your eyes are glued to the odometer.

The valley is a confusing mixture of public land and private logging tracts that are heavily posted. What follows are the falls that you can access or shoot from public lands. Most of the falls drop from the road side of Rondout Creek. Those that drop on the far side are difficult to get to and most are on private land. Of all the falls on private land, only three can be photographed without violating the law. So, if a fall doesn't appear here, don't bother trying to get to it. Finally, the sun gets above the east ridges around 9:00 A.M. You can shoot on a clear day prior to that as the west side will remain in deep shadow. After 9:00 A.M. you'll need clouds.

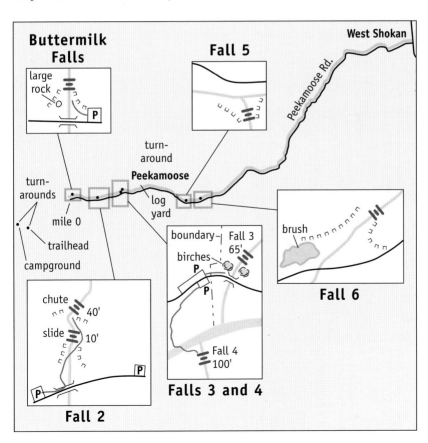

Begin the scouting run from the intersection of Watson Hollow and NY 28A. Zero your trip odometer and head down Watson Hollow Road and bear right at .5 mile where High Point Mountain comes in on the left. The road passes through the wide floodplain of Bush Kill Creek. Climbing steadily, the creek gets ever smaller until you pass over a drainage divide in a narrow valley at 5.4 miles. From here on you are in the drainage basin of Rondout Creek. At 6.2 miles pass Fall 6 on the left followed quickly by Fall 5 on the right at 6.5 miles. The road makes a quick jog over a narrow culvert crossing Rondout Creek at 6.8 miles, after which you pass Peekamoose Lake (actually a large pond with a house) at 7.1 miles. Next up is the logyard—a turnaround spot—at 7.8 miles, followed in rapid succession by Fall 4 on the right and Fall 3 way on the left across the valley. Pass the parking for Falls 3 and 4 at 8 miles. The next parking area is found between 8.3 and 8.4 miles, after which you cross a culvert and pass Fall 2 on the right at 8.5 miles, arriving at the next parking area just beyond. Finally you pass Buttermilk and its parking area at 9.0 miles. Continue along downhill and turn around at the Peekamoose Mountain Trailhead at 10.1 miles and return to Buttermilk Falls, which is now "0" for all mileages back to West Shokan and NY 28A.

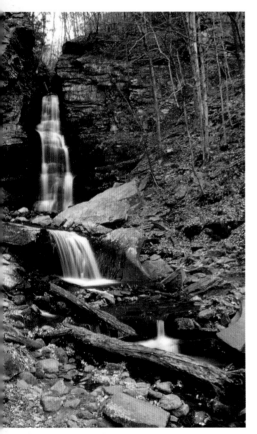

The parking area shares GPS coordinates for the falls at 41° 55.443'N, 74° 24.808'W. This 46-foot cascade is actually two distinct drops equally divided by a thin ledge. Below is a three-foot ledge that can be used to anchor the image. From the five-car-large parking area, walk up the embankment 20 yards and drop into the creek and start shooting. The fall's face is aimed at the creek's left-hand side (the side you're on) so there's no need to hop to the other side. The fall exits from a flume above, and when running hard the water does get tossed clear of the intermediate ledge. Now with the trip odometer reset, it's time to move on.

In .5 miles park on the left at GPS 41° 55.423'N, 74° 24.235'W for Fall 2. An alternate parking location is at .7 mile at GPS 41° 55.416'N, 74° 24.183'W, which is

Buttermilk Falls. The best location is from the creek's left-hand side. From here the watercourse curves through the frame and creates a pleasing line. *Canon EOS Rebel XS, Tokina 20–35, Polarizer, Kodak E100VS, f/16 @ 1 sec.*

Second Fall of Peekamoose Road. The fall's lower section is just a portion of the total drop. In this shot you can see the easy route up on the frame's left side. The upper section has nice lines and provides ample places to set up. *Canon EOS Digital Rebel, Tokina 20–35, Polarizer, ISO100 setting, f/16 @ 2 sec.*

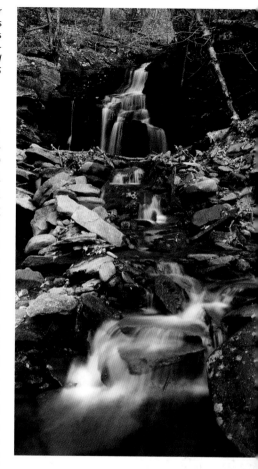

a little far to walk along this narrow road. Walk against oncoming traffic or walk on the far side of the guardrail about 60 yards to the fall. This corkscrew of a fall consists of a 40-foot chute separated from a 10-foot cascade by a few yards. Getting both drops in frame is difficult because overhanging birch branches fill the frame with frustrating "sneakers." This particular fall is best during early snowmelt or after a tropical storm, since in summer it's almost invisible.

Continue uphill and arrive at the parking area for Falls 3 and 4 at 1.0 miles, at GPS 41° 55.488'N, 74° 23.662'W. The larger and safer parking area is on the left. Fall 3, which is on the road side of Rondout Creek, is on private land and several no trespassing signs are nailed inconveniently to foreground trees. You'll have to walk quickly up this curvy section of road about 100 yards to arrive at Fall 3. The signage is not a real problem with careful framing and tripod placement. The number of signs used makes one message clear—don't cross the guardrail! The best position is between a "no parking" sign and the end of the guardrail. It's a natural vertical shot framed by two large trees; if you're lucky enough to have good flow during peak fall color you'll have a keeper.

Fall 4 is on public land across the creek. To shoot the fall, cross the road from the parking area and descend to the now rather wide Rondout Creek. Work upstream a short distance and ford the creek, which is easily done in waders. You won't be able to rock hop across in decent flow. This unnamed 100-foot cascade is fed by a weak-running creek with a small drainage basin, thus making it seasonal and with a rather short season at that. Even so, it's a nice drop and requires a little extra shutter speed to get the thin water veil to properly fill the frame. I ended up shooting four seconds and longer.

Falls 5 and 6 are on private land with no available parking. The road near Peekamoose Lake is very narrow with quite a few no parking signs. Without

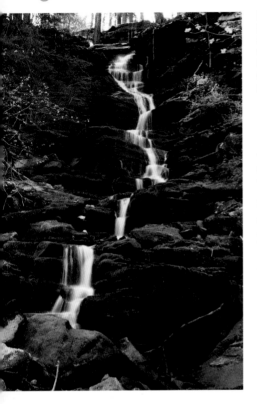

Fourth Fall of Peekamoose Road. The fall across Rondout Creek, purely a vertical, is also filled with nice macro opportunities. Always take the time to work a scene completely. In this case the composition I chose was probably my fifteenth setup. *Canon EOS Digital Rebel, Tokina 20–35, Polarizer, ISO100 setting, f/29 @ 4 sec.*

a second driver to tag-team these two drops you won't be able to shoot them. With another driver you'll have to shoot from the road with a long lens since better compositions would require that you trespass onto private land. Also, both drops sit at the highest elevation and have by far the smallest drainage basins. It's best to content yourself with just a look as you pass by at 2.5 and 2.9 miles.

Continue uphill out of the Rondout Creek Valley, passing over the drainage divide for the last time at 3.8 miles. Arrive back at NY 28A in West Shokan at 9.0 miles.

Hike 13 Vernooy Kill Falls, Ulster County

Type: Fall	**Height:** 18 feet
Rating: 4	**GPS:** 41° 52.322'N, 74° 22.225'W
Stream: Vernooy Kill	**Distance:** 2.1 miles
Difficulty: Easy	**Elevation Change:** 140 feet
Time: 1 hour	**Lenses:** 20mm to 70mm

Directions: From the intersection of US 209 (Main Street) and NY 52 (Center Street) in Ellenville, take US 209 north 7.6 miles and turn left onto CR 3 (Samsonville Road) There'll be a business selling garden sheds on the left. In 3.4 miles make a slight left onto Upper Cherry Town Road, which twists and climbs with numerous poorly signed road junctions. The road ends at a T with Sundown Road and Trails End Way at 5.5 miles; turn left on Trails End. Starting as a rather narrow paved lane, it passes through a confusing development and first becomes improved gravel, and then a woods road. Follow Trails End 1.7 miles to a yellow gate and parking lot at GPS coordinates 41° 53.048'N, 74° 21.650'W. The upper end of Trails End is nearly a high-clearance road and passable by only one vehicle at a time. Beyond the gate it becomes a jeep trail. Alternate parking is on Upper Cherry Town Road at a signed parking area at GPS coordinates 41° 51.854'N, 74° 20.773'W.

If you enjoyed the road leading to this hike, you'll like the falls. Starting from the large parking area, follow the red-blazed snowmobile trail around the big yellow gate and swing left. This wide, grass-covered woods road has intermittent rock walls on either side for much of the way. When the falls is audible near .92 mile the trail curves right; you want to bear left toward the creek and at 1.0 miles come to a footbridge that sits just below the falls. Shoot from the bridge, as well as below it and from both ends near the creek. This is a great starter hike for the kids so bring a picnic lunch. All in all it's a thoroughly delightful walk in the woods. What this fall lacks in power it more than makes up for with solitude and quiet. The creek begs to be shot above and below the drop.

If the nearly four-wheel-drive road isn't your cup of tea you can park at another trailhead along Upper Cherry Town Road. Follow a blue blaze steep uphill, gaining around 600 feet during the 1.6-mile one-way hike.

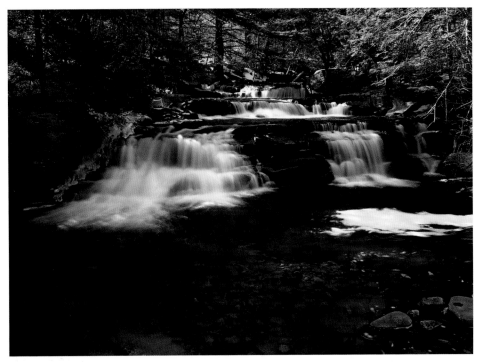

Vernooy Kill Falls. I wish I had brought a wider lens here, since 20mm was just a hair too long. Another ledge sits below the trail bridge and it would have been nice to include that element as a foreground. *Canon EOS Digital Rebel, Tokina 20–35, Polarizer, ISO100 setting, f/16 @ 1 sec.*

Hike 14 Willowemoc Creek, Sullivan County

Fall 1

Type: Cascade	**Height:** 8 feet
Rating: 2	**GPS:** 41° 54.202'N, 74° 41.857'W

Fall 2

Type: Fall	**Height:** 17 feet
Rating: 3–4	**GPS:** 41° 54.096'N, 74° 41.720'W
Stream: Tributary to Willowemoc Creek	**Distance:** 1.1 miles
Difficulty: Easy	**Elevation Change:** 165 feet
Time: 40 minutes	**Lenses:** 20mm to 50mm

Directions: From NY 17, exit 98 northwest of Liberty, take CR 84 (Cooley Road) northeast 4.8 miles and then bear left onto Anderson Road/Hill Road. In .3 mile bear slightly right onto Conklin Road. In 1.0 miles arrive at a handsome covered bridge and park on the right near either end. GPS coordinates: 41° 54.391'N, 74° 41.986'W.

From the covered bridge's south end (left-hand bank of Willowemoc Creek) follow an obvious footpath along a narrow stream that enters Willowemoc Creek near the bridge. In about 50 yards you make the first of three fords crossing to the creek's right-hand side. Like all such creeks the glen is relatively straight but the creek itself meanders. The next two fords are at the hiker's discretion in order to maintain a level line. The first fall is found at .3 mile. This small, three-tiered cascade is a nice place to sit and while away some time looking for wildflowers and salamanders.

Work up and around this drop on the right-hand side but resist the urge to make for higher ground. Instead, stick close to the creek, shooting as you go and arriving at a perfectly photogenic drop at .5 mile. This second cascade sits in a fairly open amphitheater with a wobbly large birch clinging to a rock on the right-hand side. This big tree will eventually drop into the small plunge pool and dramatically change the fall's character. When it does, be prepared to try and muscle it out of the way.

In late April, about when leaf-out gets rolling, look for pale purple flowers with five petals and yellow ones with four; bring macro gear to shoot them. Unfortunately, I didn't shoot them nor did I bring my wildflower guide.

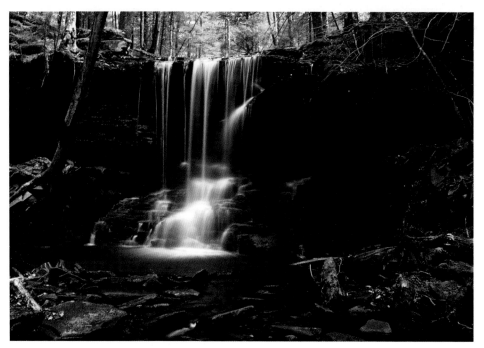

Willowemoc Creek Upper Falls. The lower drop works better for vertical compositions than the upper. The rocky tailwater of the upper fall breaks the watercourse enough so there's no leading line for the eye. This effect makes the image appear discontinuous and thus unbalanced. You don't see the effect in the viewfinder, which is why you must shoot verticals and horizontals of every location. *Canon EOS Digital Rebel, Tokina 20–35, Polarizer, ISO100 setting, f/22 @ 4 sec.*

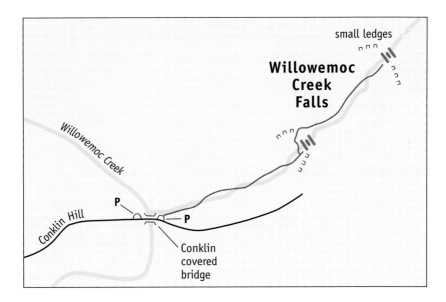

You'll have to identify them on your own, which is one of the joys of this kind of walk. I continued upstream a short distance and enjoyed every foot of it. Retrace your route and arrive back at the car in 1.1 miles.

Hike 15 Russell Brook, Delaware County

Type: Cascade	**Height:** 23 feet
Rating: 4+	**GPS:** 41° 59.747'N, 74° 56.437'W
Stream: Russell Brook	**Distance:** .5 mile
Difficulty: Easy	**Elevation Change:** 40 feet
Time: 20 minutes	**Lenses:** 17mm to 70mm

Directions: From the town of Roscoe along NY 17, take exit 94 for NY 206 and follow that road west out of town 2.7 miles before turning left onto Morton Hill Road. Bear right in .2 miles to continue on Morton Hill; Gavett Road then comes in from the left. In another 3 miles turn left onto the gravel Russell Brook Road. Descend a hill and park in large signed parking area in .5 mile. GPS coordinates: 41° 59.662'N, 74° 56.505'W. Please note that you can't approach from exit 93 since Russell Brook Road is blocked at a campground.

This simple family hike can be crowded on any weekend. Head down the wide gated road away from the parking area on the blue-blazed Mud Pond Trail. A simple quarter-mile walk brings you to a large rock face with a lovely cascade dropping over it. When you come to an old road bridge the fall will be in view; start shooting from here, especially

during fall color. Cross the bridge and follow a dirt track that leads to a breached dam; hop over the outermost edge and rock-hop upstream. A small stone wall above the fall is evidence of another dam from the region's industrial past.

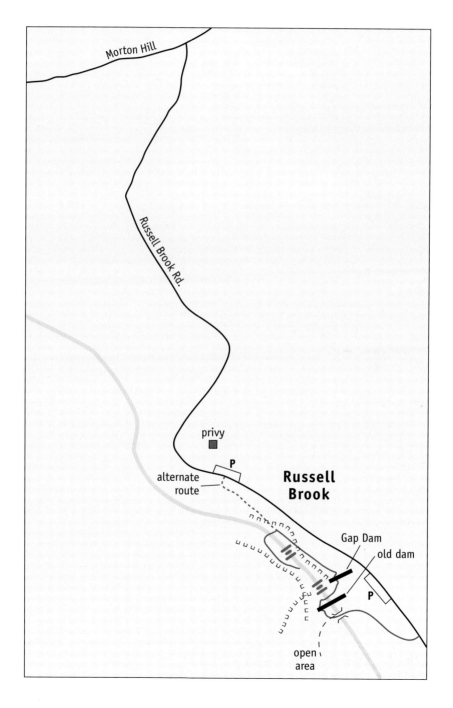

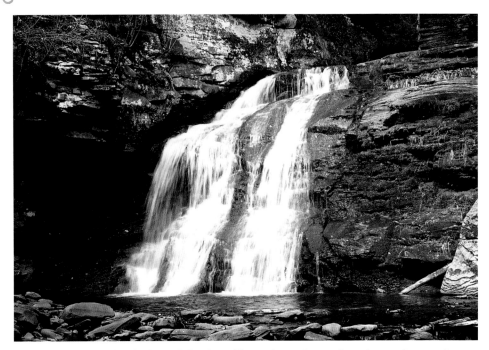

Russell Brook Falls. I had to wait for about fifteen minutes for people to clear my frame and still I had to go much tighter than I would have preferred in order to crop out heads and arms. Patience is a virtue when working popular locations. *Canon EOS Digital Rebel, Tokina 20–35, Polarizer, ISO100 setting, f/8 @ 1/13 sec.*

As you face the fall, note a wide swath of white lichen on the upper left. This lichen will be a problem since it will remain dry and very white when the rest of the area is dampened by rain. A second drop sits about 40 yards above the first. To get to it, ford to the creek's left-hand side and scramble upslope to gain the lower drop's head. Now continue upstream along the glen edge to a point about 20 yards above the upper drop and cross back to the right-hand side. Now you can work downstream and back into the creek to get to the second drop's base.

As an alternate you can park at a two-car-large parking area up the road that has a privy (you passed it on the way in). Cross the road and follow it downhill for about 50 yards, looking for a large plastic drainpipe passing under the road. Turn right and drop into the drainage, and then on to Russell Brook. Now head downstream, fording as needed to make the upper fall's head at about 100 yards or so, and scramble down the fall's right-hand side.

Hike 16 Tompkins Falls, Catskill State Park, Delaware County

Type: Fall	**Height:** 26 feet
Rating: 5	**GPS:** 42° 4.522'N, 74° 45.893'W
Stream: Barkaboom Stream	**Distance:** 100 yards
Difficulty: Easy	**Elevation Change:** 50 feet
Time: 20 minutes	**Lenses:** 17mm to 100mm

Directions: Begin where NY 30 crosses Pepacton Reservoir east of Downsville. Head east from the bridge's south end on BWS Road 8 for 1.9 miles and bear right onto Barkaboom Road. Follow Barkaboom 1.3 miles and park on the right in a large, wide spot. The fall is visible from Barkaboom Road for some distance. GPS coordinates: 42° 4.544'N, 74° 45.879'W.

Severe flooding in 2004 made this roadside fall even easier to access when a mudslide damaged the road. The hill facing the fall was regraded and the entire area opened up. All along NY 30 you'll find new culverts, revetments, and reinforcing structures. We felt the effects of this flooding in Pennsylvania as all the runoff made its way down the swollen Delaware like a football being swallowed by a snake.

A word of caution when working from the tall concrete retaining wall fronting the fall: what faces the creek is only the visible portion of two walls

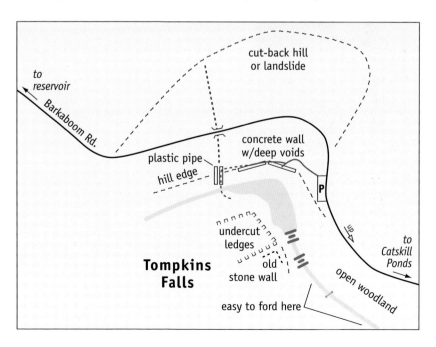

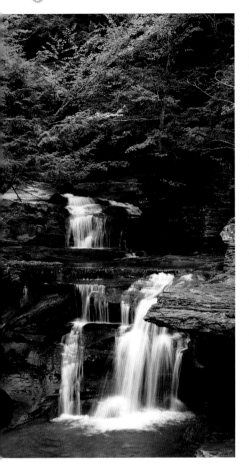

Tompkins Falls. The best shooting options are atop the wall. In late August you can see the first hint of autumn blush in the forest. Although nicely cloudy it was not raining, so to keep the surrounding rock damp I carried water using my hat. This laborious process darkens the rock so it renders properly. *Canon EOS Digital Rebel, Tokina 20–35, Polarizer, ISO100 setting, f/8 @ 1/5 sec.*

separated by a wide gap. This gap is two feet wide and ten feet deep and is hidden by brush. A monofilament seed mat covers the gap, making it more like a bear trap. You must absolutely probe the ground with a tripod leg to avoid this. If you want to shoot from the wall (which I did), walk only on the exposed portion.

From the parking area, hop the guardrail and walk to the lower fall's head, and then work downstream along the wall. As an alternate, head down the road beyond the point where two large plastic pipes pass under the road. Follow the pipes down the slope and drop into the creek yourself. This avoids a deep hole a few yards upstream. Now ford and work upstream and then work back into the creek at any convenient point and shoot. It's deep and cold so waders are in order. Enjoy!

Hike 17 Bushnell Falls, Catskill State Park, Greene County

Type: Fall over cascade	**Height:** 23 feet
Rating: 3	**GPS:** 42° 11.043'N, 74° 24.930'W
Stream: Tributary to Bushnellsville Creek	**Distance:** 100 yards
Difficulty: Easy	**Elevation Change:** 50 feet
Time: 20 minutes	**Lenses:** 17mm to 50mm

Directions: From the intersection of NY 42 and NY 28 in Shandaken, take NY 42 north 5.25 miles, passing through the hamlet of Bushnellsville. You'll cross into Greene County after 3.0 miles. Park in a wide area on the left. The fall will be visible on the left opposite a large concrete retaining wall on the right. GPS coordinates: 42° 11.054'N, 74° 24.911'W.

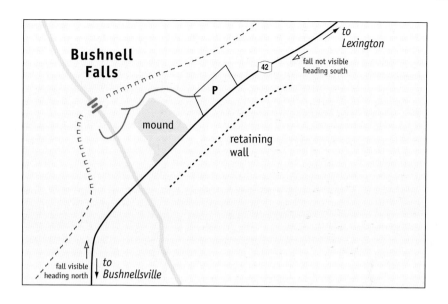

This convenient location provides a delightful seasonal horsetail cascade that drops from an unnamed creek flanking 3,408-foot-tall Halcott Mountain. The park boundary is only 1.4 miles northwest as the crow flies. Best in spring, it also runs with reasonable power during wet weather. From the parking area, take a wide, well-used footpath about 50 yards to the falls. There is one challenge in shooting this little drop and that's a large patch of white lichen on the left. This sizeable mass is sheltered from rain so it is never truly damp and thus a polarizer won't dull the highlight effect it creates. You'll have to jockey your tripod position to work for the best composition.

Hike 18 Diamond Notch, Catskill State Park, Greene County

Type: Cascade	Height: 24 feet
Rating: 4	GPS: 42° 10.514′N, 74° 15.479′W
Stream: West Kill	Distance: 1.6 miles
Difficulty: Moderate	Elevation Change: 230 feet
Time: 1 hour	Lenses: 17mm to 70mm

Directions: From the intersection of NY 42 and NY 28 in Shandaken, take NY 42 north 6.6 miles. Pass through the hamlet of Bushnellsville and turn right onto Spruceton Road in the hamlet of West Kill. Take Spruceton east 6.7 miles to a dead end and park on the right in a large parking lot. GPS coordinates: 42° 10.872′N, 74° 16.104′W.

Head up a wide, blue-blazed trail from the parking area on the Diamond Notch Trail, walk around the gate, and register. Continue along the rocky woods road for .8 mile to the falls, which are found below a large footbridge and a Y where a red blaze bears left to the Devil's Lean-To.

As the bridge comes into view through trees on the right, follow a well-trodden path leading to a root-assisted scramble down to the fall's tailwater. Once in the creek you will notice how the fall is three parallel drops. The lion's share of the flow goes over the left-hand side in a wide fan. The right-hand has two horsetails that eventually fan out over lovely moss-covered rocks. Pale sandstone caps the fall and must be wet in order to render correctly. If you intend to wet it yourself, note that the rounded-off edge is a bit slick and if you start sliding you might end up going over the ten-foot drop—not a good outcome. When working from the creek, start off well downstream, slowly working upstream, and shoot verticals and horizontals as you go.

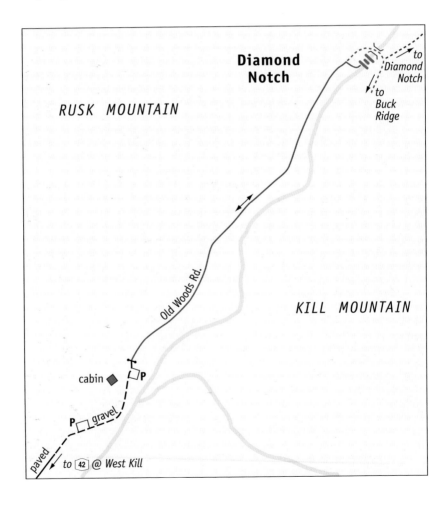

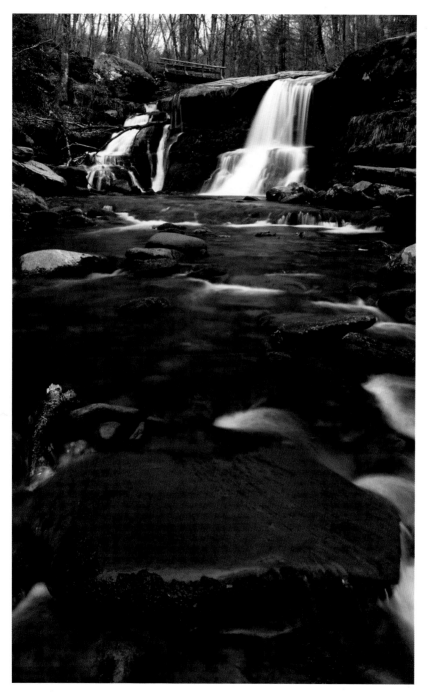

Diamond Notch Falls. The signpost in the top of the frame has an orange sign atop. Cropping it out leaves a "sneaker" jutting in from the frame edge. The only way to manage this offending element is to clone it out in Photoshop. *Canon EOS Digital Rebel, Tokina 20–35, Polarizer, ISO100 setting, f/20 @ 1.6 sec.*

If you have several hours to kill don't bother with the trail. Instead throw on some waders and make a waterborne approach, shooting as you go. You'll take some bumps and bruises, however. This creek is as nice as any in the Smoky Mountains and should be savored if possible. It's a gorgeous place indeed.

Hike 19 Stony Notch Falls, Catskill State Park, Greene County

Stony Notch Upper	
Type: Cascade	**Height:** 24 feet
Rating: 3	**GPS:** 42° 9.458′N, 74° 12.009′W
Stony Notch Lower	
Type: Cascade	**Height:** 10 feet
Rating: 3	**GPS:** 42° 9.458′N, 74° 12.009′W
Tributary Cascade	
Type: Cascade	**Height:** 40 feet
Rating: 3	**GPS:** 42° 9.458′N, 74° 12.009′W
Stream: Stony Notch Creek	**Distance:** .9 mile
Difficulty: Moderate, steep creek ascent	**Elevation Change:** 320 feet
Time: 45 minutes	**Lenses:** 20mm to 70mm plus macro

Directions: From the intersection of NY 214 and NY 28 in the town of Phoenicia, take NY 214 north 9.3 miles toward Lanesville and Edgewood. Park on the left in the large signed parking area at Notch Lake and the Devil's Tombstone. GPS coordinates: 42° 9.557′N, 74° 12.208′W.

No doubt you enjoyed the picturesque drive up from Phoenicia through Stony Clove; in autumn it's just lovely. The parking lot stands at 2,468 feet and the falls, which is 300 feet higher, will still be ice-choked in March and April, providing a fun little crampon hike. Scamper across the heavily traveled road away from Notch Lake and ascend a flight of log stairs. This rock-strewn, red-blazed trail rises quite steeply before hitting the creek at .14 mile. Here the red blaze makes a hard left to ascend a very steep, boulder-laden trail. Don't go left; instead head straight into the creek on an obvious bootpath that drops down a few feet to the rocky creekbed.

Head left up the boulder-filled streambed to the falls. I found the creek's right-hand side to be easier going than the left. Don't let a dry creekbed discourage you. The rock fill is many feet thick and thoroughly conceals the stream for a good distance. The only effective way to assess stream flow is

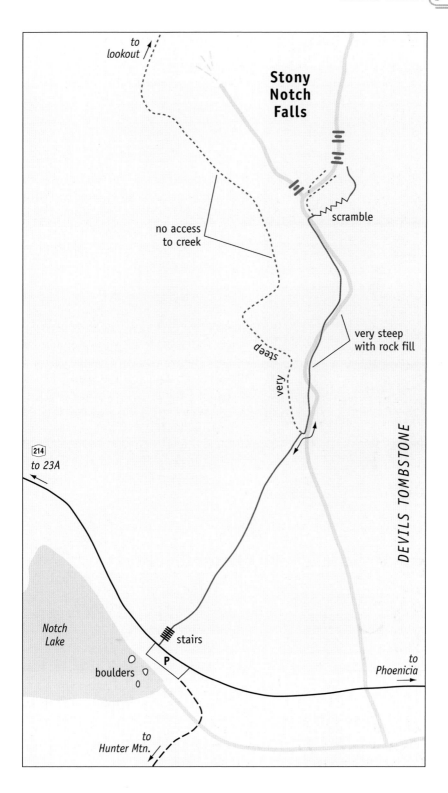

to
lookout

**Stony
Notch
Falls**

scramble

no access
to creek

very steep
with rock fill

very steep

214
to 23A

DEVILS TOMBSTONE

Notch
Lake

stairs

P

boulders

to
Phoenicia

to
Hunter Mtn.

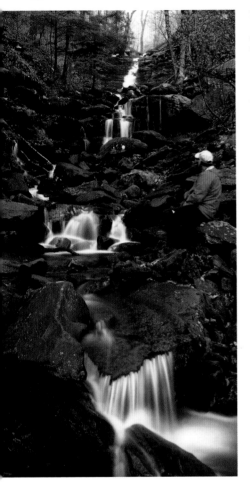

Stony Notch Falls. Placing people in the landscape helps sell photographs. In this case a self portrait is easily made using the camera's timer. Just out of frame on the left is the other drop containing Diamond Notch, which runs less vigorously than this one. Slight softness in the background is created by the steady rain I'm sitting in. *Canon EOS Digital Rebel, Tokina 20–35, Polarizer, ISO100 setting, f/20 @ 15 sec.*

by looking at the falls themselves, which should at least be damp in summer. When you hit the lower ten-foot drop, climb around it using the rocky embankment on the fall's left-hand side (your right).

If you get here in spring or after any torrential rain all three falls should be running, providing a couple hours of good shooting. Check out Notch Lake if the falls aren't worth shooting. Lily pads near the south end provide nice foregrounds for shots of Hunter Mountain (on the left) and Plateau Mountain (on the right). In fall both ridges will be riots of orange and red. A little farther up NY 214 are some swamps or bogs on the road's east side in the heart of Stony Clove Notch. Parking is a real problem, but two of you can work a shuttle so that one shoots the lake while the other shoots the swamps.

Hike 20 Schalk Falls, Ulster County

Type: Fall	**Height:** 11 feet
Rating: 3	**GPS:** 42° 6.790'N, 74° 2.990'W
Stream: Plattekill Creek	**Distance:** 50 yards
Difficulty: Easy	**Elevation Change:** None
Time: 10 minutes	**Lenses:** 35mm to 70mm

Directions: This perennial roadside fall is located in the village of West Saugerties at the entrance to Platte Clove, a famous and quite narrow seasonal road. From the intersection of the east-west running Platte Clove Road and the north-south running West Saugerties/Woodstock Road, head west (uphill) on Platte Clove Road (now CR 33) for .1 mile and park in a wide spot on the right near a stop sign where Manorville Road comes in from the right. GPS coordinates: 42° 6.790'N, 74° 2.990'W.

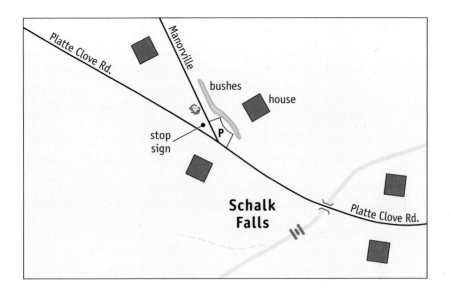

Head towards the old stone bridge that carries Platte Clove Road over the creek and scamper across to view the falls. The fall is set at an angle to the creek and I like the view of the upstream side. In low flow the water sits toward the fall's back where a tributary joins. In high flow the entire face of the wide fall will be covered. Since the bridge vibrates with every passing car, you must wait for a gap of several seconds in traffic before shooting.

Hike 21 Platte Clove Preserve, Greene County

Old Mill Falls

Type: Fall	**Height:** 9 feet
Rating: 3	**GPS:** 42° 7.984'N, 74° 5.158'W

Plattekill Falls

Type: Fall	**Height:** 78 feet
Rating: 5	**GPS:** 42° 7.934'N, 74° 5.146'W
Stream: Plattekill Creek	**Distance:** 1 mile
Difficulty: Moderate	**Elevation Change:** 144-foot descent
Time: 30 minutes	**Lenses:** 20mm to 70mm

Directions: From the intersection of the east-west running Platte Clove Road and the north-south running West Saugerties/Woodstock Road, head west (uphill) on narrow, seasonal Platte Clove Road (now CR 33) 2.5 miles. Turn right onto a narrow gravel lane and park in a large signed parking lot for the Hell Hole. Platte Clove Road is barely wide enough for two cars to pass; when heading downhill don't forget your etiquette and yield to uphill traffic. GPS coordinates: 42° 8.004'N, 74° 5.182'W.

Before we begin this hike I must warn you that downstream of the wonderful 78-foot Plattekill Falls is another, even bigger drop that's unfortunately inaccessible. I tried quite hard exploring the cliff edges left and right looking for a slope that I could scramble down. There isn't one. I also tried heading in through the Hell Hole and Hell Hole Falls (which isn't photogenic at all) to enter Platte Clove from below. The chasm-like cataracts of Hell Creek and steep, slick rock faces create an impassable route down. I even kept high along the Hell Hole looking for a ledge structure that would make the turn into the Clove and couldn't find one. I spent hours exploring *safe* routes into the upper Clove and was thwarted at every turn. I take the time to tell you all this because when you see the big drop you'll really want to

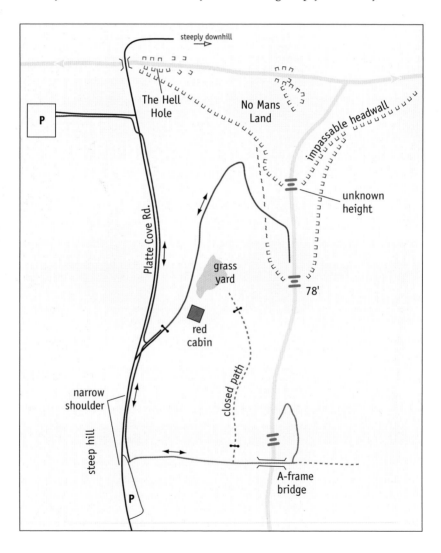

Plattekill Falls. This is a wonderful place to just hang out and enjoy the sound of falling water. There are nice shots of the glen from up trail where birches frame the fall. *Canon EOS Digital Rebel, Tokina 20–35, Polarizer, ISO100 setting, f/22 @ ¹/2 sec.*

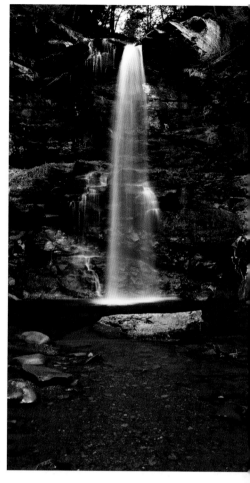

find a way in. For your money I give you this sage advice—don't try it, because doing so is life-threatening.

Now for some fun. From the parking area, walk down the lane and turn right onto the paved road; cross and walk against oncoming traffic until you arrive at a nice-looking red cabin on the left and a gated road. Hop the chain and turn right, heading downhill and looking for obvious bootpaths down to the creek. Above Old Mill Falls is a footbridge, so you will need to work from either creek bank or place someone in red on the bridge for a nice look.

Now head back to the cabin and follow a blue-blazed trail past a fence. The trail, which is wide and well-worn, runs parallel to the creek and then sweeps right and downhill, dropping you near the foot of Plattekill Falls. This horsetail fall has an adequate thin stream in summer that hits an intermediate ledge about halfway down. In spring flow, however, a flume heading the fall causes the water to leap clear of the rock face and hit near a massive stone block, creating a tumult of spray that flies well downstream. Your should start shooting from the trail as soon as the fall is in view; continue as you descend and work from the creek. When you're done, make the steep climb out and return to your car, and don't forget to yield to uphill traffic.

Hike 22 Kaaterskill Clove, Greene County

Moore's Bridge

Type: Cascade over cascade	**Height:** 40 feet
Rating: 4	**GPS:** 42° 10.624'N, 74° 3.315'W

Fawns Leap

Type: Chute	**Height:** 21 feet
Rating: 5	**GPS:** 42° 10.629'N, 74° 3.456'W

Bastion

Type: Cascade	**Height:** 30 feet
Rating: 4	**GPS:** 42° 11.480'N, 74° 4.258'W

Kaaterskill

Type: Fall over fall	**Height:** 264 feet
Rating: 5+	**GPS:** 42° 11.605'N, 74° 3.791'W
Stream: High Falls Creek	**Lenses:** 20mm to 200mm plus macro

This hike is divided into two sequences: the lower clove consisting of Moore's Bridge and Fawns Leap, and the upper section consisting of Kaaterskill and Bastion Falls. The length of the hike into Fawns Leap depends on where you can park. If you park at the large parking area below Moore's Bridge you will make the entire 1.3-mile walk. If you can find roadside parking near Fawns Leap you'll walk no more than a couple hundred yards. On weekends every roadside spot in the clove will be taken, which is why you want to get here either very early or during mid-week.

Fawns Leap and Moore's Bridge Falls

Difficulty: Moderate to Fawns Leap	**Distance:** 1.3 miles
Time: 45 minutes	**Elevation Change:** 155 feet

From the intersection of NY 32A and NY 23A in the village of Palenville, take NY 23A west 1.4 miles to a large parking area on the left (GPS coordinates: 42° 10.607'N, 74° 2.846'W). This will require 1.3 miles of road walking. If you continue uphill another .4 mile, as soon as you cross Moore's Bridge (a large concrete highway bridge) look for parking along the massive retaining wall on the right. This will put you between Moore's Bridge Falls (downhill) and Fawns Leap (over the guardrail to the left). If there's no parking you will be forced to drive all the way into the town of Haines Falls before you can make a safe U-turn.

From the lower parking area, cross the road, hop the guardrail, and make a rocky walk along the road to Moore's Bridge. Drop right down a steep rocky

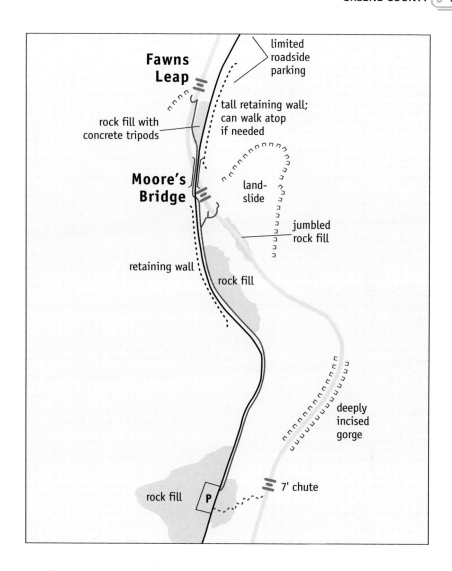

hillside into Kaaterskill Creek. The broad fall spans the length of the bridge, which hangs low over the fall and makes it impossible to keep out of frame. Rather than crossing the creek, climb back up the rock slope to the road, cross the road, and then cross the bridge as quickly as you can.

Once you come to the end of the bridge, hop the guardrail and work your way upstream and downhill over large blocks of rock fill to creek level. In order to drop into the creek proper you will need to carefully scramble over and down massive concrete tripods that now support the entire road structure above. Everything you've gone over are repairs to massive flood damage from tropical storms Floyd (1999) and Allison (2001), and a few nasty nor'easters of the last couple years. In order to shoot Fawns Leap you'll need to cross the deep, swift-flowing creek. Although I successfully rock-hopped

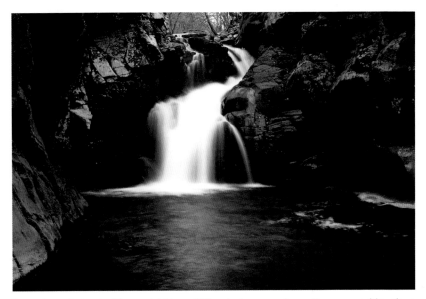

Fawns Leap. Just out of frame right is graffiti and a large overhang. From my position there were kids actually jumping from high above another cliff over my head and into the deep plunge pool. The pool's depth is masked by the long exposure; another step forward and I'd have been in over my head. *Canon EOS Digital Rebel, Tokina 20–35, Polarizer, ISO100 setting, f/22 @ 1 sec.*

across a couple of times I recommend water shoes over hip waders since these boulders could get swamped. Bear in mind though—this water is cold!

Fawns Leap is a popular swimming hole and you'll find kids leaping from cliffs on both sides of the falls. These can make nice shots, although they aren't to my liking. As you face the fall you'll find some graffiti tags to your right that you'll need to keep out of frame. The pale tan sandstone that makes up the lower segments of the cliffs will not get damp from rain because of overhanging rocks. It's unlikely you'll be able to fling water far enough to darken them so don't bother trying. When you're done, carefully make your way back to the car while keeping off the road.

Kaaterskill and Bastion Falls

Difficulty: Difficult	**Distance:** 1.6 miles
Time: 1 hour, 15 minutes	**Elevation Change:** 580 feet total

From Fawns Leap drive uphill on NY 23A another 1.5 miles to a large parking area on the left. Bastion Falls will be visible as you make a long switchback left near 1.0 miles. There's quite a bit of foot traffic here, so slow down! Continue uphill a short distance and park in a large lot on the left. GPS coordinates: 42° 11.361'N, 74° 4.433'W. Get here before 9:00 A.M. or expect to troll for a parking spot, especially on weekends.

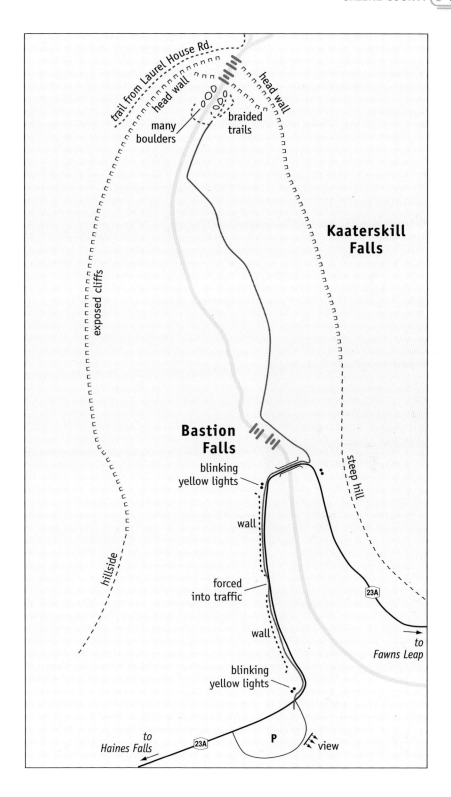

trail from Laurel House Rd.

head wall

head wall

many boulders

braided trails

Kaaterskill Falls

exposed cliffs

Bastion Falls

blinking yellow lights

steep hill

wall

forced into traffic

23A

wall

to Fawns Leap

hillside

blinking yellow lights

to Haines Falls

23A

P

view

Race across the road from the parking area, hop the guardrail, and walk in the gutter facing traffic. Heading downhill, you'll be forced onto the road surface for a few yards; then get back over the guardrail. At .25 mile you arrive at a bridge; cross it and turn left onto the yellow-blazed Kaaterskill Clove Trail. Just to your left is Bastion Falls, a 30-foot drop divided into an upper 18-foot section and a lower 12-foot section. It was the upper fall you saw on the drive in.

Ascend the steep trail and arrive at the famed falls in .8 mile. Before you is the highest fall in New York, and it is spectacular. The upper half is a true fall with a massive undercut; the lower is a large cascade. Once you get a good look don't shrug off the feeling of déjà vu you might be having. The fall was a popular subject for the Hudson River school of painters in the early 1800s. What you're looking at has graced countless paintings, postcards, and stamps for the last two hundred years.

The yellow blaze does continue up the well-trodden slopes to the base of the upper drop (even though signs indicate otherwise). I like the view from below. Exceptionally popular, especially on holiday weekends, the ravine will be mobbed most every day starting around 10:00 A.M. As always, the

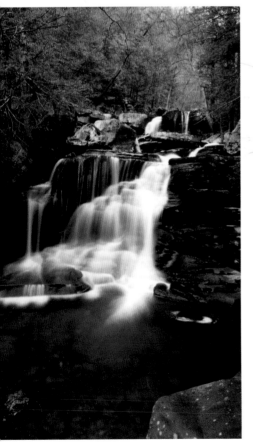

best shooting conditions are foul weather, which will drive everyone else away. The upper fall can be hidden by fog so the only way to check conditions is to be here.

There are several good setups left and right among the massive boulders in the lower drop's tailwater. You'll need to get up high to maximize the amount of the upper drop that's in the frame. It is primarily a vertical shot, but go ahead and shoot some horizontals if you have a super-wide lens.

If you do want to explore above the falls from Laurel House Road, follow a trail right and away from the creek. You'll get a couple nice views of the upper falls' ballistic arc. The only thing keeping people out of the fast-moving creek above the upper fall is a wimpy fence and common sense (which was in short supply during my first visit).

Other guides to the area list several more falls dropping from the Clove's south walls. From west to east the falls are Santa Cruz,

Bastion Falls. The trail heads uphill just beyond frame right; the highway bridge is just out of frame left. *Canon EOS Rebel Xs, Tokina 20–35, Kodak E100VS, f/16 @ 1 sec.*

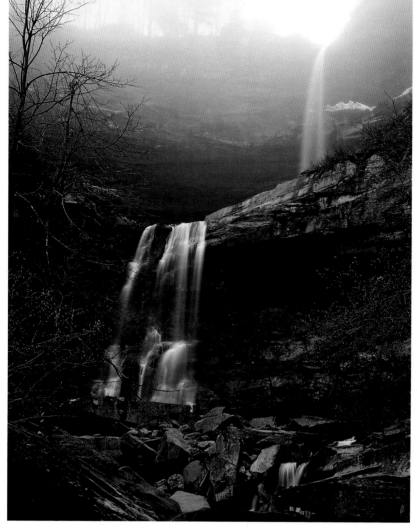

Kaaterskill Falls. I wanted something stark for this project. Shot in March during rain and fog, the upper drop is shrouded in mist and the entire amphitheater is rendered in a mono-chrome veil. This is certainly not the norm but it's what I felt about the place. *Tachihara 4x5 Field Camera, 150mm Schneider Symmar f5.6, Polarizer, 4x5 Ready Load holder, Kodak E100VS, f/32 @ 10 sec.*

Buttermilk, Wildcat, Viola, and Hillyer Ravine. I did check these out but as seasonal cascades they didn't do much for me. All the southside ravines have very small drainage areas and run only during snowmelt. In a few cases there are no safe trails down the ravines. If you'd like to explore them, by all means do so. Consult the Adirondack Mountain Club's *Catskill Trails* guide, page 55 (Kaaterskill High Peak Trail). This strenuous trail starts from near Palenville for a 9-mile round trip with a 2,750-foot elevation gain. Topographic maps do show a much shorter route beginning at the town of Haines Falls, but I didn't explore that one. Finally, there are a few falls below the town of Haines Falls that are on private land. Unless you have obtained express written permission to explore Niad's Bath and the others it will cost you a pretty penny.

Hike 23 Bash Bish Falls, Berkshire County

Type: Cascade	**Height:** 65 feet
Rating: 5	**GPS:** 42° 6.925'N, 73° 29.656'W
Stream: Bash Bish Brook	**Distance:** 1.6 miles
Difficulty: Easy	**Elevation Change:** 290 feet
Time: 50 minutes	**Lenses:** 20mm to 70mm

Directions: From the tiny village of Martindale at the junction of NY 82 and NY 23, exit onto NY 23 (Main Street) and head east towards Hillsdale. In 7.2 miles arrive in Hillsdale and turn right onto NY 22. Head south 4.0 miles to Copake Falls and then bear left onto NY 344. Turn left in .3 mile to continue along NY 344 and park at .6 mile in a large parking area on the right at a pavilion for Taconic State Park. GPS coordinates: 42° 7.073'N, 73° 30.354'W.

I seriously considered not including this fall in a New York guide because it is actually in Massachusetts—if only by a little bit—but when I finally got here that idea went out the window. I hope Massachusetts doesn't mind if I borrow one of their natural gems, since it's only 100 yards over the state line.

This easy .8-mile trail has a steady uphill climb that may require you pause once or twice. From the parking area follow the wide, graded woods road that parallels Bash Bish Brook to a set of concrete stairs, and then descend a short distance to the fall's base. The falls is a raging torrent in spring since the creek has a large drainage basin that includes half of two counties. Also, the fall's head is split by what appears to be a massive boulder or choke stone

The drop around the choke stone is the classic view you see in pictures, but the fall is actually two drops. The upper one can only be seen from the concrete viewing platform and is difficult, if not impossible,

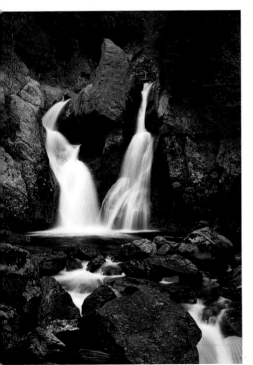

Bash Bish Falls. During low flow the water will follow the curving path on the left. What you don't see from this view is the deep flume to my right. The boulder I'm on has barely enough room for me and a tripod and it was rather slick. Always be aware of your footing. There's nothing worse than slipping and dumping a few grand worth of camera gear into an icy stream, especially when people are watching. *Tachihara 4x5 Field Camera, 150mm Schneider Symmar f5.6, Polarizer, 4x5 Ready Load holder, Kodak E100VS, f/32 @ 5 sec.*

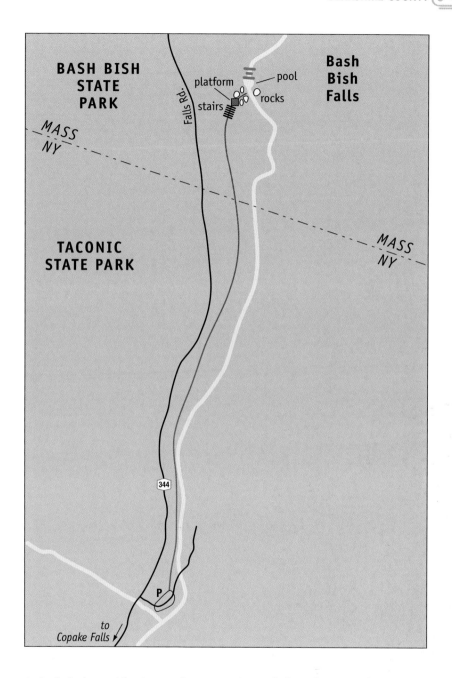

to include in a wider image. In summer's weak flow the main drop is confined to your left, which will make an image look unbalanced. A collection of huge boulders dams the plunge pool, and a slide below is an impressive bit of whitewater in high flow. These large boulders are actually too big to use as anchoring foregrounds and the torrent of water through them will render as

blank white unless you take action in post-processing toward managing the tonal variations. As large as it is, this fall is surprisingly hard to shoot.

Since this is a very popular attraction you'll have to deal with crowds walking into and out of frame. Avoid this by getting here early.

Hike 24 Creamery Falls, Schoharie County

Type: Fall over fall	**Height:** 31 feet
Rating: 4	**GPS:** 42° 28.136'N, 74° 27.580'W
Stream: Mill Creek	**Distance:** 100 yards
Difficulty: Easy	**Elevation Change:** 40 feet
Time: 10 minutes	**Lenses:** 30mm to 50mm

Directions: From the intersection of NY 23 and NY 30 in the small town of Grand Gorge, take NY 30 east out of town 9.2 miles toward Gilboa and Schoharie Reservoir. Along the way pass Mine Kill Falls (Hike 25, see page 64). As you descend a steep hill on the approach to the village of North Blenheim, make a hard left onto Creamery Road and park on the left, facing the fall. GPS coordinates: 42° 28.146'N, 74° 27.601'W.

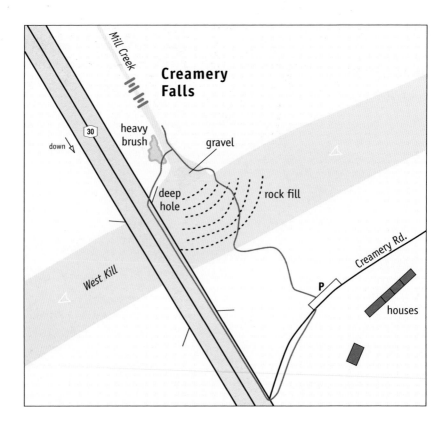

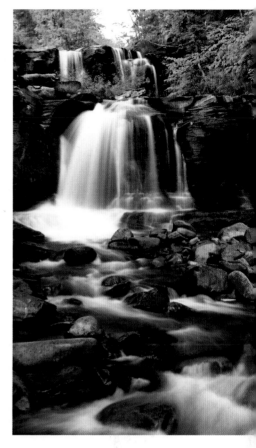

Creamery Falls. The fall's tailwater runs only a few yards before hitting West Kill, which is just behind me. There is lots of scraggly brush to the left that you need to take the time to crop out of frame by carefully selecting your setup position. *Canon EOS Digital Rebel, Tokina 20–35, Polarizer, ISO100 setting, f/22 @ 1.6 sec.*

This fall appears bigger when viewed from the road than when viewed from the creek below. You can shoot from Creamery Road with a long lens if you'd like, but it's better up close.

There are two approaches, one very wet and the other only a little wet. The very wet approach is to descend the slope in front of you and ford West Kill, which can be done with a slow, prudent bit of rock hopping. I did this in low water but on a return in much higher water I had to put on waders. West Kill's swift flow was not too difficult to overcome once I remembered to aim my feet upstream and crab-walk sideways. Once across, head up Mill Creek a few yards to the fall.

The less wet approach is to bushwhack down from the NY 30 bridge's far abutment. From where you stand on Creamery Road, observe how the far bridge abutment terminates at a deep spot in West Kill within a few feet of Mill Creek. You want to land on the gravel about ten feet upstream in Mill Creek. Walk over to NY 30 and head uphill across the bridge and hop the guardrail. Shimmy down the steep, weedy slope adjacent to the concrete abutment. Just before you bottom out, work left a few yards and then muscle your way through some brush. You'll land wet in Mill Creek but at least you didn't have to ford the wider West Kill.

I found the best position is the creek's right-hand side; however, you'll have to be fairly close to the fall to avoid overhanging trees that almost cover Mill Creek. This delightful seasonal fall has one exposure issue and that is the blank sky overhead. With no tree cover it can be tough to create a balanced composition.

Hike 25 Mine Kill Falls, Schoharie County

Upper Mine Kill

Type: Slide	**Height:** 30 feet
Rating: 4	**GPS:** 42° 25.738'N, 74° 28.325'W

Mine Kill

Type: Chute	**Height:** 70 feet
Rating: 4+	**GPS:** 42° 25.738'N, 74° 28.325'W

Lower Mine Kill

Type: Chute over cascade	**Height:** 26 feet
Rating: 5	**GPS:** 42° 25.738'N, 74° 28.325'W
Stream: Mine Kill	**Distance:** 1 mile
Difficulty: Moderate	**Elevation Change:** 240 foot descent
Time: 35 minutes	**Lenses:** 17mm to 150mm

Directions: From the intersection of NY 23 and NY 30 in the small town of Grand Gorge, take NY 30 east out of town 5.7 miles toward Gilboa and Schoharie Reservoir. After you pass Shew Hollow Road, look for a small gated lane to the right and turn right into the large "Overlook Parking" area. If you cross a large arch bridge over a deep ravine you went 50 yards too far. GPS coordinates: 42° 25.643'N, 74° 28.336'W. The parking lot opens at 8:00 A.M. and is gated closed at 3:00 P.M.

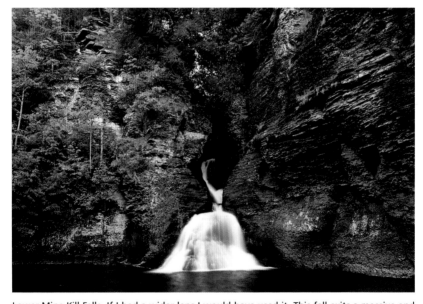

Lower Mine Kill Falls. If I had a wider lens I would have used it. This fall exits a massive and imposing cliff and even a 17mm lens just doesn't do it justice. Portraits are fine, however. As part of the one-lens drill, don't forget to shoot environmental as well. *Canon EOS Digital Rebel, Tokina 17, Polarizer, ISO100 setting, f/22 @ 5 sec.*

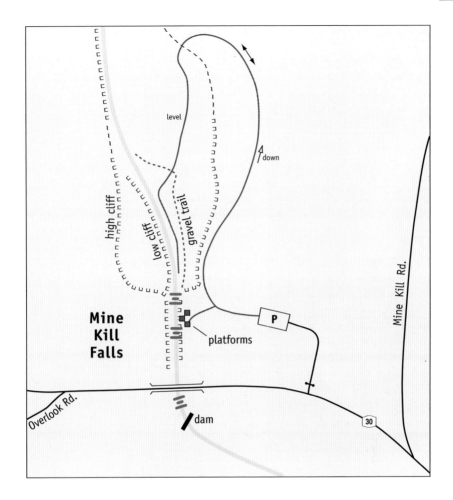

If you are wondering why three falls that are widely separated have the same coordinates, the answer is simple: you can't get to the upper, the main fall provides a clean GPS signal, and the lower is in a ravine where you can't get a good GPS lock. That's okay since all are easy to find.

Leave the parking area and follow a path through some trees. Pass a T intersection where right takes you to the lower falls and ahead to viewing platforms heading the upper fall. The lower platform gives an excellent view of the steep chute that plunges through what amounts to a saw cut in a cliff face. You can even see the little corkscrew at the base. Wedge your tripod into the upstream corner for the best view. If the weather report is for clear skies, get here at 8:00 A.M. since the deep ravine will be in shadow.

The upper drop is a long-lens shot reaching under the high arch bridge and is made a bit problematic by a weir dam heading the fall. Even though the bridge arch is attractive in its own right the white concrete will over-

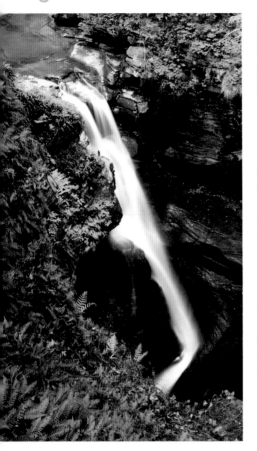

Mine Kill Falls. When shot from the viewing platform, the fall's hook is clearly visible. The platform limits your compositions to shots that look like this one. What you can't see from here is the way water has undercut the cliff below. *Canon EOS Digital Rebel, Tokina 20–35, Polarizer, ISO100 setting, f/22 @ 5 sec.*

whelm any exposure. Take great care in your framing and carefully examine the edges of the frame.

Return to the T intersection and turn left, downhill, for a .4-mile-long sweeping descent that drops you into a wide cirque with tall cliffs on three sides. Walk out along the wide cobble bar and face the lower falls. This impressive 26-foot plunge shoots from imposing 90-foot-tall gray cliffs. The vast expanse of gray is interesting with its spiky surface and has a daunting character. The rock wall's shape also reflects sound very well, and even though the fall's roar blocked out most sounds there were places where I could clearly hear the conversations of others. It was quite fun.

Hike 26 Rensselaerville Falls, Albany County

Type: Slide over cascades	**Height:** 120 feet
Rating: 5	**GPS:** 42° 30.888'N, 74° 8.608'W
Stream: Ten Mile Creek	**Distance:** .5 miles
Difficulty: Easy	**Elevation Change:** 80 feet
Time: 20 minutes	**Lenses:** 20mm to 70mm

Directions: From the intersection of NY 85 (Delaware Turnpike) and NY 143 south of Thacher State Park, take NY 85 south 6.4 miles into the town of Rensselaerville. At the stop sign at a T turn right onto CR 353 (Delaware Turnpike) and in .1 mile turn right at an old white mill house with a sign stating "Biological Research Station." Park in the large lot behind the building. If you cross a bridge over a deeply set creek you went about 20 yards too far. GPS coordinates: 42° 30.919'N, 74° 8.455'W.

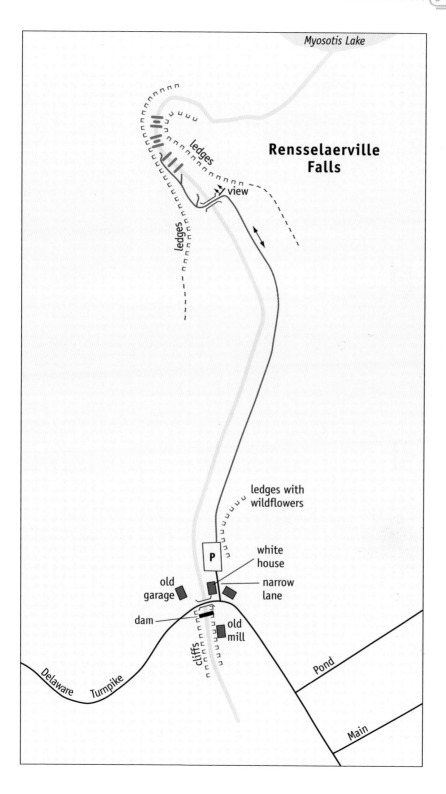

Myosotis Lake

ledges

**Rensselaerville
Falls**

ledges

view

ledges with
wildflowers

P

white
house

old
garage

narrow
lane

dam

old
mill

cliffs

Delaware Turnpike

Pond

Main

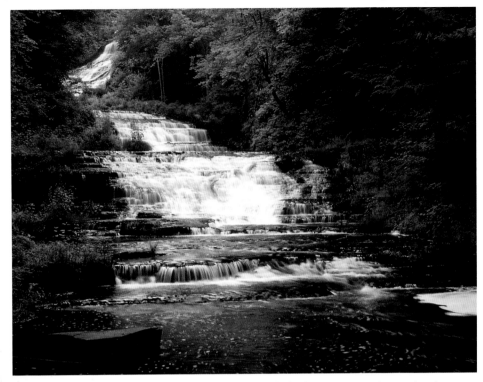

Rensselaerville Falls. This overall view is shot from the bridge. You can make out that the upper section continues out of frame in the upper right. *Canon EOS Digital Rebel, Tokina 20–35, Polarizer, ISO100 setting, f/22 @ 8 sec.*

This is a wonderful location to shoot wildflowers, moss-covered rocks, and of course, a lovely waterfall. Exit the rear of the gravel parking lot, keeping the creek to your left. In about 100 yards you cross a bridge over the creek and get your first glimpse of a spectacular series of cascades. Start shooting from here with a longer lens. In the distance the largest drop falls from right to left; the creek then twists over a long series of stairs toward you. One of the subtle things about photographic composition is the use of curved lines sweeping through the frame. For some reason our brains like S curves and sweeping forms, which is why this fall looks especially nice in a photograph.

Cross the bridge and bear right down some stairs to find a nice spot to work from, and then slowly move forward a few feet at a time, shooting as you go. Get low! Water burbling over the many ledges begs to be used as a foreground. The big drop's base is accessed from a gravel path near the footbridge.

The fall runs with decent power longer than most in the area since it sits below Myosotis Lake. It isn't as sensitive to storm flow as others so its flow is more consistent over time, which is good for you.

Hike 27 Barberville Falls, Rensselaer County

Type: Cascade	Height: 86 feet
Rating: 5+	GPS: 42° 41.108'N, 73° 32.403'W
Stream: Poesten Kill	Distance: 1.3 miles
Difficulty: Moderate, steep climb out	Elevation Change: 200 feet
Time: 45 minutes	Lenses: 24mm to 140mm

Directions: From the intersection of NY 351 and NY 355 (Main Street) in the town of Poestenkill, head east on Main Street/Plank Road for 1.3 miles. Park on the left in a small signed parking area. If the lot is filled you'll have to troll for parking until you find an open spot. Because of private land holdings, parking on Plank Road from Blue Factory Road to the signed parking area is prohibited and subject to ticketing. GPS coordinates: 42° 41.255'N, 73° 32.490'W.

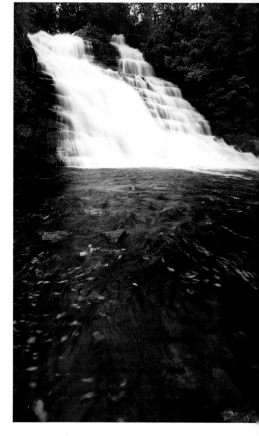

Head uphill on Plank Road, passing the cemetery and trying to avoid fast-moving traffic. In .38 mile turn left onto Blue Factory Road and cross the kill. Make an immediate left onto a wide trail. As you move along, the trail begins to braid, with footpaths branching left toward the fall's head and one wide path running downhill. Follow the wide path downhill where it sweeps right and then left, depositing you at the fall's foot—a wide, deep, and swift-moving torrent.

This vast plunge pool makes getting a face-on shot very difficult. A series of rock-falls have pushed the major portion of flow away from you. My big issue was spray. Even though the fall faces into the prevailing winds it creates its own air blast, driving spray well downstream. I went through several cleaning cloths trying to keep my lens dry. I also wore water shoes but didn't feel comfortable nearly hip deep in such a powerfully running

Barberville Falls. This was the only spot near the fall where I wasn't pounded with spray. In order to insure that the water would have detail despite the heavy flow I underexposed and then did some minor post-processing in Photoshop. I used the red-eye tool to remove bright orange "No Trespassing" signs. *Canon EOS 5D MkII, Tokina 17, Polarizer, ISO100 setting, f/16 @ .3 sec.*

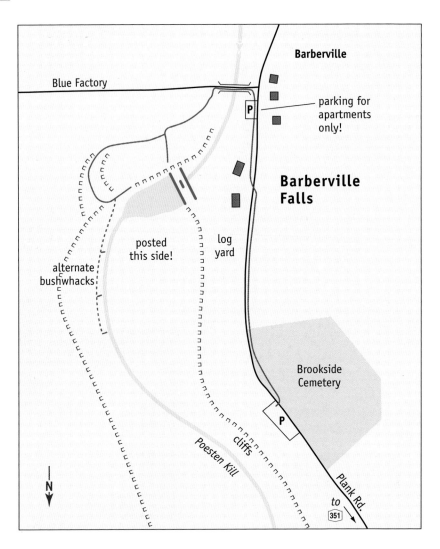

stream, and so contented myself with working from the numerous rocky outcrops along the right-hand bank (the side you're on).

The left-hand side of the kill is private land. It is impossible to get a clean shot that doesn't contain two large orange "No Trespassing" signs bolted to the fall's face. I ended up doing a few things in Photoshop to remove these frustrating artifacts. If you're unlucky, and can't get here in rain or overcast, the fall will be in shadow during the three hours before sunset. The sky will be several stops brighter but you can take care of that with careful composition.

Hike 28 Mount Ida Falls, Rensselaer County

Type: Cascade	**Height:** 46 feet
Rating: 5+	**GPS:** 42° 43.238′N, 73° 40.775′W
Stream: Poesten Kill	**Distance:** .2 miles
Difficulty: Easy	**Elevation Change:** 60 feet
Time: 20 minutes	**Lenses:** 35mm to 100mm

Directions: From downtown Troy at the intersection of NY 2 East (Ferry Street) and US 4, take NY 2 East steeply uphill. In .3 mile the divided NY 2 will merge with its westbound half to become Congress Street. In another .6 mile, turn right onto NY 66 (Pawling Road). Keep in the right lane; as soon as you cross the bridge over Poesten Kill, turn right onto Linden Avenue. As you descend again there will be a large grassy park and parking lot on the right in .3 mile. GPS coordinates: 42° 43.209′N, 73° 80.849′W.

The large grassy field before you belies the size of the fall hidden downhill among the trees. Walk across the wide field toward the sound of falling water. When you get to a fence, head right to a burned-out viewing platform. Descend to the kill. The fall's plunge pool is vast and deep, as evidenced by the number of kids jumping from the high ledges into it. I do understand the

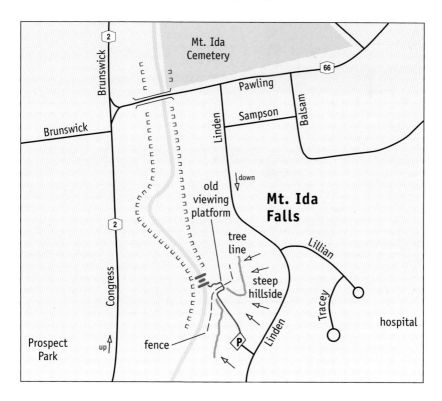

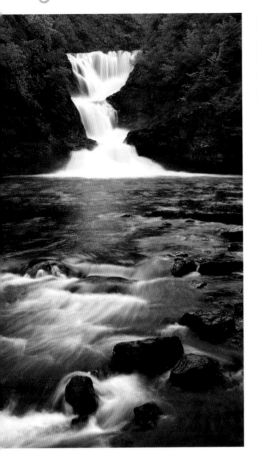

Mt. Ida Falls. Working into the frothing tailwater as far as I could, I found some rocks to use a foreground. Since it exits a massive cliff face the fall looks much smaller than it is. The drop's precipice is easily 30 yards wide and the pool is deep enough for kids to jump from the cliffs on the right. *Canon EOS Digital Rebel, Tokina 20–35, Polarizer, ISO100 setting, f/16 @ 1.3 sec.*

fun of this but every time I see someone jump off any fall I just cringe.

In weak summer flow the fall is a series of thin cascades and the plunge pool is a rock-filled affair that allows you to rock hop fairly close to the fall. In high flow the pool is a rather scary thing, as dark, swift-moving water swirls in a vast eddy waiting to swallow the inattentive photographer.

What fascinates me about this fall is the geologic contrast with its upstream brother, Barberville Falls. They are 600 feet different in elevation; where Barberville is formed of immense slabs of sandstone, Mount Ida is made of thin, black shale layers. Barberville has a sense of permanence and a castle-like quality whereas Mount Ida almost looks like it's eroding before your eyes.

Hike 29 Buttermilk Falls, Rensselaer County

Type: Cascade	Height: 16 feet
Rating: 3	GPS: 42° 53.259'N, 73° 37.264'W
Stream: Tomhannock Creek	Distance: 50 yards
Difficulty: Easy	Elevation Change: None
Time: 10 minutes	Lenses: 50mm to 100mm

Directions: Begin south of the village of Schaghticoke at the intersection of NY 67 (Farm to Market Road or Old Schaghticoke Road) and NY 40 (Reservoir Road). Take NY 40 southwest .8 mile and turn right onto Hansen Road. Turn right at the T with Buttermilk Falls Road and follow it .8 mile. Cross a railroad and park on the left before crossing the bridge over Tomhannock Creek. GPS coordinates: 42° 53.259'N, 73° 37.261'W.

This roadside fall will be hard to shoot from the road in coming years, as the embankment to the right is covered with trees-of-heaven, a fast-growing invasive species. The best view is from the bridge. A tree-clogged island below the fall is difficult to work around, although it does look nice in fall color. Buttermilk Falls, although not very tall, is wide and makes a pleasing horizontal shot. This particular Buttermilk Falls is one of about twenty or so named falls in the eastern third of the state.

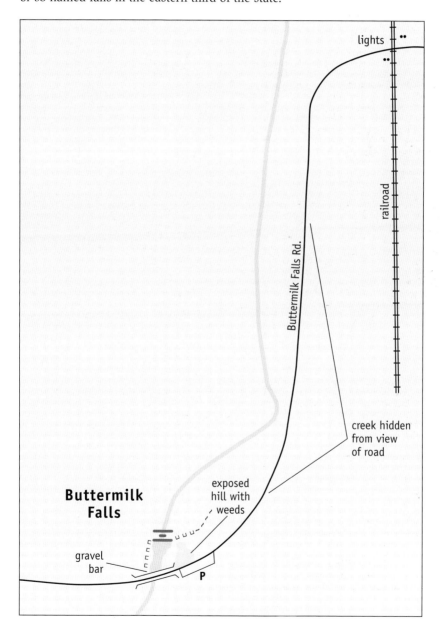

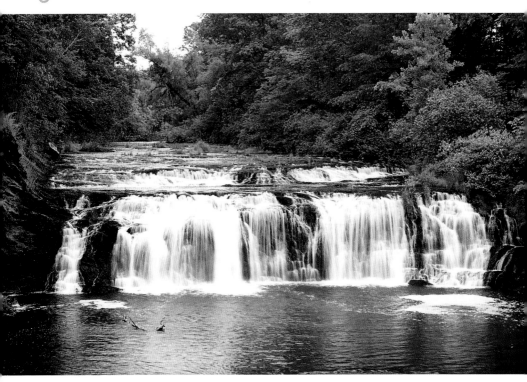

Buttermilk Falls. This fall has a wide gravel beach on the right that's got some trash on it. Knowing that I would crop the image in post-processing, I used a lens that would cover more field of view than I would need. *Canon EOS 5D MkII, Tamron 28–200, Polarizer, ISO100 setting, f/16 @ 1/5 sec.*

Hike 30 Cohoes Falls, Albany County

Type: Cascade	**Height:** 65 feet
Rating: 5	**GPS:** 42° 47.256′N, 73° 42.534′W
Stream: Mohawk River	**Distance:** 50 yards
Difficulty: Easy	**Elevation Change:** None
Time: 10 minutes	**Lenses:** 50mm to 200mm

Directions: Follow I-787 north from the Albany area and through the town of Watervleit. The interstate ends just outside of Cohoes. I-787 will cross NY 470/Ontario Street and make a sharp left to join NY 32 (Saratoga Street) at a traffic light. The intersection is a bit complex so take care to follow signs for Cohoes Falls by going straight through the intersection, crossing Ontario, and heading uphill on New Cortland Street .8 mile (it turns into Colonel Robert Craner Parkway and then into Mohawk Street). You'll pass through an old factory that is now a condominium complex called Harmony Mills. Turn right onto School Street (which looks like a wide alley) and park on the left in the first available spot. If you can't find parking continue ahead and loop around via Cataract to find a spot on Mohawk. GPS coordinates: 42° 47.049′N, 73° 42.454′W.

Walk to Cohoes Falls Overlook Park at the corner of School and Cataract. This attractive little park has picnic benches and overlooks the hydro plant adjacent to the falls. Although the fall is only 65 feet tall, it is a massive 600 feet wide. In low flow, which I experienced on my first visit, the fall isn't very impressive. With most of the Mohawk River scavenged by the power plant there were only two or three narrow sections with water running over the fall; downstream, much of the river bottom was exposed.

My second trip was during minor flooding conditions and the fall's full face was a raging torrent and thundered quite loudly. It was very impressive indeed.

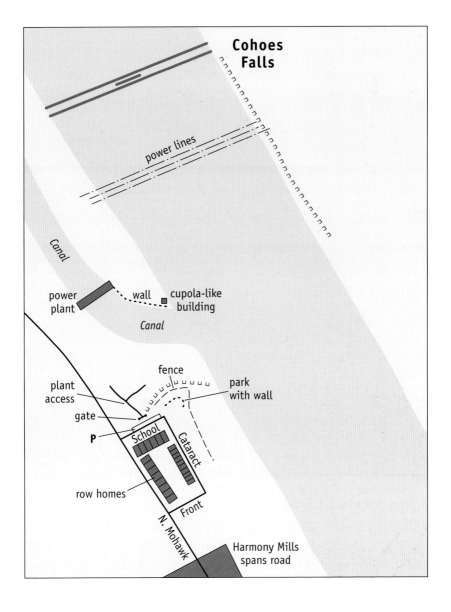

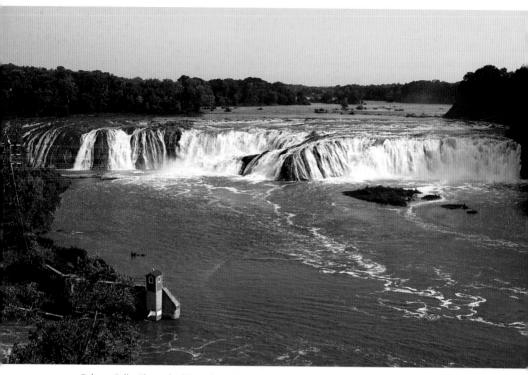

Cohoes Falls. The only thing altered in this shot is a weed cropped from the bottom of the frame. The power lines, power plant tail race canal, and everything else is how you will see it. *Canon EOS Digital Rebel, Tokina 20–35, Polarizer, ISO100 setting, f/8 @ 1/60 sec.*

The fall itself is situated a quarter-mile upstream from the park, which provides the only decent viewpoint. At that range you have to work with longer lenses. To eliminate a fence and foreground brush I stood on the wall, which gave me another four feet of elevation. On the left are the old, tired-looking industrial buildings of the power plant and tail race that can be isolated with a long lens. Several thin green power lines span the river in front of the fall; you'll just have to work with them.

The fall itself is quite fascinating, as it's kind of barrel-shaped in the way a concrete dam or spillway has a curved shape called a hydraulic curve. The river walls are nearly vertical and the river bottom and falls are made of a deep-black rock comprised of many thin layers. If you look downstream about a half mile you'll see a scarp or cliff with roughly the same shape as the falls. This shows that the fall has receded this distance since the end of the last ice age. According to Bradford Van Diver's *Roadside Geology of New York*, the dark rocks are the remains of a massive landslide from the ancient Taconic Mountains and date to around 440 million years old. The more I read and understand about the geology of places I hike the more fascinating the story becomes. Geology truly is the ultimate CSI story.

Hike 31 J. B. Thacher State Park, Albany County

Minelot

Type: Fall	Stream: Minelot Creek
Rating: 5	Height: 116 feet
GPS: 42° 38.709'N, 74° 0.121'W	

Outlet Falls

Type: Fall	Stream: Outlet Creek
Rating: 3	Height: 100 feet
GPS: 42° 39.3260'N, 74° 0.987'W	
Difficulty: Moderate, many stairs	Elevation Change: 200 feet
Time: 30 minutes	Lenses: 20mm to 70mm
Distance: 1.0 miles	

Directions: There are several parking areas in John Boyd Thacher State Park that provide access to the Indian Ladders trail. This is the best one. Begin in the small town of Altamont where NY 146 makes a jog at Main and Maple. Follow NY 146 (Main Street) west, keeping a small park on the left, for one block. Cross an old railroad track near the junction with NY 156 (Altamont Boulevard). Now bear right at the Stewart's shop onto NY 156 west, following signs for J. B. Thacher State Park and Thompson Lake State Park. The road climbs very steeply; in 1.8 miles, turn left onto Old Stage Road, and then in 2.0 miles bear left to join NY 157 (Thompson Lake Road). In .5 miles turn left onto CR 256 (Ketcham Road) and leave NY 157. If you miss this turn you'll end up at Thompson Lake. Follow Ketcham Road 1.7 miles to rejoin NY 157 (Thacher Road) and turn left onto NY 157. Park in the Minelot Picnic Area lot in .7 miles. There is a day-use fee. GPS coordinates: 42° 39.151'N, 74° 0.920'W.

There are several small falls in J. B. Thacher State Park, but the draws, besides the incredible view, are these two. When you leave the parking area, head for the cliffs and bear right on a gravel trail that leads to a little footbridge crossing the weakly flowing Minelot Creek near the fall's head. It's a heck of a view looking out over the face of the Helderberg Scarp. Follow the fence slightly uphill, keeping it on the left until you find a flight of stairs heading down to your left; you should see some green blazes along the way. Hang a left and descend 70 feet on metal stairs to the cliff base.

You'll get to Minelot Falls at .27 mile. I've seen the fall at sunrise, through thick fog, during lightning, as a dry trickle, and at full throttle after heavy rains. It never ceases to amaze me. The fall's base is radically undercut where the trail passes behind. It gives me the willies to walk all the way to the back of the little cave because overhead are several hundred thousand tons of rock. There's a little sign nearby with some historical data.

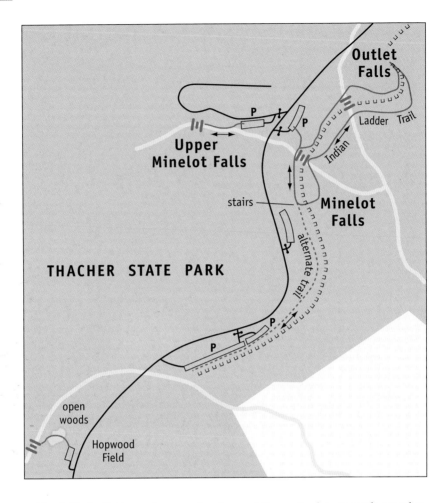

The fall's ballistic arc is very pleasing and the water has enough speed to hit about 30 feet beyond the cliff edge to land in a large rockfall. There's another sequence of drops below but they're inaccessible. The best shooting position is from where you first see the fall with the cliff on your left. The fenced trail beyond (where the cliff would be on your right facing the fall) just doesn't seem to work well photographically. The area will be crowded with people so if you want shots without them, get here early. That means you need to park across the road or at the main view parking lot farther along NY 157.

Continue along around the cliff face. The trail narrows, rises, and falls a couple times, and then dumps you at the foot of another big drop, this one running much weaker than Minelot. This is Outlet Falls. This fall's head is shaped differently so the water isn't launched clear of the cliff; instead it falls vertically with all the power of big garden hose. This is because much of out-

Minelot Falls. I shot from both sides of the fall. The path of the ballistic arc was nice but I was looking for something different. That's when I remembered to go long and explore the scene as graphic compositions. It's not necessary to see the head of the thin horsetail fall; the mind knows the water must come from somewhere. Here the fog gives the scene an ethereal look. *Canon EOS Digital Rebel, Tokina 20–35, Polarizer, ISO100 setting, f/16 @ .4 sec.*

let creek's flow is spirited away through a fracture network upstream and emerges from the fall's base as the strongly running spring you see. It's very difficult to get a good shot of Outlet Falls without an extreme wide-angle lens. I spent quite a bit of time shooting but just couldn't get anything that looked really good. At this point reverse your route and head back toward Minelot rather than completing the loop trail. You'll climb the stairs and end up back at your car at 1.0 mile.

There are two other falls in the park along upper Minelot Creek; both are small but you can get nice shots of them. If you park across the road (the west side), head into Minelot Creek and walk upstream 100 yards from the parking area to the first fall, which is at most 12 feet tall. The second is about 60 yards beyond the first and it's about 12 feet as well. I liked them both and shot them quite a bit; unfortunately, they each rate only a two. The last fall worth mentioning is along a little creek that is accessed from the Hopwood Field parking area. Head away from the bathroom and bear left through the pines; follow a little creek for at most 100 yards to a quaint nine-foot fall.

Hike 32 **Christman Preserve, Albany County**

Upper Bozen Kill

Type: Fall	Height: 16 feet
Rating: 4	GPS: 42° 44.355'N, 74° 7.714'W

Lower Bozen Kill

Type: Cascade	Height: 7 feet
Rating: 2–3	GPS: 42° 44.369'N, 74° 7.670'W
Stream: Bozen Kill	Distance: .8 mile
Difficulty: Easy	Elevation Change: 60 feet
Time: 25 minutes	Lenses: 20mm to 70mm

Directions: From the hamlet of Duanesburg at the intersection of NY 7 (Duanesburg Road) and US 20/Western Turnpike (I-88 exit 24), take NY 7 west .8 miles. Immediately after crossing a railroad go left onto Weaver Road. Follow Weaver 1.0 mile and then go left again onto Schoharie Turnpike. The Nature Conservancy's Christman Preserve is on the right in .7 mile, marked by a signed parking area. GPS coordinates: 42° 44.594'N, 74° 7.747'W.

This is a short, level hike through some nice open fields, so take your time and smell the wildflowers. Follow a mowed path into the woods and bear left at the first Y near a trail register. Remember to sign in and out. To reach the fall, follow the blue trail and cross a footbridge.

Bozen Kill Falls. Having left my tripod in the car, I had to use a log to support my camera since there was no way I was going to be able to handhold a long exposure. Always be prepared. *Canon EOS Digital Rebel, Tokina 20–35, Polarizer, ISO100 setting, f/16 @ .8 sec.*

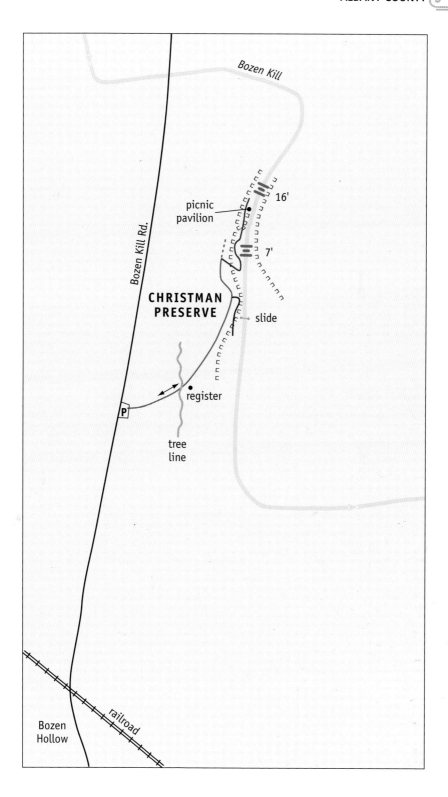

Bozen Kill

Bozen Kill Rd.

picnic
pavilion

16'

7'

**CHRISTMAN
PRESERVE**

slide

register

tree
line

P

railroad

Bozen
Hollow

The trail meanders gently uphill while the creek becomes ever louder as you approach. The blue blaze jogs left at .27 mile; take a moment and go to the ravine edge to observe the two drops, and then head downstream along the blue trail. Shortly after, at .29 mile, a yellow blaze turns sharply right. Take the turn and follow a set of stairs down that are hidden in a fissure between large stone blocks.

Careful grading gives the trail an organic feel and it's quite inviting to the feet. At .36 mile you reach the lower drop, a seven-foot-tall series of cascading ledges. Finally at .4 mile you arrive at the main drop, a 16-foot cascade headed by a four-foot ledge. Although both are small by New York standards, the fall has a cool and inviting plunge pool and nearby is a well-built picnic shelter. Bring the kids—they'll love it.

Hike 33 Rexford Falls, Schenectady County

Type: Cascade	**Height:** 19 feet
Rating: 4	**GPS:** 42° 50.486′N, 73° 52.828′W
Stream: Rexford Creek	**Distance:** 1.5 miles
Difficulty: Moderate, steep scramble	**Elevation Change:** 60 feet
Time: 40 minutes	**Lenses:** 20mm to 70mm

Directions: From the intersection of NY 7 (Cross Town Connector) and NY 146 (Balltown Road) in downtown Schenectady, take NY 146 north 3.6 miles. As you descend a hill passing under an old railroad bridge, make an immediate right on to East Street. If you miss it, turn right on Williams. If you miss that, cross a large bridge over the Mohawk River and turn around on the far side. Head steeply uphill for 100 yards and park on the right in a large gravel parking lot. GPS coordinates: 42° 50.868′N, 73° 53.288′W.

This fast walk on the Mohawk-Hudson Bikeway ends with a rather ticklish scramble that should only be attempted when the rocks surrounding the fall are dry. Head eastbound from the parking area on the paved bikeway. Pass a garage on your left and then go under a power line at .55 miles; you soon arrive at a culvert over a small creek. Turn left before you cross at an orange arrow noting an overlook and follow the well-trodden path that hangs close to the creek. If you cross and turn left you'll see the falls from the woods. The falls and an overlook of the wide Mohawk River arrive at .7 mile.

This scramble down is difficult. When the Mohawk is high it will fill the fall's tailwater like a little bay; when low there are several gravel bars exposed. If there's water from the Mohawk filling the tailwater you won't know how deep it is until you land in it. I stress that this is a difficult

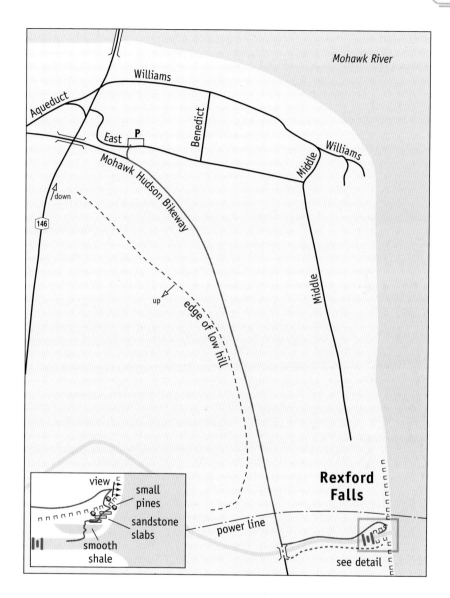

descent. This is my third outdoor book for Stackpole and this the first time I've had a fall that could have resulted in serious injury.

Work down toward the fall from the sandy ledges near the view headland until they peter out and are replaced by thin layers of shale. The shale provides no good handhold, so turn to face the rock and descend blindly down. This is the part I forgot about that led to my fall. I started down on my butt, then tried to change foot position and slipped. It was only about eight feet; unfortunately I was caught sliding on my hip. In an effort to get to my belly and try a glissade-like maneuver I ended up with some serious road rash on my right elbow and lost skin on both hands. Thankfully I

landed flat-footed in the creek. If I had landed any other way it would have meant more ankle surgery.

For being such a seasonal creek, it's quite a nice fall. If you look left you'll see that you can't scramble down from the opposite side; what appears to be an easy path when viewed from above ends in a blind five-foot ledge. You can set up anywhere that looks good and even out into the Mohawk a couple yards. Climb back out ever so carefully and return to your car at 1.5 miles. The climb out is a challenge since the sandstone ledges are more difficult to get over on the way up. Next time I think I'll bring a knotted rope and tie it off on the trees above.

Hike 34 Plotter Kill Preserve, Schenectady County

Plotter Kill Falls	
Type: Fall	**Height:** 34 feet
Rating: 5	**GPS:** 42° 49.704'N, 73° 3.068'W
Lower Falls	
Type: Cascade	**Height:** 45 feet
Rating: 5	**GPS:** 42° 49.803'N, 73° 2.864'W
Rynex Falls	
Type: Cascade	**Height:** 40 feet
Rating: 4	**GPS:** 42° 49.843'N, 73° 2.849'W
Stream: Plotter Kill	**Distance:** 2.37 miles
Difficulty: Moderate	**Elevation Change:** 800 feet total
Time: 1 hour	**Lenses:** 20mm to 70mm

Directions: From the intersection of NY 7 (Cross Town Connector) and NY 146 (Balltown Road) in downtown Schenectady, head west on NY 7 for 2.3 miles. Follow signs for I-890 East/NY 7 West and take I-890 east 1.8 miles to Exit 9A. Exit onto NY 7 (Curry Road) and follow NY 7 for 2.0 miles. After crossing NY 146 and NY 158, bear left onto NY 159 (Mariaville Road). In 5.1 miles, well after passing under I-90, turn right onto a gravel lane with a hard-to-see DEC sign for Plotter Kill Preserve and park in a large parking lot. GPS coordinates: 42° 49.531'N, 74° 3.124'W.

Follow the red-blazed trail downhill from the parking area, coming quickly to a wooden stairway; turn left down the stairs to cross a footbridge over a small stream. Now bear left uphill and away from the creek to stay on the red trail. The trail then swings right to run parallel to Plotter Kill and brings you to the head of a big fall at .21 mile. Despite your desire to make the

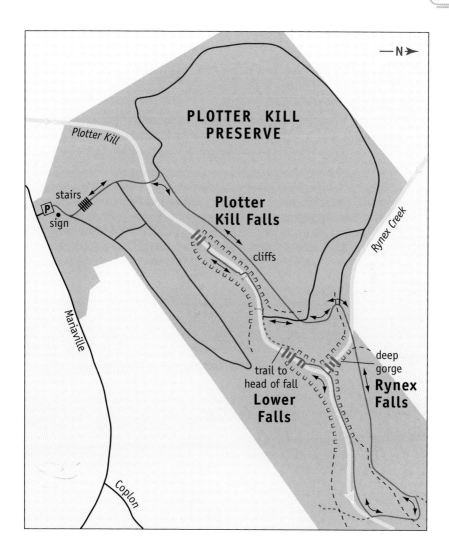

obvious scramble down, don't—instead, stick with the red trail until you come to a junction with a yellow-blazed path at .35 miles that goes down to the right. The trail junction defines the headwall of a long scarp that runs roughly parallel to the Mohawk River westward past Pattersonville. It's a nice view.

Turn right and descend sharply to the kill, arriving at .45 mile near a nice little ledge made of soft shale and capped by a 16-inch-thick layer of harder sandstone. This cap rock forms the creek's base. Head upstream on the creek's left-hand side (the side you're on) using a wide footpath until forced to ford to the right-hand side. Just as you get a good look at this large fall you're forced back to the left-hand bank for the final approach, arriving at the fall in .59 mile.

This upper fall is an imposing edifice. Nearly as wide as it is high, the fall's headwall extends well behind you, creating a massive amphitheater. In moderate flow it's an impressive fall and in high flow it's simply unapproachable. The stream runs northeasterly, the same as the prevailing winds, so spray is fired way downstream. I tried to work from a position on the right-hand side up a talus slope among some trees but was drenched within moments. Anywhere within a couple dozen yards of the plunge pool will be wet. In fact, the day I tried to shoot the fall, nearby trees were being bent over by the spray blast. There were other flooding problems in the region due to torrential rains: two washouts on NY 159 gave my Jeep a run for its money, and there was a complete washout on NY 5S where an entire culvert had shifted from under the road. That's why I came back in autumn when the kill's flow had slackened.

Ford your way back to the yellow trail and climb out to rejoin the red trail near the viewpoint at .83 mile. Look around carefully for blazes and take the red trail away from the main gorge. Go uphill and then come parallel to a tributary creek hidden in its own deep gorge. This is Rynex Creek. The trail climbs, and then descends again, crossing Rynex at .89 mile. It swings right to climb again, this time just a short way. It now follows a fairly straight line before descending as it approaches Plotter Kill. After the trail sweeps a long left to come parallel with Plotter Kill, start looking out for a poorly blazed, T-

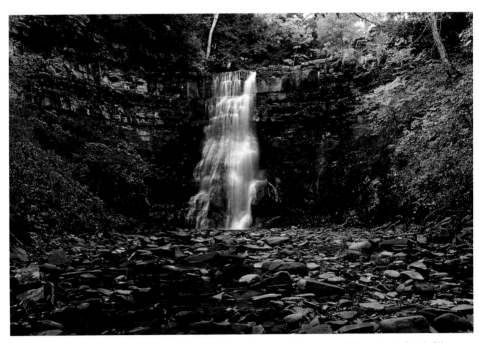

Plotter Kill Falls. This fall doesn't really have a plunge pool because of the extent of rock fill in the ravine. You can use the kill downstream as a foreground, which I did, but I liked this shot more as a geology lesson in how waterfalls are formed. *Canon EOS Digital Rebel, Tokina 17, Polarizer, ISO100 setting, f/16 @ 2 sec.*

Lower Falls. Start shooting the lower fall as soon as it comes into view when you cross Rynex Creek. The stream below the fall is filled with foreground options, so shoot every few paces. Take care, however: logs near the fall will need to be dampened or they will show up as blown-out highlights. *Canon EOS Digital Rebel, Tokina 20–35, Polarizer, ISO100 setting, f/16 @ 3.2 sec.*

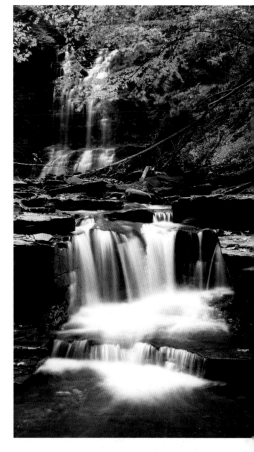

shaped intersection at 1.18 miles. The path ahead runs parallel to the kill while a right drops into the creek; turn right and arrive at the creek at 1.28 miles. There's a large landslide to the left. Check your landmarks or make a cairn because this spot can be difficult to see on the return.

Enter the creek and turn right to head upstream on the left-hand bank (the side you're on); you won't have to ford until you're at the falls. Arrive at a ledge guarding the entrance to Rynex Creek, which enters from your right. A quick hop gets you to the fall, which sits a few yards from the Plotter Kill. It's an impressive although weakly flowing cascade compared to the main channel. Whereas rain had the other falls blasting to the point of being unshootable, Rynex Falls was running well but weakly. It will be dry most of the year. Return to the main channel and stick to the wide left-hand bank for your approach to the lower fall, which you come to at 1.38 miles.

The lower fall is very different from the upper fall. It is a very wide cascade, in fact wider than it is tall, with an extensive cobble-filled base. There are ample places to work from and you can approach much closer than you can the upper fall due to less spray. There are a number of logs that have dropped in from above, so either move them or wet them down. I prefer a position near a downstream ledge close to Rynex Creek. From there you can get a nice environmental landscape; closer in are portraits and nice geologic images.

This hike is safe enough for kids so long as you don't let them into the kill above the falls. There's enough going on and the climbs aren't too demanding for elementary-aged children. Bring a lunch and spend the day. The kids may get soaked and probably muddy, but they'll have fun.

Head back downstream on the left-hand bank to the red-blaze crossing, arriving at 1.67 miles (or about .2 mile after passing Rynex Creek). Turn left to head back to the main red blaze, which you get to at 1.77 miles. Now go left again and reverse your route, returning to your car at 2.37 miles.

Hike 35 Yatesville Falls, Montgomery County

Type: Fall over cascade	**Height:** 35 feet
Rating: 4	**GPS:** 42° 52.104'N, 74° 27.029'W
Stream: Yatesville Creek	**Distance:** 50 yards
Difficulty: Easy	**Elevation Change:** 40 feet
Time: 10 minutes	**Lenses:** 20mm to 200mm plus macro

Directions: From I-90, take exit 29 for Canajoharie and NY-5S (E. Main St.). Turn left onto NY 5S and head east, driving parallel to I-90 (which is on the left) for 2.5 miles. Bear right onto a ramp for NY 162. Follow NY 162 uphill 4.8 miles and turn left onto Rankin/Rural Grove Road towards the village of Rural Grove. In .3 miles turn left onto Logtown Road. In 1.8 miles go left again onto Anderson Road (which may be unmarked), and in .8 miles turn left onto an unsigned gravel road for Yatesville Falls State Forest. In 1.1 miles, parking is available at a sharp left turn where the falls can be seen on the right. GPS coordinates: 42° 52.104'N, 74° 27.029'W. You may think that you can shorten the drive by taking Yatesville Creek Road from Currytown Road—you can't. Yatesville Creek Road is a farm lane that no longer crosses the creek.

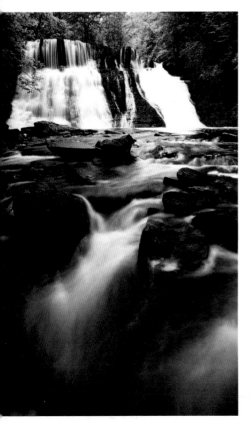

Scramble carefully down the loose slopes to a gravel bar and rocks below the falls. The fall is very seasonal and during my first visit at the end of May it was barely running. There had been minimal snowfall and spring rains were long in coming, so the entire region was bone dry. Thirteen months and lots of rain later the falls was blasting and spray made getting good shots troublesome. Worse, there was so much water that it was difficult to properly expose for the dark rocks while keeping detail in the white mass of water. I spoke to some locals who had brought their young kids along and they remarked that they had never seen the fall so full in the fifteen years they had lived nearby.

Yatesville Falls. No matter what exposure I tried, the right side of the fall rendered as white without detail (called blinkies). By minimizing the fall with respect to the foreground the overwhelming effect is reduced. *Canon EOS 5D MkII, Tokina 20–35, Polarizer, ISO100 setting, f/16 @ 1.6 sec.*

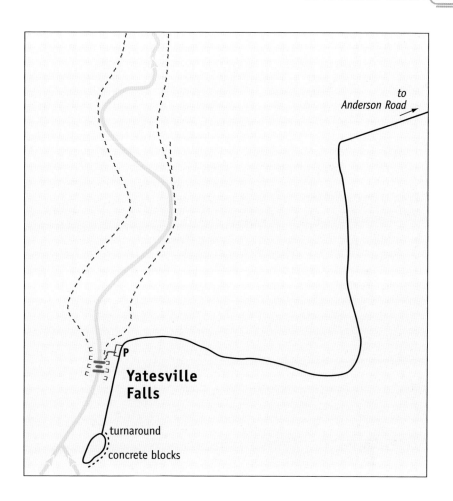

Hike 36 **Wiley Creek, Montgomery County**

Type: Cascade over cascade	**Height:** 25 feet
Rating: 4	**GPS:** 42° 49.347'N, 74° 15.857'W
Stream: Wiley Creek	**Distance:** 200 yards
Difficulty: Moderate, precarious scramble	**Elevation Change:** 80 feet
Time: 20 minutes	**Lenses:** 20mm to 70mm

Directions: From US 20 in the village of Esperance, take Charleston Street (CR 44) north a short distance and then turn right onto CR 28 (Burtonville Road). Follow Burtonville 3.9 miles as it runs along Schoharie Creek; when you come to CR 160 (Braman Corners Road), turn left to stick with Burtonville Road. If you cross Schoharie Creek you missed the turn. In .8 miles turn right onto Butler Road. Park in .5 mile at a wide spot on the right just after crossing a bridge over Wiley Creek. GPS coordinates: 42° 49.364'N 74° 15.884'W.

Wiley Creek is a seasonal tributary to the larger, swift-running Schoharie Creek. From the parking area, walk across the bridge to the creek's right-hand side and turn left (uphill) onto a bootpath. Starting steeply, it tops out in 30 yards before turning left to drop again. From here to the fall's base is a rather dicey descent. In dry weather it's not much of a problem; it's more unnerving than anything. However, in wet weather it can be downright hairy.

The path follows a narrow rock fin separating Wiley Creek from its larger sibling. Thirty feet straight down on the left is Wiley Creek, full of nasty sharp rocks, and on the right is Schoharie Creek, sporting a deep hole near the rock wall you're on. In two places thin shale slabs wobble underfoot, with the path being no more than a boot's width. Working along, you encounter a four-foot ledge that you must drop blindly over, followed by a second ledge. Both have white lichen on them that becomes slimy and slick in the rain. I almost couldn't get a grip on the lower ledge to hoist myself back up. At this point you may want to ask yourself the question—once down, can you get back up?

Once you make it down, turn left through some trees and then ford to the left-hand side. It's only 40 or so yards to the fall, which sits below a bridge that intrudes on an otherwise pleasant scene. It will be difficult to frame it

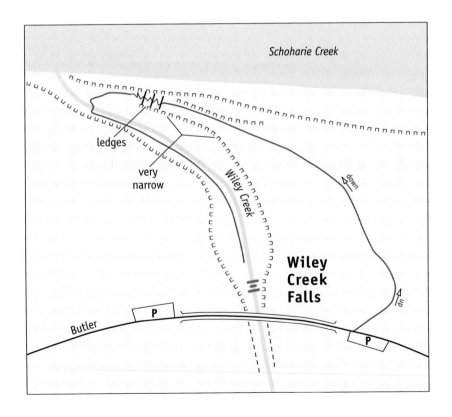

Wiley Creek Falls. The only way to keep the bridge out of frame is to get extremely close and use a super wide lens like a 12mm. The issue then becomes the open sky above and lack of foreground. I don't mind having the bridge in frame; I'm not thrilled by it but it is what it is. *Canon EOS Digital Rebel, Tokina 20–35, Polarizer, ISO100 setting, f/18 @ 8 sec.*

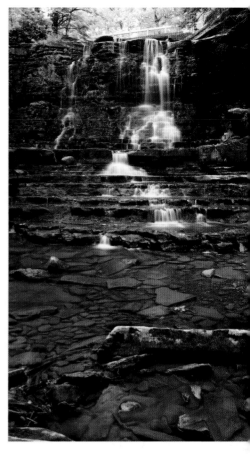

out unless you get very close. Another issue to deal with is the blank open sky above, since in late afternoon the fall is in shadow as you face the sun.

Despite these minor problems, this is a lovely location, especially if you can sit still for a while and wait for the frogs to return. I had been dodging violent thunderstorms all day and by the time I got here I was thankful to have an hour of dry weather in which to work. After a little time I heard rumbling—very low and violent rumbling—from way upstream, indicating that another storm was on the way. While changing lenses I noticed that the fall's sound had suddenly changed and become more distinct; the flow over the fall was increasing moment by moment. I was never in any danger of getting caught in a flash flood but it struck me as odd. Having visited more than one thousand falls in writing two guides, I had never seen this kind of sudden change in flow.

When you're done, head back downstream and ford back to the right-hand side where you crossed earlier. Head up the steep slope to the two ledges. The best way to get back up is to place your gear on the rock ahead of you; this will give you a better center of gravity to work with. Continue your scramble up the narrow fin and return your car.

Hike 37 Woodruff Outdoor Learning Center, Herkimer County

Sawmill

Type: Cascade	Height: 8 feet
Rating: 2–3	GPS: 42° 53.852'N, 74° 49.446'W

Cheese Box

Type: Cascade	Height: 10 feet
Rating: 3	GPS: 42° 53.885'N, 74° 49.381'W

Creamery

Type: Cascade	Height: 15 feet
Rating: 3–4	GPS: 42° 53.904'N, 74° 49.257'W
Stream: Otsquago Creek	Distance: 1.5 miles
Difficulty: Moderate, many stairs	Elevation Change: 185 feet
Time: 30 minutes	Lenses: 20mm to 70mm plus macro

Directions: From I-90, take exit 29 for Canajoharie. Take NY 5S (Main Street) north 3.6 miles, passing through Canajoharie, to the town of Fort Plain. Turn left onto Main Street (away from I-90). Go one block and bear right onto NY 80 (Reid Street). Follow NY 80 for 11.6 miles to the hamlet of Vanhornsville; turn right into the school parking lot and park in the large lot below the school bus parking area at a signed lot for the Robert B. Woodruff Outdoor Learning Center. GPS coordinates: 42° 53.837'N, 74° 49.533'W.

There are a total of eight falls along the upper section of Otsquago Creek, which begins uphill from the school. Three of the falls are easily accessible from the nature trail. Cross the little footbridge and first bear left toward the composting toilet, then right to follow a wide trail that parallels the creek on your left. In about 100 yards you arrive at Sawmill Falls. This eight-foot drop is made interesting by a moss-covered turbine and gearhead sitting nearby.

Continue downstream and arrive at a Y at .13 mile. Bear left toward The Caves and bear left again at a sign for Cheese Box. Descend a rocky path to the wide ten-foot-tall fall that cuts across the creek at an angle. Return to the trail and head downstream toward The Caves, where you'll find a sign for Creamery Falls at .38 miles. This is by far the best fall: its travertine ledges remind me of Elves Chasm deep within the Grand Canyon. Off to one side is a very seasonal 45-foot fall.

Creamery's plunge pool is deep and guarded by large blocks of pale limestone. As you face the fall one of them to the left has an exposed bare facet. This lone spot, perhaps softball-sized, will render as a blown-out highlight if you aren't careful. Dampen this surface or move to the creek's left-hand side

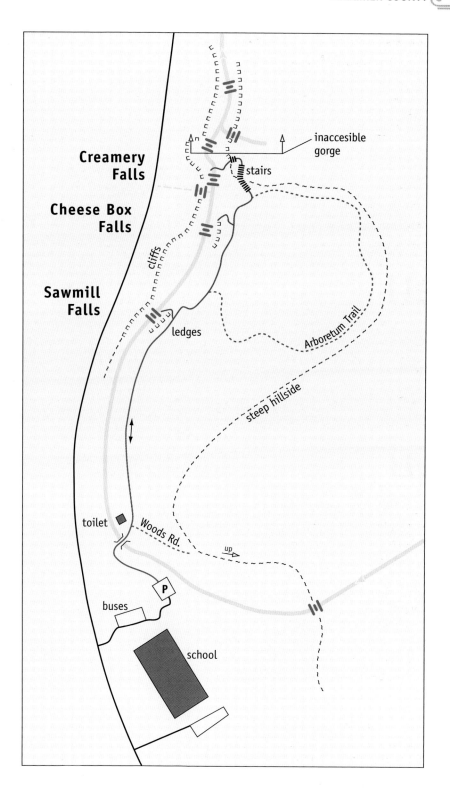

Creamery
Falls

Cheese Box
Falls

Sawmill
Falls

inaccesible
gorge

stairs

cliffs

ledges

Arboretum Trail

steep hillside

toilet

Woods Rd.

up

P

buses

school

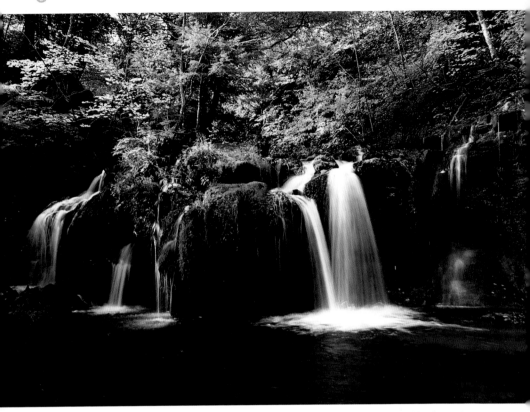

Cheese Box Falls. This is one of the few places where I have seen travertine-like formations. It was cloudy when I arrived but the sun popped out as soon as I set up. Fortunately the fall color was backlit and the trees overhanging the ravine muted the light's intensity enough to get good exposure. When the forecast is for sunny skies, work deep ravines in the very early morning. *Canon EOS Digital Rebel, Tokina 20–35, Polarizer, ISO100 setting, f/8 @ .3 sec.*

to keep it out of frame. Hanging gardens drip from the gorge walls, so bring macro gear for shooting spring wildflowers.

There's another drop just below and it's the largest of the drops here, but there's one big problem. This is technically private land and there's no trail to the lower fall. As such, it would be unethical to make the scramble without written permission from the school district. The ravine is shockingly deep, and the exposed ledges are unstable and blind in the descent. All of which makes it dangerous and foolish to try. Be content with what you've got and head back uphill to your car.

Hike 38 Faville Falls, Herkimer County

Type: Cascade	**Height:** 16 feet
Rating: 3–4	**GPS:** 43° 6.316'N, 74° 48.380'W
Stream: Ransom Creek	**Distance:** .3 miles
Difficulty: Easy	**Elevation Change:** 60 feet
Time: 20 minutes	**Lenses:** 20mm to 50mm

Directions: From the center of Dolgeville at NY 167 (Main Street) and CR 168 (Spencer Street), take Spencer west out of town 1.0 mile. Cross Carlson–Lyon Road where Spencer becomes Peckville (CR 148). Continue for another .7 mile to a Y and bear left, staying on Peckville Road. Take an immediate left into a large parking area just as you cross a culvert over Ransom Creek. GPS coordinates: 43° 6.316'N, 74° 48.380'W.

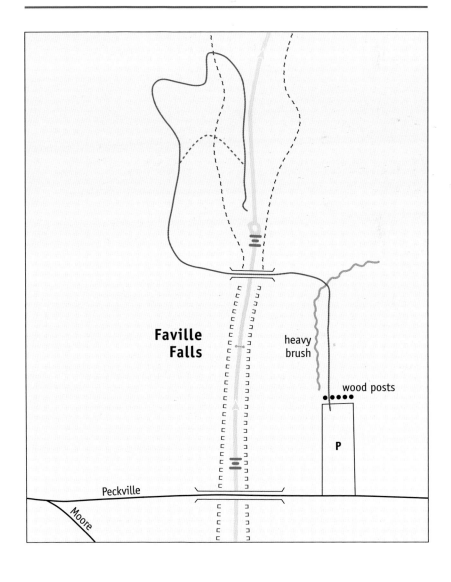

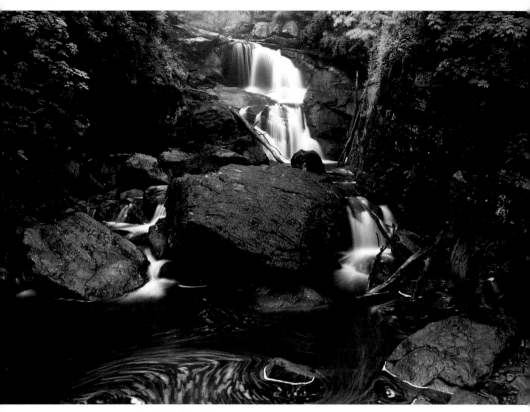

Faville Falls. The slightly soft focus is due to heavy rain. Fast shutter speeds will make individual raindrops show up and slow shutter speeds will "hide" them. Unfortunately, at some point no amount of shutter trickery will eliminate the blurring effect. In this case I kind of like the soft effect the rain creates. *Canon EOS Digital Rebel, Tokina 20–35, Polarizer, ISO100 setting, f/18 @ 6 sec.*

The parking area sits adjacent to the fall's head, hence the same coordinates. From the end of the parking area, walk down a mowed path where tall brush obscures the creek; bear left across a substantial footbridge and then turn right to follow the trail. At .13 mile you come to a Y; bear left to follow a descending, looping switchback path to the creek. The only shooting position (safe, that is) is downstream of a choke boulder that sits below the fall. You may be inclined to try and scramble this large rock, but it's covered in a pale green patina of algae that is slicker than ice when wet. This delightful fall is secluded even though it's less than 50 yards from a well-traveled road, so loiter a while and enjoy the time away from the rest of the world.

Hike 39 Pixley Falls, Oneida County

Type: Fall over Cascade	**Height:** 30 feet
Rating: 5	**GPS:** 43° 24.137'N, 75° 20.644'W
Stream: Lansing Kill	**Distance:** .1 mile
Difficulty: Easy	**Elevation Change:** 40 feet
Time: 40 minutes	**Lenses:** 20mm to 50mm

Directions: From the center of Rome, take NY 46 (Black River Boulevard) north 18.2 miles to the entrance of Pixley Falls State Park and turn right into the park. Cross a bridge over Lansing Kill and make a right onto a wide gravel loop and park near a fence guarding the fall's head. GPS coordinates: 43° 24.119'N, 75° 20.585'W.

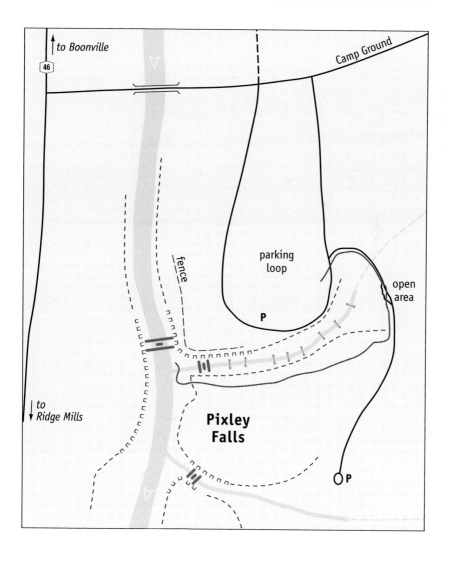

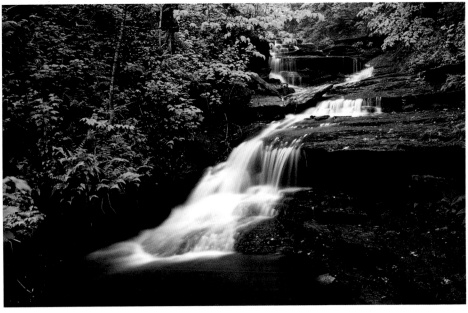

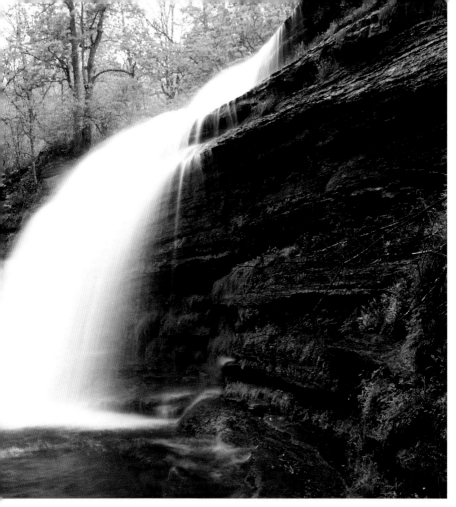

Above: Pixley Falls. I had never before used Photoshop's image merge utility to create panoramas of waterfalls, and I think it worked perfectly. I liked the fall's profile but couldn't get enough of the rock or tailwater into a single shot with a 17mm lens. So, I shot two frames and merged them. *Canon EOS Digital Rebel, Tokina 17mm, Polarizer, ISO100 setting, f/16 @ 1 sec.*

Facing page: Tributary to Pixley Falls. A small curved run joins Lansing Kill near Pixley Falls. The curve creates a pleasing composition from an otherwise average little stream. *Canon EOS Digital Rebel, Tokina 20–35, Polarizer, ISO100 setting, f/16 @ 13 sec.*

A wet, miserable final day of May (perfect for waterfalls) brought me to a thundering Pixley Falls. A short walk of 100 yards from the parking area drops you at the vast tailwater and plunge pool for this Empire State gem. Shooting is straightforward from downstream along the Kill's left-hand side (the side you're on). Spray was being carried well downstream, making it a challenge to keep my lens dry, so I walked up to the falls and nuzzled close to the drop to shoot a different and ultimately more pleasing perspective. Two side creeks also have nice drops in them so take the time to shoot both. To get to either tributary, enter from where they join Lansing Kill near the big fall and walk up their easily accessible glens. You won't need to go more than 30 yards up either one.

Hike 40 Beecher Creek Falls, Saratoga County

Type: Cascade	**Height:** 11 feet
Rating: 3+	**GPS:** 43° 13.279'N, 74° 6.018'W
Stream: Beecher Creek	**Distance:** 60 yards
Difficulty: Easy	**Elevation Change:** 30 feet
Time: 10 minutes	**Lenses:** 20mm to 70mm

Directions: From the intersection of Main Street and Water Street in Northville, head east on Water Street .4 mile to a T and turn right onto CR 149 (Ridge Road). When you come to Tennantville Road in .8 mile, turn left. In 1.2 miles go right onto Johnson Road. In .8 mile turn left onto CR 4 (Northville Road). Follow CR 4 for 1.1 miles, and then go left onto North Shore Road (CR 4). In .3 mile cross Beecher Creek and follow North Shore Road, which swings hard right. You'll be moving quickly past buildings close to the road, so go slow. Head downhill .2 mile and park on the right just downhill from a carriage shop. GPS coordinates: 43° 13.248'N, 74° 6.046'W.

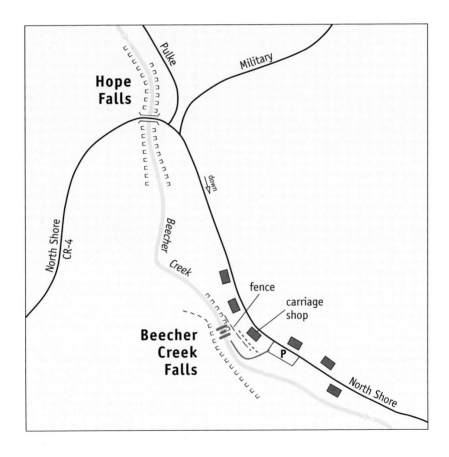

This small but wonderful roadside cascade is worthy of your time as you travel to or from Northville to shoot bigger game. Looking like a tiered wedding cake, Beecher Creek drops over several shelves and larger ledges. From the little parking area, walk to the left of the fence and follow a path down to the plunge pool. This is one of the few falls in the state that has a handicapped-accessible observation platform. Hang out for a while and enjoy this little cascade.

Hike 41 Groff Creek, Madison County

Fall 1

Type: Slide over slide	Height: 26 feet
Rating: 4	GPS: 43° 19.092'N, 74° 17.093'W

Fall 2

Type: Cascade	Height: 13 feet
Rating: 3–4	GPS: 43° 18.979'N, 74° 17.231'W

Fall 3

Type: Cascade	Height: 11 feet
Rating: 3	GPS: 43° 18.852'N, 74° 17.389'W
Stream: Groff Creek	Distance: 4.5 miles
Difficulty: Strenuous, much bushwhacking	Elevation Change: 1,250 feet
Time: 2 hours, 45 minutes	Lenses: 20mm to 70mm

Directions: From the intersection of Bridge Street and Main Street, at the town of Northville, take Bridge Street west toward Sacandaga Lake .6 miles. Turn right to head north on NY 30. In 3.3 miles turn left onto Benson Road/River Road where NY 30 swings right to cross Scandaga via a large bridge. Follow the improved gravel River Road 4.7 miles, parking on the left in a large parking area set among some pines. GPS coordinates: 43° 18.812'N, 74° 15.458'W.

Two roads leave the parking area: one ahead and parallel to the river that becomes four-wheel-drive necessary, and the other away from the river to the left. Follow this left road as it rolls gently up and down and crosses Peters Creek at .48 mile. When you cross into DEC lands near .7 mile the road peters out but an obvious trail continues. Bear left of a "No Motor Vehicles Allowed" sign and head uphill; water will be audible on the right. The trail frustratingly vanishes at 1.1 miles. I had to move toward and away from the creek several times while moving upslope so that I cut back and forth across where the trail should have been. Looking for ground-up leaf litter or

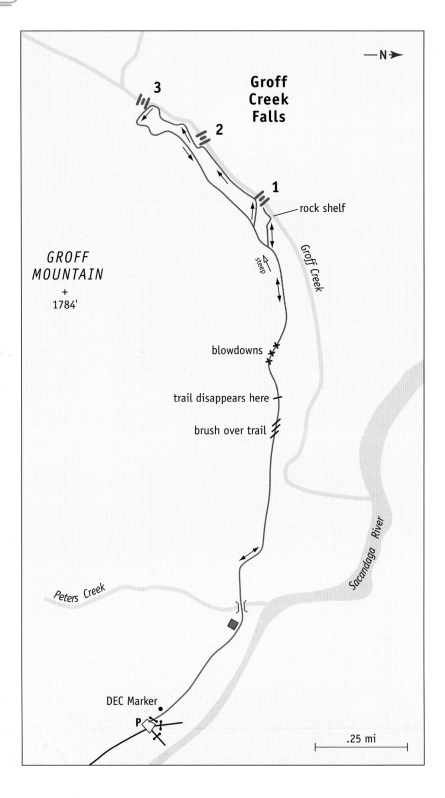

—N→

3

**Groff
Creek
Falls**

2

1

— rock shelf

*GROFF
MOUNTAIN*
+
1784'

steep

Groff Creek

blowdowns

trail disappears here —

brush over trail

Peters Creek

Sacandaga River

DEC Marker

P

.25 mi

other sign, I finally found a deep rut of what looked like an old road, which I followed for a short distance. After working around a mass of tangled blowdowns I finally found a clearly defined trail. If you're not comfortable bushwhacking for trail sign, use the GPS coordinates 43° 19.137′N, 74° 16.447′W.

At 1.58 miles the trail's pitch slackens and the creek, which had been well below you, is now only about 60 feet below. Look carefully at the creek and scan until you see the faint head of the first fall upstream of your position. Bear right off trail and side-hill your way down through piney litter and over numerous deadfalls, adjusting your course so that you land in the creek about 10 yards above the head of Fall 1.

From here you get a good look downstream at a total drop of 50 feet; however, you have no shot from here. What you do have is a route upstream to the second fall. Head upstream, fording numerous times and bushwhacking over or around blowdowns (possibly earning a few bruises along the way) and arrive at Fall 2 at 1.9 miles. This smallish, moss-encased cascade is as photogenic a fall as you'll find. Sitting in a narrow cleft, the fall has a Y shape where the divided flow joins above a shallow pool. Every rock within a dozen yards has a thick covering of emerald-green moss. Notice that the rocks lining the stream also have moss on their tops, which is indicative of little-to-no foot traffic in this creek section.

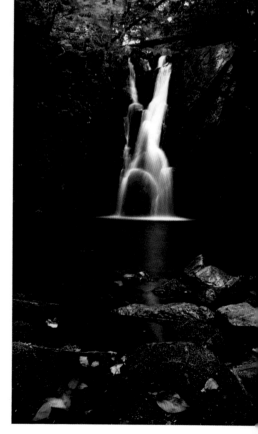

Face the fall and work up the moss-covered talus to your left (the creek's right-hand side), following the terrain's bowl shape directly away from the creek. When you're about 20 yards above the fall's head, turn right and carefully side-hill past the fall's head. Now angle downslope back into the creek. You've followed an upside-down, U-shaped path that avoids some ledges above the fall.

Once back in the creek, head upstream and ford as needed. The valley of Groff Creek is basically a straight furrow, but the creek meanders while creating numerous deep pools and carving out steep banks on the outside of every turn. For this reason you'll have to ford more times than you

Middle Groff Creek Falls. Fall 2 has a number of nice set-ups, including these nice moss-covered rocks as foregrounds. *Canon EOS Digital Rebel, Tokina 20–35, Polarizer, ISO100 setting, f/14 @ 13 sec.*

can count. You will pass three very nice little drops that can be shot as part of larger environmental scenes. When you come face-to-face with an 11-foot-tall cascade at 2.14 miles you've arrived at the farthermost point of your hike.

The geology has changed since Fall 2, which was closed to the sky. This fall is entirely open, which will make it render a stop or two brighter than

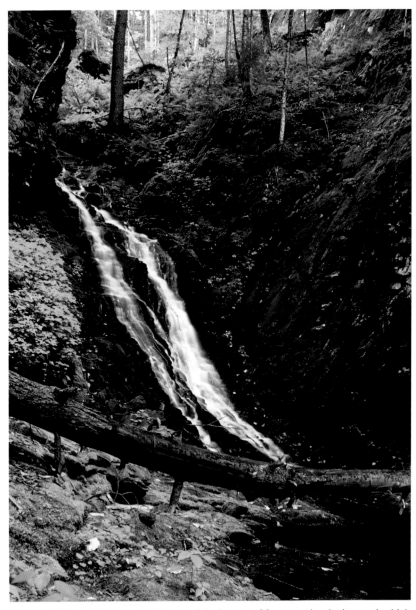

Lower Groff Creek Falls. I wasn't able to pull the log out of frame so I just had to work with it as best I could. *Canon EOS Digital Rebel, Tokina 20–35, Polarizer, ISO100 setting, f/8 @ 6 sec.*

the foreground. Also, an exposed rock ledge on the right is mirrored by a large hemlock blowdown on the left. I wouldn't spend too much time here—it's nice, but a better view is down the trail.

Stand on the creek's right-hand side while facing the fall. Look upslope to your left and scan the forest until you find a bright orange, diamond-shaped blaze. Although the blaze makes a nice target, it's okay if you don't find it. Head uphill away from the creek toward the orange blaze; when you get to it, go another 20 paces uphill and pop out onto the trail. You're at the 2.25-mile mark and have gained about 990 feet, although with all the ups and downs the total is more than 1,100 feet.

Now turn left to head downhill on the trail. As you once again approach the visible head of Fall 1, look downstream for a large green rock platform or ledge; it's about 50 yards below the fall. Continue along the trail until you align with this feature. Now go left and head steeply downhill toward the creek, skidding on your backside if needed. As you approach the rocky green ledges, turn upstream and drop into the creek just to the upstream side. The last three feet are quite steep so take care. Make a cairn so you can identify this spot on the return.

Once you are safely in the creek, head upstream and ford as needed. As you catch a glimpse of the lower slide, the way ahead is blocked by a large blowdown. Hung up atop some ledges, the blowdown is made of large tree trunks covered by a mass of tangled small limbs. This mat of limbs hangs above a couple very deep holes; should you break through you're going to get very wet. I should warn of the worst-case scenarios in this situation: first is falling forward over a knee and ripping it to shreds, second is wedging a boot to the point that you can't pull your foot out. This is why I always have a whistle around my neck.

The reason I didn't have you head for Fall 1 earlier is that access down into the creek looks much different heading down trail than up. I'm also working under the assumption that you don't do this kind of off-trail stuff that often, so I used the first two falls as a confidence-booster to give you a feel for the terrain before trying something a little more difficult.

When you finally reach the two slides you have traveled 2.9 miles. The lower one is okay but the upper is much better. Climb up along the lower fall's right-hand side (your left) by looking for rocks with their moss cover worn away, indicating the path with the most foot traffic. The upper slide is reclined at a shallow angle that increases in pitch with height. The fall's precipice is hidden from below (you saw it earlier) which is why I have it listed as 26 feet as opposed to its real total of about 40 feet. The tailwater is wide and numerous rocks make for comfortable seating that invites you to linger. This kind of hiking brings me great joy; on my first trip here it was raining off and on, and there's something magical about a forest in the rain. It took me about four hours to scout this route and in all that time I never saw another soul. There's a sense of accomplishment in doing something

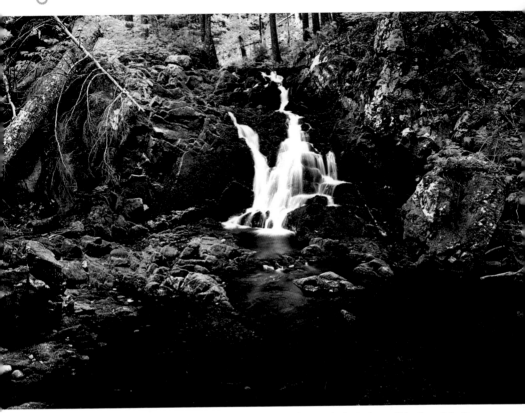

Upper Groff Creek Falls. The debris on the left side is typical of what will be found fouling the creek below and making various logjams, one of which is a challenge to get over. *Canon EOS Digital Rebel, Tokina 20–35, Polarizer, ISO100 setting, f/8 @ 3.2 sec.*

difficult. The slow pace that's forced by so much off-trail movement requires that you stop and carefully examine your surroundings.

Make the challenging retreat downstream past the blowdowns to the stone ledges where you dropped into the creek. Using roots and rocks as handholds, head uphill out of the creek and return to the trail at 3.0 miles. Then turn left and head downhill, returning to your car at 4.5 miles. Hikes like this connect us to nature more so than well-blazed herd paths.

As a bonus for your efforts, as you head back to NY 30, pull over at GPS coordinates 43° 16.437'N, 74° 14.081'W. You'll find a large set of ledges rising from the road for quite a ways, and they may be running.

Hike 42 Tennant Creek Falls, Hamilton County

Type: Slide	**Height:** 19 feet
Rating: 4	**GPS:** 44° 54.569'N, 74° 5.176'W
Stream: Tennant Creek	**Distance:** 1.4 miles
Difficulty: Easy	**Elevation Change:** 134 feet
Time: 30 minutes	**Lenses:** 20mm to 70mm

Directions: From the town of Speculator and the intersection of NY 8 (Lake Pleasant Road) and NY 30 (Indian Lake Road), take the combined NY 8/30 east out of town 22.2 miles to the hamlet of Hope. Turn left onto Creek Road. Stay on Creek for 2.9 miles and then turn left again onto CR 7 (Hope Falls Road). Go 4.8 miles and park at the road's end. GPS coordinates: 43° 20.967'N, 74° 11.077'W.

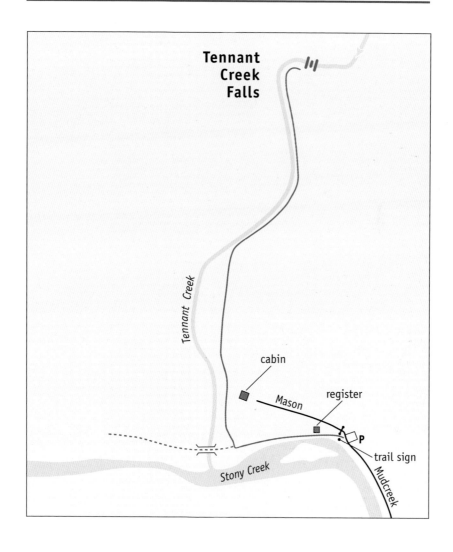

Tennant
Creek
Falls

Tennant Creek

cabin

Mason

register

P

trail sign

Stony Creek

Mudcreek

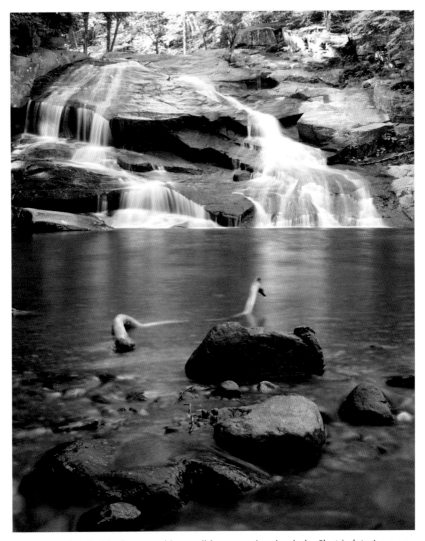

Tennant Creek Falls. The large pool is a well-known swimming hole. Shot in late June, you can see how slight the flow is despite the long shutter. It's best to get here in mid-May to see the full slide engulfed in water. *Canon EOS Digital Rebel, Tokina 20–35, Polarizer, ISO100 setting, f/14 @ 3.2 sec.*

Follow the wide, well-worn trail that parallels Stony Creek. When a footbridge comes into view around .1 mile, turn right onto another well-worn path. In short order a bunch of arrows appear urging you to stick with the path rather than walking into the backyard of the handsome cabin on your right.

Here the trail leaves Tennant Creek and veers to cut off a long creek meander before returning to it at .45 mile. Now the fall should be faintly audible. Arrive at a delightful slide at .7 mile. The fall's plunge pool is vast and the cool water begs you linger and soak your feet, so take the opportunity to

do so. Many gravity-defying and whimsical cairns dot the area and they also make interesting subjects. Retrace your route and return to your car at 1.4 miles.

Hike 43 Jimmy Creek Falls, Hamilton County

Type: Cascade	**Height:** 7 feet
Rating: 3	**GPS:** 43° 27.169'N, 74° 14.018'W
Stream: Jimmy Creek	**Distance:** 175 yards
Difficulty: Easy	**Elevation Change:** 30 feet
Time: 10 minutes	**Lenses:** 20mm to 70mm

Directions: Start from the town of Speculator and the intersection of NY 8 (Lake Pleasant Road) and NY 30 (Indian Lake Road). Take the combined NY 8/30 east out of town 9.7 miles, crossing the outlet of Lake Pleasant and passing closely along the Sacandaga River. Then turn right onto NY 8. Park in a large pullout adjacent to the left guardrail in 1.2 miles. GPS coordinates: 43° 27.201'N, 74° 14.045'W.

Cross the road and follow a bootpath that enters the woods next to a sign marking culvert "8-2209-1387." In less than 200 feet you come to a charmingly picturesque cascade that drops into an emerald-green, moss-covered ravine. The fall, the little ravine, and the way the water swirls

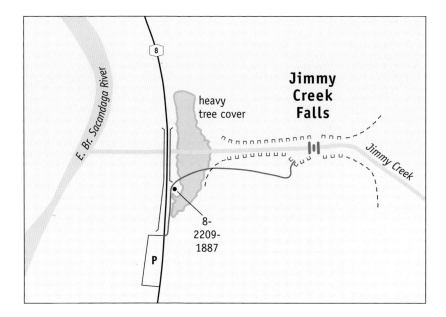

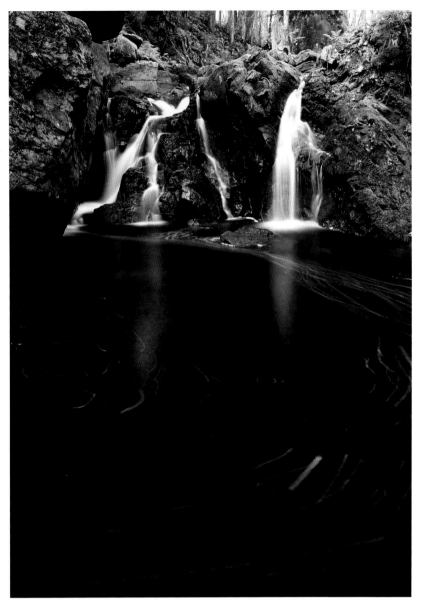

Jimmy Creek Falls. We can create foregrounds resembling "star trails" by manipulating time. By increasing the shutter speed I was able to paint the foam bubbles as they swirled through a slow-moving eddy. It's a common technique I use to add visual interest to a scene. *Canon EOS Digital Rebel, Tokina 20–35, Polarizer, ISO100 setting, f/10 @ 25 sec.*

through a wide eddy make for photographs dripping with texture. Upstream the little creek is jumble of boulders, hemlocks, and delightfully burbling water. I think this is the smallest fall in this guide, and small though it may be, Jimmy Creek is on my personal favorites list.

Hike 44 Auger Falls, Hamilton County

Type: Chute	**Height:** 22 feet
Rating: 4	**GPS:** 43° 28.037'N, 74° 14.792'W
Stream: Sacandaga River	**Distance:** 1.0 miles
Difficulty: Easy	**Elevation Change:** 116 feet
Time: 40 minutes	**Lenses:** 20mm to 70mm

Directions: From the town of Speculator and the intersection of NY 8 (Lake Pleasant Road) and NY 30 (Indian Lake Road), take the combined NY 8/30 east out of town 8.0 miles, crossing the outlet of Lake Pleasant and passing closely to the Sacandaga River. Turn left to park in a large unsigned parking lot. If you get to the NY 8/NY-30 split you went 1.8 miles too far. GPS coordinates: 43° 28.184'N, 74° 15.099'W.

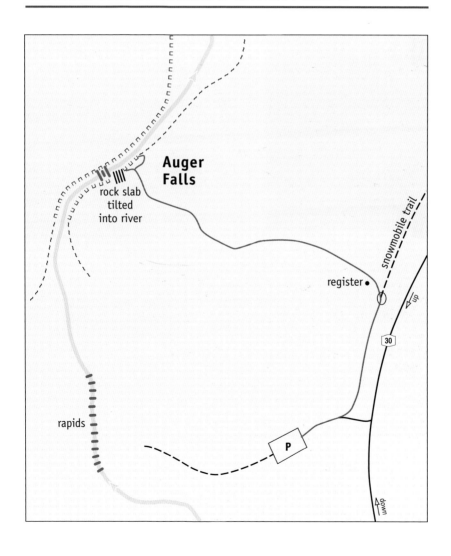

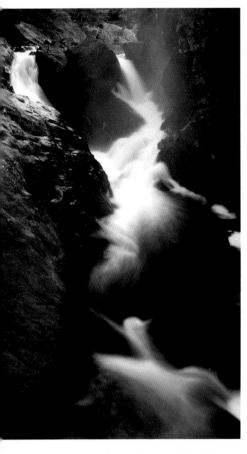

Auger Falls. With two dramatically different tones—tan granite on the left and black on the right—it can be difficult to make an image feel balanced. By exposing so the histogram touched the left edge, I had enough information to do some dodging in Photoshop to even out the scene's tonality. This method was routine in the black-and-white days and it's more true with digital. *Canon EOS Digital Rebel, Tokina 20–35, Polarizer, ISO100 setting, f/16 @ 4 sec.*

Leave the large parking lot by walking back toward NY 30. Turn left onto a woods road/ATV trail that runs parallel to NY 30. In .18 mile you reach another parking area that is actually a turnaround. Now turn left, register, and make note of the yellow hazard signs. Follow a heavily used, yellow-blazed trail to arrive at the fall's head at .5 mile.

Like all Adirondack rivers the Sacandaga follows a joint fracture system. Where two fracture lines meet, or when there's a vertical displacement, some kind of cataract will be found. In this case the fault the river follows crosses a vertical fracture plane choked by two huge boulders that divide the river into two nearly parallel chutes. Each in their own right would be a nice drop, but together they are quite something to see at full throttle. During my second visit I could feel the rocks vibrating through my knees as I composed my shots.

The best position is a ledge about 30 yards downstream. Look for a car-sized block of rock hanging toward the river and carefully scramble down the fissure that separates it from the surrounding ledges.

The rock slopes of Auger Falls are smooth and dip toward the fall. Should you slip you'll be funneled into the river. From the falls to your shooting perch there's maybe 30 yards of exposed rock that is slick when wet; however, there has been enough boot traffic on it to keep the slippery lichens and algae patina down. This is not the case for the perches themselves—they are very slick. Linger a while and don't be afraid to seek different perspectives. Just make sure of your footing whenever you move among the rocks near the fall's chasm.

Hike 45 Lake George Wild Forest, Washington County

Shelving Rock Falls

Type: Fall over cascade	**Height:** 46 feet
Rating: 5+	**GPS:** 44° 33.200'N, 73° 36.146'W

Fall 2

Type: Slides	**Height:** 20 feet
Rating: 3	**GPS:** 44° 32.886'N, 73° 35.420'W

Fall 3

Type: Cascade over cascade	**Height:** 13 feet
Rating: 3+	**GPS:** 44° 32.749'N, 73° 35.174'W

Fall 4

Type: Cascade	**Height:** 6 feet
Rating: 3	**GPS:** 44° 32.701'N, 73° 35.119'W

Fall 5

Type: Cascade	**Height:** 38 feet
Rating: 5	**GPS:** 44° 32.651'N, 73° 35.069'W
Stream: Shelving Rock Creek	**Distance:** 1.1 miles total
Difficulty: Moderate, some bushwhacking	**Elevation Change:** 300 feet total
Time: 1 hour total	**Lenses:** 20mm to 70mm

Directions: From the intersection of NY 9 and NY 149 south of Lake George near The Great Escape amusement park, take NY 149 east toward Fort Ann for 10.7 miles. As you approach Fort Ann, bear left onto Nicholson Road. In .8 mile turn left onto CR 16 (Kane Falls Road). Head north on CR 16 for 5.7 miles and bear left onto the poorly signed gravel Hog Town Road (you may see hand-painted signs for Hog Town or Shelving Rock). Hog Town Road twists and turns as it climbs sometimes steeply uphill; in 3.8 miles bear left at some houses (there may be a hand-painted stop sign). In .2 mile, when you come to a T where Sly Pond Road goes left with a sign for a Boy Scout camp pointing left, turn right onto Shelving Rock Road. In .7 mile come to the large, signed Hog Town Rock Parking Area and zero out your trip odometer to check distances to the three parking areas that follow. Turn left and pass Parking 3 on the right at 1.6 miles, followed by Parking 2 on the right at 1.9 miles. Then turn left into a very small parking area marked on the map as Parking 1 just beyond a bridge at 2.4 miles. GPS coordinates: 43° 33.124'N, 73° 35.795'W.

The reason for taking you to the farthest parking area first at Shelving Rock Falls is so you can scout the road. Also, it's much easier to see the other falls as you head uphill looking through the driver's side window.

This hike to Shelving Rock Falls is only .6 mile round trip with a net loss of 100 feet. Hike into the woods from the small parking area, keeping Shelv-

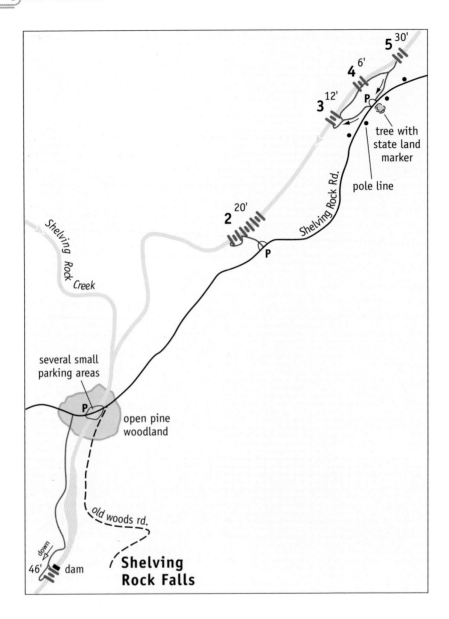

ing Rock Creek on the left. At .15 mile the sloping terrain funnels you to a large meadow. The meadow is actually the silt-filled remnant of a lake formed by a dam heading the fall. Angle uphill away from the meadow, heading in a downstream direction while keeping within sight of the creek. You shortly arrive at an old mill dam. You should hear the fall by now, as it's about 30 yards downstream. From here, follow an old road downstream to the fall's base and arrive at .3 mile. As the fall's face comes into view you'll find footpaths into the rocks below.

Shelving Rock Falls is a surprisingly large drop considering its location. Almost as wide as it is high, it carries a tremendous volume of water after a good rain. In summer it will be just a big trickle; however, I got lucky when severe storms dropped four inches of rain overnight and made it a veritable monster. The tailwaters are a long slide of boulders that increase the overall height to more than 60 feet.

You can shoot through the veil of trees or nuzzle up close among the rocks for a better view. If you'd like to shoot the main drop as a portrait, use the alternate trail noted on the map. When you get to the head, work downhill away from the cliffs on a well-worn footpath. This position gives you a good view of the main drop but shows more of the dam above the fall. This is why I prefer the view from the right-hand side.

Return to your car, arriving at .6 mile. Drive uphill for just over .4 mile and park in a wide spot on the left at GPS coordinates 43° 32.846'N, 73° 35.458'W. Face the creek and look downhill for a long series of slides that drop more than 60 feet. Head downhill through the open woodland, angling slightly left (downstream) as you go; you reach the slide's base in .05 mile, losing about 70 feet in the process. This places you on the creek's left-hand side looking up at the slides. When looking upstream the sequence is less impressive since the lower 20-foot slide hides the others above, the reason I listed this fall at 20 feet. You can easily work uphill along the creekbank exploring graphic designs or you can shoot from higher in the woods so that the whitewater cuts through the frame at an angle and makes a nice environmental shot. This would also be a nice fall color shot.

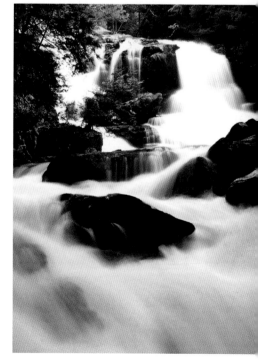

Arrive back at your car at .1 mile, regaining all the elevation you lost. Drive uphill for just over .3 mile, parking again on the left in the larger pullout at GPS coordinates 43° 32.681'N, 73° 35.157'W. Below you are three nice falls.

Facing the creek, the lowermost drop is downhill to your left; the uppermost is about level with you in the woods to your

Shelving Rock Falls. Yes, the image is level. I always use a level mounted to the camera's hot shoe. Keeping the camera level by eye is quite tricky; the best way is to compose the scene and then step back and look to see if the camera body is level. Many times visual cues, like the rock shelf in the middle ground here, can be misleading. *Canon EOS Digital Rebel, Tokina 20–35, Polarizer, ISO100 setting, f/16 @ 1 sec.*

right along a prominent woods road (which will be your return route). Head left downhill through the open woodland for a little more than 100 yards, losing 120 feet before arriving at a 12-foot-tall cascade that's divided into two watercourses. A little six-footer surrounded by lush forest is upstream about 100 yards. Continue upstream another 100 yards to a twisting 38-foot cascade that slowly reveals itself as you move. There are many nice shooting positions to work from all along the creekbank so take your time. To return, follow an old woods road away from the last fall and arrive at your car at .4 mile.

I scouted this route in mid-July and was unimpressed by the flow over the upper three falls. I was camping at Cherry Valley to the south and over the course of several nights big storms raged over the mountains. On three successive nights the thunder was so intense that the ground shook me awake through my crash pad and lightning flared so brightly I could see trees silhouetted through my eyelids. It was a heck of an experience. One particular night the rain fell so hard that the sound in my tent was almost painful. Having gotten no sleep at all I got up before dawn and headed to Shelving Rock Falls and was greeted by a raging torrent. It just goes to show, fortune favors the prepared and the sleep-deprived.

Hike 46 Northwest Bay Brook, Madison County

Type: Cascade	**Height:** 20 feet
Rating: 3	**GPS:** 43° 37.687'N, 73° 36.564'W
Stream: Northwest Bay Brook	**Distance:** .4 mile
Difficulty: Moderate, steep climb	**Elevation Change:** 100 feet
Time: 20 minutes	**Lenses:** 20mm to 70mm

Directions: From the village of Hague at the intersection NY 9N (Lake Shore Drive) and NY 8 (Graphite Road) take NY 9N south 12.8 miles and park on the left in a large, signed fishing access parking area. GPS coordinates: 43° 37.547'N, 73° 36.474'W.

You can get a sense of the flow by checking the water volume running under 9N a hundred feet north of the parking area. Sprint across NY 9N directly opposite the parking area, hop the guardrail, and ascend the steep, tree-lined hill in front of you. Once you top out, turn right and follow some old footpaths toward the sound of rushing water that will be off to your left a little. The fall won't be visible until you come to a series of cliffs hanging over a deeply entrenched meander in Bay Brook. The fall appears where Bay

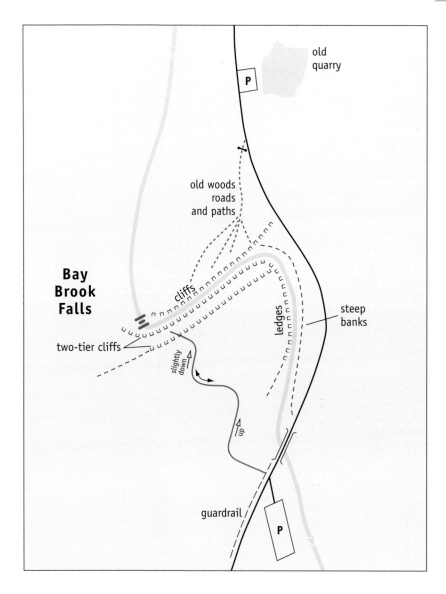

Brook makes a 90-degree turn and plunges over an inky black rock face before sweeping through a 180-degree meander. With no safe access to the plunge pool (believe me, I tried) you'll have to be content with a veiled shot through the trees. I think it looks best as a horizontal. Thick moss carpets everything around you and I have to say these are some of the most comfortable boulders I've ever sat on.

Hike 47 **Hague Brook, Warren County**

Type: Slide	**Height:** 20 feet
Rating: 3+	**GPS:** 43° 44.937'N, 73° 30.264'W
Stream: Hague Brook	**Distance:** 60 yards
Difficulty: Easy	**Elevation Change:** 30 feet
Time: 10 minutes	**Lenses:** 20mm to 70mm

Directions: From the intersection of NY 9N (Lake Shore Drive) and NY 8 (Graphite Mountain Road), take NY 8 west uphill .4 mile. Park on the left at a signed fishing access pullout. GPS coordinates: 43° 44.951'N, 73° 30.293'W.

Head downhill from the parking area across a little footbridge and turn right into a fenced view area. You can shoot from here or from a small perch near the fence. For an alternate view, walk uphill along SR 8. Hop the

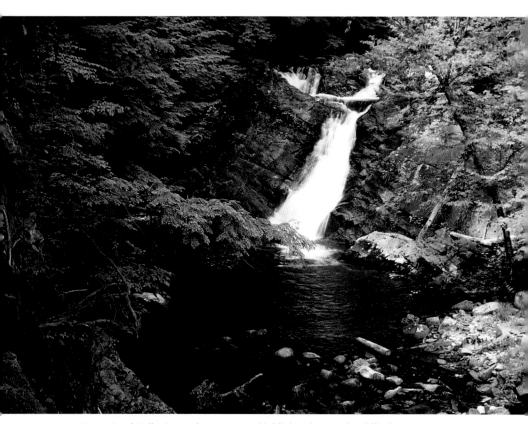

Hague Brook Falls. Dry rocks can create highlights that can be difficult to manage. Sometimes you have to take what you get and wait for a nice big cloud to even out the exposure. *Canon EOS Digital Rebel, Tokina 20–35, Polarizer, ISO100 setting, f/8 @ ¹/₅ sec.*

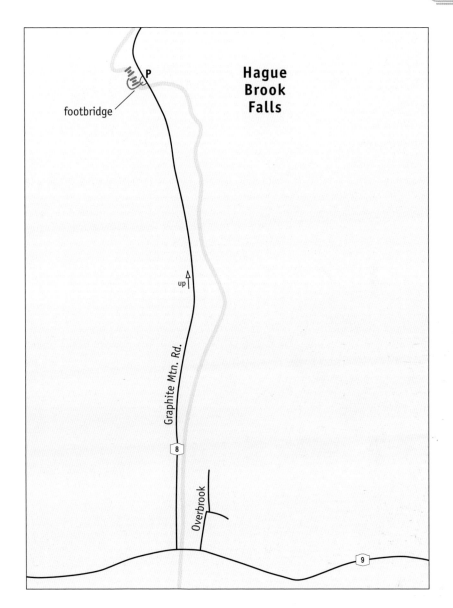

Hague Brook Falls

footbridge

P

up

Graphite Mtn. Rd.

8

Overbrook

9

guardrail as soon as you can and then traverse a series of boulders down to the plunge pool. The fall cuts crosswise and is quite attractive considering that the road is just a couple yards away.

You can make out another fall from NY 8 where it crosses the brook upstream of here. It's not accessible because the trail ends at the viewpoint. Unfortunately, you'll have to be content with a glimpse as you drive past.

Hike 48 Salmon River Unique Area, Oswego County

Type: Fall	Height: ~110 feet
Rating: 5	GPS: 43° 32.871'N, 75° 56.445'W
Stream: High Falls Creek	Distance: .6 mile
Difficulty: Easy	Elevation Change: 160 feet
Time: 40 minutes	Lenses: 35mm to 70mm

Directions: From the center of Pulaski at the intersection of US 11 (Salina Street) and NY 13 (Rome Road), follow US 11 north .4 miles, making a jog left over the Salmon River, and then turn right onto CR 2 (Maple Avenue). In 3.8 miles turn left onto Main Street and make an immediate right back onto Richland, now CR 48 (Richland–Orwell Road). In 2.9 miles turn right onto CR 22 (Lacona–Orwell Road) and then left in 2.7 miles onto Falls Road. Park in the large signed parking area in 1.4 miles. GPS coordinates: 43° 32.938'N, 75° 56.596'W.

Follow the graded cross-country ski trail a few yards to the first overlook—and then say "Wow!" This is one massive fall; it's several times wider than high and when I was here the flow was confined to three large braids despite torrential rains. I can't imagine what this fall is like when a large vol-

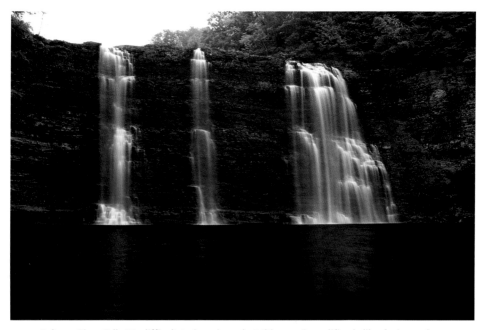

Salmon River Fall. It's difficult to imagine what this massive edifice is like during a dam release. Even under this "weak" flow, spray was an issue. If you have a chance to shoot it at full throttle please do so. It must be amazing. *Canon EOS Digital Rebel, Tokina 20–35, Polarizer, ISO100 setting, f/22 @ 2 sec.*

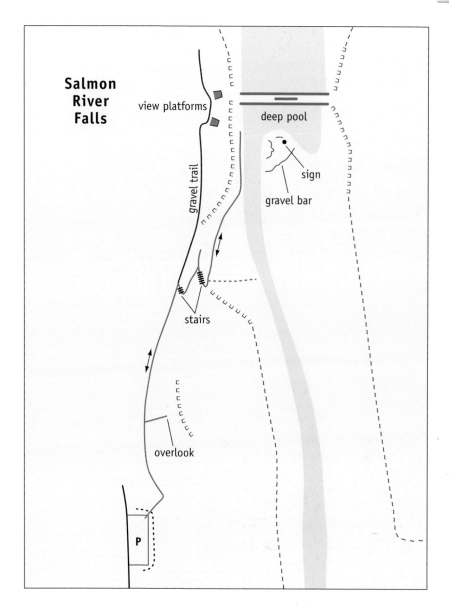

Salmon River Falls

view platforms

gravel trail

deep pool

sign

gravel bar

stairs

overlook

P

ume of water is allowed out of Salmon River Reservoir so the fall runs at full throttle. The ground must shake.

Continue along the gravel ski trail and then turn right onto the Gorge Trail. Descend more than 100 feet to the fall's base, shooting as you go. The steep trail has grades between 15 percent and 30 percent, so take your time. Starting with a steep set of stairs, the trail levels until the first switchback (which provides a nice fall color spot) before plunging to the river below. Once you get to the bottom, work close, somewhere around 60 yards. Don't cross to the gravel bar opposite since it's signed as a restricted area. This yellow sign is a real pain and you'll need to take care to keep it out of frame

from any position. Or you can remove in post-processing. Take care when working in or near the plunge pool since dam releases occur without warning and the river can rise several feet in moments.

Shoot every lens you have as vertical and horizontal. Linger, explore, and shoot until you run out of memory—you won't regret a moment.

Hike 49 Talcott Falls, Jefferson County

Type: Cascade over slide	**Height:** 35 feet
Rating: 4	**GPS:** 43° 53.520'N, 75° 58.729'W
Stream: Stony Creek	**Distance:** 100 yards
Difficulty: Easy	**Elevation Change:** None
Time: 10 minutes	**Lenses:** 20mm to 50mm

Directions: From I-81 exit 43 for US 11, take US 11 north .8 mile and pull over on the right near a large fall. Park where Old Route 11 merges with US 11. GPS coordinates: 43° 53.515'N, 75° 58.821'W

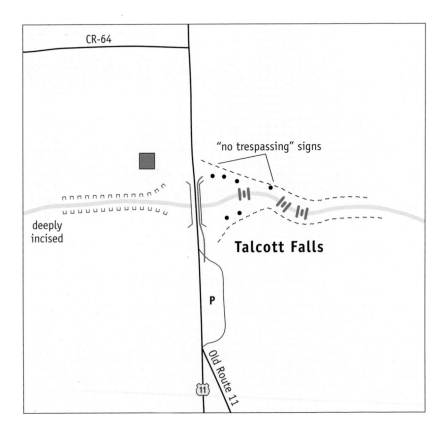

Talcott Falls. Curved lines make pleasing compositional elements that lead your eye through the frame. Think of shooting waterfalls in terms of graphic design elements, not portraits. To see the full effect of the twist requires a bit more water than I had. *Canon EOS Digital Rebel, Tokina 20–35, Polarizer, ISO100 setting, f/22 @ 6 sec.*

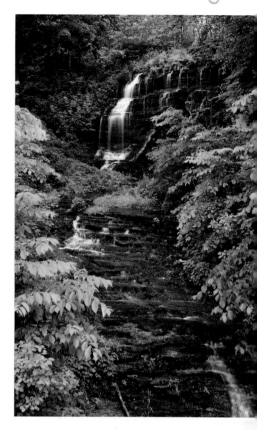

Sitting just 50 yards from the parking area is impressive Talcott Falls, with two distinct drops featuring a 25-foot cascade that twists above a 10-foot slide. This popular location is posted all along the creekshed, so shoot from the guardrail facing the fall. It's okay to hop the guardrail to work around foreground obstructions, but go no farther than a couple feet.

Hike 50 Gleasemans Falls, Lewis County

Type: Cascade over slide	**Height:** 25 feet
Rating: 4	**GPS:** 43° 47.946'N, 75° 13.855'W
Stream: Independence River	**Distance:** 6.2 miles
Difficulty: Moderate	**Elevation Change:** 300 feet
Time: 2 hours, 15 minutes	**Lenses:** 20mm to 100mm

Directions: From the center of Lowville at the intersection of NY 26 (State Street) and NY 12 (Dylan Avenue), take NY 26 south a couple blocks and turn left onto CR 22 (River Street). Follow River 2.6 miles and turn left onto CR 26 (Number 4 Road). In another 2.4 miles turn left onto the poorly signed Chase's Lake Road. From here on out road signs are either hand-painted or non-existent. In 3.9 miles turn left onto Erie Canal Road (may be signed as Brooklyn Street) into an odd-looking housing development; then in .6 mile turn right onto the gravel Beach Mill Road. Follow Beach Mill to the end at 3.2 miles. GPS coordinates: 43° 48.506'N, 75° 16.583'W.

Bring a head net and all the bug repellent you have, preferably pure DEET, as you'll need it on this hike. Follow the sandy multiuse trail; descend slightly, cross a footbridge, and then swing left to a register. Now put on the head net. If you have a topo map, you'll notice that the Independence River is a slow-moving, slack-water stream that passes through innumerable swamps and bogs, therefore the spring and summer mosquito population numbers in the billions.

At .57 mile look for a large opening on the left with a footpath leading into a large meadow; go ahead and take some time to explore and shoot. At 1.1 miles you will arrive at a large swamp with a multitude of standing dead trees. In the right light this spot would be astounding. On my approach I spooked an osprey that screamed as it circled twice before departing. I guess I interrupted lunch. I did glass what snags I could see but didn't find a nest—perhaps you will. After a long, boring traverse over many drumlins, meaning lots of ups and downs, you come to a footbridge over Second Creek at 2.53 miles. When you finally make the Independence River at 2.78 miles Gleasemans Falls will be in view on the left. You probably noted that the damp woodsy soil gave way to thin dry soil in the last 50 yards. This is because granite is now close to the surface.

I wandered along the ledges above the river for several yards up and downstream looking for an easy route down. I found one hidden among some scraggly pines where the blazed trail drops about five feet and then immediately climbs back ten feet. You should have no trouble locating it if you look for a rock cleft with ground-up leaf litter indicative of heavy foot traffic dropping right into the river. To deal with high water, bring a longer lens like a 200mm so you can shoot from the cliffs where you first saw the fall.

This river follows a complex system of rock fractures or faults. As such, the little gorge's walls have smooth vertical surfaces and rough horizontal surfaces; either will be slick when wet. Also, the river above and below the falls is quite narrow, deep, and swift. Once down at the river's edge you can

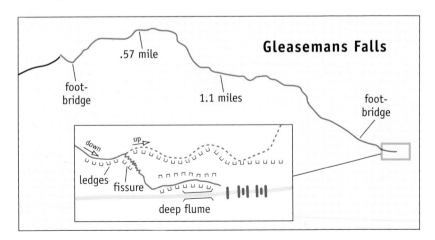

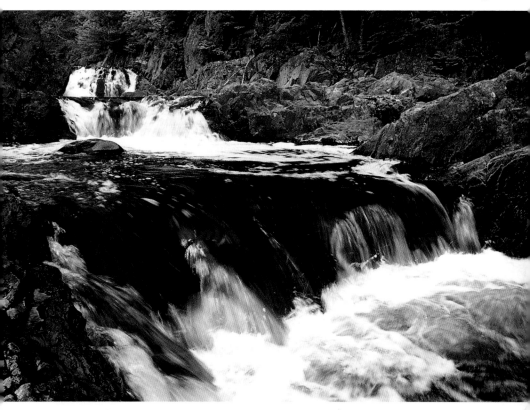

Gleasemans Falls. You might be able to sense how deep the flumes below the fall are in this image. The water's tea color comes from the tannin the water leaches from the expansive pine forest it passes through. It smells nice too. This shot was handheld using the rule of shutter speed equals 1/focal length. *Canon EOS Digital Rebel, Tokina 20–35, Polarizer, ISO100 setting, f/8 @ 1/20 sec.*

work upstream on the right-hand side (the side you're on). There are two places where wide, rough ledges disappear into toeholds that require some dexterity, skill, and fortitude to get beyond. We're talking maybe two feet here; however, a slip brings a huge penalty. The bigger upper drop is around 15 feet and the lower slide sequence around 10 feet. Below all is a narrow chute with a deep hydraulic that will pull you under should the worst happen. To test it I tossed in a stick. It never came up.

In fact, I would not recommend a river-level approach in damp weather since the exposed rocks have a black lichen covering that becomes exceptionally slick in the rain. I fell a couple times myself when it wasn't raining.

I have the hike listed as a little over two hours, but that won't do the area justice. If you're serious about your craft you could spend more than two hours at the meadow and swamp noted earlier. You should really plan on making a day of it. Bring a good map, a compass, GPS, and a lunch—and don't forget the head net.

Hike 51 **Buttermilk Falls, Hamilton County**

Type: Slide over cascade	**Height:** 15 feet
Rating: 4	**GPS:** 43° 54.887'N, 74° 29.043'W
Stream: Raquette River	**Distance:** .2 mile
Difficulty: Moderate, many stairs	**Elevation Change:** 40 feet
Time: 15 minutes	**Lenses:** 20mm to 100mm

Directions: From the intersection of NY 28 and NY 28N/30 in the town of Blue Mountain Lake, take NY 28N/30 north 7.6 miles and turn left onto CR 3 (North Point Road). In 2.1 miles park on the right in a paved, signed pullout for Buttermilk Falls. GPS coordinates: 43° 54.833'N, 74° 28.992'W.

Spanning the full 40-yard width of the Raquette River, this popular fall and swimming hole will be crowded on any summer's day. It's also popular with fishermen, so keep an eye out for brightly colored floats or yellow line that you probably won't notice until you view images on a monitor.

From the parking area, walk .1 mile down a wide path to the fall's tailwater. Large rocks extend from the shore to near midstream and make access to a good position rather easy. In high flow, however, all the rocks will be swamped with swift-moving water, so chest waders or water shoes will be a better choice; just be careful with the very cold spring runoff. Starting as a

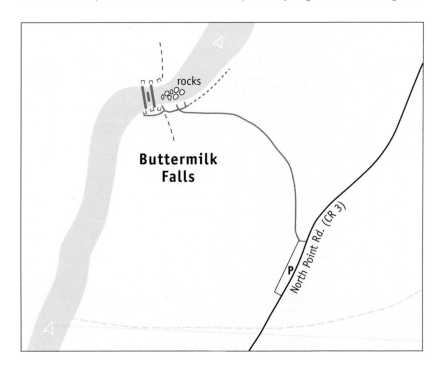

casual slide, the fall's pitch increases as it drops until in the last eight feet it's nearly vertical. The river above is open so shooting in overcast means the sky will be blank white, leaving no tonal separation with the fall's crest. You might want to try a blue sky day and shoot what is called a High Dynamic Range (HDR) sequence. This is where you shoot several frames of differing exposure and then combine them in post-processing.

Hike 52 Hanging Spear Falls, Essex County

Opalescent

Type: Cascade	**Height:** 10 feet
Rating: 3	**GPS:** 44° 6.341'N, 73° 59.458'W

Hanging Spear

Type: Fall	**Height:** 75 feet
Rating: 5+	**GPS:** 44° 6.104'N, 73° 59.442'W
Stream: Opalescent Creek	**Distance:** 11.2 miles
Difficulty: Strenuous	**Elevation Change:** 1,485 feet
Time: 5 hours	**Lenses:** 20mm to 100mm

Directions: From the intersection of NY 28 and NY 28N/30 in the town of Blue Mountain Lake, take NY 28N/30 north 29.1 miles and make a slight left onto CR 25 (Tahawaus Road), which changes signs to CR 84 and back again to CR 25 all in the span of a mile. Head north on CR 25 and in 7.7 miles bear left onto Upper Works Road. Park at the road's end at 3.5 miles. Although National Geographic map 742 shows another trailhead that's closer, Tahawaus Road is gated just after the Upper Works Road cutoff. GPS coordinates: 44° 5.349'N, 74° 3.360'W.

I set off on this hike in late June knowing that I was probably going to be rained out. For the previous nine days large thunderstorms had swept the High Peaks Region during the predawn hours, often followed by another round of storms late in the day. This was working in my favor, because so long as storms pounded the region there would be enough stream flow to shoot everything I needed. It didn't matter that I wasn't getting any sleep, only that at some point the weather would break, the skies would clear, and my shooting would be over. So far I had been very lucky working from dawn to dusk, with nearly fourteen days of rain out of eighteen. I had gotten a radar report from my wife and thought I had a several-hours-long window to work with—boy, was I wrong. About an hour up the trail I could hear thunder echo off the surrounding peaks; it then began to rain lightly. My last thought was, "This isn't too bad." That's when all hell broke loose. Even though I was surrounded by thick woods I was blinded by a couple flashes

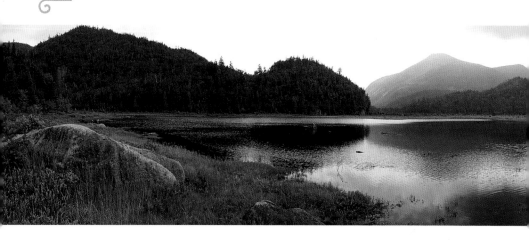

of lightning hitting fairly close; based on the fusillade of thunder, I knew Mount Adams and Calamity Mountain were taking the brunt of it. I had no choice but to hunker down, wait out the worst of it, and then retreat. My second attempt was the next day when the forecast called for clouds followed by severe storms late in the day. Perfect conditions indeed.

Sign in at the trail register and make note of the bear warnings. Head up a wide gravel road running parallel to the Hudson River. Cross a brook at .3 mile and bear right to follow the yellow and red blazes. When you come to a Y at .4 mile the yellow blaze heads left to Duck Hole and Indian Pass; the red blaze goes right to Mount Marcy and Lake Colden. Turn right on the red blaze (trail 121).

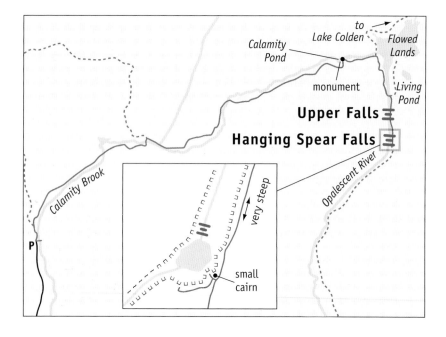

Flowed Lands Panorama. Never forget to stop and enjoy the view. The High Peaks Wilderness is filled with many such locations. *Canon EOS Digital Rebel, Tokina 20–35, Polarizer, ISO100 setting, f/8 @ 1/25 sec.*

Cross Calamity Brook at 1.18 miles on a wooden cable swing. Below is a little drop. In fact, the brook is very photogenic for many yards above and below the bridge. Cross another bridge at 1.65 miles and arrive at another junction, this one a T, at 1.9 miles. Left follows a lesser-used blue blaze to Henderson Lean To, Indian Pass, and Duck Hole. Right is a heavily used blue blaze to Calamity Lean To, Lake Colden, and Mount Marcy. Turn right.

When you cross your third stream at 1.78 miles the trail is generally uphill with several steep pitches. For the next 2 miles the trail is made of mud and boulders followed by boulders and mud. Many of the rocks that you're now dealing with were set in place years ago to help with erosion; unfortunately, immense amounts of foot traffic and rain have incised the trail so deeply that the rocks are an impediment. They will slow you down considerably but the rewards are well worth it.

Cross Calamity Brook for the last time at 2.68 miles and then come to a marsh or pond on the left at 3.9 miles. Keep an eye out for the trail, which turns sharply left away from the marsh. If you'd like to explore some of the little side trails, have fun and look for a stone monument to David Henderson, who died here in 1845 (GPS coordinates: 44° 6.746'N, 73° 59.971'W). From here it's less than a mile to the fall as the crow flies.

When you reach the popular Flowed Lands Campground you will have hiked 4.7 miles and climbed nearly 1,000 feet. Register again and then go ahead and take some time to wander around the lake—it's a glorious place to kick back and relax. I sat on a boulder for a long time watching a mother loon with a couple babies on her back. The little family swam within feet of me as they slowly cruised along the lakeshore. If you sit quietly and try to become part of the landscape, most critters will ignore you. That's when the magic happens.

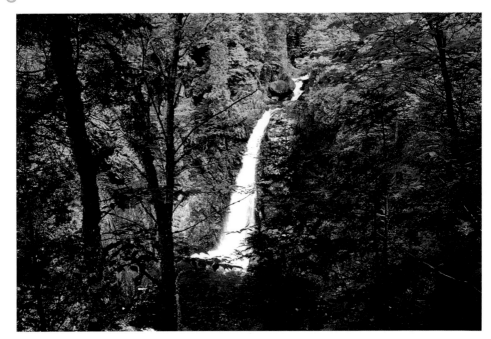

Hanging Spear Falls. I decided to handhold this location. With the fall blasting after recent rains, I knew that using a long shutter wouldn't be necessary. Upping the ISO setting guaranteed a fast shutter to counteract the fact that my knees are wrapped around a tree as I hung from a cliff to clear foreground brush. *Canon EOS Digital Rebel, Tokina 20–35, Polarizer, ISO800 setting, f/8 @ 1/80 sec.*

Make a hard right around the lake (keeping it on your left) and come to an old dam spanning the lake at 5.1 miles. This dam heads Opalescent Creek. Look for a series of stepping-stones and boards that make a haphazard ford, and carefully cross to the far bank. This brings you to a junction where a yellow blaze goes left to Livingston Point and your red blaze to the falls goes right. Starting with an uphill pitch the trail drops suddenly over exposed sharp ledges. From here to the falls you'll lose 330 feet in about .35 mile.

As you drop you'll pass within yards of Opalescent Falls. When the creek begins to sound like it's well below, keep a careful eye out for a cairn or other indication of a small side trail right at 5.6 miles (.5 mile from the last trail junction). Turn right and arrive at a small headland with a "No Camping" sign that overlooks Hanging Spear Falls from a downstream position. I'm not sure "spectacular" is the right word; perhaps "awe-inspiring" works best.

Opalescent Creek doesn't so much fall over the precipice as it's thrown. The creek slides over a series of ledges and gathers momentum as it passes through a narrow notch, where it flies clear of the cliff and pounds into the pool below, which as advertised is opalescent green. Although listed at 75

feet the drop is much bigger when you take into account everything that you can see above (which isn't much). If you work left along the headland to take a more downstream position you'll see that the entire sequence is well over 150 feet, but that's only a guess.

To get the best look I nuzzled against a tree guarding the 100-foot cliff, set my tripod up, and blasted away with my legs hanging into space. After a long time I broke out a couple granola bars and counted myself lucky for being able to experience this superb spot.

Another smaller view that's down trail has a more head-on view of the fall and is roughly even with the head. From here you can see that Opalescent Creek follows an immense fissure that splits Calamity Mountain from Cliff Mountain. I didn't like it as a shooting spot though. As you head back up trail toward Flowed Lands, stop and shoot Opalescent Falls. Reverse your route and head back to the car, arriving at 11.2 miles.

If you've planned well ahead you may have built in time to hit Lake Colden (Hike 53) from this side. This would add 3.4 miles roundtrip and 400 feet of elevation gain to your hike. If you have the legs to ramble off 15 miles it will be worth the effort.

Hike 53 Lake Colden, Essex County

Not Named

Type: Cascade	Height: 34 feet
Rating: 4	GPS: 44° 7.673'N, 73° 58.783'W
Stream: Not named	Distance: 11.5 miles
Difficulty: Difficult	Elevation Change: 1,500 feet
Time: 5 hours, 30 minutes	Lenses: 17mm to 100mm plus macro

Directions: Ample parking is available at the Adirondack Loj south of Lake Placid. From the downtown intersection of SR 86 and SR 73 (Mirror Lake Drive and S. Main Street), follow SR 73 east 3.2 miles, passing the airport on the left and the Olympic Ski Jump complex on the right. Turn right onto Adirondack Loj Road and follow it 4.8 miles to the end. GPS coordinates: 44° 10.978'N, 73° 57.782'W.

The difficulty of this hike isn't the length or the elevation gain—it's the deeply incised, boulder-laden trail that reminded me of U.S. Navy "knee knockers." An alternate route to Lake Colden is via the Upper Works and Hanging Spear Falls (see Hike 52, page 127). To begin, stop in at the Loj entrance hut and pay the $9 non-member parking fee. As you exit the hut, bear slightly right and walk to the end of the southernmost parking area and look for the blue-blazed Van Hovenburg Trail.

For the next 2.1 miles you'll follow this trail and ignore all others. A little before 1.0 miles you pass a DEC sign announcing that you've entered wilderness lands that require you pack out all waste. At 1.0 miles you arrive at an intersection where a blue blaze to Mount Marcy turns left (trail 61) and a yellow blaze to Algonquin Peak turns right (trail 64); turn left for Marcy Dam.

As you move briskly along, Marcy Brook rises to meet the trail and the telltale noise of whitewater becomes louder. As tantalizing as some of these drops might be, they're all created by boulder chokes and thus are not true falls. If you'd like to pop into the creek to shoot, take a side trail down at 1.5 miles (44° 9.747'N, 73° 57.099'W).

At 2.1 miles arrive at Marcy Dam Lake. Wonderful images can be made from the bridge spanning the dam, especially in the early hours of dawn. Cross the dam and come to a trail junction; here you'll follow a yellow blaze toward Avalanche Lake and Lake Colden Interior (trail 68). As you move along the lake edge you'll still see some blue blazes; within 100 yards bear left onto the wider of two paths and shortly after arrive at a signed Y. Here the blue-blazed trail 61 to Mount Marcy continues left and the yellow-blazed trail 68 to Colden bears right. Follow the yellow brick road. This sequence crosses a series of heavily traveled side trails, although the main trail is wide and well-worn. If you pass a shelter on the right and can still hear Marcy Brook then you're in the right spot.

You'll turn right to cross a footbridge over Marcy Brook at 3.2 miles. If conditions are good take some time to shoot the boulder-strewn brook. About 100 yards after the bridge is another Y. A blue-blazed path to Lake Arnold, Mount Colden, and Feldspar heads left (trail 73) and your yellow blaze for Avalanche Lake, Lake Colden, and Interior Outpost heads right (trail 68). After a long, strenuous climb over boulders you arrive at the base of an epic landslide at 3.76 miles. Look up to the left at the exposed granite face of a mountain. The debris field you're in came from that summit and is the result of thin soil on the mountain's flank sliding off like carpet across a floor. In heavy rain the soil's tenuous grip is broken and it slides downslope, carrying all vegetation with it. What you're in is like a massive train wreck where railcars pile atop one another as cars at the train's rear careen over the ones ahead. In fact, where you're standing is a small portion of a much larger slide. Such slides are common and this striping effect can be seen from any highway.

Moving still upward you cross Avalanche Pass at 3.9 miles and begin catching glimpses of Avalanche Lake to the southwest; you arrive at this photogenic gem at 4.27 miles. To the right and left cliffs rise upwards of 500 feet. The lake is tea-colored and clear enough that you can see many feet down. When looking along the lake, spy a sharp-topped peak 2.7 miles distant: this is 3,620-foot-tall Calamity Peak, which is near Hanging Spear Falls and 3.4 miles from the Upper Works trailhead. For the next mile the path along the lake can only be described as delightfully brutal. You'll go up and

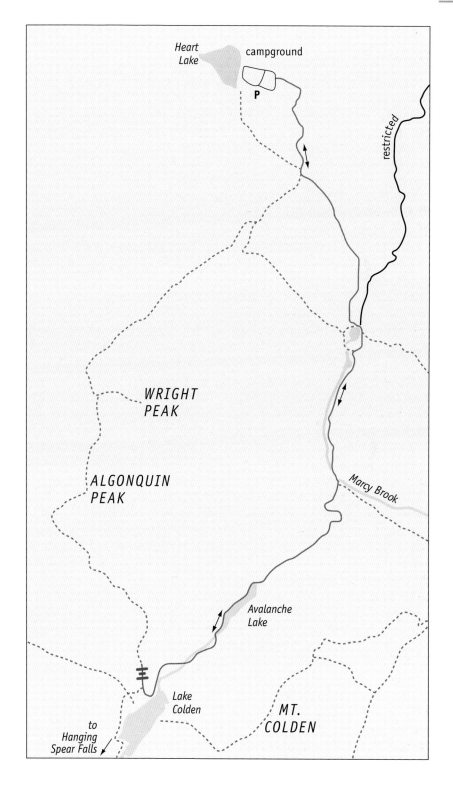

over boulders that Avalanche Mountain has been shrugging off since the last ice age, cross three boardwalks hanging over icy depths, and use more than a dozen ladders. It's insanely fun!

I was thinking of how crazy it would be to haul a full sixty-pound pack over this section when a lone woman of about seventy did just that. She was all of five feet tall, and perhaps ninety pounds, and her legs looked as if Michelangelo had chiseled them from the surrounding granite. We spoke for a short time and I asked her how she thought the younger hikers we had both passed were faring. With a little shrug she said, "Some with great ease and some with great pain." I ought to put that on a T-shirt.

At 5.14 miles you come to the trail junction for Lake Colden. A yellow blaze for Mount Colden and Mount Marcy heads left (trail 68) and a blue blaze for Lake Colden heads right (trail 69); go right. The trail first swings toward the lake and then away to follow a small brook, reaching a footbridge at 5.47 miles. You've arrived at the trail junction for the 2,350-foot ascent of Algonquin Peak. The blue-blazed trail for Lake Colden turns left across the bridge and the route to the falls and Algonquin heads straight. You're going to go about .2 mile from the bridge up the Algonquin Peak trail.

Within the first 100 yards a small four-foot cascade with a large plunge pool appears. Just ahead, the trail pops out into the brook facing a 34-foot, stair-stepped cascade with an invitingly cool plunge pool. Most of the flow runs down the fall's left-hand side (your right). The best shooting position is from rocks just below the trail; set up low to avoid some tree limbs. Take care because the plunge pool is very deep. Careful use of a polarizer will reveal large rocks on the pool's bottom about eight feet down. Linger a while and enjoy the area. There's another fall about .5 mile farther. It's a long, steep slide and isn't nearly as nice as this one. Investigate this second fall only if you have some extra time to spare.

If you want, go ahead and summit Algonquin Peak, which will add 3.2 miles and 2,202 feet of elevation, or three hours, to your hike. It's a very strenuous climb, so take care. You can also head for Hanging Spear Falls (Hike 52, see page 127), which will follow a red-blazed trail for Flowed Lands (trail 121). The trail begins .4 mile from the last bridge following the blue blaze to the DEC Interior Outpost on Lake Colden. This will add a little more than 5 miles and 907 feet of elevation, or about two-and-a-half hours. If you're considering adding either extension, plan ahead and expect to be out for at least ten hours total. Even though the math works out to eight hours you'll need a couple meal breaks and time to soak in the experience, so please plan ahead.

Reverse your route and head back to the Loj parking area. During my hike, as I again approached Avalanche Lake I caught the faint sound of singing. A light variable breeze carried the sounds of voices to me in subtle waves. As I got closer I realized it was Gregorian chant. The stone walls of Avalanche Lake funneled the sound to me in wonderful resonating tones.

Resting halfway up the lake was a group of Catholic seminarians from Brazil, one of whom had twisted a knee.

I offered to take a look at their comrade when one of them declined by saying, "No thank you, we've asked God for guidance." I replied, "Have you seen another person in the past hour?" "No we have not," he said. I then asked, "Have you considered that I may be the answer to your call?"

With that they looked quizzically at each other and I stepped in to examine their friend. His knee was slightly swollen and he flinched as I touched the medial collateral ligament. This was not good. I gave them my supply of granola bars and pointed them down the trail. On my way out I informed the DEC ranger from the Interior Outpost of their plight. I never found out what happened to them but I will always remember the luxurious sounds of chanting rolling across Avalanche Lake.

Hike 54 Upper Ausable River, Adirondack Mountain Reserve, Essex County

Wedge Brook

Type: Cascade over cascade	**Height:** 85 feet and 16 feet
Rating: Upper 4–5, Lower 3	**GPS:** 44° 8.165′N, 73° 48.675′W

Beaver Meadows

Type: Cascade	**Height:** 65 feet
Rating: 4	**GPS:** 44° 7.754′N, 73° 48.942′W

Rainbow Falls

Type: Fall	**Height:** 154 feet
Rating: 5	**GPS:** 44° 7.105′N, 73° 49.774′W

Artists Falls

Type: Cascade	**Height:** 22 feet
Rating: 3	**GPS:** 44° 7.493′N, 73° 48.589′W
Stream: Various tributaries to the Ausable River's East Branch	**Distance:** 10.0 miles
Difficulty: Strenuous	**Elevation Change:** 1,900-plus feet
Time: 5 hours	**Lenses:** 15mm to 75mm

Directions: From the intersection of Ausable Road and NY 73 in St. Huberts, take NY 73 east .5 mile and turn right onto Ausable Club Road at a sign for the Ausable Club (which is opposite the Roaring Brook trailhead). Shortly after turning, park on the left in the large signed parking area. GPS coordinates: 44° 8.983′N, 73° 46.083′W. Note that you are not permitted to drive Ausable Road onto club property from St. Huberts; you must enter club property from this point and only on foot.

It wasn't until this hike that I began to appreciate something that was said to me at a café in Keene Valley a month earlier: "Adirondack Park is more of an idea than a park as you know them." Adirondack Park is a coalition of public and private entities and most of the 6.1 million-acre reserve is in private hands—and a great deal of that is closed to the public. The Ausable Club, also known as the Adirondack Mountain Reserve (AMR), is an exception to this and their vast trail network is privately maintained. Their land holdings are extensive and include both Lower and Upper Ausable Lakes.

If you plan to just hike you'll be gone about five hours; if you plan on shooting you'll be gone all day. Either way, make sure you have ample water, food, raingear, bug spray, and most importantly, toilet paper.

Walk up the gravel road leading from the parking area. In a little over 100 yards you will pass a red-blazed trail to Round Mountain on the left and an

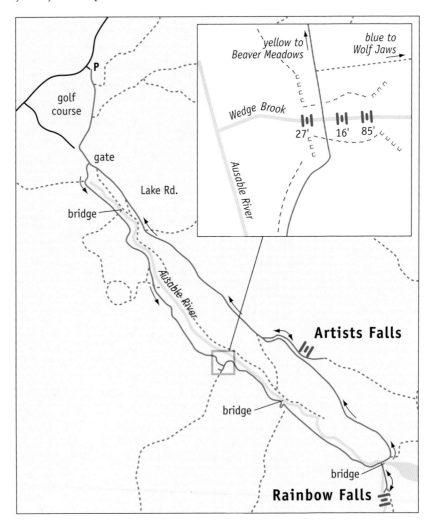

imposing hikers' notice on the right. At .4 miles gravel gives way to pavement and you arrive at a golf course. On the left is a trail heading to Noonmark Trail Way and yellow blazes for Noonmark Mountain, Round Mountain, Dix Mountain, and Elk Lake. Stay on the paved road with the golf course on the right.

When you come to tennis courts on the left, turn left onto Lake Road Way. You'll pass between two tennis courts and the first tee/Starter's House on the left. Ahead you'll see another imposing set of hikers' signs; check in at the adjacent ranger shack (if anybody's there), and then turn right to head for the East Branch of the Ausable River. This puts you on the yellow-blazed Adirondack Mountain Reserve Trail (AMR-T). The trail swings left and brings you to the river's right-hand side. You reach the first bridge a couple hundred yards from the check-in station, at .88 mile. Turn right and cross it to arrive at the trail junction. The yellow-blazed West River Trail turns left while the red-blazed W. A. White Trail goes straight. Turn left onto the West River Trail.

At 1.25 miles you arrive at another bridge with a red-blazed trail heading right into the woods for Cathedral Rocks; stick with yellow. The trail swings right to climb at 1.35 miles and then left again at 1.48 miles. After this sequence, cross Pyramid Brook at 1.63 miles and then come to a red-blazed side trail heading right for Bear Run, Pyramid Brook, and Cathedral Rocks. There is a fall farther up Pyramid Brook but there's no safe access into its gorge, so continue along the yellow trail. The junction with the Canyon Bridge Trail is at 1.9 miles; there are some nice shots looking upstream from the bridge. A blue-blazed trail climbs south away from the river and out of the gorge to Lake Road.

For the next .8 mile you climb up and away from the river, gaining more than 300 feet of elevation in the process. However, trail undulations make it feel like much more. At 2.7 miles you come alongside Wedge Brook. Turn uphill to climb some more before crossing the brook on a bridge that heads a fall at 2.79 miles.

Wedge Brook Falls consists of three distinct drops; the lower two are here at the bridge. The 85-foot upper fall, which is the one you want to shoot, is 50 yards upstream along a blue blaze. The 16-foot middle section is visible from the bridge and it drops through a dramatic fissure choked by an enormous, wedge-shaped boulder, hence the name. Above is a sawtooth section carrying most of the flow. Work from the bridge and find a position that frames both sections. Most of the exposed granite is covered with luxuriant green moss; however, uncovered portions have a slick white lichen cover that makes for tricky exposures. The 27-foot lower fall is a three-tiered cascade that's emerald green and quite lovely. Dead trees clog the smallish plunge pool so finding a good set-up is a challenge.

To get to the dramatic upper drop, follow signs and the blue blaze upstream toward Wolf Jaws. You'll be on the brook's right-hand side, and in just 50 yards you arrive at the 85-foot drop. The best set-up is to the right of

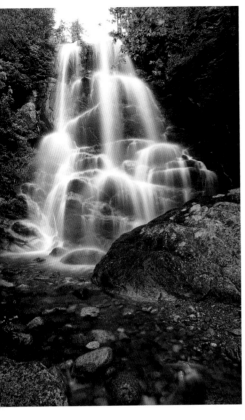

Beaver Meadows Falls. Bright sky above makes getting tonal separation at the fall's head difficult. By underexposing I was able to capture some image data at the precipice that I could burn in Photoshop. When using digital, think in terms of exposing for what will be needed in post-processing, just like we did with black and white years ago. *Canon EOS 5D MkII, Tokina 20–35, Polarizer, ISO100 setting, f/16 @ 4 sec.*

a moss-covered boulder that sits center trail. The plunge pool offers a shot of only the fall's bottom 30 feet, so don't bother heading there. There are some additional slides and drops above as the brook zooms over exposed rock, but getting a safe set-up is a problem. In low flow the rock faces are just a bit slick with algae cover; in high flow there is no safe footing to be had. Unless you want to be flung over the main 85-foot cascade, don't try working the upper section in the rain. Return to the footbridge at 2.87 miles and turn right to continue along the Ausable.

Back on the heights above the river the trail follows a level line while the river rises quickly to join you. At around 3.0 miles there is a powerful chute in the river. Unfortunately you are not permitted off trail to get a good look at it. There's a decent perch just downstream at a wide tree gap where you can get a long-lens shot.

A short distance farther, the Ausable changes from a torrent to a calm mountain stream at trail level. At 3.5 miles you finally come to the main attraction, Beaver Meadow Falls, which sits right in front of the footbridge over its creek. This is a wonderful cascade and on a hot day it's a great place to cool off.

When you leave the fall heading upstream along the Ausable you'll hit an intersection where a blue blaze crosses; continue along the yellow West Rim Trail, where you'll see a sign for Rainbow Falls. The next half mile or so is along a marshy section where the Ausable meanders along a wide valley. It's quite warm through this section, and from here to Rainbow's side trail at 4.4 miles you alternate from smooth woodland trail to one with ample roots, trees, and boulders.

The red-blazed Lost Lookout Trail joins on the right at 4.35 miles. At 4.4 miles, after a small footbridge over Cascade Brook, you arrive at Lower Ausable Lake Dam. The West River Trail ends here at a blue-blazed junction; left takes you to Lake Road and your return route, right to Rainbow Falls. Turn right and reach another trail junction in about 50 yards. Head straight along

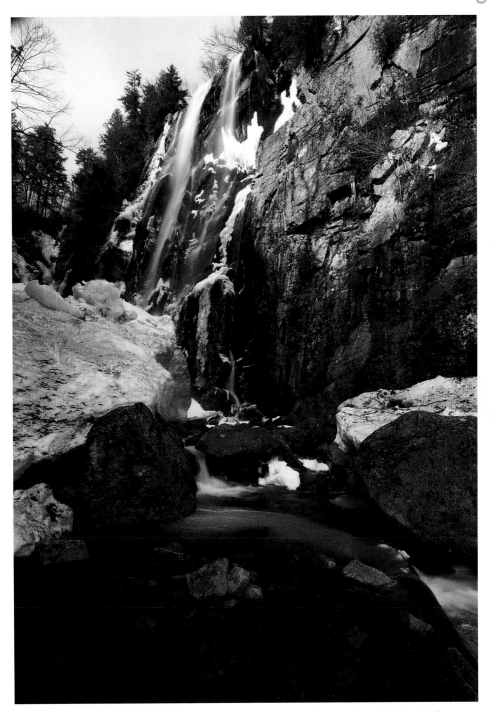

Rainbow Falls. I had to use hiking studs on the road and trail when I shot this in April. The pale white stream is slush emerging from under the boulder mid-frame. To say the water here was cold would be an understatement. *Canon EOS 5D MkII, Tokina 20–35, Polarizer, ISO100 setting, f/8 @ 3.2 sec.*

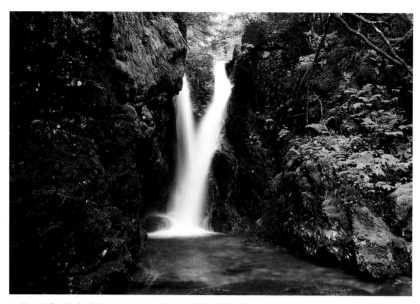

Artists Falls. Tucked into a narrow fissure, this fall is best shot by getting your feet wet and getting close. Take care: the water is shockingly cold. *Canon EOS 5D MkII, Tokina 20–35, Polarizer, ISO250 setting, f/8 @ 3.2 sec.*

the blue blaze for Rainbow, Gothics, and Saw Tooth. After a brief climb you reach a signed right turn for the falls; do not follow the Gothics trail. The trail into Rainbow Falls follows some pipes, and if you fixate on them like I did, you won't realize you've entered a big chasm at 4.6 miles. When the fall finally comes into view it is an inspiring sight. A veil of water slides 154 feet down a nearly vertical granite face. Water slips behind a cleaved slab into a large fissure, and there's little moss providing contrast against the rock face. Pick a spot that looks good and just blast away. I liked nuzzling up to the opposite and adjacent rock faces. The area is very tight and a super wide lens like a 15mm will have its limits as you push close to the plunge.

Return to the dam at 4.83 miles and cross a bridge in front to arrive at a trail junction with the East River Trail. Bear right uphill around a brown building with a green roof. When you hit Lake Road, turn left and continue uphill. You'll be on Lake Road the whole way back to the golf course, so speed hike and ignore all other trail junctions until you hear Gill Brook on the right at 6.22 miles where the road slowly descends and sweeps left. At 6.42 miles you reach a sign for the red-blazed Gill Brook Trail on the right. The sign will be hidden behind a boulder facing away from you; turn right up the red-blazed path.

Gill Brook has several small falls, including the famous Artists Falls. The brook has ample shooting opportunities and it will take considerable time to do it justice. During my first trip I didn't leave enough time to thoroughly explore and felt that I had somehow missed a grand prospect. As you amble

up Gill Brook you'll find several granite slides with lush, green, moss-covered boulders strewn around. About a half mile in (a total of 6.74 miles) you'll pass a ten-foot cascade with a massive logjam above increasing its height. Bypass this and continue upstream to another series of smallish drops. When the creek again runs over smooth granite you're close to your target. Look for footpaths heading down and left toward a large fissure. Tucked into the far end is Artists Falls, a 22-foot drop over a choke-stone landing in a cool deep plunge pool. The area has a Zen garden feel and the cool water begs you to soak your aching feet.

The small glen is long, narrow, and surrounded by forest. Some degree of warming filtration will be needed since it's in shadow all day. Adding to the challenge is that the fall's left-hand side will be a couple stops brighter than the right, even on a cloudy day. You may want to consider using a soft-edge graduated filter to even things out. Regardless, if you carefully expose for the highlights everything should work out.

If you have a topo map you'll notice that Fairy Ladder Falls is upstream along the Gill Brook Trail. This fall is near Elk Pass at 3,100 feet elevation and as such it's quite seasonal, running weakly or not at all most of the time. You'll add 4 miles and more than 1,000 vertical feet to your hike for not much result, therefore I recommend turning around here. When you return to Lake Road you've gone a total of 7.47 miles. Turn right onto Lake Road and follow Gill Brook downstream.

Gill Brook parallels the road for quite a distance but it's rather boring. Some distance after you pass a check dam a side trail will appear on the right at 8.07 miles, taking you to a flume. If you have time, turn right and arrive in less than 100 yards. Upstream is a tiny chasm with a little ten-foot fall (GPS: 44° 8.265'N, 73° 47.879'W). A quick scramble down a broken ledge provides a shot veiled by trees. If you don't mind wading in chest-deep icy water you can get closer. Just make sure your gear is well-insured. Return to Lake Road. When Gill Brook passes under Lake Road at 8.12 miles you can get some nice shots looking upstream from the bridge.

At 8.4 miles a spur heads left off Lake Road along with a blue blaze for Canyon Bridge; stick with the main road. Shortly after, at 8.65 miles, you will pass a trail on the right for Dial Mountain and Nipple Top. A little farther ahead, the red-blazed East River Trail joins; after that is an exercise loop called "The Ladies Mile." Walk through an impressive rustic gate, pass the ranger hut, and arrive at your car at 10.0 miles.

If you're pressed for time and only have three-and-a-half hours I recommend hitting Beaver Meadows Falls, which will be a 6.5-mile round trip with an 800-foot elevation change. From the parking area, walk through the golf course, check in at the ranger station, and then continue down Lake Road. At 2.6 miles bear right on a blue blaze for Meadow Brook Falls and the river crossing, which is at 3.1 miles. Now climb steeply up, crossing the red-blazed West River Trail, and arrive at the falls. Reverse your route and return to your car.

Hike 55 Deer Brook Cascade, Adirondack Park, Essex County

Type: Slide	**Height:** 75 feet
Rating: 3–4	**GPS:** 44° 9.487'N, 73° 47.484'W
Stream: Deer Brook	**Distance:** 1.6 miles
Difficulty: Difficult	**Elevation Change:** 630 feet
Time: 1 hour	**Lenses:** 15mm to 75mm

Directions: From the intersection of Ausable Road and NY 73 in St. Huberts, take NY 73 west .4 mile. Park on the right at a wide spot where a guardrail begins just before crossing a bridge over the Ausable River's East Branch. House number 1371 will be on the opposite side of the road. GPS coordinates: 44° 9.762'N, 73° 46.672'W.

You may be tempted to move your car across the bridge to the north end; don't, as there are small driveways that you don't want to block lest you get towed. Following the first sequence of turns can be a challenge. Cross the road and bridge, hop the guardrail, and walk along the road. You come to Deer Brook Lane marked "Private" on the left; find a sign for "Snow Mt., Wolf Jaws via Deer Brook." Follow the blue blazes running parallel to the road a short way and then turn left to follow a blue-blazed trail that crosses private land. The trail runs generally uphill along Deer Brook's right-hand side (on your right).

In a short distance you will cross a driveway and continue along the amply blazed trail. A high-water route around Deer Brook goes left and is marked with yellow blazes; stick with the blue along the creek. There will be a sign for Snow and Wolf Jaws. On the right is a nice house with a small pond.

At .3 mile cliffs have enveloped you without much notice; turn right at a sign, first crossing to Deer Brook's right-hand side and then left to follow the brook. Here you'll scramble up a steep rock slide choking the brook. Oddly enough, pipes appear on and along the trail. Follow them for the best route. Once atop the slide, cross back to the right-hand side and continue to follow the blue blazes. Now look carefully for signs and chainsaw work directing you around and through a rock slide at .46 mile, at which you'll cross yet again to the left-hand. After this, steeply climb with the brook over large boulders passing countless slides and riffles, any one of which could keep you occupied for the better part of an hour. When the boulder-hopping gymnastics exercise is over, cross back to the right-hand side.

In a short distance you surprisingly have to cross back to the left-hand side. No blazes mark the location, as they're on fallen trees. Look for a massive old hemlock bridging the creek with baby trees growing on it. (This is called a nurse log.) This all occurs near .64 mile. At .7 mile cross another time back to the right-hand side. Here the trail climbs up and away from the

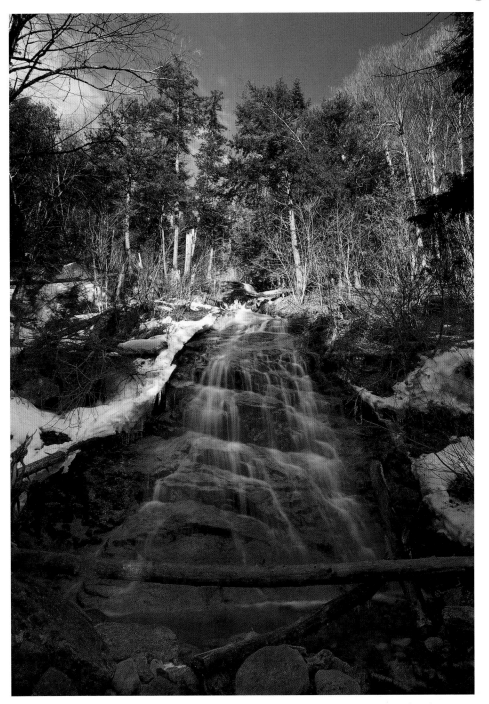

Deer Brook Falls. The forecast was for heavy cloud cover. Sometimes you have to take what you can get and move on. *Canon EOS 5D MkII, Tokina 20–35, Polarizer, ISO100 setting, f/16 @ .5 sec.*

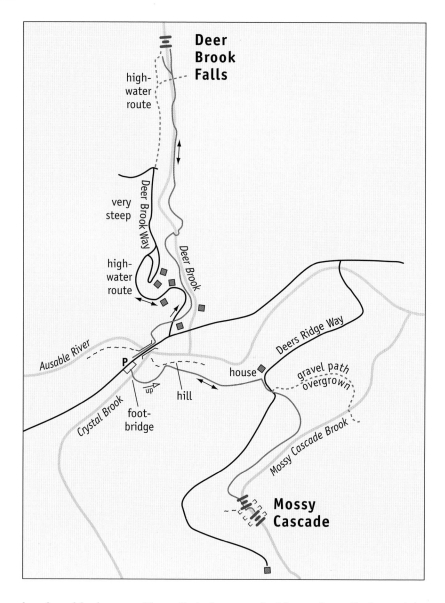

brook and looks more like a ditch than a trail. After a short climb you join the yellow-blazed, high-water route, which comes in on the left. The blue blaze ends here with a sign for Lower Wolf Jaws via White Trail. Turn right on the now red-blazed trail and head uphill parallel and above the creek to a footbridge at .76 mile. Don't cross; instead follow a signed side trail another 250 feet to the fall and arrive at .8 mile.

The sliding fall is inclined at around 45 degrees, and as such you can nuzzle up to it if you want. In low flow it's just a series of showering steps; however, in high flow it's a torrent, which explains the high-water route. By

the way, the yellow blaze is much easier than the blue trail I described here. So why take such a frustrating route when there's an easier way? Because the creek walk is a challenging bit of fun. If you'd prefer the easier route, just follow the yellow-blazed high-water route .76 mile to the bridge, although it's really boring. Once you're done with the falls it's probably a good idea to take the yellow blaze back though.

Hike 56 Mossy Cascade, Essex County

Type: Cascade	**Height:** 34 feet
Rating: 3	**GPS:** 44° 10.025′N, 73° 46.280′W
Stream: Mossy Cascade Brook	**Distance:** 1.8 miles
Difficulty: Moderate	**Elevation Change:** 340 feet
Time: 1 hour	**Lenses:** 15mm to 50mm
Directions: Follow the directions and GPS coordinates for Hike 55 (see page 142).	

This is a fun woodland hike with a good scramble at the end. From the parking area, follow the guardrail and then cross a flimsy footbridge over a ditch. You'll see a small trail sign for "Hopkins, Giant and Mossy Cascade." There will also be an adopt-a-trail sign and the trail will be blazed with red plastic markers. From here on the trail is wide and obvious as it climbs steeply right and then swings left around a headland high above the NY 73 highway bridge, now behind you on the left. As the trail swings left again it makes a steep side-hill descent. This whole sequence happens in the first couple hundred yards and can be a rude awakening to a weary set of legs.

The trail undulates lazily with a generally uphill trend. The wide path has soft loamy soil that's quite pleasant to walk on. At .4 mile you pass behind a cabin and join a woods road called Beer Ridge Way (I wonder how that got its name). Turn right onto the road and then shortly after go left off it; the sequence is well marked. Next, look for a sign indicating a right turn.

At .53 mile, you reach a Y where you can hear water on the left; bear left as noted on a small green sign nailed to a tree. Shortly after the trail joins the brook on its left-hand side. Climb with the brook and arrive at another Y at .8 mile; left is to Mossy Cascade and right ascends Hopkins and Giant mountains. Turn left onto a narrow footpath and in short order you're met by what can only be described as tree carnage.

I don't know when the landslide happened, but it dumped a number of trees into the now-narrow ravine holding the brook. For the next hundred yards to the fall the area looks like a bomb went off. Enormous trees clog the ravine, forcing you to go over, under, or around to make headway. It can be

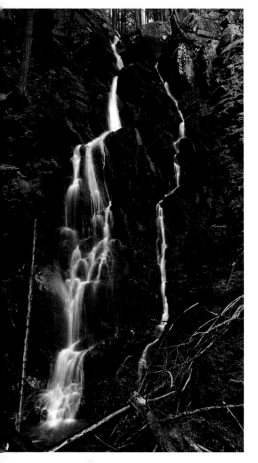

Mossy Cascade. I used my 17mm lens mounted to a body with an APS-sized sensor, which meant that I was using essentially a 28mm lens. That's not wide enough for this tight spot. *Canon EOS Digital Rebel, Tokina 17mm, Polarizer, ISO100 setting, f19 @ 15s.*

quite a task. Clinging to the left-hand side, push ahead until you come to a four-foot drop. Then cross to the right-hand side where you'll get a good look at Mossy Cascade's faceted face. Don't bother trying to get to the base; the way is blocked by trees. Instead, scramble up and left to a level spot.

The cascade is emerald green with moss, hence the name. With pale trees veiling the base you may want to work just the upper 90 percent unless they are damp. Sectioning the fall into graphic patterns is also fun as the water spills down at an angle starting on the upper right. Older logs in the area have large fans of vibrant orange fungus clinging to them. If you can find fans with a green background, shoot them with abandon. When you're done, reverse your route and return to the car knowing that you'll have climb up and around the headland again.

Hike 57 Roaring Brook, Adirondack Park, Essex County

Type: Cascade	**Height:** 200-plus feet
Rating: 2	**GPS:** 44° 9.025′N, 73° 45.617′W
Stream: Roaring Brook	**Distance:** 50 feet
Difficulty: Easy	**Elevation Change:** None
Time: 5 minutes	**Lenses:** 100mm to 350mm

Directions: From the intersection of Ausable Road and NY 73 in St. Huberts, take NY 73 east .7 mile. Pass the Roaring Brook trailhead and park on the left in a wide spot along an uphill section of the road. There will be a pedestrian warning sign marking the location. If you miss the parking area while heading east it will be almost 4 miles before you can make a safe u-turn. GPS coordinates: 44° 8.960′N, 73° 45.947′W.

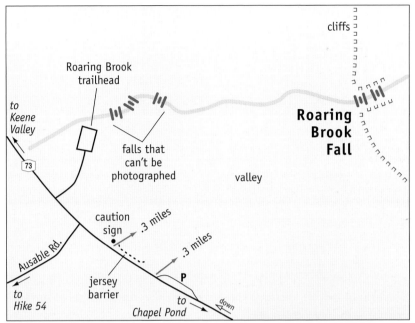

to
Keene
Valley

73

Roaring Brook
trailhead

falls that
can't be
photographed

valley

cliffs

**Roaring
Brook
Fall**

caution
sign

.3 miles

.3 miles

Ausable Rd.

jersey
barrier

P

to
Hike 54

to
Chapel Pond

down

Set up near the car and shoot a dark line of water sliding off a mountain across the valley. Roaring Brook rarely lives up to its name, hence the weak rating for such a large vertical drop. There are two good spots, one over the guardrail near a pedestrian crossing sign and the other nuzzling up to a jersey barrier. Both are long-lens vertical shots. Facing more or less southwest you can work warm afternoon light until the sun drops below the mountains to the west. You can't shoot the falls from below, so don't park at the Roaring Brook trailhead on NY 73. Instead park on the road's north side as noted here.

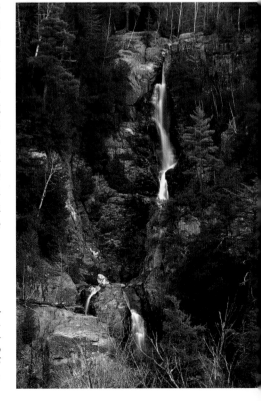

Roaring Brook Falls. I used my camera's mirror lockup feature to help avoid shake induced by mirror slap. Even with a sturdy tripod an SLR will experience visible vibration with exposures from 1/3s to 1.3 seconds when shooting a long lens. *Canon EOS 5D MkII, Tokina 28–200, Polarizer, ISO100 setting, f/16 @ .5 sec.*

Hike 58 Split Rock Falls, Adirondack Park, Essex County

Type: Cascade	**Height:** 46 feet
Rating: 4	**GPS:** 44° 7.436'N, 73° 39.497'W
Stream: Bouquet River	**Distance:** ~.3 mile
Difficulty: Easy	**Elevation Change:** 90 feet descent
Time: 30 minutes	**Lenses:** 20mm to 70mm

Directions: The paved parking area is along US 9, 2.2 miles north of the NY 73/US 9 junction. When heading north, the lot is on the right just after crossing a bridge over the Bouquet River. GPS coordinates: 44° 7.436'N, 73° 39.497'W.

Split Rock Falls is three distinct drops, with the upper two separated from the third by a large pool. The upper drop is around 25 feet and consists of two stairs over granite. The second is 12 feet and the third is a 9-foot slide divided into three distinct channels. Together they make a powerful sequence. In summer the fall is a popular swimming hole but is empty during cool spring weather.

Leave the parking area and head for the fence. Turn left and walk downstream around the fence's terminus. A footpath leads down through some trees to a set of ledges hanging above the upper section. This is the best shooting position. There's ample moss cover and the trees above are lush, making for a verdant scene. Of major concern is a white speed-limit sign

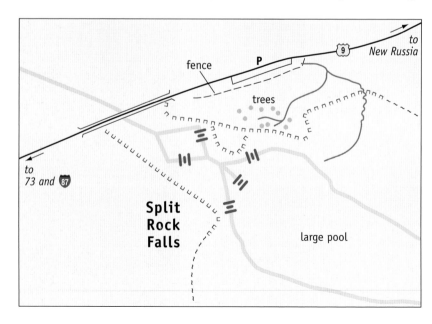

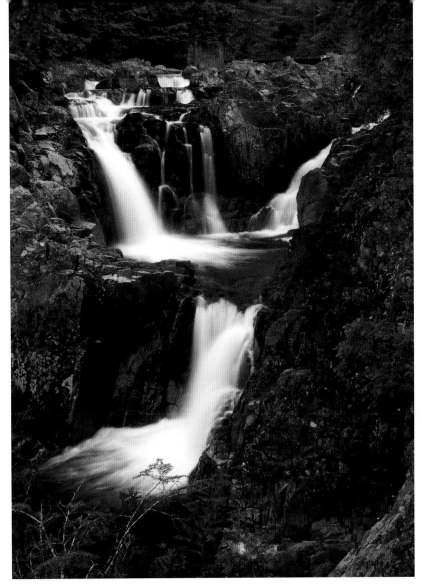

Split Rock Falls. The speed limit sign would be on the right but was cloned out using Photoshop. *Canaon EOS Digital Rebel, Tokina 20–35, Polarizer, ISO 100 setting, f 29 @ 15 sec.*

that's in view near the bridge; I couldn't get a position to crop it out so I did a little Photoshop work to remove it.

Continue downstream and scramble into the wide, cobble-filled creek below. I found it quite difficult to get a pleasing shot of the lower nine-foot drop. Something about the drop's width, its three drainage channels, and just being so far away made the image look foreground-heavy. You can shoot the cobbles below the water and create attractive graphic patterns; just be sure to use to use a polarizer.

There's a nice meadow .7 mile north of the bridge along US 9. Look for a big pull-off on the left; the meadow will be on the right.

Hike 59 **High Falls Gorge, Essex County**

Main Falls

Type: Chute	**Height:** 156 feet
Rating: 4	**GPS:** 44° 20.937'N, 73° 52.442'W

Mini Falls

Type: Chute	**Height:** ~20 feet
Rating: 3	

Grand Flume

Type: Chute	**Height:** ~60 feet
Rating: 5	

Climax

Type: Fall over chute	**Time:** 30 minutes
Rating: 5	**Distance:** ~.3 mile
Height: 40 feet	**Elevation Change:** 90 feet descent
Stream: West Branch, Ausable River	**Lenses:** 30mm to 130mm
Difficulty: Easy	

Directions: High Falls Gorge is located on NY 86, 4.3 miles west of Wilmington. From Lake Placid take NY 86 east about 7.9 miles. Park in the large parking lot for this paid attraction. GPS coordinates: 44° 20.841'N, 73° 52.613'W.

High Falls has been in operation for well over one hundred years and has brought joy and wonder to thousands. If you don't have much time to spend in the Adirondacks this is the best place to get a sense of the region's

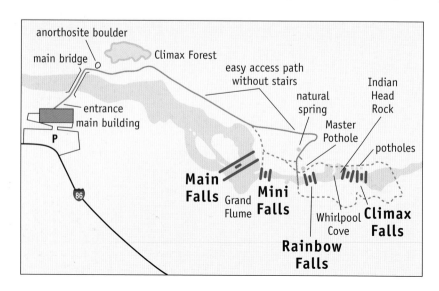

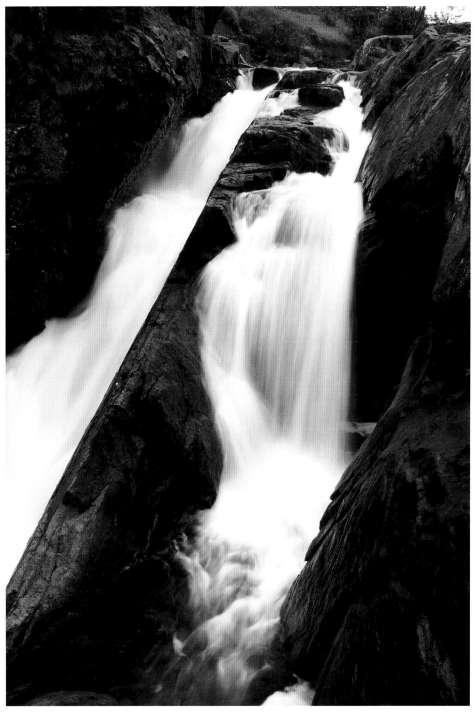

Main Falls. The dividing rock fin is called a dike, which is an intrusion of rock into existing strata. Even when dry the fin shows a high a degree of polish. *Canon EOS Digital Rebel, Tokina 20–35, Polarizer, ISO100 setting, f/16 @ 1/4 sec.*

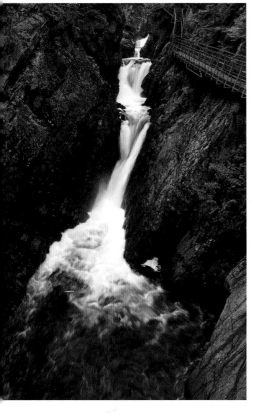

Climax Falls. Put somebody in red on the catwalk and you have a real keeper. *Canon EOS Digital Rebel, Tokina 20–35, Polarizer, ISO100 setting, f/8 @ ¹/4 sec.*

character. Catering to kids, High Falls Gorge is a good spot to kick back and let the youngsters explore. You can even let the kids touch one of the oldest rocks they may ever see, an approximately 1.1 billion-year-old anorthosite boulder. High Falls is open year-round and you can even rent snowshoes to explore the chasm when it is choked with ice. Visit www.highfalls-gorge.com for more information.

After you pay the $11 fee, exit the gift shop and head across the wide bridge. Follow the path to a boardwalk on the right. Make certain to wander every inch of the gravity-defying trail using whatever route you like and be sure not to create backups in narrow areas when you open up a tripod. I especially like the stairs next to Grand Flume and the bridge spanning the chasm below Climax Falls. Shots showing the granite dike splitting Grand Flume will work well and shots that isolate the chasm from the footbridge especially so. Shoot wide to show the trail clinging to the gorge and get long-lens shots of Climax Falls. Even though it's a vertical environment, don't forget to shoot horizontals as well.

Hike 60 Wilmington Notch, Adirondack Park, Essex County

Type: Cascade	**Height:** 55 feet
Rating: 5	**GPS:** 44° 20.952'N, 73° 51.705'W
Stream: West Branch, Ausable River	**Distance:** .36 mile
Difficulty: Difficult, no trails	**Elevation Change:** 170 feet descent
Time: 30 minutes	**Lenses:** 30mm to 100mm

Directions: Wilmington Notch Campground is located on NY 86, 3.5 miles west of Wilmington. When heading west from Wilmington, pull into the campground just after passing Whiteface Mountain Ski Area. From Lake Placid, take NY 86 east about 8.5 miles. GPS coordinates: 44° 20.952'N, 73° 51.705'W.

Before setting out, check in with the campground host at the office and obtain a day-use permit. After you exit, look for the bathrooms to the left and behind the office; head for them. There will be a section of cyclone fence and to its left a steep hill can be seen. It will look a bit like the head of a ravine. Bear left and follow the terrain steeply downhill. Once you drop a few feet the falls will be audible far below to the right.

Drop steeply down a loose-soil slope and begin to angle slightly right towards the sound of water. When you hit a flat area in a wide drainage depression, turn right and follow it to the river, where you'll encounter cliffs. These cliffs are canted toward the river so stick to the pines to avoid any unpleasantness.

By now the drainage depression has turned into a wet ditch; this is how you'll get to your set-up position. Follow the ditch to where it appears to ledge out and carefully scramble down a boulder choke to a notch above the river. The granite exposures are quite sharp and will grab or tear clothing easily. They can be slick when wet so work within your limits. You'll be about twenty feet above the river and behind a large rock slab hanging over the churning tailwater. Tree limbs will intrude on the left and they're impossible to get rid of without taking a huge risk. Setting a tripod as high as possible, even extending the center post, will gain enough height to minimize these sneakers on the left and bottom.

When I shot this in spring flood the tannin-infused water had a strong tea color and what would normally be frothing whitewater was a pale tan mass of spray. It was impossible to hear my camera fire over the fall's roar.

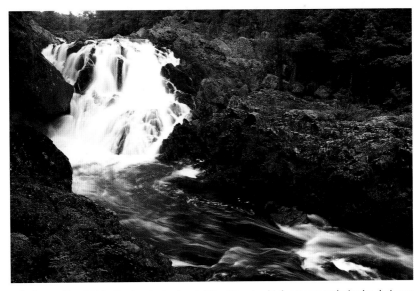

Wilmington Notch Falls. To shoot a horizontal like this, stay high among rocks in the drainage ditch you followed to reach this point. To shoot a vertical, carefully work lower to the boulder top you can see at middle bottom. Don't slip on the slick rocks though—it's a long way down. *Canon EOS Digital Rebel, Tokina 20–35, Polarizer, ISO100 setting, f/16 @ .6 sec.*

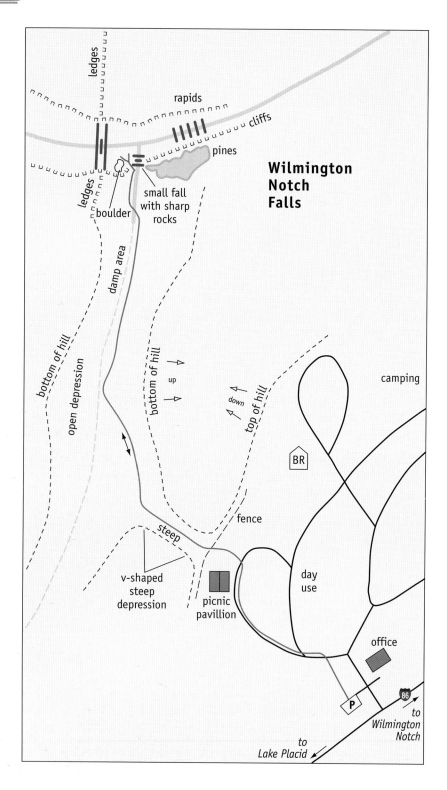

ledges

rapids

cliffs

pines

Wilmington Notch Falls

ledges

boulder

small fall with sharp rocks

damp area

bottom of hill

open depression

bottom of hill

up

down

top of hill

camping

BR

fence

steep

v-shaped steep depression

picnic pavillion

day use

office

P

86

to Wilmington Notch

to Lake Placid

Trapped air escaped from the tailwater in a loud, foaming hiss that added to the roar. On top of that I could feel the rocks vibrate with a low hum through my feet.

Hike 61 The Flume, Adirondack Park, Essex County

Type: Chute	**Height:** ~30 feet
Rating: 4	**GPS:** 44° 21.987'N, 73° 50.409'W
Stream: West Branch, Ausable River	**Distance:** .15 mile
Difficulty: Moderate	**Elevation Change:** 50 feet
Time: 15 minutes	**Lenses:** 30mm to 70mm

Directions: The Flume is next to NY 86, 1.9 miles west of Wilmington. When heading west from Wilmington, park on the right in a large paved parking lot just before crossing the Ausable River's West Branch. From Lake Placid, take NY 86 east about 10.3 miles and park on the left just after crossing the bridge. GPS coordinates: 44° 21.970'N, 73° 50.488'W.

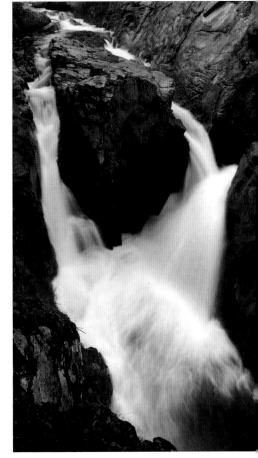

The first of two distinct drops occurs right under the bridge. To get to the larger downstream drop, carefully cross the bridge on foot and then cross the highway. Move as quickly as possible since traffic flies along this straight section of NY 86.

Once across the road, now at the bridge's west end, follow a wide footpath downhill and downstream running parallel to the Ausable's right-hand side. Keep to the footpath and not the river edge; in about 100 yards look for exposed boulders and cliffs below. Head for these and find a wide outcrop looking upstream at the main drop. If you look downstream you'll

The Flume. To get a better angle in locations like this, I'll hang my tripod over the ravine edge and sit on the legs to hold it fast. This time, the risk of failure was too great. The rain-slickened rocks were like ice and even in the position I used my feet slid twice. It was very unnerving. Never underestimate how slick lichen-covered granite can be. *Canon EOS Digital Rebel, Tokina 20–35, Polarizer, ISO100 setting, f/29 @ 1 sec.*

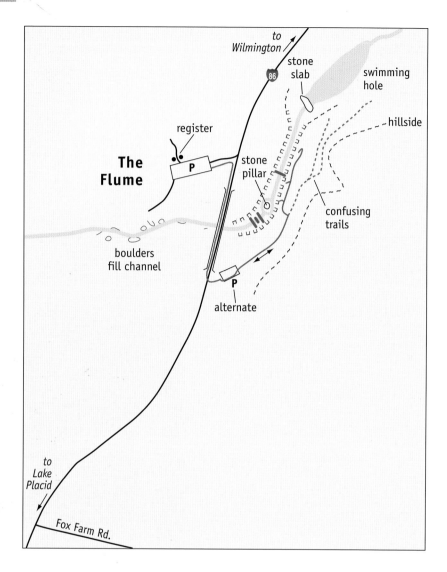

note calm, flat water where the chasm suddenly opens to become a popular swimming hole. You should be roughly halfway between the bridge and the swimming hole.

The Ausable's tea-colored west branch rumbles under the bridge before being funneled through a narrow gap holding the main drop's chute. Walls on both sides are shear and have a pale-green lichen patina. Any rocks with this covering will be slick when wet and are not for those with acrophobia; a slip anywhere along them could be fatal so take extreme caution with your footing.

Another good spot is a small promontory looking straight down into the lower drop's gaping maw. In low summer flow the chasm is still impressive, but in spring flood its unbridled power is terrifying. Spray will be a problem so bring a shower cap (for the camera) and a good lens chamois.

Hike 62 | Ausable Chasm, Clinton County

Rainbow Falls

Type: Fall	Height: 45 feet
Rating: 5	GPS: 44° 31.420'N, 73° 27.625'W

Ausable Chasm Falls

Type: Fall	Height: 30 feet
Rating: 5	GPS: 44° 31.420'N, 73° 27.625'W
Stream: Ausable River	Distance: 150 yards
Difficulty: Easy	Elevation Change: None
Time: 10 minutes	Lenses: 35mm to 150mm

Directions: From I-87 south of Plattsburg, take exit 34 for Keeseville. Head north on NY 9N through Keeseville 1.4 miles to join US 9 north. After going another 1.4 miles, pull over into an enormous parking area on the right just before going over a long bridge. GPS coordinates: 44° 31.456'N, 73° 27.845'W.

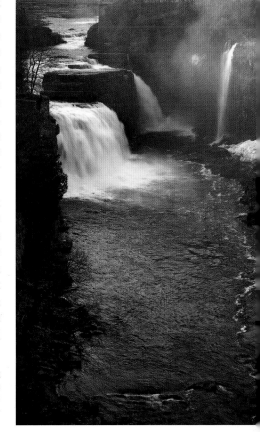

This is a quick shoot-and-scoot. Walk along the sidewalk to just beyond the bridge's mid-span and shoot away. The taller thin fall on the right is Rainbow Falls and the large block fault cutting across the river is Ausable Chasm Falls. Below the bridge begins a series of rapids that runs through this private, paid attraction. You can shoot wide and include the turbine hall on the right or go long and isolate portions of either drop by shooting over the turbine hall.

Other than bridge vibration, the biggest problem is the shiny roof on the turbine hall. Older pictures show a dark green slate roof; it now appears to be a simulated slate or aluminum-like material. The problem this creates is that a polarizer won't knock much of the reflection down, even when the surface is wet. Older images show the building fitting into the landscape like good

Rainbow Falls. A vertical shot can be used to work around the turbine hall. Here the rising sun warms the spray cloud that kicks up from the right. *Canon EOS 5D MkII, Tokina 28–200, Polarizer, ISO100 setting, f/16 @ 1/8 sec.*

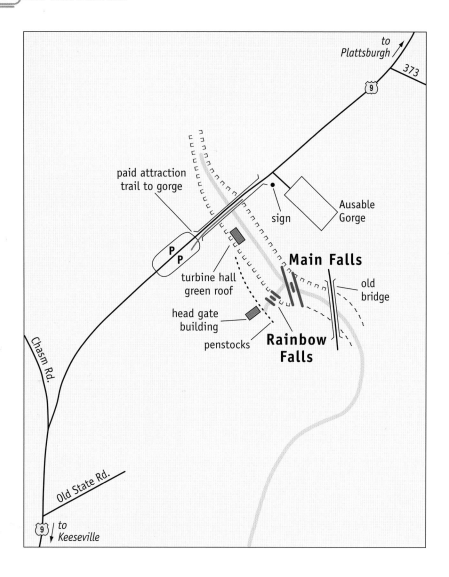

architecture should. Now, because of the roof, it's tough to get around the building's intrusive nature—which is why I mounted a long lens and shot over the building from the bridge's north end.

An old road bridge upstream will be in frame unless time is taken to carefully frame it out. Also, the penstocks can be visible during harsh light through the trees well to the right. If you can't get here on a cloudy day, arrive shortly after dawn when the falls are in deep shadow. The falls will be lit and unworkable about two hours after sunrise.

To get the whole experience, which is why you're here, pay the fee and walk the gorge. The same people that own High Falls Gorge (Hike 59, see page 150) run this facility and you can get a dual admission discount for

High Falls simply by asking. Topographic maps also show Alice Falls being upriver about .4 mile away. Don't worry about finding it; Ausable Chasm is the best stuff going.

Hike 63 Kent Falls, Clinton County

Type: Fall	Height: 65 feet
Rating: 4+	GPS: 44° 41.778′N, 73° 36.704′W
Stream: Saranac River	Distance: 100 yards
Difficulty: Easy	Elevation Change: 50 feet
Time: 15 minutes	Lenses: 150mm to 400mm

Directions: From I-87 exit 37, take NY 3 west 6.4 miles, passing the airport and going through the village of West Plattsburgh. Turn left onto Goddeau Road. In .5 mile turn left again onto Kent Falls Road after passing the Cadyville Recreational Park. In another .5 mile park in a gravel lot on the left near the closed Kent Falls bridge. GPS coordinates: 44° 41.934′N, 73° 36.494′W.

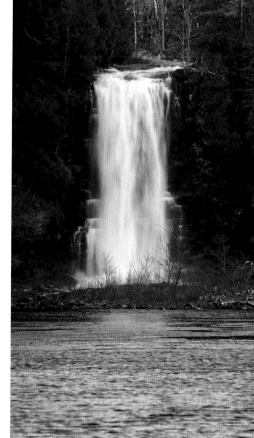

This is strictly a long-lens shot and will require a good tripod. Cross the road, scramble down the steep bank to the reservoir's edge, and look upstream toward the large dam. Left of the dam is a tall fall easily seen against the gray cliff. Use a lens around 400mm to get a frame-filling portrait and blast away. The real Kent Falls is submerged by the reservoir and forms the foundation of the dam near the closed bridge. It's unfortunate because if you look closely at the dam and powerhouse you can see that it was easily around 80 feet tall.

Kent Falls. When using a long lens you'll never have enough depth of field to keep the lake surface in focus. Take care that the rock face is in focus and let everything else go soft. If you have mirror lockup, use it to reduce camera vibration due to mirror slap. *Canon EOS 5D MkII, Tamron 200–400, Polarizer, ISO100 setting, f/16 @ 1/6 sec.*

West
Plattsburgh

Rand Hill
CR 16

22B

Morrisonville

22B

Sand

374

3

Kent Fall

power
plant

Kent
Falls

closed
bridge

long lens

dam

P

Kent Fall

3

Woods Mills

dam

Goddeau

Park Row

power
plant

374

Cadyville

3

◄–N–

Hike 64 High Falls Park, Franklin County

Type: Fall	**Height:** 120 feet
Rating: 5+	**GPS:** 44° 54.569'N, 74° 5.176'W
Stream: Chateaugay River	**Distance:** .6 mile
Difficulty: Moderate, many stairs	**Elevation Change:** 160 feet
Time: 40 minutes	**Lenses:** 20mm to 70mm

Directions: From the center of Chateaugay, take US 11 west out of town 1.0 miles. Cross a huge bridge over Chateaugay Gorge and turn left at a red barn onto CR 22, then immediately turn left again onto Creamery Road. From there follow the signs to High Falls Park by turning left onto Jerdon Road in 1.1 miles. The campground and park entrance are on the left in .3 mile. GPS coordinates: 44° 54.547'N, 74° 5.347'W.

You're going to love this! High Falls Park is a locally popular family campground whose busy season begins on July 4; prior to that the place is empty. Enter the campground office and pay the $2 fee. Upon exiting, bear left away from the mini-golf and follow a wide, meandering path. When you hit the stairs it's about 140 feet down to the fall's base. The return will test your legs.

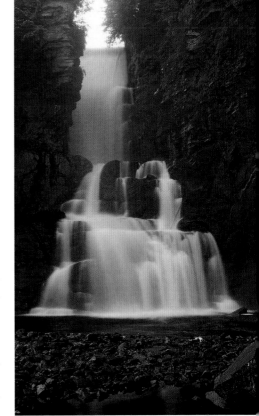

The falls is a monstrous affair with water dropping free until it pounds into a ledge 30 feet from the base. Listed as 120 feet, the top 20 feet is a concrete dam that keeps the correct head pressure on the turbine room across the gorge. This man-made top section does not detract from the fall's grandeur. Lovely green hemlocks cling to high ledges on your left and the nearly 200-foot-tall Potsdam sandstone cliffs rise like castle battlements on the right. A large rock pile divides the plunge pool from the tailwater; in order to avoid an uncomfortable frame separation, work high and right and shoot from the slick rocks above the creek.

High Falls. It is a truly massive thing and the sound is thunderously glorious. The cliff shape drives the sound and spray toward you, enveloping you in a roaring, damp veil. *Tachihara 4x5 Field Camera, 150mm Schneider Symmar f5.6, Polarizer, 4x5 Ready Load holder, Kodak E100VS, f/32 @ 10 sec.*

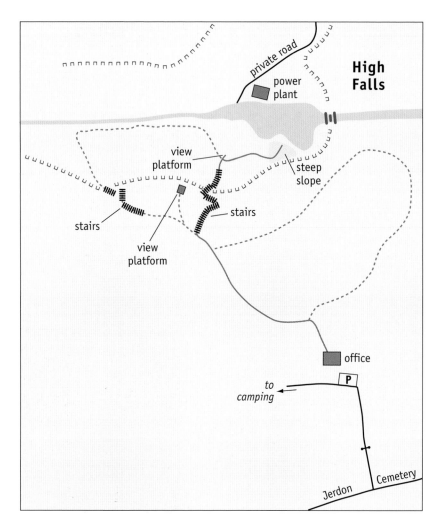

Linger a while and explore the nature trail downstream. The campground caters to kids and a family exploration of this portion of Chateaugay Gorge will be time well spent. The gorge downstream is a well-known fishing area; unfortunately, there's no more falls from here to the St. Lawrence River.

Hike 65 High Falls, Franklin County

Type: Cascade	**Height:** 30 feet
Rating: 4+	**GPS:** 44° 42.586'N, 74° 10.326'W
Stream: Salmon River	**Distance:** 1.5 miles
Difficulty: Easy	**Elevation Change:** 92 feet
Time: 50 minutes	**Lenses:** 20mm to 70mm plus macro

Directions: From the center of Malone at the intersection of US 11 (Main Street) and NY 30 (Finney/Fort Covington streets), head east on US 11 and turn right onto Duane Street (CR 25). Follow Duane Street south out of town 7.6 miles and make a slight left onto CR 27 (Pond Road). In 3.1 miles turn right again to keep with CR 27. (If you cross an old railroad grade you missed this turn by about 100 yards.) Slow down after about a mile; at 1.6 miles turn right onto an apparently abandoned gravel road, Barnesville Road. If you hit the Trail Side Bar you went too far. Park in a small parking spot on the right at .7 mile near a closed bridge. GPS coordinates: 44° 42.250'N, 74° 9.852'W.

The parking area places you on the Salmon River's right-hand side. You will be heading downstream on a quiet and magical blue-blazed trail. This High Falls is one of more than a dozen so-named falls that I visited and

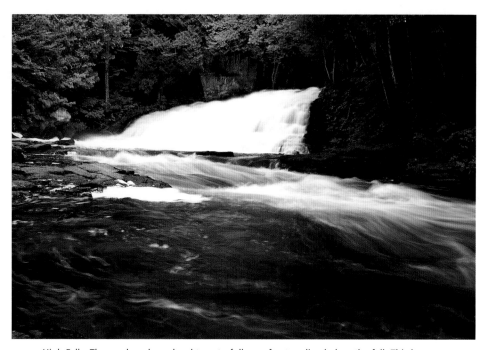

High Falls. The creek makes a hard turn to follow a fracture line below the fall. This leaves a large shelf to the left where you can sit and hang your feet in cold water and just enjoy the day. *Canon EOS Digital Rebel, Tokina 20–35, Polarizer, ISO100 setting, f/8 @ 1/20 sec.*

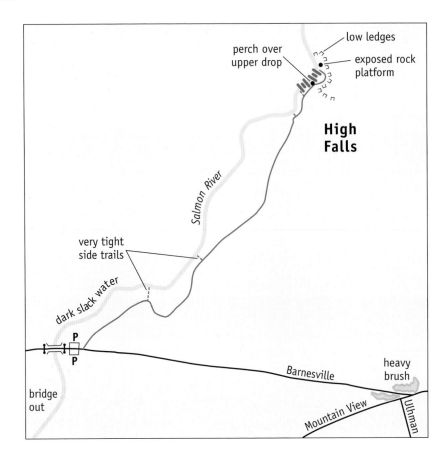

it stands out as a personal favorite. This is my third hiking guide for Stack-pole and I typically put about 300 miles on my boots per season, so it's easy to become jaded, especially after exploring all that New York has to offer. This hike got my creative juices flowing again and reminded me of the simple joy of wandering through the woods in the rain.

The easy-to-follow blue-blaze trail meanders to and from the Salmon River. It's difficult to approach the slow-moving, ebony-colored slack water along the trail because of thick brush. There are several footbridges across little side drainages and vernal pools. Many of the seeps and bogs were filled with small, delicate wildflowers during my mid-June visit. As you move along note how the soft soil gives way underfoot like a wrestling mat; this is some lovely hiking. If you have kids who are new to hiking bring them here—they'll probably get black with mud but they'll love every minute of it.

The trail finally arrives at a rock ledge guarding the fall at .7 mile and then deposits you at the base at .75 mile. High Falls is a two-tiered cascade with the two drops separated by about 30 yards. You won't be able to get a position high enough to get both in frame and the lower is by far the easier one to shoot. Linger and enjoy.

Hike 66 St. Regis Falls, Franklin County

Type: Cascade	**Height:** 35 feet
Rating: 5+	**GPS:** 44° 40.407'N, 74° 33.023'W
Stream: St. Regis River	**Distance:** .6 mile
Difficulty: Easy	**Elevation Change:** 60 feet
Time: 20 minutes	**Lenses:** 20mm to 100mm

Directions: From the center of Potsdam at the intersection of US 11, NY 11B (Elm Street), and NY 56 (Park Street), take NY 11B east out of town 16.1 miles. Cross into Adirondack Park and turn right onto NY 11B/NY 458 in the hamlet of Nicholville. Continue along the sometimes twisty NY 11B/NY 458 for 7.4 miles into St. Regis Falls. Just as you cross the bridge over the St. Regis River turn left into the St. Regis Falls Campground and park near the entrance station. GPS coordinates: 44° 40.461'N, 74° 33.067'W.

St. Regis Falls is a small community at the northernmost canoe access to the St. Regis River. I had a long and informative conversation with the campground manager about what falls in the region were on private lands. She carefully went over every map I had and marked all the problematic locations; this is why less of what exists in the North Country appears in this guide.

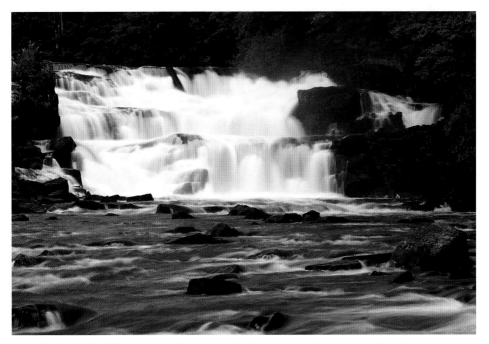

St. Regis Falls. When shooting from the footbridge you need to be aware of how the wood structure vibrates. *Canon EOS Digital Rebel, Tamron 28–200, Polarizer, ISO100 setting, f/29 @ .8 sec.*

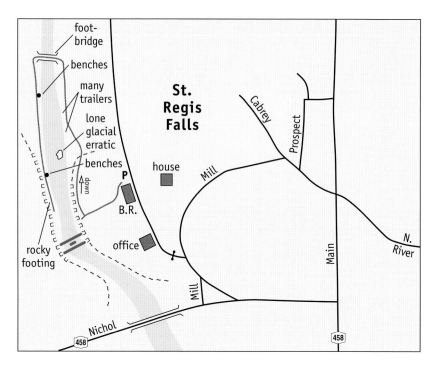

The trail follows a U-shaped path down the gravel road from the entrance station, crossing the river on a large footbridge and then heading back upstream among the rocks on the far shore. It's a quick and pleasant walk. I found it easy to shoot from the far bank upstream of the footbridge. What fascinated me was a lone glacial erratic sitting halfway between the footbridge and the fall. This boulder, weighing many tons, has been sitting in the same spot since retreating glaciers dropped it here as little as nine thousand years ago. Any composition that puts this erratic in a comfortable context within the scene will be a keeper.

Hike 67 **Allen Falls, St. Lawrence County**

Type: Slide	Height: 35 feet
Rating: 5	GPS: 44° 39.353'N, 74° 50.995'W
Stream: High Falls Creek	Distance: .7 mile
Difficulty: Easy	Elevation Change: 84 feet
Time: 25 minutes	Lenses: 20mm to 50mm

Directions: From the center of Potsdam, take NY 11B east out town 6.6 miles to the hamlet of Southville. Turn right onto CR 47 (Parishville–Northville Road) In 1.5 miles turn right onto Allen Falls Road and park on the left in .5 mile in a large gravel parking area. GPS coordinates: 44° 39.197'N, 74° 51.072'W.

A short quarter-mile walk followed by a steep drop from a headland brings you to the most popular swimming and party spot in this area. I noted a lot of beer bottles and cans littering the fall's tailwater. Campers I spoke with stated that this is also a popular weekender location. They were kind enough to offer me some of the bacon they were frying, along with some coffee.

You may have some big blowdowns to get around. Huge storms in 2008 ravaged much of St. Lawrence County and leveled entire forests. I rode out much of that weather in my little tent and I can tell you that it was unnerving. I even got a picture of a house in nearby Parishville that was split to the foundation when a humongous oak fell on it.

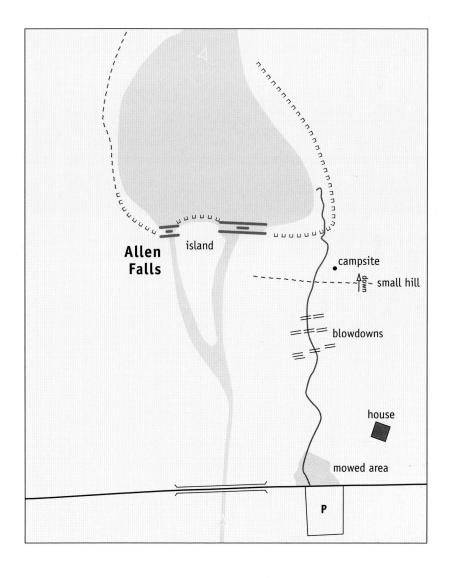

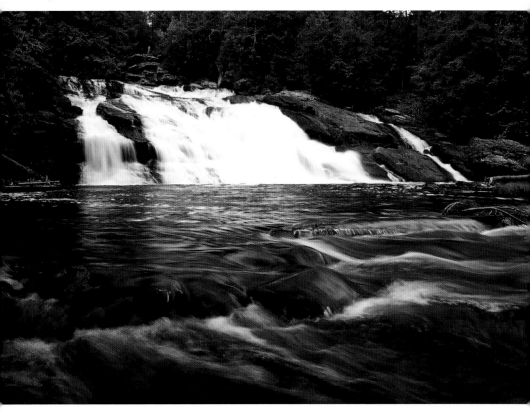

Allen Falls. You can create foregrounds out of almost anything, in this case a small riffle. Get low, go wide, and stuff the lens into the foreground and use the smallest aperture you can manage. *Canon EOS Digital Rebel, Tokina 20–35, Polarizer, ISO100 setting, f/22 @ .3 sec.*

With waders or water shoes you can get well into the tailwater, but I liked working from the fall's right-hand side (the side you're on) using an eddy and some rocks as a foreground. An island near the far shore hides a second, less spectacular drop that carries about 15 percent of the St. Regis's flow. I wouldn't bother trying to get a position to work it.

Hike 68 Stone Valley, St. Lawrence County

Fall 1

Type: Slide	**Height:** 40 feet
Rating: 3+	**GPS:** 44° 33.304'N, 74° 56.373'W

Fall 2

Type: Slide	**Height:** 35 feet
Rating: 4	**GPS:** 44° 33.418'N, 74° 56.322'W

Fall 3

Type: Slides	**Height:** 35 feet
Rating: 5	**GPS:** 44° 33.711'N, 74° 56.584'W

Fall 4

Type: Slide over cascade	**Height:** 16 feet
Rating: 5	**GPS:** 44° 33.793'N, 74° 56.712'W

Stream: Raquette River

Difficulty (East Side Hike): Easy	**Difficulty (West Side Hike):** Easy
Time: 1 hour	**Time:** 50 minutes
Distance: 2.0 miles	**Distance:** 1.8 miles
Elevation Change: 160-foot descent	**Elevation Change:** 195-foot descent

Lenses: 17mm to 70mm

Directions: To get to Colton, begin in the center of Potsdam and take NY 56 (Pierrepont Avenue) south out of town 9.3 miles. Turn left onto Main Street and head towards a large lake. The West Side Trailhead parking is adjacent to the Colton Museum (don't cross the bridge). GPS coordinates: 44° 33.213'N, 74° 56.305'W. To reach the East Side trailhead parking area, cross the bridge and turn left onto Riverside Drive at the fire company and park behind it. GPS coordinates: 44° 33.355'N, 74° 56.373'W.

West Side Hike: The West Side Trail is best for Fall 1 and Fall 4 only. Walk down the gravel road past a gate near the dam. In a short distance turn right to cross a metal footbridge over an enormous green penstock. This immense pipe carries a majority of the Raquette's flow two miles north to a power plant at Browns Bridge. Once over the pipe, bear left on a wide footpath; as a fall below the dam comes into view, take a side trail right to its base and a nice shooting position. You should set up low enough to keep the dam and other workings out of view.

Return to the main path, turn right, and speed hike downstream, bypassing Falls 2 and 3 in favor of Fall 4. (Falls 2 and 3 are best viewed from the East Side trail). Fall 4 will be audible in .8 mile and in view at .85 mile. Once you are beyond the fall's head, turn right on a faint footpath and scramble down to the ledges adjacent to the base. The fall's face is a

continuous slab of dark brown granite with small potholes that make nice foregrounds. When you're done, return to your car and head for the East Side trail.

East Side Hike: Also called the Stone Valley Nature Trail, this hike alternates from being deep in the woods to near the water. It is a pleasant hike for kids with just enough happening to keep a youngster's interest. Walk down the paved lane away from the firehouse heading to Fall 2 (Fall 1 is better from the other side). Fall 2 is situated well below the main trail; there is an obvious footpath down 150 yards from the parking area. Turn left and drop 60 or so feet to the base of a 35-foot slide. You can work beyond the trees by rock hopping to get a nice view.

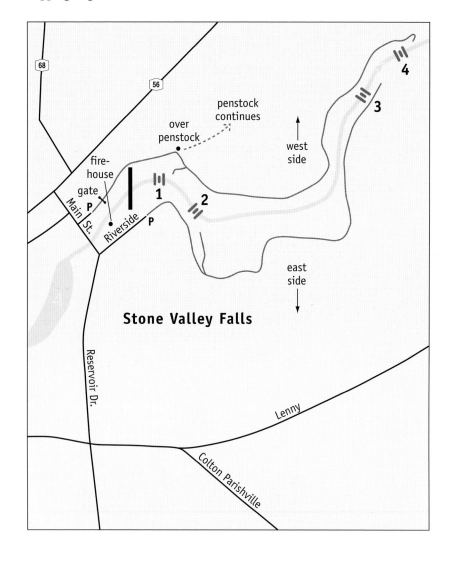

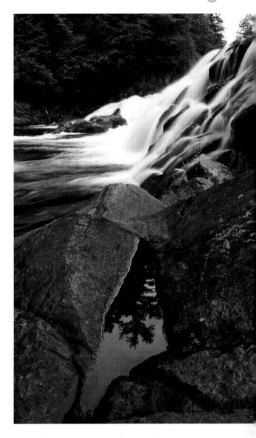

Fall 4. Look for a foreground in any situation where you're confined to an edge-on view of a fall. To enhance this one I added water to the puddle and concentrated on placing the reflection comfortably in the frame; I then managed background highlights from the sky. This is from the west side trail. *Canon EOS Digital Rebel, Tokina 20–35, Polarizer, ISO100 setting, f/22 @ .5 sec.*

Return to the main trail and turn left to continue downstream. The trail loops away from the river and climbs before topping out at .4 mile. It then drops again into a forested mudflat. I found a few frogs in vernal pools that weren't very active because of the chill. After bottoming out at .55 mile, the trail again climbs, this time slowly as it side-hills along a headland. After a pleasant walk among pines and rocks you arrive at Fall 3 at .85 mile. This long, S-shaped slide has two big potholes carved into its face on the left. Imagine the size of the rock and flow required to pound out a hole that big.

Continue downstream along the ledges to the final fall, arriving at 1.0 miles. You'll note a big difference in how this fall looks compared to the West Side trail. The channel before you has a shallow angle compared to the opposite bank. It also carries more flow. There are several conveniently positioned rocks in the tailwater that make shooting quick and easy. When you're done, reverse your route and climb back along the Raquette, returning to your car at 2.0 miles.

Hike 69 South Branch Grass River, St. Lawrence County

Basford Falls

Type: Slide	Height: 20 feet
Rating: 4	GPS: 44° 20.420'N, 75° 3.478'W

Sinclair Falls

Type: Slide	Height: 12 feet
Rating: 3	GPS: 44° 20.270'N, 75° 2.812'W

Stewart's Rapids

Type: Cascade	Height: 24 feet
Rating: 5	GPS: 44° 19.953'N, 75° 1.595'W

Twin Falls

Type: Cascade	Height: 18 feet
Rating: 4	GPS: 44° 19.953'N, 75° 1.595'W

Rainbow Falls

Type: Cascade	Height: 30 feet
Rating: 5+	GPS: 44° 18.403'N, 74° 59.945'W
Stream: South Branch Grass River	Lenses: 20mm to 200mm plus macro

Directions: This drive through the Adirondacks' Tooley Pond Tract along the South Branch of the Grass River makes for a delightful series of short hikes with some great photography. To get to the start of this route from Watertown, take US 11 north 35.1 miles to the town of Gouverneur. Turn right onto NY 58/812 (William Street) to head south out of town. Follow NY-58 for the next 22.0 miles into the small town of Fine. When NY 58 begins a long right turn to join NY 3, bear left onto CR 27/27A, which will quickly become CR 122. In 1.8 miles turn left onto CR 27 (DeGrasse–Fine Road) The road will change names a couple times to become Fine-Canton-Lisbon Road as you head north. Enter the hamlet of DeGrasse in 7.8 miles and at a T turn right onto CR 27 (Clare Rd.). In .5 mile bear right onto Tooley Pond Road after crossing the Grass River and park. Reset your trip odometer since all road mileages begin from this point. GPS coordinates: 44° 21.091'N, 75° 4.394'W.

Basford Falls

Difficulty: Easy	Distance: .7 mile
Time: 25 minutes	Elevation Change: 90 feet

Directions: Head southeast on Tooley Pond Road 1.4 miles and park on the right near a 30 MPH "curvy road" caution sign. There will be two faded red posts and a large boulder. GPS coordinates: 44° 20.581'N, 75° 3.233'W.

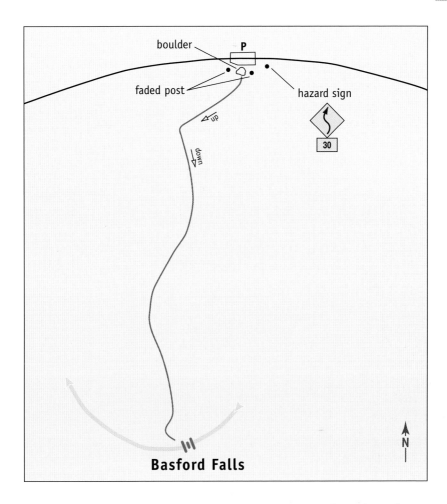

boulder

P

faded post

hazard sign

up

down

30

Basford Falls

N

Follow a well-defined unmarked trail slightly uphill through raspberry brambles. The trail bears left at .1 mile to begin its descent to the river. Another left is made at .15 mile and from this point the river should be audible through the forest. The trail jogs left and right at .21 mile and makes a final easy descent to the fall's head, arriving at .35 mile.

Basford Falls is a slide-and-cascade combination. At the head is a lone boulder sitting midstream that has two pines, one quite tall, growing from it. The tailwater is quite deep and the best setup is 30 to 60 yards downstream among some mid-channel rocks. Reaching them requires waders and a steady hand. The Grass River's water is a dark tea color and it's difficult to see your feet even when you use polarized sunglasses. There are also some deep holes that you can only find by hitting them, so before hauling gear out make a pilot run with empty hands. If you find a comfortable route then go ahead and ferry out your expensive gear.

Don't ford to the opposite bank—it's posted. Return to your car, which you reach in .7 mile.

Sinclair Falls

Difficulty: Easy	**Distance:** 100 yards
Time: 10 minutes	**Elevation Change:** 40 feet

Directions: Continue along Tooley Pond Road to 2.0 miles and turn right onto the gravel Lake George Road. Park on the right near the bridge. GPS coordinates: 44° 20.268'N, 75° 2.752'W.

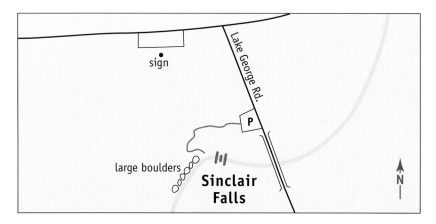

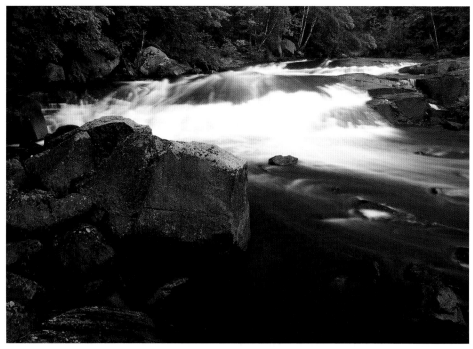

Sinclair Falls. I'm not fond of Photoshop "trickery," but in this case I did something I hardly ever do. I cloned out the bright green plate-girder bridge above the creek. I wouldn't hang it on my wall but it works at the small scale published here. *Canon EOS Digital Rebel, Tokina 20–35, Polarizer, ISO100 setting, f/22 @ 8 sec.*

Follow an obvious footpath away from the road through boulders and down-hill to where it peters out along the river. Sinclair Falls is a long, S-shaped slide that terminates at a three-foot ledge. With a total drop of twelve feet, I'm told it can be kayaked. However, I'd be worried about getting clothes-lined by the bridge above the fall. You'll have to confine yourself to working among the rocks on the right-hand side (the side you're on) since the tailwa-ter is deceptively deep. The road bridge above makes getting a clean, natural-looking shot almost impossible.

Stewart's Rapids and Twin Falls

Difficulty: Easy	Distance: 100 yards
Time: 10 minutes	Elevation Change: 40 feet

Directions: There are two parking areas for this pair of falls. One is a wide and sandy area at 2.9 miles where the road swings right after descending (GPS coordinates: 44° 20.071'N, 75° 1.590'W). The other is at 3.1 miles at the top of slight rise adjacent to Twin Falls (GPS coordinates: 44° 19.989'N, 75° 1.548'W).

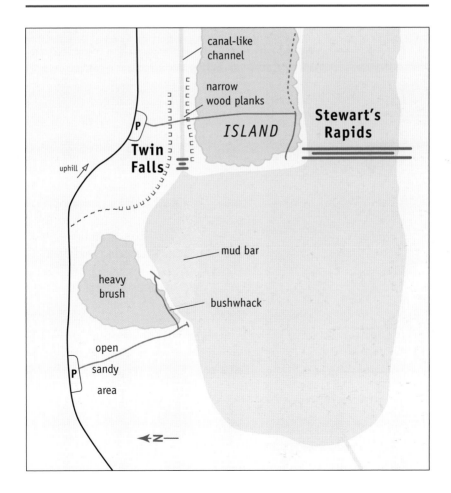

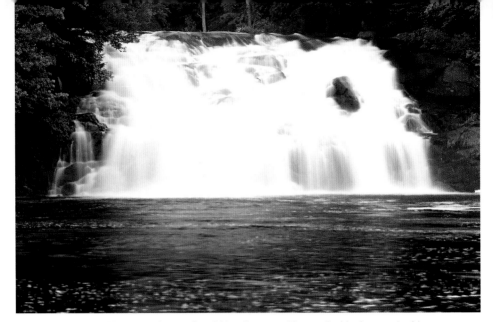

Stewart's Rapids. To me the word rapid implies something navigable, but not in this case. To counteract the effect of open sky on the large foreground pond I did some subtle dodging to darken it just a hair and gain balance in the image. *Canon EOS Digital Rebel, Tamron 28–200, Polarizer, ISO100 setting, f/22 @ 1.6 sec.*

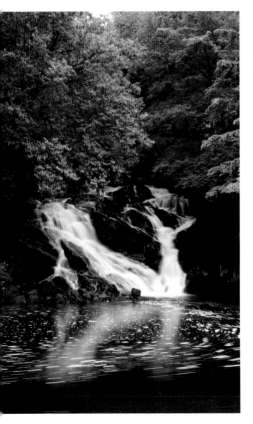

I prefer the parking spot at 2.9 miles. The other one has a little trail that takes you to the head of both falls, and as such doesn't provide a shooting position. The lion's share of the flow goes over Stewart's Rapids. Since it's on the river's far side, the flow creates a huge, slow-moving eddy. As the flow works its way downriver the eddy brings all the fine silt to your side, depositing a series of muddy bars. I take the time to tell you this because if you enter the river for a better view of either drop, don't be surprised if you get sucked down to your knees and lose a boot. I barely avoided this with some very quick footwork.

Follow a footpath to the river from the first parking area. Turn left and bushwhack through heavy brush, using a deer trail to find a position that faces both falls. If you

Twin Falls. Standing ankle-deep in damp, stinky muck is the price of getting this view of the fall. *Canon EOS Digital Rebel, Tamron 28–200, Polarizer, ISO100 setting, f/22 @ 2 sec.*

work farther left you'll get a nice front-on view of the narrow Twin Falls. Keep right and you get a nice long-lens view of the 100-foot-wide Stewart's Rapids. In spring flow the ground will be a bit swampy and bugs will be a nuisance. In summer the smaller Twin Falls will run lightly or be almost dry as the bigger Stewart's Rapids takes all the flow. In bright sun, wait till noon to shoot Stewart's so that shadows are off the dark rock face. Twin Falls is set back among some trees and can only be shot in overcast or rain.

Rainbow Falls

Difficulty: Easy	Distance: .6 mile
Time: 35 minutes	Elevation Change: 85 feet

Directions: Continue along Tooley Pond Road and drive past the private Flat Rock Falls. At 6.0 miles park on the right near several large boulders fronting a clearing. GPS coordinates: 44° 18.436'N, 74° 59.673'W.

Cross the clearing and enter the woods on a wide unmarked path. Descending slowly, cross a footbridge over a small drainage at .18 mile. From here the path braids; follow what appears to be the widest or most-used pathway generally downhill until you hit the river just downstream of the fall at .25 mile.

Look up and left for two rock outcroppings that overhang the narrow chasm, one covered with grass and the other not. These are the two shooting set-ups. The better one is the one farther from the fall that's not covered in grass. The fall's shape funnels spray up the cliffs on your side, which is

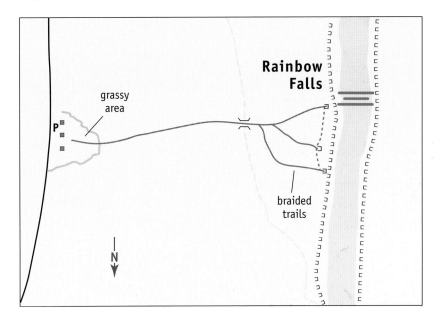

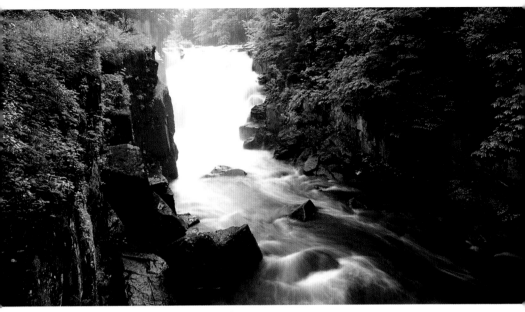

Rainbow Falls. Not wanting to change lenses amid all the spray, I opted to merge two images into a panoramic to show the gorge's true size. By setting the exposure to manual you can guarantee that no seam will be visible. *Canon EOS Digital Rebel, Tokina 20–35, Polarizer, ISO100 setting, f/22 @ 2 sec.*

why that one rock is covered with so much grass. All the ledges have lichen rings on them and in damp weather they will be quite slick. Extreme care is required to keep from plunging into the foaming tailwater.

This is an impressive drop in high flow. I was here in mid-June after a good snow year with a couple months of damp weather. This left the fall running violently, more so than one would expect in June. Tannin makes the water appear dark like strong tea; as it goes over Rainbow Falls the water is aerated, giving it the color and character of a well-pulled Guinness. During peak snowmelt the fall will have so much flow that you won't be able to distinguish where the precipice and base are. I've seen pictures of Rainbow at full throttle and it looks like a 10-foot rapid instead of a 30-foot cascade.

You probably have a GPS coordinate for Copper Rock Falls, which is at the 8.7-mile mark on Tooley Pond Road. Don't bother. Copper Rock is a rocky rapid that is known to kayakers as good bit of whitewater. It drops maybe 40 feet in about 100 yards and sits at a point where the Grass River is much narrower than at Rainbow Falls. When Rainbow was blasting Copper Rock was running weakly. Again, don't bother. Instead head back to the village of Degrasse and the next hike at Lampson Falls.

Hike 70 Lampson Falls, St. Lawrence County

Type: Slide	**Height:** 40 feet
Rating: 5+	**GPS:** 44° 24.337'N, 75° 4.279'W
Stream: Grass River	**Distance:** 1.2 miles
Difficulty: Easy	**Elevation Change:** 50 feet
Time: 45 minutes	**Lenses:** 20mm to 100mm

Directions: Head east from the small village of Degrasse on CR 27. Pass Tooley Pond Road and park on the left in 4.5 miles where the road widens. There will be a sign for Lampson Falls and several marked handicapped spots. GPS coordinates: 44° 24.287'N, 75° 3.693'W. For directions to Degrasse see Hike 69 (page 172).

This is a first-rate starter hike for young kids because the trail is mostly a stroller-accessible gravel woods road to the fall's head. For the first .2 mile the trail traverses private land; stop and register as soon as you cross back into parkland at .2 mile. Even though this popular trail can be crowded it's still important to register. The information helps the DEC determine usage, average group size, and length of stay. Come to a curbed handi-capped trail at .45 mile that heads left to an overlook at the fall's head; fol-low it at first but then swing right and down before the fall, where you'll end up at a large beach with the falls to the left. This is one reason this location is so popular—it's a huge swimming hole. After a couple days of hiking I popped my boots off and cooled my feet for quite some time.

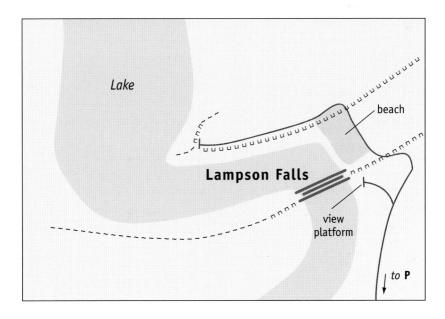

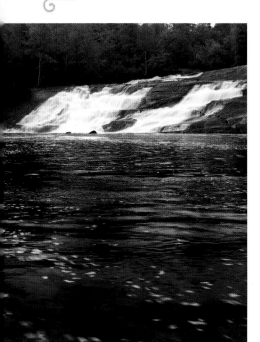

Lampson Falls. You can create foregrounds out of something as simple as foam and bubbles by merely manipulating time. Maximize shutter speed and paint in a foreground with something normally hidden to the eye. *Canon EOS Digital Rebel, Tokina 20–35, Polarizer, ISO100 setting, f/22 @ .3 sec.*

Now follow a blue-blazed trail away from the falls up a steep slope to cliffs facing the fall. Continue along the cliffs to a spot you like. Now you can see the full scale of Lampson Falls, spanning some 100 yards of the Grass River. This slide is massive. In summer the flow is divided evenly, leaving a dark dry island on the fall's face, while in spring the full veil is covered in whitewater. Below, the tailwater is slow-moving and inky dark, while downstream around a bend is a wonderful lake.

Although shooting from the cliff facing the fall provides a classic shot, I recommend working out along the rocks to where they peter out in the dark water. Long skeins of foam break free of an eddy near the beach and slowly swing past this point. You can use these to create an anchoring foreground with a sense of motion by using a very long shutter speed. Although it's best in overcast you can shoot under blue sky since the fall's head is completely open.

Hike 71 Harper Falls, St. Lawrence County

Type: Slide over chute	**Height:** 23 feet
Rating: 3–4	**GPS:** 44° 26.120′N, 75° 4.479′W
Stream: North Branch Grass River	**Distance:** 1.4 miles
Difficulty: Easy	**Elevation Change:** 150 feet
Time: 35 minutes	**Lenses:** 20mm to 70mm

Directions: Head east from the village of Degrasse on CR 27 7.2 miles to Donnersville Road. Turn left onto Donnersville. In .5 mile park on the left at a large wooden DEC sign for the Grass River Wild Forest Preserve. As you leave Degrasse you'll pass Tooley Pond Road (Hike 69) and Lampson Falls (Hike 70). GPS coordinates: 44° 26.494′N, 75° 4.159′W.

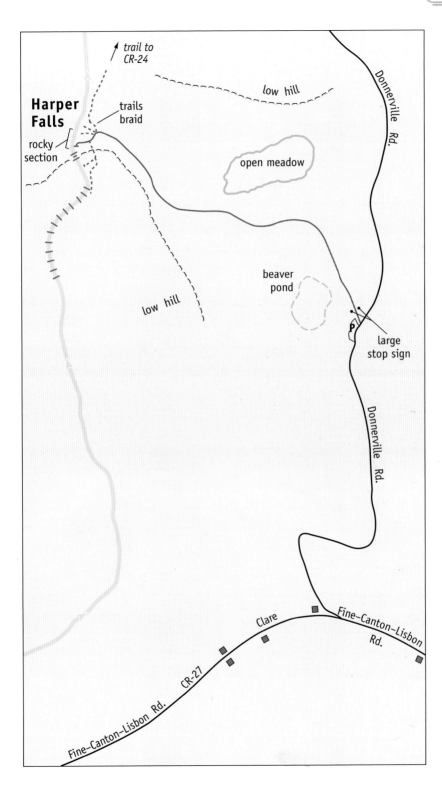

trail to
CR-24

low hill

**Harper
Falls**

trails
braid

rocky
section

open meadow

Donnerville Rd.

beaver
pond

low hill

large
stop sign

Donnerville Rd.

Clare

Fine–Canton–Lisbon
Rd.

CR-27

Fine–Canton–Lisbon Rd.

Close to the parking area is a large beaver pond accessible from Don-nersville Road or just beyond the gate blocking the trail. In early spring look for large mats of wildflowers along the damp edges of this pond. It's an easy .7-mile jaunt to the falls along an old grassy woods road and you can set a rather brisk pace. The surrounding forest is a mixture of birch, maple, and oak species that will be a riot of color come fall. At .35 mile look for an arboreal meadow on the right where a metal pipe cuts across the trail. I didn't bring my waders along—otherwise I would have thoroughly explored this wonderful spot.

At .7 mile you arrive at Harper Falls, a slide-over-chute created by a long exposed joint or fracture in the granite underlying the forest. These joints or faults riddle the Adirondacks and the North Country and most rivers follow them. Falls tend to be situated along vertically displaced joints. This fall's upper section is long and broad while the lower section has a narrow, V-shaped channel. A flume separates the upper and lower sections and it is difficult to see both drops from below. In fact, from the lowest viewpoint the fall appears much smaller than it really is. I found the upper section to be more attractive, however; at full flow it was difficult to shoot without foreground obstructions.

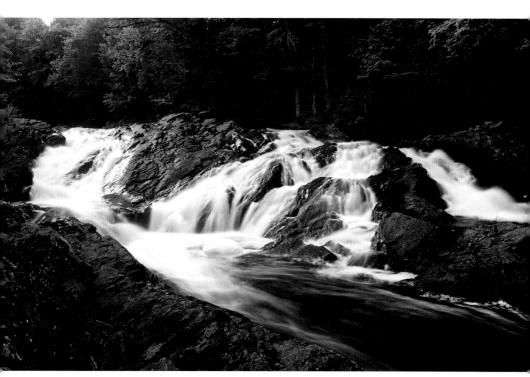

Harper Falls. Work above and below the drop, shooting verticals and horizontals until you find a composition that works for you. This was my eleventh setup and 130th frame. Keep shooting until it "clicks" in your mind. *Canon EOS Digital Rebel, Tokina 17, Polarizer, ISO100 setting, f/22 @ 1.6 sec.*

Rocks on the right-hand side (your side) make good, stable perches to shoot from. Small pools fill the little crevices and can be used as foregrounds by carefully positioning the camera to pick up the reflections of clouds or a handsome tree. I found one lone frog in the largest pool but it wouldn't remain still long enough for me to work into the larger scene. He jumped from under my tripod with a neat little splash; with his bulbous eyes peaking through the water's surface we stared at each other for a long time. That's when I learned that frogs don't blink—or at least rarely do.

Hike 72 Stockbridge Falls, Madison County

Type: Cascades	**Height:** 41 feet
Rating: 3	**GPS:** 42° 57.088′N, 75° 36.272′W
Stream: Oneida Creek	**Distance:** 50 yards
Difficulty: Easy	**Elevation Change:** None
Time: 10 minutes	**Lenses:** 20mm to 70mm

Directions: From the small town of Morrisville on US 20, head north on CR 45 (North Street) for .7 mile. Turn right onto CR 42 (Rocks Road). In 2.3 miles turn left onto CR 49 (Pratts Road) and then in .8 mile go left again at Streeter Road. Follow Streeter for .4 mile and continue straight (north) on Falls Road. As you approach a small bridge over Oneida Creek, park in wide area on the right near the bridge. GPS coordinates: 42° 57.088′N, 75° 36.272′W.

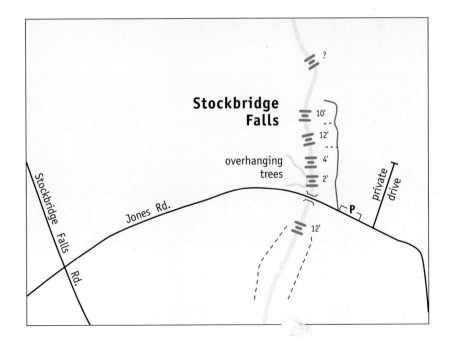

Stockbridge Falls is a long series of stairs that drops Oneida Creek off of Munnsville West Hill into a ravine where it enters the wider valley. The land around the falls is private, although it is not currently posted and is a popular swimming hole. It is best to work from the small bridge over the creek. The creek passes through some farms and residential areas and so it carries all manner of human detritus with it. The lower-most falls, which sit below the bridge, had a complete swing set hung up in a tree near the base along with a bright red lawn tractor. However, since that fall isn't accessible it was no big deal.

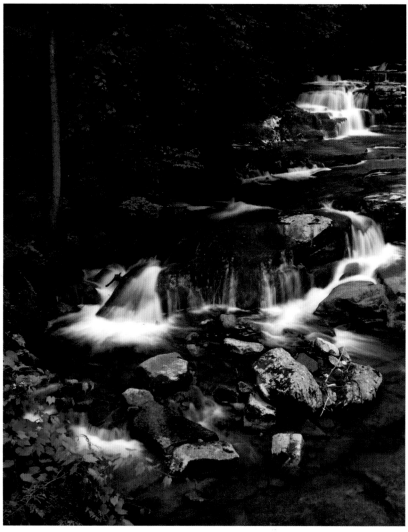

Stockbridge Falls. Wait patiently for bathers to get out of frame. In this case I quietly ate my lunch while a mother took several young kids for a swim. I got off 10 frames before the next group arrived. I waited an hour just to get this shot. *Canon EOS Digital Rebel, Tokina 20–35, Polarizer, ISO100 setting, f/22 @ 1.6 sec.*

About 50 yards upstream from the bridge is a nice cascade of about 20 feet that's visible through the trees. Even though I saw a number of bathers I felt that I should respect the landowner's rights and not approach that drop to shoot. The bridge provides an excellent view of the stairway series of cascades. Although no single step would make a perfect image, the combined series does. It is popular, so get here early or be very patient with all the kids running around.

Hike 73 Chittenango Falls, Madison County

Type: Cascade	**Height:** 167 feet
Rating: 5	**GPS:** 42° 58.721'N, 75° 50.494'W
Stream: Chittenango Creek	**Distance:** .15 mile
Difficulty: Moderate	**Elevation Change:** 180 feet descent
Time: 15 minutes	**Lenses:** 20mm to 200mm

Directions: Chittenango Falls State Park is 4 miles north of Cazenovia on NY 13. The quaint town sits on Cazenovia Lake along US 20, east of I-81 exit 15. NY 13 (Gorge Road) is quite twisty with unguarded drops on the right in many places, so obey the speed limit. GPS coordinates: 42° 58.697'N, 75° 50.555'W.

When Chittenango Creek is swollen with spring rain this fall is a thundering monster. Even in weaker flow it's still quite a sight. Popular at any time of year, this location is a must-see for any photographer. It's well-signed and has ample picnic tables. The park is made for kids.

From the parking lot, head to a viewing area at the fall's head; you won't get a good shot from here but you can see your shooting location, which is the bridge across the creek far below. Follow the yellow-blazed Gorge Trail, a paved path with many stairs. Halfway down is a small viewing platform. Here you have great

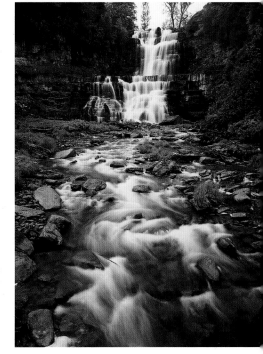

Chittenango Falls. I shot this from the bridge near the collapsed stairs. You'll note how the blank sky is broken up by the two trees. In tighter shots this doesn't look as vacant as it does in this wide view. *Tachihara 4x5 Field Camera, 75mm Rodenstock Grandagon f6.8, polarizer, 4x5 Ready Load holder, Kodak E100VS, f/32 @ 4 sec.*

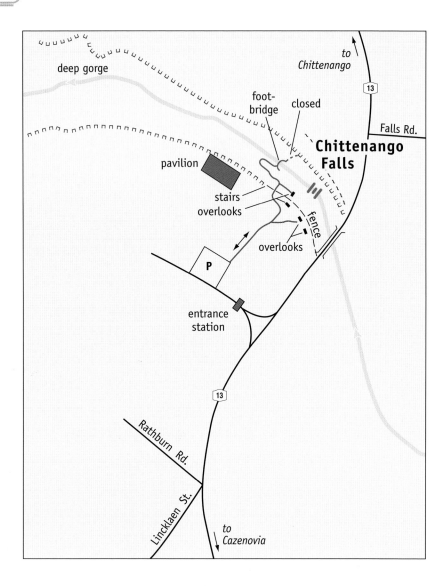

views of the fall as well as excellent signage telling the geologic story. Perhaps the best shooting position is from a bridge on the creek's right-hand side. The bridge is narrow and bouncy so work fast. Shoot every lens you own—you won't be disappointed. The only issue I had was the large expanse of blank white sky heading the fall. It's best to keep this to a minimum.

If you picked up a map you'll notice sections of the gorge marked with X's. These areas are closed and access is strictly prohibited. Heading off-trail in the gorge could cost you a minimum of $75. A trail up the gorge's north side (the right-hand) is closed due to a landslide that wiped out a long flight of stairs.

Hike 74 Pratt's Falls, Onondaga County

Type: Cascade	**Height:** 137 feet
Rating: 5	**GPS:** 42° 55.871'N, 75° 59.645'W
Stream: Pratt Creek	**Distance:** .5 mile
Difficulty: Easy	**Elevation Change:** 160 feet descent
Time: 25 minutes	**Lenses:** 20mm to 70mm

Directions: Begin at the village of Pompey on US 20, east of I-81 exit 15, and follow signs for NY 91 north. In about 100 yards bear right onto Sweet Road, and then make an immediate right onto Academy Street, followed by a left at a T onto Henneberry Road. This whole sequence is like navigating a big parking lot surrounded by three churches. Follow Henneberry 1.9 miles north and then turn right onto Pratt's Falls Road (CR 218), following signs for the county park. Turn left into the park in .5 mile. Once in the park, pay the $1 fee at the honor kiosk, bear right at the park office (which is a brown trailer), pass a lot of black fencing with "Danger" signs, and turn left into a huge parking area. Park under pine trees near a swing set in the back corner. GPS coordinates: 42° 55.906'N, 75° 59.631'W.

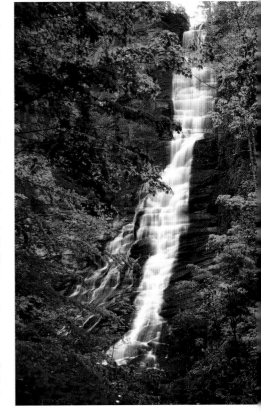

As you passed the park office and the black fencing you probably made note of a drop-off on your left. This is the fall. Leave the parking area, pass by the big "Danger" sign, and head down some concrete stairs on a blue-blazed trail. At the bottom, turn left to follow the graded trail to a viewing platform. Ample signage states not to go off-trail to approach the falls. The long ribbon of water is seen through a veil of trees, so moving just a few feet left or right will dramatically change what you can see. The fall, fed by a small stream, will be a trickle by late June. The absolute best shooting is if there's heavy flow during peak fall color, usually the result of big storms coming off the Great Lakes. To check conditions contact the park at (315) 682-5934. The park is open 8:30 A.M. to 8:30 P.M.

Pratt's Falls. Access restrictions mean you have one setup position and two compositions—vertical and horizontal. *Canon EOS Digital Rebel, Tokina 20–35, Polarizer, ISO100 setting, f/22 @ 3.2 sec.*

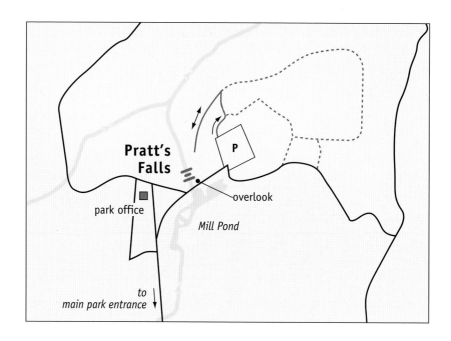

Hike 75 Tinker Falls, Cortland County

Type: Fall	**Height:** 55 feet
Rating: 5	**GPS:** 42° 46.954'N, 76° 1.978'W
Stream: Tinker Creek	**Distance:** .6 mile
Difficulty: Easy	**Elevation Change:** 100 feet
Time: 25 minutes	**Lenses:** 20mm to 70mm

Directions: From I-81 exit 14 north of Cortland, take NY 80 east 4.3 miles. Pass through the town of Tully and onto the village of Apulia. Turn right onto NY 91 south and go 3.3 miles. Park in one of the two large parking areas on the right. Pedestrian crossing signs announce the location. GPS coordinates: 42° 46.862'N, 76° 2.199'W.

This is a popular spot, so don't be surprised if there are more than a few people here. Tinker Falls is an impressive drop into an enormous amphitheater. From the parking area cross the road and follow the wide trail to the falls. Take care crossing the road: northbound traffic (from your right) will be doing close to 60 MPH and a small rise hides cars from view. If you're bringing small kids it's best to carry them across.

What was a rough gravel trail is now handicapped accessible. Follow it until the falls comes into view, and then take the side trail that drops into the creek. Start shooting from here and slowly work upstream through massive boulders, refining compositions as you go. Boulders fill the fall's base,

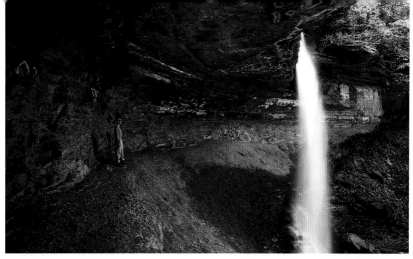

Tinker Falls. Everybody walks behind the veil of this massive fall. Put somebody in frame to get a sense of the size. *Canon EOS 5D MkII, Tokina 20–35, Polarizer, ISO100 setting, f/22 @ 5 sec.*

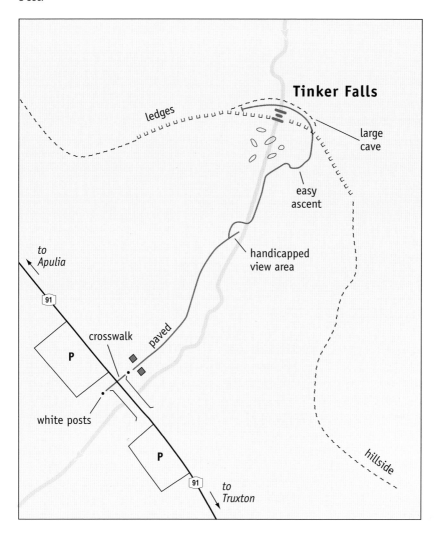

Tinker Falls

ledges

large cave

easy ascent

to Apulia

91

handicapped view area

crosswalk paved

P

white posts

P

91 to Truxton

hillside

which you'll need to go over or around to see. A footpath goes behind the fall and you can work images from the fall's flanks and up fairly high. Shoot through trees to get an environmental perspective, do frontal and side portraits—in short, fill a memory card.

Tinker Falls has one problem: graffiti. Between scouting trips in 2007 the rock wall behind the falls was tagged with graffiti over an extensive section of about 100 feet. This made it impossible to shoot super-wide compositions of the amphitheater. Fortunately, the soft shale behind the fall erodes easily, so when I returned in 2009 all of the tagging was gone. I simply don't understand why anyone would ever deface such a phenomenal location as this.

Hike 76 Carpenter Falls, Cayuga County

Type: Fall	**Height:** ~90 feet
Rating: 5+	**GPS:** 42° 48.732'N, 76° 20.643'W
Stream: Bear Swamp Creek	**Distance:** .3 mile
Difficulty: Easy	**Elevation Change:** 100 feet
Time: 20 minutes	**Lenses:** 15mm to 100mm

Directions: The small town of Moravia sits at the south end of Owasco Lake. From the town center at the intersection of NY 38/38A (Main and Cayuga), take NY 38A (E. Cayuga Street) north out of town 6.9 miles and turn right onto Burdock/New Hope Road. In 1.9 miles turn left onto NY 41 and in .8 mile turn right onto Apple Tree Point Road. Follow the twisting road down .5 mile and park in a signed area on the left near the intersection with Carver Road. There is no roadside parking, as the ample signage notes, and regular ticketing occurs. If the lot is full you'll have to troll around, or if absolutely necessary, park at the Millard Fillmore picnic area on Carver Road. GPS coordinates: 42° 48.801'N, 76° 20.509'W.

This 90-foot fall is one New York's gems, and locations like this are why I love my job. The falls and upper gorge are now under DEC control while the lower section, called the Bahar Preserve, is owned by the Finger Lakes Land Trust (FLLT). At the time of this writing there is one trail joining the two tracts along the small ridge running parallel to Bear Swamp Creek. Trails into the lower gorge section, where there are two other falls, have yet to be established. The FLLT and DEC are working on this; however, significant erosion has occurred downstream of Carpenter Falls due to heavy off-trail foot traffic. Until trails are established please make no effort to enter the lower gorge. Contact DEC Region 7 or the FLLT (www.fllt.org) for more information.

From the parking area, descend a wide trail to an information kiosk and grab a map. Turn left and follow an orange-blazed trail a short distance to the fall. The falls can be heard in short order after making a winding descent

through hemlocks. There is some stinging nettle around so long pants are in order, even on a hot day. At a Y the falls come into view, and oh what a view! Bear right to descend, following a level line toward exposed ledges, and then switchback down the marked trail.

A unique position is found where the ledges terminate in the hillside on your left. Here you get a great view of the fall's power as it makes a lovely ballistic arc plunge. Once down at creek level, work from the rocks on the right-hand side (the side you're on). With extremely wide lenses you'll be able to get the whole drop including the pool entry. Since everybody shoots portraits of the fall it's important to work on different views and composi-tions. For example, longer lenses allow you to isolate interesting graphic pat-terns such as the horsetail disappearing behind rocks.

Spray will be a big problem during high flow so you'll have to work from farther downstream or from the gorge flanks. Look for a medium-sized rockpile on the creek's far side; cross and work from there. This position will add a three-foot ledge to a composition, allowing the viewer's eye to follow the watercourse through the frame. Continuing downstream along either bank will provide dozens of keepers. About 30 yards downstream the

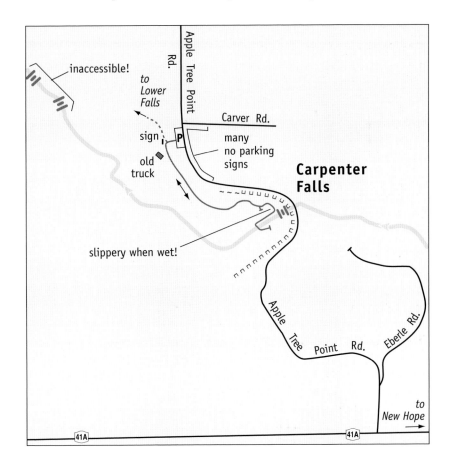

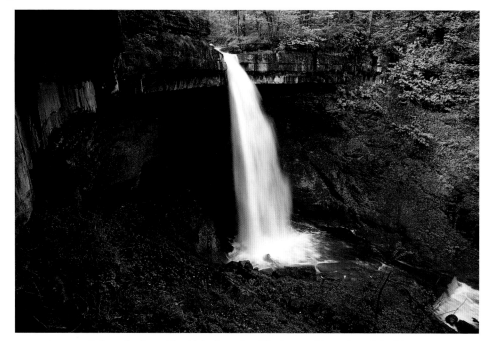

Carpenter Falls. A classic position high along the cliff edge provides a view of the fall's arc and the glen below. *Canon EOS 5D MkII, Tokina 20–35, Polarizer, ISO100 setting, f/8 @ 1/4 sec.*

banks clutter the scene and you're left with no other option but to head back to your car. Take your time, work slowly and deliberately, and you'll have a couple fun hours here.

Hike 77 Bucktail Falls, Onondaga County

Type: Fall	**Height:** 21 feet
Rating: 3	**GPS:** 42° 49.337'N, 76° 14.479'W
Stream: Bucktail Creek	**Distance:** 100 yards
Difficulty: Moderate	**Elevation Change:** None
Time: 5 minutes	**Lenses:** 15mm to 70mm plus macro

Directions: From I-81 exit 13, take NY 281 south a short distance into the village of Preble. Turn right onto Preble Road (CR 108A) and go .5 mile, and then turn right again onto Ostico Valley Road (CR 103) heading north towards Rice Grove and Ostico Lake. In 7.9 miles turn left onto poorly marked Sawmill Road (there might be a brown DEC fishing access sign) to cut across the valley for .5 mile. Where West Valley Road joins from the right, go straight about 50 yards and then turn right onto Moon Hill Road. Park in the two-car-wide spot on the left just after the turn. GPS coordinates: 42° 49.347'N, 76° 14.466'W.

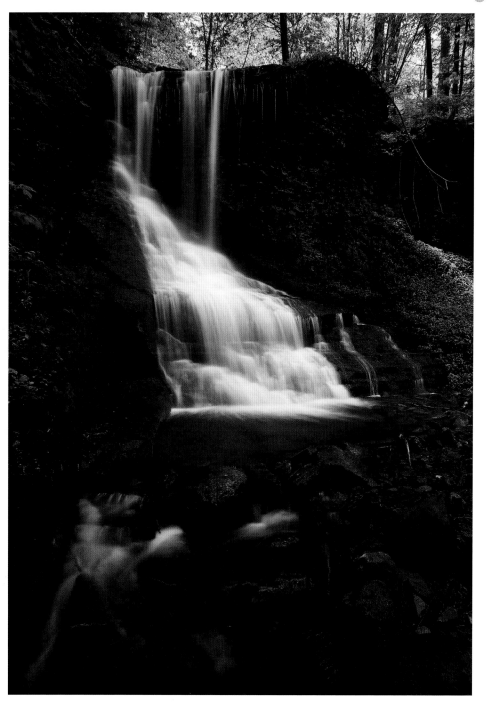

Bucktail Falls. Even when the sun is beginning to peak through clouds, this fall remains in shadow. You can readily shoot under these conditions if you carefully manage background highlights. *Canon EOS 5D MkII, Tokina 20–35, Polarizer, ISO100 setting, f/16 @ 2 sec.*

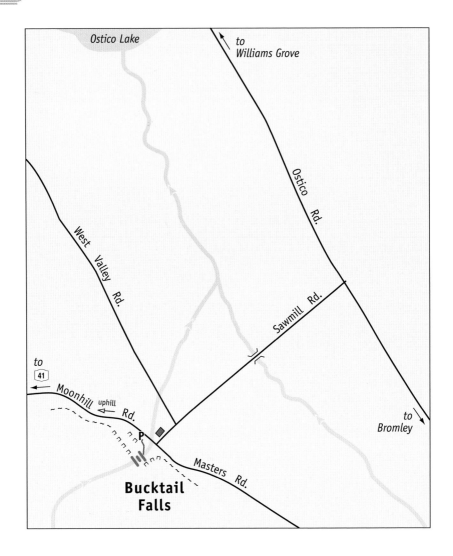

Ostico Lake

to
Williams Grove

Ostico Rd.

West Valley Rd.

Sawmill Rd.

to
41

Moonhill uphill Rd.

to
Bromley

P

Masters Rd.

**Bucktail
Falls**

A 25- to 50-yard walk brings you to this smallish yet nice fall. In summer's heat the weak flow will still be shootable as it comes off the fall's right-hand side and hits a slate nose. This splash gives the water enough motion to render on film. In early spring, just before leaf-out, it's a whole different story as the fall's full width is covered. The ledges comprising the fall and the slate nose below are set 90 degrees to each other so the fall's veil hits obliquely relative to your viewpoint. This change in direction creates some visual interest in an otherwise boring location. A massive rockpile clogs the tailwater—which is where you want to work from. Branches overhang part of the head and finding a comfortable composition is a challenge. Include the lush moss gardens hanging from nearby rocks by using a super wide-angle lens. Also, bring some macro gear to play around with the lichen rings found on the cliffs fronting the parking area.

Hike 78 Fillmore Glen State Park, Cayuga County

The Cow Sheds

Type: Fall	Height: 40+ feet
Rating: 4	GPS: 42° 41.892'N, 76° 24.799'W

Bridge 7

Type: Cascade	Height: 25+ feet
Rating: 4	
Stream: Dry Creek	Distance: 1.0 miles
Difficulty: Moderate	Elevation Change: 260 feet
Time: 45 Minutes	Lenses: 20mm to 100mm

Directions: From the center of Moravia at the intersection of NY 38/38A (Cayuga and Main), take NY 38 (Main Street) south out of town .9 mile to the signed park entrance and turn left. Park near a large white picnic pavilion. GPS coordinates: 42° 41.924'N, 76° 25.009'W.

Perhaps a better name is Footbridge Park, because that's how you know where you are. From the parking area head left around the large picnic pavilion and follow a paved path past the swimming area, which will be on your left (the creek's left-hand side). At the stone footbridge turn right and climb a long stairway to the Gorge and Rim trails. In May the hillside is covered with trilliums so bring macro equipment. Next, bear left away from a picnic grove and pick up the Gorge Trail. After a level section, descend some stairs; this puts you above the Cow Sheds, which you'll get at hike's end.

The path hangs along the creek's left-hand side until you arrive at Bridge 1 at .32 mile. The first four bridges come in rapid succession and the entire section is only photogenic when fall color breaks the glen's monotone green.

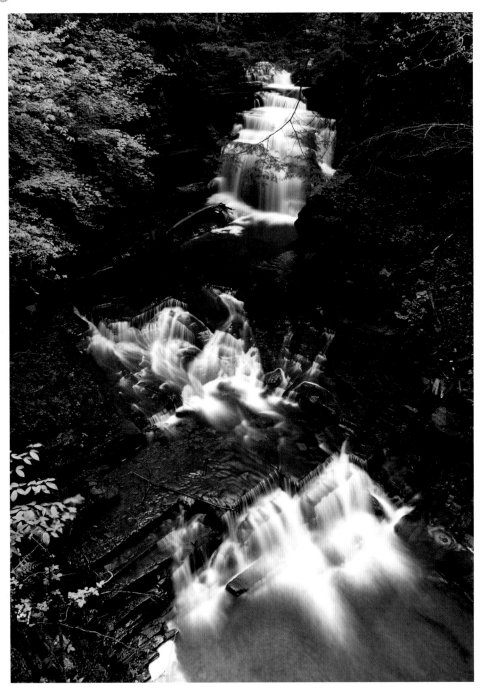

Bridge 7 Falls. Shoot a wide lens with a tripod balanced precariously atop the stone wall. If needed, crop out the wall and brush that will be on the left. The objective is to get the twist to sit comfortably in the frame. *Canon EOS Digital Rebel, Tokina 17, Polarizer, ISO100 setting, f/22 @ 5 sec.*

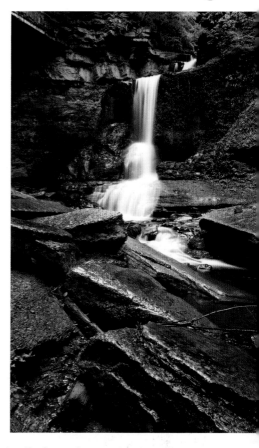

Cow Sheds. The rock slabs in the foreground must be wet in order to get a decent shot. Unfortunately, you can't enter the creek to wet them down. You need rain to do that for you. *Canon EOS Digital Rebel, Tokina 17, Polarizer, ISO100 setting, f/22 @ 2.5 sec.*

Speed walk to Bridge 6. When looking upstream from the bridge you will see some lovely patterns in the creek; shoot long, wide, horizontal, and vertical.

A minor fall is found just before Bridge 7, dropping in from the right-hand side, now opposite you. Upstream of Bridge 7, and now on the right-hand side, descend stairs to a platform overlooking a 25-foot cascade occupying a tight bend. The viewpoint is from a sheer cliff so you need to set up on the wall, along the stairs, or where a temporary wooden repair was made to the stone wall. If you can lean a tripod over the wall, so much the better, since a small, ledge-hugging bush sneaks into the lower left edge of the frame. Veiling the cascade's upper section is a large hemlock. In low flow you won't be able to see the watercourse through the tree.

Sixty yards upstream of this fall, and .5 mile from the car, is a small eight-foot drop that can be shot with a long lens. The shooting ends here so either head back to the car, arriving in one mile, or continue to the upper parking area. Regardless, when you get back to the swimming area, cross the stone bridge and turn right, now on the right-hand bank. In less than a hundred yards the trail dead-ends at the Cow Sheds. Make note of the signage and shoot away. Pale blocks of conglomerate fill the foreground and they will become blown-out highlights unless they are wet. Unfortunately, you can't enter the creek to water them down, so in dry weather you must carefully compose and meter to account for this. When you're done, head back to the car.

Hike 79 **Great Gully, Cayuga County**

Fall 1

Type: Cascade	**Height:** 9 feet
Rating: 3	**GPS:** 42° 48.457'N, 76° 42.062'W

Fall 2

Type: Fall and cascade	**Height:** 13 feet
Rating: 4	**GPS:** 42° 48.459'N, 76° 41.441'W
Stream: Great Gully	**Distance:** 1.3 miles
Difficulty: Moderate, many fords	**Elevation Change:** 50 feet
Time: 45 Minutes	**Lenses:** 20mm to 100mm

Directions: From the center of Auburn at the intersection of US 20 and NY 34/38 (Genesee and South), take NY-34/38 (South Street) south out if town 5.4 miles, passing through the village of Sherlock Corners and into the village of Fleming. In Fleming, bear right onto NY 34B south and go 3.7 miles toward the village of Number One; then turn right onto Great Gully Road (CR 89). In 4 miles you come to a T at NY 90; turn left. In .3 mile turn left onto a dirt lane just after you pass the "Indian Mounds" state historical marker. The parking area is found where a section of guardrail ends. GPS coordinates: 42° 48.485'N, 76° 42.082'W.

From the parking area, follow the dirt lane 260 feet to the creek and its wide, nine-foot-tall cascade. If the cascade's full veil is not covered, head back to the car because the thirteen-foot drop farther up won't be worth the time. If conditions look good put on waders or water shoes because you're going to get wet. The directions that follow are for high flow; in low flow this is a simple creek walk.

Backtrack about 100 feet from the nine-footer and turn right up a dirt lane that leads to the fall's head. In a short distance bear right to descend into the creek; avoid a path on the left going away from the creek. Stick to the extensive rock flats on the right-hand side (the side you're on). If there's enough flow to lick your ankles you can keep to this side and side-hill the bank if needed. Near .14 miles the creek makes an S-curve, going from right to left when looking upstream. Use the right-hand creekbank to avoid a deep flume entrenched in this meander.

Rock slabs are now replaced by large cobbles. Ford to the left-hand side to avoid getting ledged out. In low flow it's no big deal; in high flow the water will be more than calf-deep. Look for a wide footpath that hugs some more ledges and avoids a large blowdown. At .28 mile you come to a three-foot ledge in a long, sweeping bend. The footpath holds close to the left-hand bank as you follow this bend.

Shortly beyond, at .35 mile, you become ledged out and are forced to ford to the right-hand side. Advance upstream along a wide bank. Again you get

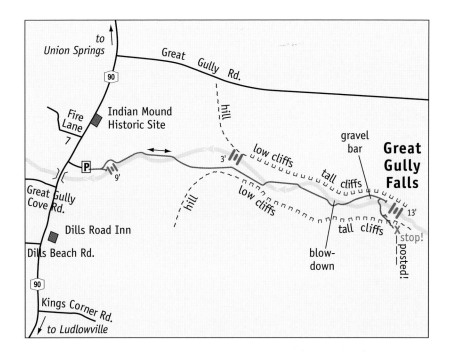

ledged out and have to dodge back to the left-hand side. It's a good idea to look up about now and note that the creek-side ledges are getting quickly higher so your fording options will dwindle.

The next obstacle is found at .48 mile: a massive hemlock blowdown lodged in the creek just where you get ledged out and want to get back to the right-hand side. With limited options the best course is to ford and fight through heavy tree cover along a cobble bar on the right-hand side. Suddenly a wide footpath appears as the next fall becomes audible. Reenter the creek about 40 yards below the fall and ford to a large cobble island. This is your spot.

The best all-around shot is from the cobbles or the left-hand side. Tight compositions from the left-hand bank are also quite nice, although two pale trees above will stand out against a dark background. The plunge pool is created by two straight-line rock dams. These unnatural shapes will render uncomfortably on film so some extensive gardening will be needed to create a more natural look. The fall portion is deeply undercut, and with a little work you can get behind the water veil to shoot through it. This is a truly unique view and the principal reason why I've included this small fall.

Above this fall is a combination of private and Nature Conservancy lands. There are no more falls and land postings are many and quite clear. Turn around and head back to the car, and try to stay dry.

Hike 80 **Ludlowville Falls, Tompkins County**

Type: Fall	**Height:** 36 feet
Rating: 4	**GPS:** 42° 33.278'N, 76° 32.373'W
Stream: Salmon Creek	**Distance:** ~200 yards
Difficulty: Easy	**Elevation Change:** 50 feet
Time: 15 minutes	**Lenses:** 20mm to 100mm

Directions: From Ithaca, take NY 13 north and exit onto NY 34 at Cayuga Heights (East Shore Drive). Take NY 34 north along the lake 5.8 miles to a T with NY 34B in the village of South Lansing. Turn left onto NY 34B (Ridge Road) and drive 2.7 miles, passing Lansing High School on the right and crossing Salmon Creek. Just after Pine Grove Cemetery turn right onto Ludlowville Road. In .4 mile turn left into Ludlowville Park. GPS coordinates: 42° 33.210'N, 76° 32.240'W.

This grassy town park makes for some quick work. Head for the fence at the park's far end and pick a position that gives the best view of the fall's wide expanse. This true fall is undercut on the right-hand side (the side you're on), creating a large cave. Most of the flow is over the more cascade-like far edge. In high flow the full width will be covered; however, foreground brush is an issue. If you can bring a step stool or ladder you'll have enough height to avoid the brush and branches that overhang the creek on your left. The trees beyond the fall are in good shape, making this a nice fall

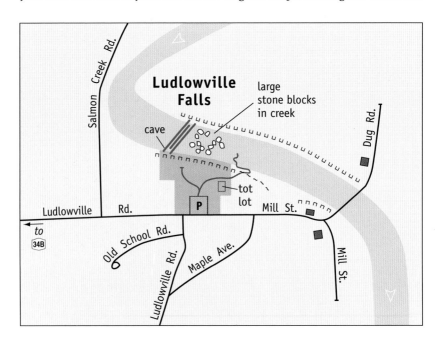

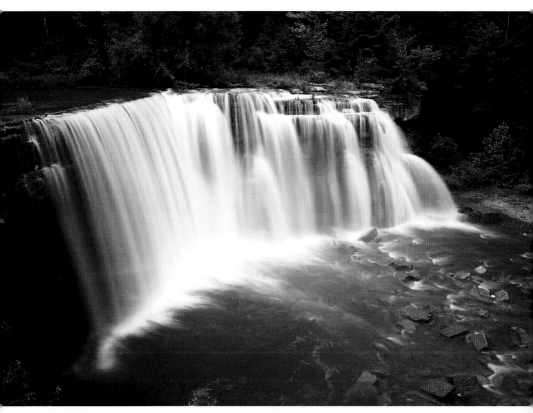

Ludlowville Falls. Keeping brush out of the foreground is difficult from behind the fence. I used a picnic table to gain elevation and then fiddled with tripod placement inches at a time until I had what I wanted. *Canon EOS 5D MkII, Tokina 20–35, Polarizer, ISO100 setting, f/22 @ 1 sec.*

foliage location. The creek below has pale-colored cobbles so wet weather is a must to manage highlights.

There is fishing access to the creek that can be used to approach the fall. Locate the downstream end of the fence guarding the cliff. It will be near the small-tot lot. A wide footpath leads down to the creek about 60 yards downstream from the drop. When Salmon Creek runs full, spray will be carried well downstream, especially if there's any kind of westerly breeze. I tried to work from the creek but was driven out by voluminous spray. You can rock hop to mid-creek or use waders. There are several deep holes on the creek's left-hand side (opposite the park) which will swallow even the tallest photographer, so take care.

Hike 81 Ithaca Falls, Tompkins County

Type: Cascade	**Height:** 100 feet
Rating: 5+	**GPS:** 42° 27.171'N, 76° 29.496'W
Stream: Fall Creek	**Distance:** 300 yards
Difficulty: Easy	**Elevation Change:** 30 feet
Time: 20 minutes	**Lenses:** 20mm to 100mm

Directions: One-way streets, dead ends, and some confusing intersections near Cascadilla Creek make getting to the parking area a little frustrating. The easiest route when approaching from the south on NY 13 is to turn right onto Hancock Street just before NY 13 north and south join. Follow Hancock for six blocks, crossing Lake and Willow avenues. Hancock will bear right to become East Tompkins Street. In three blocks turn left onto North Tioga Street and in five blocks turn right at a T onto Lincoln Street. (You might have a map showing Lincoln, Falls, and York streets connecting with NY 13—they don't.) When you T into Lake Street, turn left and then make an immediate right into one of two parking areas. GPS coordinates: 42° 27.166'N, 76° 29.670'W.

From the north, follow NY 13 south and exit at Cayuga Heights. Turn quickly left onto North Cayuga Heights Road. In .8 mile, with NY 13 close on your right, turn left onto East Shore Drive, which will turn into Lake Street. Follow Lake Street for .7 mile; as soon as you cross Fall Creek, make an immediate left into the parking area. GPS coordinates are same as above.

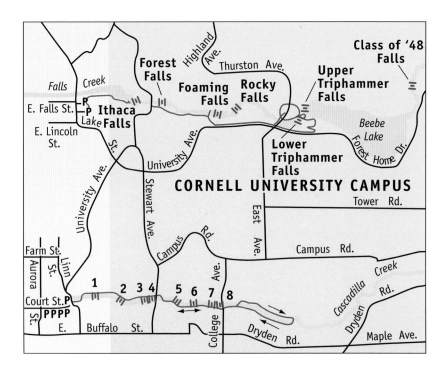

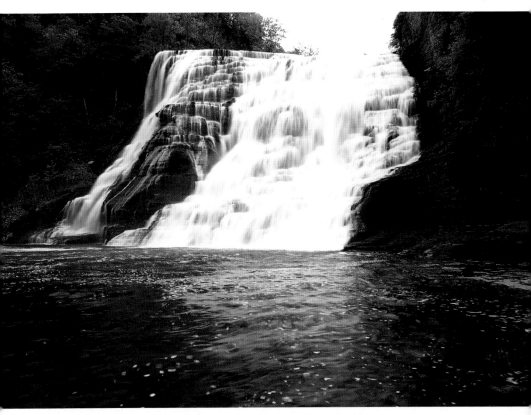

Ithaca Falls. I caught Ithaca Falls on a day when it was raging. The problem this created was all the foregrounds I had scouted were under water, so I had to content myself with a classic portrait. *Canon EOS Digital Rebel, Tokina 20–35, Polarizer, ISO100 setting, f/16 @ ¹/5 sec.*

This big fall is a simple walk to a large shooting area. From the parking areas, head for the creek and turn right (upstream), following wide ledges to the fall. You'll be on the creek's left-hand side. A gravel bar protrudes into the fast-moving water and with waders you can get well into the creek. Ledges at water level provide nice leading lines, so work them as well. Overcast skies will render blank white, so try days with puffy white clouds waiting for the falls to be in shadow. Patience will be an enormous virtue since this popular location will be mobbed most days. A nice alternate shooting location is the Lake Street Bridge. If you're visiting for several days in spring, don't forget to check graduation dates for Cornell University and Ithaca College, which will consume every hotel room for miles.

Hike 82 Ithaca Gorge, Cornell Campus, Tompkins County

Forest

Type: Cascade	Height: ~25 feet
Rating: 5+	GPS: 42° 27.147'N, 76° 29.382'W

Foaming

Type: Cascade	Height: 20 feet
Rating: 4	GPS: 42° 27.118'N, 76° 29.144'W

Rocky

Type: Cascade	Height: ~30 feet
Rating: 4	GPS: 42° 27.126'N, 76° 29.061'W

Triphammer (Lower)

Type: Cascade	Height: ~35 feet
Rating: 3	GPS: 42° 27.110'N, 76° 28.790'W
Stream: Fall Creek	Distance: 1.5 miles
Difficulty: Easy	Elevation Change: ~300 feet
Time: 1 hour	Lenses: 20mm to 100mm

Directions: Before you begin you'll need a good map of Ithaca, or better yet, a Cornell University campus map. You can download one as a PDF from www.cornell.edu/maps; use the "Large Searchable Map" link. There is always some kind of construction and road closings on campus that will hinder navigation. Find your way to the metered parking lot next to Alumni House, located on the north side of the Thurston Avenue Bridge near Cradit Farm Drive (see campus map, zone D-3). GPS coordinates: 42° 27.114'N, 76° 28.854'W.

This book does not include how to access Ithaca Gorge in high spring flow. With a watershed of 132 square miles, Fall Creek runs furiously in spring, which makes a creek hike a rather dubious affair. All the falls have deep plunge pools; as recently as June 12, 2008, an eighteen-year-old student was pulled under the base of Foaming Falls *from the downstream side.* There is one well-defined route into the gorge that gives you a view of Foaming Falls; however, after speaking with the *Ithaca Journal* and the fire department about some twenty incidents over the past ten years I felt that the risks are simply too great. I've been into the gorge myself during heavy rain and was unwilling to make the venture upstream, so what follows is a thoroughly delightful loop of the gorge rim.

From Alumni House follow a path east to the Triphammer Foot Bridge. The bridge crosses Fall Creek downstream of a tight bend that hides lower

Triphammer Falls, and brings you to the gorge's south side. The upper fall is now part of a large dam containing Bebe Lake; the lower fall is right under you and difficult to see. If you turn left (east or upstream) and walk behind the Hydraulics Lab you'll get broken views of what is now a sliver of water created by the dam's spillway.

Walk around the Hydraulics Lab, away from the gorge, and turn right onto Forest Home Drive. Pass the Thurston Avenue Bridge to follow University Avenue. Pass the Foundry on the right and then Sibley and Olive Tjaden halls on the left. When you get to Central Avenue, turn right onto a path taking you to the Suspension Bridge. You're now in campus map zone B-3. From the Suspension Bridge you get a bird's-eye view of Foaming Falls and a partial view of Rocky Falls. You can shoot from here but the bridge does sway in the wind and from foot traffic.

Turn around and head back toward University Avenue. Now turn right onto a footpath that parallels both the gorge edge (heading west) and University Avenue. When you get to Stewart Avenue turn right onto the bridge and walk to the far end (the gorge's north side) for a view of Forest Falls at .75 mile (now in map zone A-3). This is the most photogenic of the four campus falls. On the way to Stewart Avenue you passed a side trail that drops right into the gorge below the Suspension Bridge. Bypass this trail.

You can create a loop hike using Fall Creek Drive; however, there's no sidewalk and traffic moves briskly. Instead, reverse your route and turn left to cross the Thurston Avenue Bridge. Here you get the best view of Triphammer Falls' lower drop, much better than the view from the upper section at the dam. A gravel bar in Fall Creek has a large tree in its middle that veils the fall when viewed from the bridge's midpoint to the far end. Tilting up might work but frame-edge sneakers are a problem. From the bridge's south end you can use a tight composition to eliminate the footbridge above. If you include the old millworks on the right be sure to include a lot of it. If you leave a little brickwork in frame, or maybe a window edge, it will ruin the image. In this case, more of the mill works better than less in satisfying our brain's curiosity about incomplete frame-edge shapes. This attention to detail is important, especially if you plan to sell your images.

Now continue across the bridge and turn right into the Alumni House parking lot and return to your car. Another fall, Class of '48 Falls, is east of here and can be accessed from the metered parking at Apple Commons (campus map zone E-2). Just follow a wide footpath from the Fuertes Observatory east a short distance.

Hike 83 **Cascadilla Gorge, Tompkins County**

Fall 1

Type: Cascade	**Height:** 40 feet
Rating: 3	**GPS:** 42° 26.585'N, 76° 29.594'W

Fall 2

Type: Slide over Cascade	**Height:** 80 feet
Rating: 5	**GPS:** 42° 26.585'N, 76° 29.594'W

Fall 3

Type: Cascade over chute	**Height:** 8 feet
Rating: 2	**GPS:** 42° 26.588'N, 76° 29.474'W

Cascadilla Fall

Type: Cascade	**Height:** 26 feet
Rating: 4	**GPS:** 42° 26.562'N, 76° 29.544'W

Fall 5

Type: Cascade	**Height:** 45 feet
Rating: 4	**GPS:** 42° 26.581'N, 76° 29.314'W

Fall 6

Type: Slides	**Height:** 25 feet
Rating: 4	**GPS:** 42° 26.589'N, 76° 29.270'W

Fall 7

Type: Fall over cascade	**Height:** 45 feet
Rating: 4	**GPS:** 42° 26.588'N, 76° 29.225'W

Giant's Staircase

Type: Cascade	**Height:** 50 feet
Rating: 5	**GPS:** 42° 26.577'N, 76° 29.167'W
Stream: Cascadilla Creek	**Distance:** 2.2 miles
Difficulty: Moderate, many stairs	**Elevation Change:** 450 feet
Time: 1 hour, 15 minutes	**Lenses:** 20mm to 100mm

Directions: Please be aware that parking is at a premium for this walk. Before you begin you'll need a good map of Ithaca (Refer to Ithaca Gorge, Hike 82). From either north or south, take NY 13 to West Buffalo Street and head east (into town). In seven blocks turn left onto North Tioga Street and then right onto East Court Street. Start looking for parking as soon as you make the turn. There is metered parking on both sides and just three spots on Linn Street that front the gorge. There is no parking anywhere else on narrow Linn Street or nearby Terrace Place. If you're forced to troll for a spot, make a loop consisting of East Court, Linn, Farm, and North Tioga until you locate a spot. GPS coordinates: 42° 26.560'N, 76° 29.701'W.

I love this hike. If you're out early the gorge will be in shadow for a couple hours, making for splendid shooting. All eight falls are more than worthy of at least a half-day's effort. Furthermore, as you exit the falls section at College Avenue there's a wonderful little bagel shop on the corner of College and Oak. A pleasant walk, waterfalls, and breakfast—what's not to love?

Begin your walk by entering the city park from the entrance on Linn Street and head across the first footbridge you find. This places you on the creek's right-hand side. At .13 mile you arrive at Fall 1, a 40-foot cascade. Look for some stairs down that first place you on ledges facing the fall before returning to the main path. As you climb stairs that follow a tight S-curve, the base of Fall 2 comes into view. In low flow you can carefully enter the broad, flat creek to shoot this long, sliding cascade. In high flow stick to the trail since this steep creek runs with great power. If you see any whimsical cairns lining the creekbed, incorporate them into the scene. As you make the head of Fall 2, a small drop 100 yards upstream comes into view followed by Fall 3, a short chute-and-slide combination.

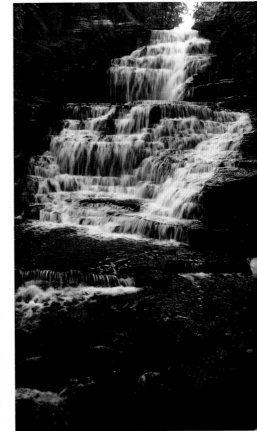

Cascadilla Falls, the fourth drop, sits below the Stewart Avenue Bridge at .53 mile. This delightful cascade comes with some issues, however. The retaining wall on the fall's left-hand side has been rebuilt using pale concrete block. The quality of the work is nowhere near that of the CCC masons who did the original work more than 70 years ago. It looks just plain bad. You'll need to work from the right-hand side or center creek, shooting tight verticals, to crop this masonry out of frame. Don't forget to mind stream flows when fording this slick-bottomed section.

Crossing a footbridge above brings you to the creek's left-hand side and Fall 5, which is tucked into a tight creekbend. Fall 5 is a long staircase, broad and flat below, so you can shoot from the creek. Take care with your footing though. A

Giant's Staircase. If had any clue I wouldn't be able to get back here for more than two years I would never have hand-held anything in Cascadilla Gorge. But I was just scouting and waiting for better weather. Always come prepared. *Canon EOS Digital Rebel, Tokina 20–35, Polarizer, ISO400 setting, f/4 @ 1/4 sec.*

ledge below that's prominent in low water looks less intimidating in higher flow. This ledge heads a flume leading to Fall 4. As always, slips in this kind of terrain can be quite costly.

As you climb above Fall 5, numbers six and seven come into view. Fall 6 is an okay 25-foot slide with a very deep plunge pool. If you intend to shoot this one you'll need to work from the rocks well below the fall. Fall 7 is a really nice fall-over-cascade combination.

The last drop in the gorge is the main event: Giant's Staircase, a gorgeous 50-foot cascade that some combine with Fall 7 for measurement purposes. The best position is on the right-hand side at a rockfall that requires a ford. Above is the dramatic stone arch of College Avenue. You can spend more than an hour working these last two plunges and still feel like you've not shot it well.

So ends your falls sojourn. You're only .84 mile from Linn Street. You can either turn around or explore the gorge's upper section; might as well push on. Climb the stairs away from Giant's Staircase and find yourself behind the Schwartz Center (Cornell campus map zone B-7). Cross College Avenue and walk towards a large concrete sitting circle; then turn left and head for the Trolley Footbridge, which crosses Cascadilla Gorge parallel to College Avenue. From the bridge you get a look at how the gorge edges overhang the wider floor by quite a bit. Fencing keeps you well away from the edge. Despite this, several students have fallen into the gorge with catastrophic consequences. Once across, now at .9 mile, turn right up a tree-lined path running along the gorge edge. At the next footbridge, at 1.1 miles, turn right and then right again to start the return route, now on the gorge's left-hand or south side. Return to the concrete sitting circle at 1.35 miles; the bagel shop is across Oak Street. Cross College Avenue, descend the Giant's Staircase, and return to Linn Street, arriving at 2.2 miles.

Hike 84 Sweedler Preserve, Tompkins County

Fall 1

Type: Cascade	**Height:** 70 feet
Rating: 3	**GPS:** 42° 23.995'N, 76° 32.330'W

Fall 2

Type: Cascade	**Height:** 60 feet
Rating: 3	**GPS:** 42° 23.995'N, 76° 32.296'W
Stream: Lick Brook	**Difficulty:** Easy (falls-only hike)
Difficulty: Moderate (full loop hike)	**Time:** 40 minutes
Time: 1 hour, 30 minutes	**Distance:** 1.2 miles
Distance: 2.7 miles	**Elevation Change:** 600 feet
Elevation change: 430 feet	**Lenses:** 17mm to 700mm

Directions: From the entrance of Buttermilk Falls State Park south of Ithaca, take NY 13 south 1.9 miles. You will approach a wide bridge and signage near a major road divide for NY 13 south to Elmira and NY 34/96 west to Spencer. Slow down at a yellow-painted traffic island and look for a dirt lane to the left just after the bridge's south end. It's a disconcerting left turn since you feel like you're going the wrong way into oncoming traffic. If you miss the turn, follow NY 34/96 west a couple hundred yards; as you pass under NY 13, make a U-turn onto NY 34/96 east. As the bridge comes into view turn right into the parking area. GPS coordinates: 42° 23.896'N, 76° 32.754'W.

If time is not an issue I recommend the full loop hike. If you don't have much time then the in-out route will more than satisfy. From the parking area, follow the white-blazed Finger Lakes Trail; it begins as a dirt lane heading away from the highway. Within a few yards it turns right onto a bootpath through high brush and then left to hug a tree line adjacent to a field. Enter the woods at .15 mile. When you get to a rail trestle the FLT crosses the tracks to ford the very deep creek below. Turn left to cross the trestle, taking every precaution to make sure trains are not coming down the long, straight track.

Continue with the FLT and pass under power lines at .25 mile. Cross the weakly flowing Lick Brook at .4 mile and turn right to follow the trail. Tucked into trees on the right is a brass plaque marking the Howard Edward Babcock Preserve, given to Cornell University in 1997. The preserve, adjacent to the Finger Lakes Land Trust's Sweedler Preserve, provides some additional hiking. For more information on either park, seek out the FLLT at www.fllt.org or Cornell Plantations at www.plantations.cornell.edu.

At .5 mile you arrive at a cliff containing a broad but rather flat 70-foot cascade. Lick Brook, with its small drainage basin, runs weakly much of the

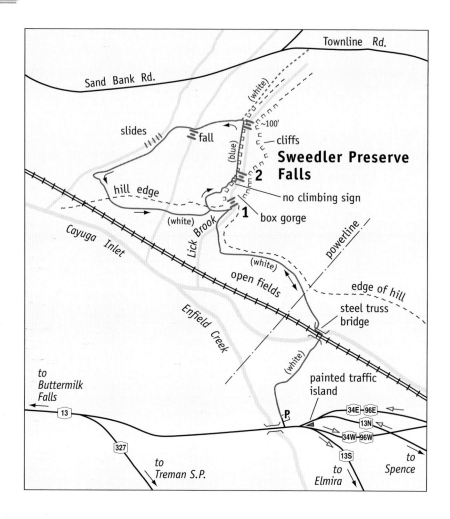

time but spring snowmelt and rain is a different story. There is no plunge pool to speak of; rather, a set of ledges and cobbles provide a large working area. You'll need wide lenses here since the best foregrounds are relatively close to the drop. Situated just above but out of view is the next fall. Head away from the creek on the white-blazed FLT and in about 50 yards come to a T. The FLT continues ahead and a blue blaze climbs right, steeply ascending a hill. All around you are delightful wildflowers and lush ground cover, so take the time to shoot the forest floor.

Turn right onto the blue-blazed trail, which is steep enough to make keeping your boot heels down a challenge. Around .6 mile the pitch slackens where the trail turns left. A broad area is found on the right at an obvious drop-off. Head for the ledge and set up on a small promontory overhanging the second falls. Looking down into the gorge provides you with an interesting view of a 60-foot cascade. Be sure of your footing and tripod position: it's a long way down.

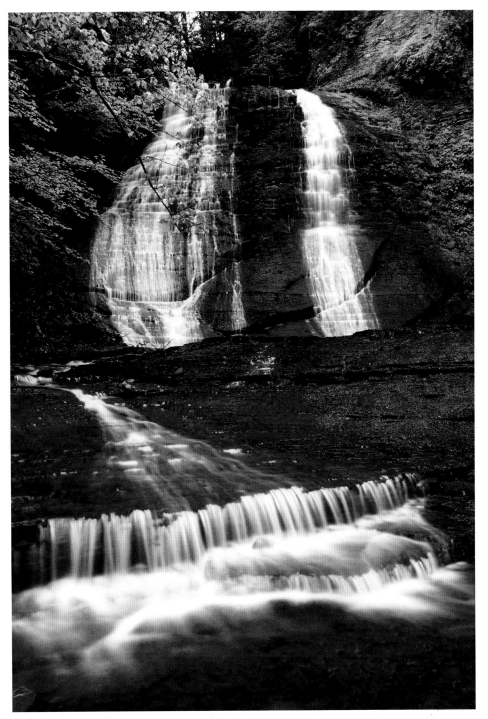

Fall 1. Little riffles can be used to make big foregrounds if you get close and mash a wide lens inches from the feature. Just stoop down all the way to maintain depth of field. *Canon EOS Digital Rebel, Tokina 17, Polarizer, ISO100 setting, f/22 @ 5 sec.*

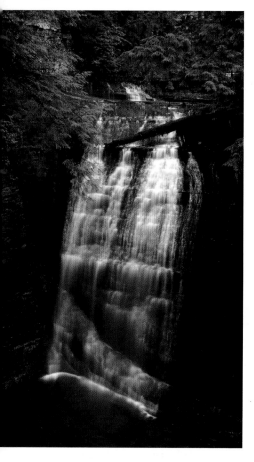

Fall 2. Hanging from a small perch high above can be a bit unnerving. If you're not comfortable around heights, find another spot or skip this shot. *Canon EOS Digital Rebel, Tokina 20–35, Polarizer, ISO100 setting, f/22 @ 25 sec.*

You can return to your car or continue with the loop. To hike the loop, continue uphill and arrive at the head of a really big drop at .81 mile. There's a nice leaves-off view in early spring. Where the blue blaze finally tops out at this fall's head the white-blazed FLT joins from the left. Turn left. The FLT loops left and down to align with a small rocky brook on your right. At .9 mile you cross this narrow brook at a five-foot drop, followed by a left turn heading downhill. Traveling through nice open woodland while moving downhill, the trail passes an interesting slide at 1.3 miles (42° 24.072'N, 76° 32.159'W). This is the weakly running Spring Brook, which spends much of the year as a dry ditch. This long slide doesn't merit inclusion on its own; however, as part of longer hike it is worth a gander. The dark rock is resplendent with green moss, and when there's any whitewater the slide will make simple yet interesting images. The best spot is halfway down where two hemlocks overhang.

Continue downhill and soon you find yourself on a ridge spine not much wider than the trail itself. Spring Brook has been on the right the whole way down. At 1.5 miles make a hard left away from the brook where a large cairn can be seen in the woods nearby. You've now returned to the marvelous green-carpeted valley floor you saw earlier. The FLT is a brown line winding its way through this emerald world. At 1.74 miles you complete the loop section at Fall 1's base. Head back to the car, arriving at 2.7 miles.

Hike 85 Buttermilk Falls State Park, Tompkins County

Buttermilk

Type: Slide	**Height:** 100+ feet
Rating: 4	**GPS:** 42° 24.952'N, 76° 31.208'W

Fall 2

Type: Fall	**Height:** 15 feet
Rating: 3	

Fall 3

Type: Fall	**Height:** 20 feet
Rating: 3	

Fall 4

Type: Fall over fall	**Height:** 30 feet
Rating: 5	

Fall 5

Type: Cascade	**Height:** 10 feet
Rating: 3	
Stream: Buttermilk Creek	**Distance:** 1.1 miles
Difficulty: Moderate, many stairs	**Elevation Change:** 394 feet
Time: 1 hour	**Lenses:** 20mm to 100mm

Directions: The park is located on NY 13 just south of downtown Ithaca and a series of strip malls, or just north of the NY 13/13A split near the Norfolk Southern railroad grade crossing. A small sign marks the entrance at Park Road; a blue pedestrian bridge is nearby. GPS coordinates: 42° 24.996'N, 76° 31.248'W. There is a $9 fee.

Bring a calm heart on this one—you'll shoot every few steps once you get into the glen. Note that I only have a GPS coordinate for the big fall near the parking area. That's because I had a heck of a time keeping a satellite lock in narrow sections of the glen. I've also been liberal with the time because you don't speed walk this park—you stroll and absorb it.

Leave the parking area and head for the large swimming area. Estimates put Buttermilk's total height in the 180- to 200-foot range; however, you can only get a clear shot of the lower section, which is at most 80 feet high. Look for a small concrete step near the swimming pool and set up on that. You can shoot from a number of spots around the pool but this platform gives a little added height. You won't be able to shoot the fall when people are swimming, so get here early. It's best to visit before Memorial Day, at which time pool boundary ropes and floats are installed.

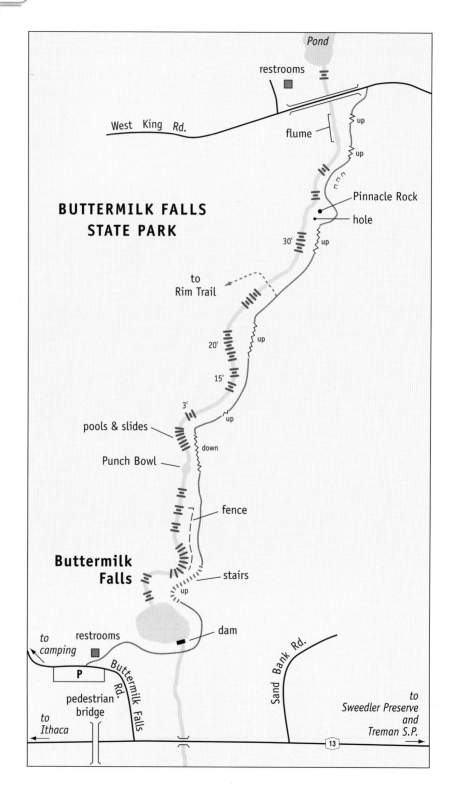

Pond

restrooms

West King Rd.

flume

up

up

**BUTTERMILK FALLS
STATE PARK**

Pinnacle Rock

hole

30' up

to
Rim Trail

20' up

15'

3'

pools & slides

up

Punch Bowl

down

fence

**Buttermilk
Falls**

stairs

up

dam

to
camping

restrooms

P

Buttermilk Falls Rd.

pedestrian
bridge

to
Ithaca

Sand Bank Rd.

to
Sweedler Preserve
and
Treman S.P.

13

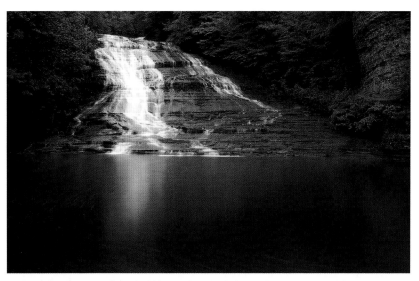

Buttermilk Falls. Using foam bubbles and a time lapse technique I created foreground out featureless green water. You won't be able to do this if anybody's swimming. *Canon EOS Digital Rebel, Tokina 20–25, Polarizer, ISO100 setting, f/16 @ 15 sec.*

Head across the footbridge at the swimming area's end and turn left (upstream) on the paved Gorge Trail. If you pause often you can shoot graphic patterns in the slide as you ascend its twisting path. Whereas only two drops were visible from below, you can now see Buttermilk is actually four distinct drops, hence the discrepancy in estimated height. When the long flight of stairs turns hard right you come to the uppermost section. A sign marking the turn warns you to keep out of the vegetated area, which is a shame since the upper section is quite picturesque.

The creek then exits a narrow glen dropping over a nice cascade. The trail now has a fence on the left keeping you from the deeply incised glen, which offers leaves-off views of a lovely series of drops totaling about forty feet. At the top of the next staircase you're upstream of this series of slides and tubs. A few yards after and still with the fence, a sequence of two falls totaling fifteen feet comes into view; this is Fall 2. When the fence finally ends you are near creek level.

Atop another flight of stairs, Fall 3, a twenty-foot sequence of three drops, comes into view. A wide stone outcrop provides a shooting spot. You will also find a memorial plaque to William J. Chapman, who died in March 1986 while trying to rescue someone. No matter how benign the groomed parklands of New York look, they always have the potential to bite. From this point to the bridge that connects the banks there are no falls; however, when the creek makes a hard left you're presented with the best image the park has to offer, Fall 4. Consisting of two distinct drops, there's a lot to work with if you slowly climb the adjacent stairs. Below the upper drop is a deep hole and above is Pinnacle Rock, a freestanding pillar.

At Pinnacle Rock's base is a deep pothole marking the entrance to another glen. This glen is similar to the one at the earlier fence line except you walk *through* the magic, not above. Just above Pinnacle Rock is the last plunge, Fall 5, a ten-foot cascade. The flow is split into a fan with the right-hand (far) side taking most of the flow. Above are more stairs and a left turn that brings you to a delightful flume. You can turn around here or wander a little ways to a bridge at West King Road. Another option is return via the Rim Trail; either will get you to the same parking lot. I think the best bet is to head back down the gorge.

Hike 86 Treman State Park, Tompkins County

Fall 1	
Type: Cascade	**Height:** 22 feet
Rating: 3	**GPS:** 42° 23.845'N, 76° 33.670'W
Fall 2	
Type: Cascade	**Height:** 16 feet
Rating: 3	**GPS:** 42° 24.060'N, 76° 35.105'W
Lucifer Falls	
Type: Cascade	**Height:** 115 feet
Rating: 5	**GPS:** 42° 24.038'N, 76° 35.047'W
Fall 3	
Type: Cascade	**Height:** 12 feet
Rating: 3	**GPS:** 42° 24.114'N, 76° 35.403'W
Stream: Enfield Creek	**Difficulty (hike to Lucifer overlook):** Easy
Difficulty (hike to Lucifer's base): Moderate, many stairs	**Time:** 45 minutes
Time: 45 minutes	**Distance:** 1.0 miles
Distance: 1.1 miles	**Elevation Change:** 120 feet
Elevation Change: 180-foot descent	**Lenses:** 20mm to 100mm

Directions: To the lower parking area and Fall 1: from the combined NY 13, 34, and 96 about 3.7 miles south of central Ithaca, take NY 327 (Enfield Falls Road) south .1 mile and make the first left into Robert H. Treman State Park. Pay the $9 fee and follow the winding entrance road to a large parking lot fronting a picnic area. GPS coordinates: 42° 23.882'N, 76° 33.405'W.

To the upper parking area and the other falls: take NY-327 (Enfield Falls Road) south past the park's main entrance. NY 327 climbs steeply. In 2.5 miles, make a looping left into a signed entrance at Park Road. Follow Park Road to its end at a large parking lot near an old white mill. GPS coordinates: 42° 24.154'N, 76° 35.333'W.

It's a level half-mile round trip to Fall 1, which is located at the end of the gated, paved road that departs the parking area and passes through the picnic grove. This wonderful fall heads a large swimming pool, making photography a challenge. If you want decent shots you have to get here before the adjacent diving board is installed. A small dam downstream is used to fill the pool area; when the pool is open, the bed is covered with gray gravel to provide a flat bottom for swimmers. This gravel is the same material used in road paving and looks entirely unnatural on film. If the dam is open, go as far as you can across the gravel to shoot the fall's broad face without any foreground rock. If the dam is closed and the pool filled, cross the dam's footbridge and shoot from the rock ledges on the far side.

You're more than welcome to wander up the glen on the Gorge Trail, although there's nothing to shoot until you get close to Lucifer Falls at the upper end. Instead, move your car to the upper lot. Fall 3 is located behind the mill. It's a nice drop and can be conveniently shot from a wall that provides enough height to put you at the same elevation as the fall.

You have two spots from which to shoot Lucifer Falls: one from the stairs along the fall's left flank or from an overlook (more like an aerie) hovering well above the fall. I prefer the overlook, but if you've got a couple hours, shoot both. To get to Lucifer's base, follow a paved path called the Glen Trail. Upon entering the glen at .11 mile you arrive in an oddly angular world. The creek makes right-angle turns, flowing along slip planes rather

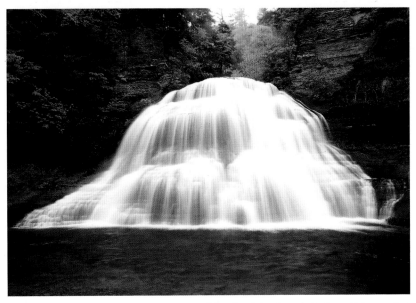

Fall 1. Just out of frame right is the stone wall for the diving board platform. This was shot in May before the pool area was filled. After Memorial Day you'll need to work from a small catwalk out of view on the left near the dam. *Canon EOS Digital Rebel, Tokina 17, Polarizer, ISO100 setting, f/16 @ .8 sec.*

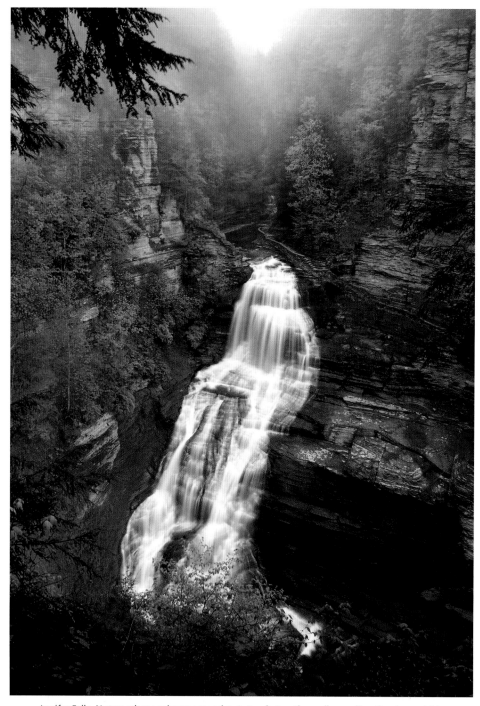

Lucifer Falls. Not another soul was around as I stood atop the wall guarding the view, which is unfortunate. You can imagine the sense of scale that could be added by having someone in red standing along the walkway. *Canon EOS Digital Rebel, Tokina 17, Polarizer, ISO100 setting, f/16 @ 1.6 sec.*

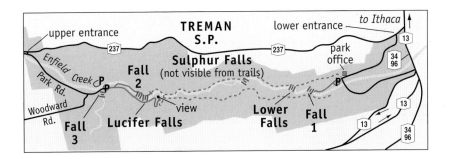

than making smooth curves. This makes the upper glen look like it's been drawn on graph paper.

Around .35 mile you arrive above the 16-foot drop heading Lucifer Falls. Dry rock on the far side will be a highlight issue, even in damp conditions, so work tight compositions from the trail and stairs descending the fall's left-hand side. There are some nice patterns in the rock so shoot some long lenses and explore graphic compositions.

You get a good look at Lucifer from the long twisting staircase. The problem is that the flow is along the far wall, so even in high flow there are yards of exposed rock. You have to go all the way to the bottom where the path curves right to front it. Once there you'll need a super wide lens to get the entire drop, or a good "stitch utility" to merge images. I tried merging images and couldn't get anything I liked, which is why the overlook is a better bet. Make the long climb up and head back to the car for a snack.

Follow the South Rim Trail to get to the overlook. The overlook is only about fifty feet higher than the parking lot; unfortunately, you have to go over a ridge to get there. From the parking area, ascend the steep trail and bypass the first viewpoint you find. Continue along the meandering path and drop into the overlook at .5 mile. Normally the foreground is well-groomed so there shouldn't be any need to stand atop the wall. I wouldn't recommend that anyway since there's 250 feet of air under you. Spray from the fall isn't a problem; however, on cool mornings, fog being pushed up the glen is a problem. You're quite a distance away from the fall so even light fog or rain can blur an image. For this shoot you need wet and overcast, but not rainy, conditions. When you're done head back to your car.

On a crisp May morning after two days of torrential rains I returned to this point to get my final set of shots. The fall's full face was a maelstrom of whitewater, and unlike other trips here the sound at the overlook was loud enough to drown out the chattering finches and towhees that greeted me with a flurry of calls. Wisps of fog moved up Enfield Glen and hit the face of Lucifer Falls like soft ocean waves crashing on a cliff. With the rising sun shooting light beams up the glen the effect was one of pure magic. Unfortunately the scene didn't render on camera with the same beauty seen by my eye. A sunrise like this, when you have such a glorious location to yourself, is why we venture gladly into the woods.

Hike 87 Taughannock Falls State Park, Tompkins County

Taughannock Falls

Type: Fall	**Height:** 215 feet
Rating: 5+	**GPS:** 42° 32.138'N, 76° 36.647'W
Stream: Taughannock Creek	**Lenses:** 35mm to 100mm
Difficulty: Easy	**Distance:** 2 miles
Time: 1 hour	**Elevation Change:** 80 feet

Upper Falls

Type: Cascade	**GPS:** 42° 31.942'N, 76° 36.955'W
Rating: 2–3	**Distance:** 100 yards
Difficulty: Easy	**Elevation Change:** 20 feet
Time: 15 minutes	**Lenses:** 35mm to 100mm
Height: ~80 feet	

Directions: Taughannock Falls State Park is on NY 89, 9.2 miles north of the intersection of NY 89 and NY 79 (West State Street) in Ithaca. There is parking on both sides of the highway, the best option being the lakeside lot. GPS coordinates: 42° 32.725'N, 76° 35.897'W.

The Falls Overlook viewing area is found by turning right out of the lakeside parking area (so the lake is on your right) and making a series of quick lefts, following signs onto Taughannock Park Road. The upper viewing area lot will be on the left, .8 mile after leaving NY 89. GPS coordinates: 42° 32.282'N, 76° 36.593'W.

To get to the upper falls, take Taughannock Park Road 1.3 miles from NY 89 and turn left onto Falls Road-Jacksonville Road. Cross Taughannock Creek and make an immediate left into a gravel parking lot. GPS coordinates: 42° 31.923'N, 76° 36.969'W.

Taughannock Falls State Park is enormously popular and will be crowded almost any time of year for good reason—it is spectacular. The best way to appreciate what you'll see is to have a copy Bradford Van Diver's *Roadside Geology of New York*, which was a primary resource in creating this guide. Also make a point to visit The Museum of the Earth on Cayuga Lake's east side along NY 96 a couple miles north of Ithaca. It's an amazing place where any dinosaur-crazed child will have a wonderful time.

To see the falls from below, follow the wide gravel road 1 mile from the lower parking areas. Within sight of the parking area is one of the most popular swimming spots in the park, the 10-foot ledges of the lower falls. From here the creekbed is made of flat stone slabs. Above this layer is weak shale forming the gorge. The main fall comes into view as you cross a footbridge to the creek's left-hand side. Begin shooting from here, working composition all the way to the trail's end about 100 yards farther on. People in the creek will be problematic so be very patient and wait them out.

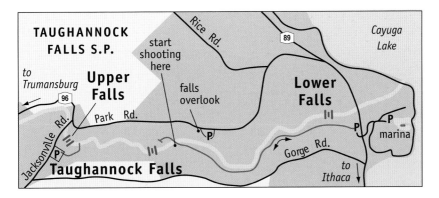

Once at the plunge pool viewing area you get one of the two classic views, the other being from the Falls Overlook atop the cliff behind you. Signs at the view note "Falling Rock." Every few minutes you can hear rocks fall from above; they sound a lot like falling water but the sound doesn't come from the stream. I saw several large rocks drop 300 feet into the plunge pool and create large splashes. Swimming is prohibited in the plunge pool for this reason.

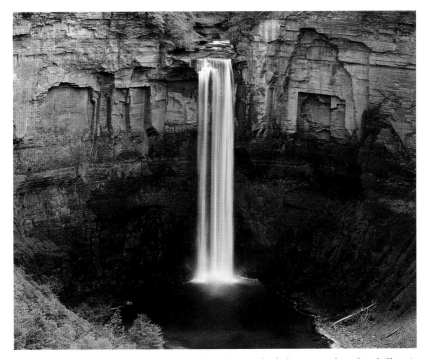

Taughannock Falls. This classic view, shot from the overlook, is one not be missed. There's lots of jockeying for position on the small platform and there's no other option because the view platform hangs from a cliff. Just be patient and wait your turn, then be quick. *Tachihara 4x5 Field Camera, 210mm Rodenstock Grandagon f6.8, polarizer, 6x7 roll film back, Kodak E100VS, f/32 @ 4 sec.*

The view from the Falls Overlook is the one gracing the cover of Derek Doeffinger's *Waterfalls and Gorges of the Finger Lakes*. Simply descend the stairs and shoot everything from frame-filling portraits to wide angles that include the entire gorge. Don't forget both horizontals and verticals. If you can catch the fall after a big autumn storm it will be your money shot.

Upper Falls would not make this guide on its own merits since the view is quite restricted. From the upper parking area, follow a gravel path a few yards before turning left to climb stairs to an abandoned rail bridge. The view is almost straight down into a punchbowl-like gorge. It's a unique perspective with the challenge of keeping the road bridge out of frame. I explored downstream looking for safe access into the creek and couldn't find any.

Hike 88 Oak Tree Falls, Seneca County

Type: Fall	Height: 75 feet
Rating: 4	GPS: 42° 40.604′N, 76° 43.764′W
Stream: Ovid Creek	Distance: 1.2 miles
Difficulty: Moderate	Elevation Change: 80 feet
Time: 1 hour	Lenses: 17mm to 50mm

Directions: From Taughannock Falls State Park, take NY 89 north 12.2 miles to the intersection with Center and Weyers Point roads. Turn right onto Weyers Point Road and descend 1 mile to the lake. The paved road swings hard right near some little cottages and crosses a small bridge. Continue another 50 yards and park in the large parking area on the right (the lake will be on the left). Take care not to block any vehicles or trailers. GPS coordinates: 42° 40.720′N, 76° 43.281′W.

Walk down the road back to the little bridge and look at the gravel bar on the upstream side. Unless this gravel bar has water flowing over it, don't bother with the falls. Oak Tree is a seasonal cascade and its season is short due to a small drainage basin. If the flow looks good, or you just want a nice walk, hop into the creek by scrambling down the bridge abutment. No matter how hard you try you'll land wet in ankle-deep water. Now head upstream. At .24 mile the stream divides; bear right to follow Ovid Creek. Steep ledges and banks confine you to the creek for a short time; at .27 mile you'll be forced right, going up and over a steep rock slide in order to avoid a deep hole. Shortly after this point the creek broadens; accessible banks are available on both sides so you can avoid other deep spots. A sizeable logjam (which may be gone by now) appears at .34 mile. Climbing over some logjams is no big deal, but this one was less than solid and had some

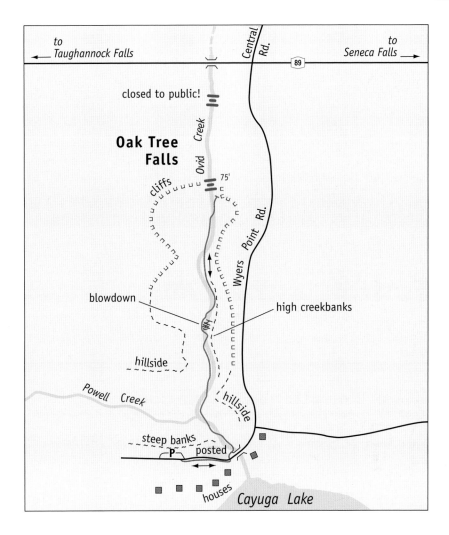

big openings that are made for ACL injuries. It's best to work around it if you can.

Regardless of which bank you're now on, get to the left-hand side when the fall comes into view and set up atop a small ledge facing the fall. This avoids some overhanging trees on the right.

My third trip here held a startling surprise. While ambling up a narrow section I saw some small fish rush away from me, a common occurrence when creek walking. A few yards farther on much larger fish darted from my approach and startled me. Seconds later about seven catfishlike behemoths decided they'd been pushed far enough and raced headlong right for my sandaled feet with their dorsal fins kicking up spray. It was like *Jaws* in miniature and it scared the heck out me. The exact same thing happened on my return. Don't be surprised if you are "attacked" by fish as well.

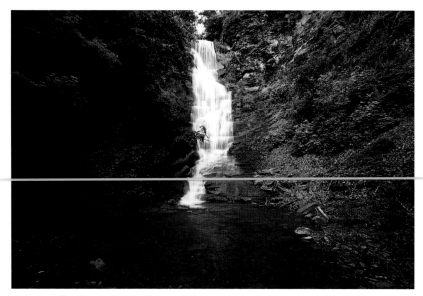

Oak Tree Falls. There will several stops difference between the gorge's two sides. Expose for the highlights so the histogram touches the right edge and adjust the image in post-processing. *Canon EOS 5D MkII, Tokina 20–35, Polarizer, ISO1000 setting, f/22 @ ¹/4 sec.*

Hike 89 Wolcott Falls, Wayne County

Type: Cascade	**Height:** 50 feet
Rating: 5	**GPS:** 43° 13.285'N, 76° 48.733'W
Stream: Wolcott Creek	**Distance:** .32 mile
Difficulty: Easy	**Elevation Change:** 50 feet
Time: 20 minutes	**Lenses:** 30mm to 100mm

Directions: From the junction of NY 104 and NY 89 just south of Wolcott, head north on NY 89 (Auburn Street) north 1 mile and turn left onto Mill Street. As soon as you cross Wolcott Creek turn right into Wolcott Falls Park. GPS coordinates: 43° 13.282'N, 76° 48.762'W. The park entrance can be seen on Google Maps' street view utility.

If you entered town via a different route, for instance from the west, you probably noted a lack of good street signage, especially at Main and Oswego. This is a minor complaint for such a wonderful fall. The park is open only from sunrise to sunset, so plan accordingly. A good view is from a handicapped-accessible platform overlooking the fall; however, a short walk will bring you to fall's base.

Walk from the parking area past the John Betts Pavilion and look for a path through a gap in the safety fence. Follow a wide road downhill and arrive at the fall in .16 mile. Gravel and other fill used on the parking lot and road

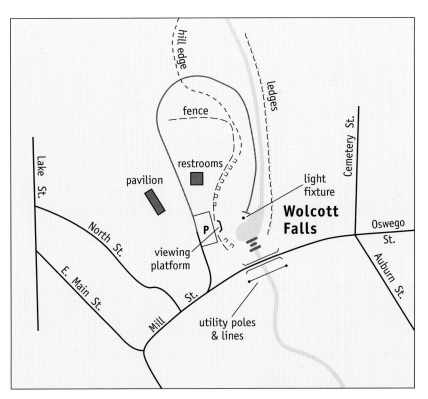

Legend labels: hill edge · ledges · fence · restrooms · pavilion · light fixture · **Wolcott Falls** · Cemetery St. · Lake St. · North St. · P · viewing platform · E. Main St. · Mill St. · utility poles & lines · Oswego St. · Auburn St.

Wolcott Falls. The utility lines above the fall are a pain to deal with. In decent light there'll also be a blank sky above. Move around, get low, and do whatever is needed to find a position that will maximize your opportunities in post-processing. *Tachihara 4x5 Field Camera, 150mm Rodenstock Grandagon f6.8, polarizer, 6x7 roll film back, Kodak E100VS, f/32 @ 1 sec.*

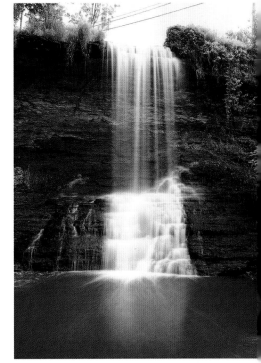

have filled what was once a large plunge pool. Now the tailwater exists through gaps in the expansive gravel bar on the right-hand side. This fill will be grassy and brush-filled so the only way to get the tail-water as a foreground is to hug the opposite ledges. Unfortunately this puts a telephone pole in the frame above the fall's head. Although I'm not a fan of doctoring images in Photoshop, this is one of those times when I think it's perfectly acceptable. In fact, any position that places the plunge pool in frame will have to contend with utility lines above.

Hike 90 Watkins Glen State Park, Schuyler County

Sentry

Type: Chute	Height: 25 feet
Rating: 3	

Lower Cavern Cascade

Type: Fall	Height: 12 feet
Rating: 4	

Upper Cavern Cascade

Type: Fall over cascade	Height: 43 feet
Rating: 5	

Fall 3

Type: Chute	Height: 23 feet
Rating: 3	

Rainbow

Type: Slide over fall	Height: ~50 feet
Rating: 4	

Fall 5 (Pluto)

Type: Chutes	Height: ~35 feet
Rating: 4	

Stream: Glen Creek	Distance: 3.0 miles
Difficulty: Moderate, many stairs	Elevation Change: 580 feet
Time: 2 hours, 15 minutes	Lenses: 15mm to 130mm

Directions: The lower parking area is located near the intersection of 10th Street and Franklin Street (NY 14/414) in the heart of Watkins Glen. GPS coordinates: 42° 22.558′N, 76° 52.289′W. The upper lot is located on Station Road. From the lower parking area, turn left onto Franklin and then left again at the light onto West Fourth Street (NY 409). Fourth will turn into Steuben; stick with signs for NY 409. In 1.5 miles turn left into the upper lot, which is next to some railroad tracks. There is a $9 fee. GPS coordinates: 42° 22.407′N, 76° 53.509′W.

This is the best-known park in the Finger Lakes region, if not the entire state, and as such it gets awfully crowded. Come early, come often, and come prepared for a spectacular experience. The trail carved into the glen provides a rare opportunity to enter the heart of a mountain to see how water turns stone into art. Since the Glen is so tight I wasn't able to get GPS coordinates for any falls. That's no problem since everything is concentrated into one glorious mile. On overcast days the deep glen will be quite dark and

require the use of a tripod. Be respectful of others and work quickly; if a back-up occurs near you, collapse your tripod and let people by.

As you walk from the large parking area toward the entry tunnel you enter a world that looks like it could be filled with hobbits. Prior to entering, walk to the end of the lot to catch a view of Sentry Cascade, a 25-foot-tall chute exiting a cliff. Now enter the tunnel and climb some stairs (which can become crowded quite easily throughout the glen) and cross Sentry Bridge above the chute's head. There is some nice pattern work available here. Pause on the bridge and look up-glen for a jaw-dropping view.

The paved trail widens as the lower drop of Cavern Cascade comes into view. A short set of stairs descends to a viewing platform. From here you need a wide lens to capture the entire drop where a glimpse of the top is caught. Extreme contrast makes shooting both drops a challenge. Rocks heading the lower drop will be two stops brighter than the upper section and the trees above will be brighter still. Bracketing is a must, even with digital. Perhaps the best vantage point for both drops is near the "A Staircase of Waterfalls" interpretive sign.

Ascend the stairs to enter the now very narrow glen and look downstream—the view is breathtaking. Place some models (i.e. family) in bright shirts on the view platform below and you have an image that provides a wonderful sense of scale, not to mention a cool Christmas card. As you work ahead take a shot every couple feet until the fall is lost on the Spiral Tunnel staircase. All will be keepers.

A bridge is seen upon exiting Spiral Tunnel. Below it is a series of slides and tubs; this is pretty much what the rest of the gorge looks like. The glen's character has changed in the last couple hundred feet since leaving Spiral Tunnel. The creek bottom has passed from hard material to soft and then back to hard as it has ascended. Climb more stairs in a tunnel and make a quick walk to the next stair flight for good shooting positions of two nice three-foot drops.

When the "Shade and Sun" interpretive sign comes into view near a stairway up to the rim, you have a good vantage point of a 23-foot chute; this is Diamond Falls. To avoid surrounding vegetation you'll have to move around a little bit. From here to the next interpretive sign is a section called Glen

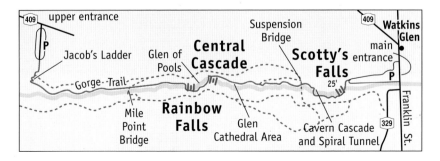

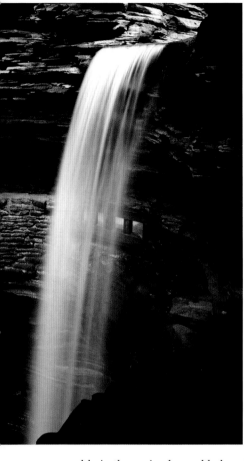

Upper Cavern Cascade. The classic shot is from along the walkway left of frame in this image. I wanted something different so I instead shot from the Spiral Tunnel stairway. I settled on this image that uses the handrail as a pleasing leading line through the frame. Always look for unique views of common things. *Canon EOS Digital Rebel, Tokina 20–35, Polarizer, ISO100 setting, f/11 @ 3.2 sec.*

Cathedral, a fitting name. Another bridge can be seen ahead, and below it is Central Cascade, now more or less .5 mile into the hike. The best shot is near the stair's base using a normal to long lens to establish a nice frame. Good locations exist all along the staircase.

Adjacent to the bridge (next to another interpretive sign) is Watkins Glen's second-most famous image: looking upstream through a chain of pools, called Glen of Pools, with rock overhangs. Getting a shot with nobody else in frame is a question of patience.

Passing through a tunnel and climbing yet another in a series of endless stairs brings you to the right-hand side. Here's the signature shot: Rainbow Falls dropping over top of the trail into the deep glen below, with Cascade at Rainbow Falls visible in the main channel below. Three distinct chutes and pools totaling more than 30 feet carry Glen Creek under a picturesque arch bridge. It's a classic view that begs to be lingered over. From here to Mile Point Bridge is a section called Spiral Gorge, where the glen resumes its chute-and-pool configuration. Sometimes called Pluto Falls, this series of two-to-three-foot chutes and pools drops Glen Creek about 35 feet. It's a lovely series that can be shot as graphic details. Once at Mile Bridge the Glen's magic has ended. From here to the upper lot the glen is just a flat creek; however, if you've taken the time to get this far, go the rest of the way and just absorb it all. You may be tempted to ascend Jacobs Ladder and head back via Indian Trail. Don't—instead, reverse you route and backtrack via the Gorge Trail. Looking down Glen Creek is a totally different experience. Don't hurry along; it took nature a few thousand years to create the glen so take your time.

Hike 91 Twin Falls, Schuyler County

Upper Falls

Type: Cascade	**Height:** 16 feet
Rating: 2–3	**GPS:** 42° 22.118'N, 76° 57.541'W

Lower Falls

Type: Cascade	**Height:** 9 feet
Rating: 2–3	**GPS:** 42° 22.118'N, 76° 57.541'W
Stream: Glen Creek	
Difficulty: Easy	**Elevation Change:** 30-foot descent
Time: 45 minutes	**Lenses:** 20mm to 50mm
Distance: .2 mile	

Directions: From Watkins Glen State Park's upper parking area, turn left onto Station Road. In 1.6 miles turn right onto Ellison/Stamp Road and then make the first left onto County Line Road. In .4 mile bear left at a Y onto Van Zandt Hollow Road. In 1.1 miles Cross Road joins from the right, after which you follow a short twisty section for .4 mile to join Templar Road. In about 100 yards, bear left away from Locust Lane and follow Templar Road another .1 mile. Park on the right where the Finger Lakes Trail (FLT) crosses the road. GPS coordinates: 42° 22.124'N, 76° 57.490'W.

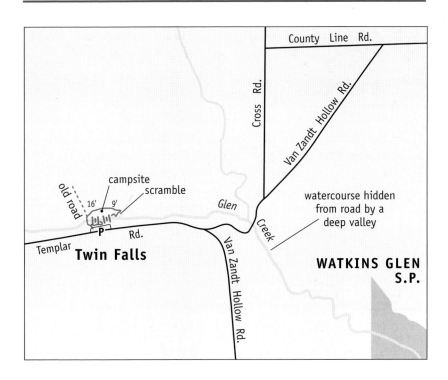

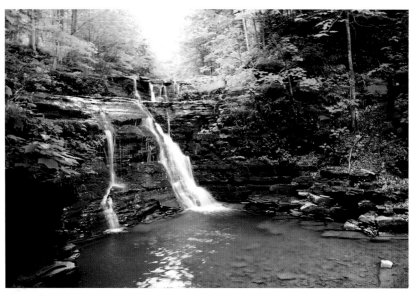

Twin Falls. Sitting well upstream of its famous cousins at Watkins Glen, this smallish fall makes for handsome shots of the two drops in tandem. The tailwater is warm so you may go barefoot if needed. *Canon EOS Digital Rebel, Tokina 20–35, Polarizer, ISO100 setting, f/4 @ .3 sec.*

After the magical Watkins Glen, Glen Creek holds one more surprise in the form of these two small but pleasant drops. The upper drop is just 200 feet from the parking area. Head downhill away from the road toward Glen Creek along the FLT. Don't try to cross the upper fall's head to shoot; instead, scramble down the right-hand side and work from a gravel bar below. To reach the lower drop, cross above the upper drop on the FLT and then turn right toward an illegal campsite. Pass this site and scramble easily down a few feet of muddy slope entering the creek. This location is a mess, so bring a trash bag to pack out all the beer cans before you try and shoot.

Hike 92 Aunt Sarah's Fall, Schuyler County

Type: Cascade	**Height:** ~90 feet
Rating: 3	**GPS:** 42° 21.148′N, 76° 51.377′W
Stream: Falls Creek	**Distance:** 50 yards
Difficulty: Easy	**Elevation Change:** None
Time: 5 minutes	**Lenses:** 20mm to 200mm plus macro

Directions: From the intersection of NY 14 and NY 414 (Franklin and Fourth) in Watkins Glen, take NY 14 south out of town 2.1 miles and park in a wide spot on the left opposite a large fall. GPS coordinates: 42° 21.154′N, 76° 51.356′W.

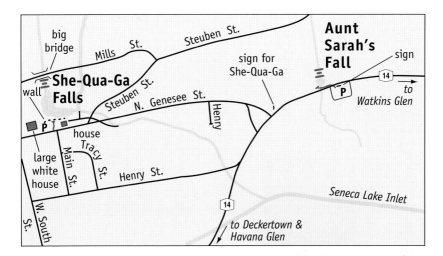

Aunt Sarah's Fall. At this tight location, you'll need a wide lens and as long an exposure as you can manage in order to fill in this normally weak-running drop. *Canon EOS Digital Rebel, Tokina 17, Polarizer, ISO100 setting, f/22 @ 1 sec.*

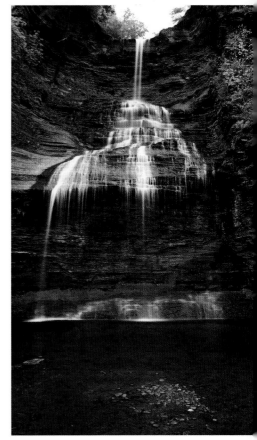

A s you drive south out of Watkins Glen you catch glimpses of large and small drops along the roadside; all amount to vertical drainage ditches. Aunt Sarah's Fall is the only one with a parking area and a sufficient drainage basin to qualify as a real waterfall. Scamper across heavily traveled NY 14 and work from the weakly running creekbed with the widest lens you have. A couple quick snaps is all this is worth because better falls are a short distance south in the village of Montour Falls.

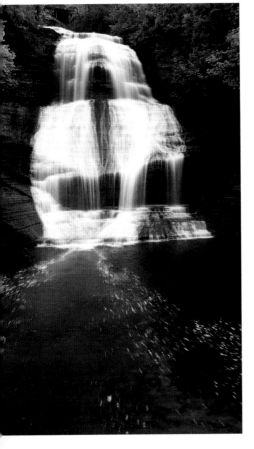

Hike 93 She-Qua-Ga Falls, Schuyler County

Type: Cascade	**Height:** 156 feet
Rating: 5	**GPS:** 42° 20.688'N, 76° 51.052'W
Stream: Shequaga Creek	**Distance:** 100 yards
Difficulty: Easy	**Elevation Change:** None
Time: 10 minutes	**Lenses:** 15mm to 70mm

Directions: The falls is located on South Genesee Street near its intersection with West Main Street in the heart of Montour Falls. From Watkins Glen (Hike 90) or Aunt Sarah's Fall (Hike 92), take NY 14 south and follow the signs. Parallel park along Genesee, being careful not to block any driveways. GPS coordinates: 42° 20.710'N, 76° 51.004'W.

Walk up the wide path, stand at the tall retaining wall, and shoot away—it's that simple. The fall's name is derived from a Seneca phrase meaning "tumbling waters," and this fall is all of that. The enormous plunge pool is now a deep-channeled affair that exits to your right. Above is a road bridge carrying Mills Street over the fall's head; there's a spectacular view from here. Please respect the private backyards on either side of the paved path.

She-Qua-Ga Falls. To minimize the bridge above you'll need to move your tripod in small steps left along the wall until you minimize its presence relative to the fall. There is no position that truly eliminates it. For a unique view, shoot from across the street. *Canon EOS Digital Rebel, Tokina 20–35, Polarizer, ISO100 setting, f/22 @ 1 sec.*

Hike 94 Deckertown Falls, Schuyler County

Fall 1

Type: Chute	Height: 10 feet

Rating: 3

Fall 2

Type: Slide	Height: 9 feet

Rating: 2

Deckertown Falls

Type: Cascade	Height: 37 feet

Rating: 4	
GPS: 42° 20.623'N, 76° 49.810'W	Distance: .15 mile
Stream: Catlin Mill Creek	Elevation Change: 45 feet
Difficulty: Easy	Lenses: 15mm to 100mm
Time: 20 minutes	

Directions: From the intersection of NY 14 and NY 224 (Catherine Street and Clawson Boulevard) in the heart of Montour Falls, take NY 14 south .9 mile and turn left onto Havana Glen Road. In .2 mile turn left onto South Lhommedieu; then in .4 mile turn right onto East Catlin Street and park at the road's end. GPS coordinates: 42° 20.602'N, 76° 49.881'W.

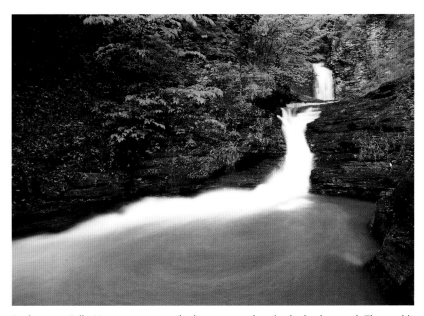

Deckertown Falls. Here you can see the large upper drop in the background. The pool is quite deep and rocks on the right are very slippery, so take care. *Canon EOS Digital Rebel, Tokina 20–35, Polarizer, ISO100 setting, f/22 @ 1 sec.*

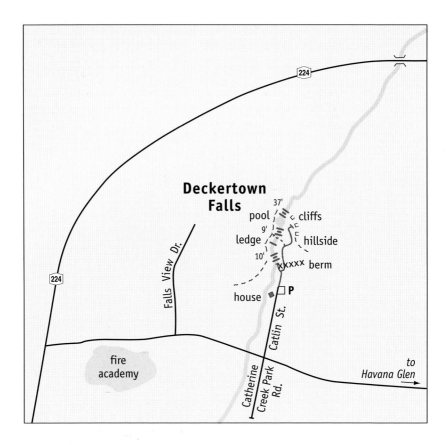

The three drops in Catlin Mill Creek's glen are pretty much on top of each other, hence only one GPS coordinate for the main falls. From the parking area, follow a wide gravel path about 50 yards to a ledge; hop down and work Fall 1 from any place your feet are comfortable and dry. This chute has a really cool swirl within its plunge pool which is also quite deep, so don't enter the creek and don't slip either—that will be *bad*. You'll also see the next drop hovering above.

To reach the second drop, hop back up on the ledge and follow a path left and uphill to a point where it cuts through ledges. Look downslope towards the creek and find a rockslide; use this to scramble to the creek. Once at the creek you can shoot Fall 2 and Deckertown from a gravel bar on the right-hand side. To get there, ford several feet above the lower fall and take care with your footing because of some deep holes. The two falls are separated by a very deep pool. I tried to get up the slide's face in low water but it was a serious challenge and I slipped badly twice. Each six-inch terrace is not quite level and is covered with slick black slime. In high water it's an impossible and dangerous task.

You can get a view of Deckertown's plunge pool by making a muddy scramble up and around Fall 2 along ledges dividing the two drops. I don't recommend this for a couple reasons: the view of the combined drops is much better, and there are a lot of wildflowers on the slope that shouldn't be disturbed. When you're done, scramble back to the hilltop, turn right, and return to the car. If you're muddy from the waist down consider it a badge of honor.

Hike 95 Havana Glen, Schuyler County

Eagle Cliff Falls

Type: Fall	**Height:** 41 feet
Rating: 5	**GPS:** 42° 20.096'N, 76° 49.640'W
Stream: McClure Creek	**Distance:** 300 yards
Difficulty: Easy	**Elevation Change:** 25 feet
Time: 15 minutes	**Lenses:** 15mm to 70mm

Directions: From the intersection of NY 14 and NY 224 (Catherine Street and Clawson Boulevard) in the heart of Montour Falls, take NY 14 south .9 mile and turn left onto Havana Glen Road. In .1 mile make a right into a community park and campground. If no attendant is there to collect the fee, drop a dollar in the honor kiosk and drive to a parking area next to the ballfield. GPS coordinates: 42° 20.148'N, 76° 49.778'W.

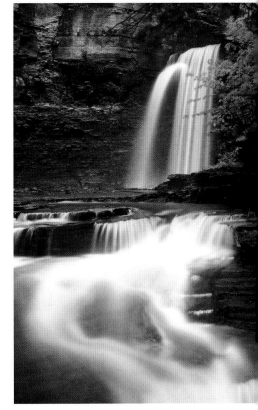

Havana Glen is a jewel not to be missed. Walk up the wide path toward the creek and bear left to ascend stairs bolted to a cliff. Continue along a graded path to a box-shaped glen and the fall. The creek drops from a sharp ledge, with part of the watercourse hitting a projection and spraying down. From a head-on portrait view

Havana Glen. Everybody shoots the portrait facing the fall. I prefer this view that shows the arc of water bouncing from the stone that creates the second launch. *Canon EOS Digital Rebel, Tokina 20–35, Polarizer, ISO100 setting, f/22 @ 25 sec.*

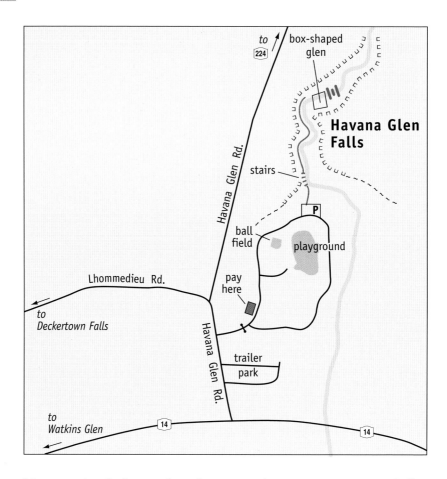

it's a smooth veil of water; from downstream it appears as a gossamer ballistic arc. With it being so easy to shoot from anywhere in the entire glen, there's no reason not to fill a memory card, even a big one. I particularly love shots looking upstream near some stanchions holding a handrail/cable. This small county park has robust visitation so be considerate of others.

Hike 96 Excelsior Glen, Schuyler County

Fall 1

Type: Cascade	Height: 32 feet
Rating: 3	GPS: 42° 23.445'N, 76° 51.295'W

Fall 2

Type: Cascade	Height: 90+ feet
Rating: 4	GPS: 42° 23.476'N, 76° 51.012'W

Fall 3

Type: Slide	Height: 12 feet
Rating: 2	GPS: 42° 23.449'N, 76° 50.880'W
Stream: Excelsior Glen Creek	Distance: 1.8 miles
Difficulty: Difficult	Elevation Change: 520 feet
Time: 2 hours	Lenses: 15mm to 70mm, plus macro

Directions: From the intersection of NY 14 and NY 414 (Franklin and Fourth) in Watkins Glen, take NY 414 east out of town 1.3 miles and park at the south end of a short guardrail. Pull off as far as possible in a wide, steeply inclined spot. A small dirt lane will be nearby on the left. If you hit the NY 79 cutoff you went .2 mile too far. GPS coordinates: 42° 23.444'N, 76° 51.355'W.

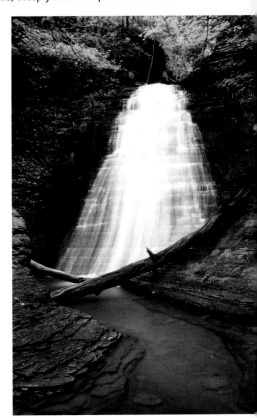

I love this hike. It has all the things I enjoy: no real trails through a narrow glen, nice climbs and scrambles, lovely falls, and complete solitude. When nearby Watkins Glen is a mob scene this place will be empty.

Follow a prominent footpath from the parking area to a large gap in the adjacent cliff; you'll see white blazes for the Finger Lakes Trail (FLT). Turn right at the brown FLT stake to enter the glen, climb slightly, and sign in at a trail register.

Head along a narrow ledge with the creek on your left (the FLT climbs right,

Fall 1. You don't get a real sense of how narrow this section of the lower glen is from this picture. It's about six feet wide, and getting right as far as possible is key to gaining a good perspective of the first fall. *Canon EOS Digital Rebel, Tokina 20–35, Polarizer, ISO100 setting, f/18 @ 30 sec.*

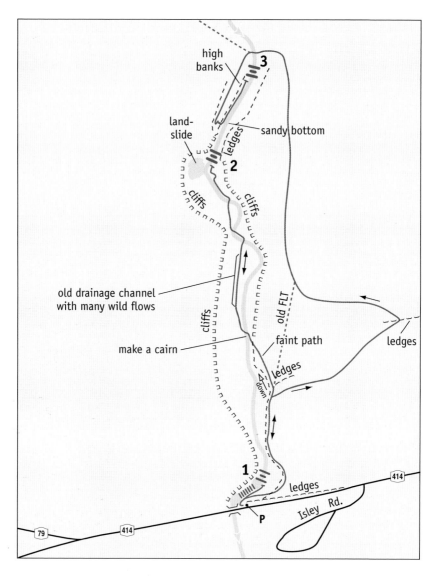

up and away). In about 50 yards you reach a drop well below on your left where the creek passes through a boulder-choked chute. This is *not* the first fall listed above. As the creek rises to your level the trail begins to fade. Enter a bowl-shaped depression filled with flat ledges and swing left to follow the creek. Look for a 32-foot drop tucked in a narrow rock cleft; this is Fall 1, which is less than .1 mile from the car. A deep hole fronts the cleft so you'll need to get wet for the best angle. Return to the trail register, arriving at .15 mile.

From the register, follow the white-blazed FLT up and away from the creek. The trail will flank the ledges you were just on and in short order you

will arrive at the top of the bowl you were in. Here the FLT hugs the glen's edge a short distance before swinging away and uphill near .21 mile. Take a moment to orient yourself; following the glen edge is an abandoned FLT section, and if you look uphill you'll see a couple painted-over blazes. This will be your entry route into Fall 2, which you'll get to on the way back from Fall 3. Follow the current white-blazed route away from the glen.

Work uphill. The highway is hidden below on the right, and ledges jut through the hillside above on the left. You'll run parallel to these, climb over them, and then switchback left to pick up the glen again at .33 mile. Note that the old FLT section rejoined at .3 mile. The now level, well-marked route takes a hard left at double blazes at .55 mile and drops into the flat creekshed at Fall 3's head. Cross the creek using the FLT and make a hard left off trail to side-hill parallel to the creek for about 30 yards downstream. Pause and look down into the creek for a gravel bar jutting into it that emanates from your side (the left-hand side). Once you see the cobble bar, hang a left and scramble down loose, loamy soil to the creek. The last couple feet are a steep drop to the cobbles. Please note that the head of 90-plus-foot Fall 2 is very close to this spot. Turn left and head a few yards upstream to Fall 3, a nifty little slide with lots of green moss cover. Using the sandstone patterns as foregrounds adds interest to the scene. You are now .6 mile from the car; reverse your route and climb out of the creek. Return to the

Fall 3. There's not much in the way of foregrounds at this fall. The smooth stone below runs for several yards, leaving a lack of riffles or ledges to work with. A classic portrait works best. *Canon EOS Digital Rebel, Tokina 20–35, Polarizer, ISO100 setting, f/16 @ 30 sec.*

Fall 2. It's surprisingly tight here. A landslide fills a portion of the glen to my left, which is why a wide lens is the key to working this large fall. *Canon EOS Digital Rebel, Tokina 17, Polarizer, ISO100 setting, f/22 @ 5 sec.*

point where the FLT and old FLT divided near the trail register, about 1.1 miles into your hike.

At this point landmarks are more important than mileage. Look uphill along the old FLT for ledges jutting out about 30 yards uphill on the right. Follow the old FLT uphill that distance; just after passing one prominent old white blaze on a Y-shaped tree, you come almost even with these ledges. Stop here. Now look for a footpath to the left. Even with leaf litter on the ground this path will appear as a distinct boot-wide notch cut into the hill flank and following a relatively level line.

Bear left onto this bootpath, side-hilling and gradually descending to the creek, which you'll drop into about 50 yards above the head of Fall 1. Make a cairn to mark this spot and cross the creek, following a wide bootpath on the right-hand side. The path will head left of a big hump sitting adjacent to the creek. Here you'll find a large damp area filled with spring wildflowers. From here all the way to Fall 2 I found large patches of red trillium interspersed with the painted variety in mid-May. This trail section has a wonderful woodsy smell, unlike the sulfurous smell near Fall 3. I also found some animal tracks, including a right front print from a small bear, probably a yearling cub. Skirting a meander in the stream, you're forced to cross to the left-hand side.

Now about 1.3 miles into your sojourn, hold the left-hand side for several yards and then cross back, thus avoiding some ledges. When the creek swings hard left you're forced to cross again back to the left-hand side. Use narrow ledges hanging from a small cliff to advance upstream. When you find yourself forced off the ledges it becomes hiker's choice as how to best advance. Once you arrive at the fall you'll see that the left-hand side has a nice wide spot for a picnic.

This is a large fall more than 90 feet high and with cliffs rising well beyond. The ribbon of water cascades slowly down the fall's face as if in no hurry to get to Seneca Lake. The entire fall is covered in moss and a little

rock dam creates a smallish plunge pool (which is shockingly deep on the right-hand side). Facing the fall and filling part of the glen is a landslide that forces you to use the widest lens you have. Foreground cobbles have a bright white travertine glaze on them created by acidic or sulfurous outlets above. Because of this you'll need to wet all the foreground rocks and flip over the brightest offenders.

When you're done, work your way back to the cairn you made earlier. Climb up and out on the narrow bootpath to the old FLT, turn right, and head down to join the current FLT at 1.63 miles. Continue downhill and return to you car, making sure to check out at the trail register.

Hike 97 Hector Falls, Schuyler County

Type: Cascade	**Height:** 100+ feet
Rating: 5	**GPS:** 42° 25.083'N, 76° 52.013'W
Stream: Falls Creek	**Distance:** 50 yards
Difficulty: Easy	**Elevation Change:** 30 feet
Time: 10 minutes	**Lenses:** 20mm to 200mm

Directions: From the intersection of NY 14 and NY 414 (Franklin and Fourth) in Watkins Glen, take NY 414 east out of town 3.4 miles (bear left at the NY 79 split) and parallel park in one of four wide spots at a large concrete bridge. GPS coordinates: 42° 25.083'N, 76° 52.009'W.

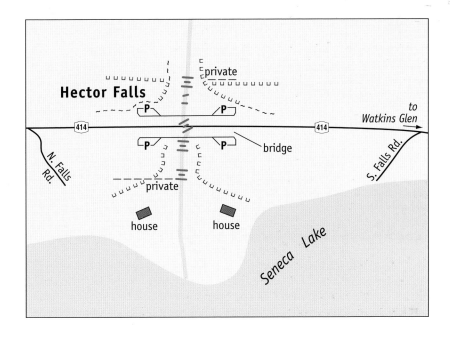

Hector Falls. I positioned under the downstream section of the highway bridge, putting the foreground in shadow. This requires careful exposure to keep the foreground and fall in range of the camera's sensor. *Canon EOS Digital Rebel, Tokina 20–35, Polarizer, ISO100 setting, f/16 @ 1 sec.*

Hector Falls is a massive affair that can be fully appreciated only when seen from Seneca Lake. Plunges downstream of the bridge are on private land, so work from the creek below the bridge. Hop the guardrail from any of the four parking areas and scramble under the bridge. Even in high flow the creek will only have water skidding over your boot toes; however, don't work close to the ledges near the downstream edge when the bridge is directly overhead. A slip will take you a long way down to lake level. The best position is from the fall's right-hand side. Carefully check your frame for orange posted-land signs along illegal trails ascending the fall's right-hand side.

Hike 98 Seneca Mills Fall, Yates County

Type: Fall over slide	**Height:** 40 feet
Rating: 5	**GPS:** 42° 39.650'N, 77° 00.263'W
Stream: Keuka Lake Outlet	**Distance:** .5 mile
Difficulty: Easy	**Elevation Change:** 40 feet
Time: 20 minutes	**Lenses:** 20mm to 70mm

Directions: From the small town of Penn Yan at the intersection of NY 54 and NY 54A (Elm and Main), take Elm east out of town 3.1 miles (Elm will become Outlet Road after passing Cornwell at .9 mile) and park on the right in a large lot with a trail register. GPS coordinates: 42° 39.864'N, 77° 00.172'W.

The trail follows an old railroad grade now called the Keuka Lake Outlet Trail. Leave the parking area and head upstream (so water is on the left and the road on the right). Just as a large boulder comes into view this pow-

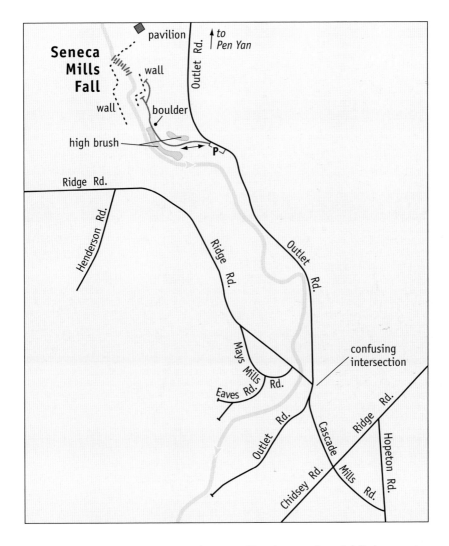

Seneca
Mills
Fall

pavilion

to
Pen Yan

Outlet Rd.

wall

boulder

wall

high brush

P

Ridge Rd.

Henderson Rd.

Ridge Rd.

Outlet Rd.

confusing
intersection

Mays Mills Rd.

Eaves Rd.

Outlet Rd.

Cascade Rd.

Ridge Rd.

Hopeton Rd.

Chidsey Rd.

Mills Rd.

erful fall will be heard. At .25 mile you will arrive at a broad fall that carries the entire outlet volume of Keuka Lake to Seneca Lake. Headed by an old mill dam about ten feet high, the fall is made of three distinct drops: the dam, a 15-foot ledge, and a 15-foot slide. Because the fall sits astride the lake's outlet channel it runs with power all year long. The best shooting position is atop a stone wall fronting the fall; just be aware that it's a good ten feet straight down. To the right is a massive stone wall with two penstocks plugged with brick. Take time to explore the park but don't bother trying to cross the channel. It's deep and dangerous. If you have kids along, bring a picnic lunch and relax at a large pavilion above the fall.

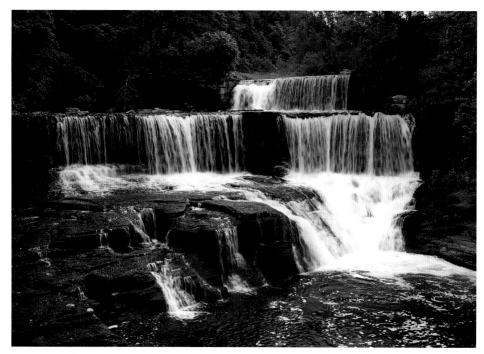

Seneca Mills Fall. Because of the relatively short handheld exposure, I couldn't use the foam bubbles to paint a foreground into the scene. I needed to tighten up somewhat to minimize the tailwater in the picture. *Canon EOS Digital Rebel, Tokina 20–35, Polarizer, ISO100 setting, f/8 @ ¹/20 sec.*

Hike 99 Grimes Glen, Ontario County

Fall 1

Type: Cascade	**Height:** 45 feet
Rating: 4	**GPS:** 42° 37.097'N, 77° 25.111'W

Fall 2

Type: Cascade	**Height:** 65 feet
Rating: 4	**GPS:** 42° 36.949'N, 77° 25.181'W
Stream: Grimes Creek	**Distance:** 1.2 miles
Difficulty: Easy	**Elevation Change:** 130 feet
Time: 1 hour	**Lenses:** 17mm to 70mm

Directions: From the intersection of NY 21 (Cohocton Street) and NY 53 (South Main) at the south end of Naples, follow NY 21 north .5 mile to an intersection with Vine and Sprague streets. Turn left onto Vine Street, taking care to follow Vine instead of Cross Street. Follow Vine .5 mile to a dead end in front of a blue gate. GPS coordinates: 42° 36.921'N, 77° 24.823'W.

This popular location draws people for lunchtime or after-work walks. It's a great place to unwind. From the parking area, walk around the gate and follow a wide trail for 30 yards. Turn left, cross a footbridge, and then turn right to continue upstream along the right-hand bank. Cross back to the left-hand side on a stream-level footbridge at .15 mile. The first fall comes into view at .17 mile on the left across the creek near a stone altar. Shoot from the embankment opposite the falls (the side you're on). If you happen to be

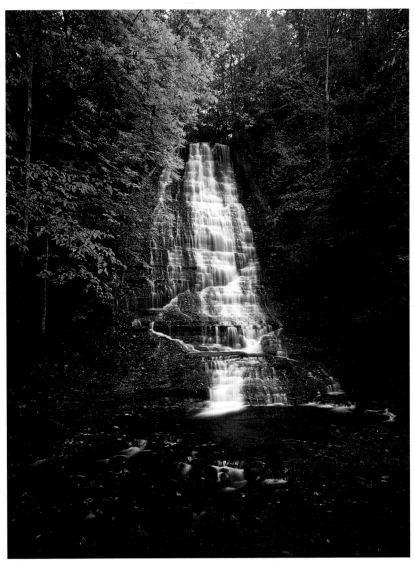

Grimes Glen Fall 1. You'll need to stand in the creek to shoot below overhanging branches along the trail. *Tachihara 4x5 Field Camera, 90mm Symar f6.8, polarizer, 4x5 Ready Load holder, Kodak E100VS, f/32 @ 10 sec.*

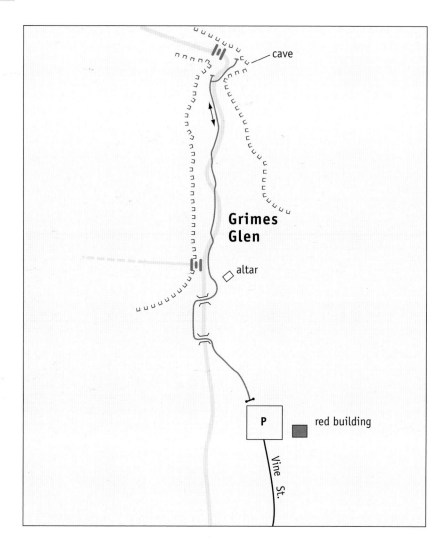

out on a blue-sky day this fall will be in shadow in the early morning and
again after about 5:00 P.M.

Continue upstream and cross to the right-hand side, following a footpath
and fording as needed to continue ahead. As the glen closes in overhead
you'll eventually end up on the right-hand side as you approach the next
fall. From this side you can work extreme wide-angle shots; however, if you
have water shoes or waders you can ford a deep spot to the far (left-hand)
bank and shoot the fall's full expanse. Even in weak summer flow, Grimes
Glen is the best thing going in Naples—that is, except for the Huntone's
Cones ice cream stand on NY 21 south of town.

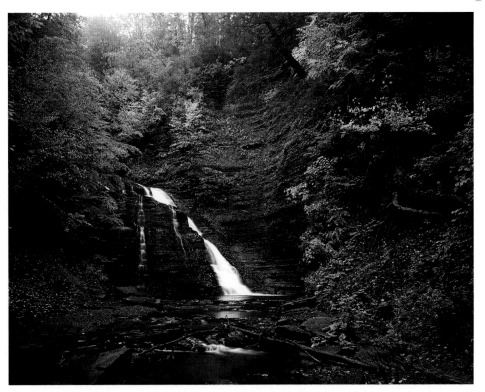

Grimes Glen Fall 2. A little more water would have helped this image. I had to take what nature gave me. *Tachihara 4x5 Field Camera, 210mm Rodenstock Grandagon f6.8, polarizer, 4x5 Ready Load holder, Kodak E100VS, f/32 @ 10 sec.*

Hike 100 Tannery Creek, Ontario County

Type: Cascade	**Height:** 20 feet
Rating: 3	**GPS:** 42° 36.014'N, 77° 24.151'W
Stream: Tannery Creek	**Distance:** .8 mile
Difficulty: Moderate	**Elevation Change:** 250 feet
Time: 1 hour	**Lenses:** 17mm to 50mm

Directions: From the intersection of NY 21 (Cohocton Street) and NY 53 (South Main) at the south end of Naples, follow NY 53 south out of town .1 mile and bear right onto Tannery Creek Road. In a little over .1 mile you will come to a set of highway department maintenance sheds; park opposite a salt-storage barn. GPS coordinates: 42° 36.232'N, 77° 24.393'W.

Water shoes or waders might be a good idea for this hike since it's probable the water will overtop a pair of hiking boots. Walk toward the creek, which is behind the sheds, and enter it at the far corner of the work-

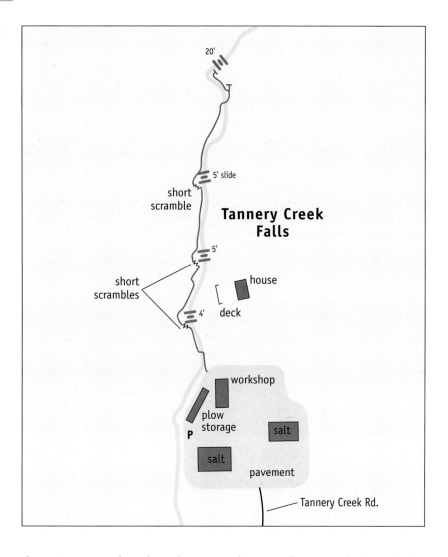

shop. It's a steep drop down loose gravel on a well-worn path. Once in the creek, turn right to head upstream. Ford at your earliest opportunity and hold the right-hand side until you come to the first drop, a five-foot cascade within sight of the workshop. Scramble up and to your left, sticking with the right-hand bank, even if it involves steep side-hilling to keep well above the creek. The terrain will bring you back to the creek near .25 mile, where you'll encounter a five-foot slide. As you try to work up and around you can expect to overtop your boots, but continue to hold the right-hand bank! Massive ledges now appear above on the right and you're forced to ford. When you encounter a three-foot slide it's time to head back to the right-hand side. Work slowly upstream to the first real fall, which is found at .4

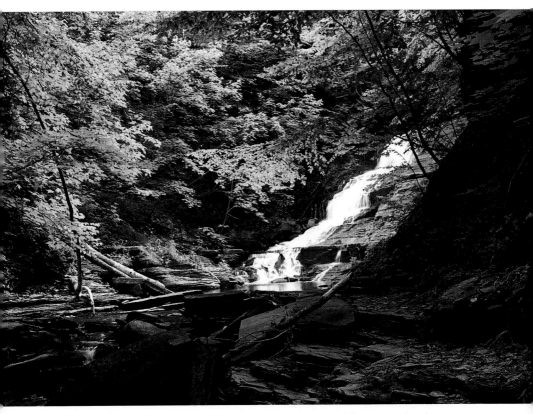

Tannery Creek. This fall changes shape and character as you approach, so start shooting as soon as the fall comes into view. *Canon EOS Digital Rebel, Tokina 20–35, Polarizer, ISO100 setting, f/8 @ ¹/10 sec.*

mile and is a 20-foot cascading series of ledges. As this fall comes into view you have no choice but to head back to the left-hand side, side-hilling a series of ledges to avoid a deep flume with some nasty-looking holes.

The fall sits at a sharp turn. Shooting from the left-hand side shows the fall as a narrow white line slicing at about 45 degrees. It's hard to work from the right-hand side even though it faces the fall; this is due to steep ledges and overhanging brush that make finding a comfortable tripod location frustrating.

Your hike ends here, so head back to the car after you get some nice shots. Regardless of what other guides might say, or what you see other people do, proceed no further. Beyond this fall is some seriously dangerous terrain.

Hike 101 Conklin Gully, High Tor Wildlife Management Area, Yates County

Fall 1

Type: Slides	Height: 30 feet
Rating: 2	GPS: 42° 39.914'N, 77° 21.707'W

Fall 2

Type: Slide	Height: 20 feet
Rating: 4	GPS: 42° 37.916'N, 77° 21.682'W

Fall 3

Type: Slide	Height: 25 feet
Rating: 4	GPS: 42° 37.920'N, 77° 21.659'W
Stream: Clark Gully	Distance: 1.6 miles
Difficulty: Strenuous, challenging scrambles	Elevation Change: 480 feet
Time: 1 hour, 30 minutes	Lenses: 17mm to 50mm

Directions: From the intersection of NY 21 (Cohocton Street) and NY 53 (South Main) at the south end of Naples, follow NY 21 north through town 1.5 miles and turn right on NY 245 towards Middlesex. In 1.7 miles look on the right for a gap in the guardrail as you approach Parish Road. There will be a sign announcing High Tor Conklin Gully and Parish Glen. The parking area is just before Parish Road and a green-roofed pole building. GPS coordinates: 42° 38.117'N, 77° 22.059'W. Additional parking is a few yards up Parish Glen Road at a wide spot on the right.

A successful hike up Conklin Gully can be measured by some minor bumps and bruises. An unsuccessful hike can be measured by . . . well, let's not discuss that possibility. My first excursion ended short of finishing the loop hike by the second fall. In a return during some very high water I changed my footgear to a pair of very grippy water shoes and altered how I climbed the second drop.

Exit the parking area by hopping into the creek, then turn right and work upstream away from NY 245. In a few yards cross to the right-hand bank and then quickly back again to the left-hand side. Stick to this bank by following a bootpath and drop back into the creek at .15 mile. In high water, continue holding the left-hand side for as long as possible, then ford and work the right-hand side as best you can. This fording is needed; although the glen is relatively straight, the creek meanders radically within steep banks and cliffs, making the high water more than ankle-deep.

When you encounter a logjam at .25 mile, look for a bootpath on the left (the stream's right-hand side) that avoids a deep flume. Here you'll encounter a four-foot ledge; scramble up the right-hand side on an obvious bootpath and then cross about 15 feet above the ledge's head. Now hug the

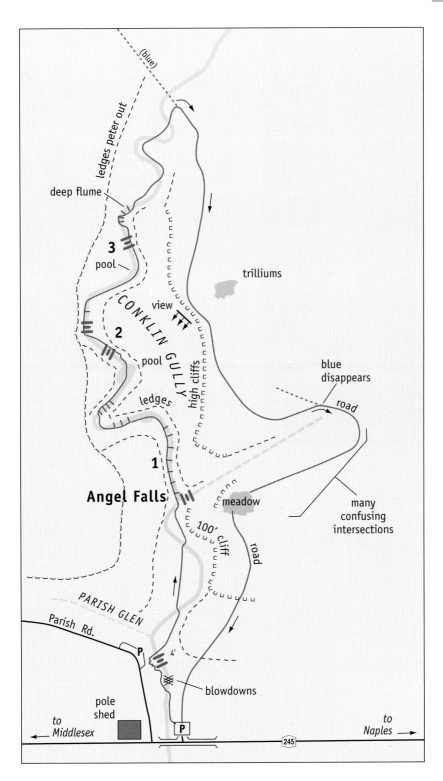

(blue)

ledges peter out

deep flume

3

pool

CONKLIN GULLY

trilliums

view

2

pool

blue
disappears

road

ledges

high cliffs

1

Angel Falls

meadow

many
confusing
intersections

100' cliff

road

PARISH GLEN

Parish Rd.

P

4'

blowdowns

pole
shed

to
← *Middlesex*

P

to
Naples →

245

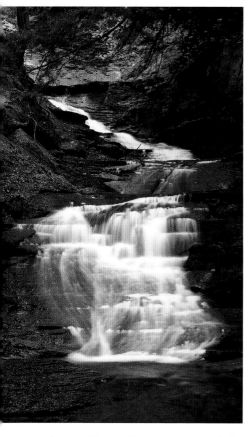

Fall 1. It's tough to get a good shot of the entire drop as it twists like a corkscrew. Also, the hemlock on the right may have fallen by the time you arrive. It wasn't healthy on my last visit and loose rock was in evidence all around the tree's base. *Canon EOS 5D MkII, Tamron 28–200, Polarizer, ISO100 setting, f/16 @ 1.3 sec.*

left-hand side as long as possible to cut off a deep meander. While you're in the process of hugging the bank make note of the thin shale lamina on the opposite side. Shale is made of clay deposits and when wet it turns back to slick clay. You'll also notice fresh rocks in the creekbed. These have dropped from high above, so don't forget to look up often and *avoid overhangs at all costs.*

When forced, ford back to the right-hand side and follow another bootpath that cuts off yet another meander. You've now arrived at a Y at .5 mile. On the right is a large 120-foot fall tucked into a very tight glen. Don't bother with this glorified drainage ditch; instead turn left and encounter a long series of stone steps bedding the creek and creating a long slide. This is Fall 1. Here you're ledged out on both sides and forced to ascend this slick surface along whatever edge appears best. I found that digging my shoe edges into soft shale made all the difference. Just after .53 mile the creek makes a sharp left around tall ledges fronted by a deep pool. This creates a dilemma: turn back or push on? In writing three hiking guides I've never fallen and been pushed downstream until this moment. Fortunately for me it was only a three-foot fall, and it was a hot day, so having wet underwear was not a big deal.

If you find a rope hanging on the left-hand side, use it to ascend this obstacle. Bear in mind that the brown patina coating the rocks is algae and it is very slick. It took me three tries before I made it. There's no shame in turning back at this point—better safe than sorry.

Once you've surmounted this obstruction you arrive at a large fall tucked into a cliff, which in turn is encased in a sharp, tight turn. This is Fall 2. As you face it, look for a path or boot prints to your right that cling to the loose shale adjacent to the fall's face. Carefully use this path. Stick to whatever dry material you might be able to find and work to a sandstone ledge two-thirds of the way up. Use the ledge to work slightly left and then continue up.

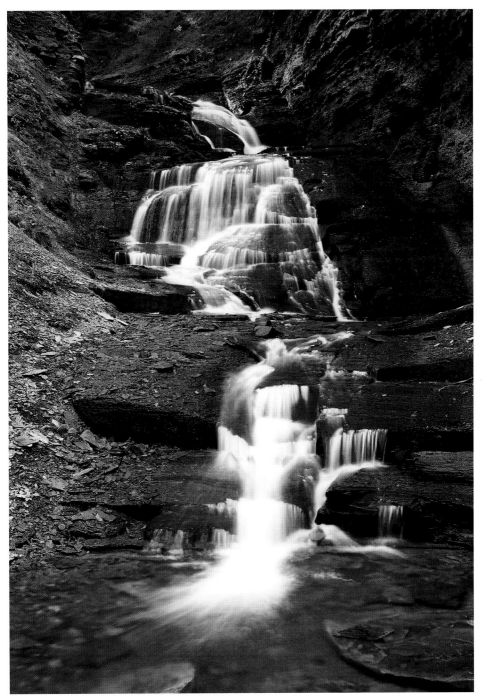

Fall 2. The fall's head is out of sight around the bend. If you're here when the right side of the fissure is covered you'll have a real keeper. *Canon EOS 5D MkII, Tamron 28–200, Polarizer, ISO100 setting, f/16 @ 1 sec.*

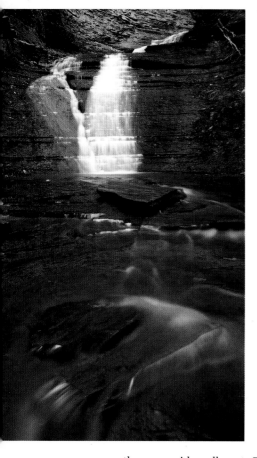

Fall 3. The third fall twists through a full 180 degrees. This is just the lower half, and still it twists out of view. Your path up is shown by the boot prints. *Canon EOS 5D MkII, Tokina 20–35, Polarizer, ISO100 setting, f/29 @ 5 sec.*

Once safely above the second fall, head upstream and ford as needed to follow a bootpath that clings to the creek edge. The creek has gotten quite narrow and the glen confining so you'll need to get wet a few times to keep going.

Next up is Fall 3, a nice 25-foot slide. There are some nice foregrounds where the water fans over a wide expanse of rock. If you turn your back to the fall you'll face a tall cliff with interesting rock strata. Your next major landmark will be atop this cliff. To get above this fall, use the same techniques as Fall 2, again working up to your right. By the time you top out the glen's character has changed greatly. Although more flumelike, the walls are not vertical and the trees are closer.

Continue around lovely little flumes and small ledges until you arrive at a prominently marked, blue-blazed trail that crosses the now-wide valley at .7 mile. Turn right and follow the steep path out of the valley where it turns right to run parallel to the creek. At about .8 mile you arrive at the cliff above Fall 3. Stay clear of the crumbly ledges! Behind you, and uphill of the view, is a small field of white and painted trilliums set among tall trees. Perhaps three hundred plants were at their peak in mid-May during a wet spring. Continue adjacent to the cliff's edge and note a road at .85 mile. The blue blaze clings to the cliffs and then swings hard left at .9 mile to run parallel to the big side gully you encountered earlier. At about 1.0 miles, merge with the road and stick with it. When you approach the side gully again (now from the left-hand side) you'll enter a meadow or food plot. Walk through the meadow, keep the gully to your right, and head steeply downhill. At every point where a trail beaks off or the road divides, bear right, keeping Conklin Gully in view or within earshot on your right. Return to your car at 1.6 miles.

Hike 102 Clark Gully, High Tor Wildlife Management Area, Yates County

Fall 1

Type: Slide	Height: 15 feet
Rating: 3	GPS: 42° 39.850'N, 77° 20.088'W

Fall 2

Type: Slide	Height: ~75 feet
Rating: 3	GPS: 42° 40.129'N, 77° 20.050'W

Fall 3 (View only)

Type: Slide	Height: ~80 feet
Rating: 4	GPS: 42° 40.057'N, 77° 20.082'W
Stream: Clark Gully	Difficulty (hike to falls 2 and 3): Difficult
Difficulty (hike to Fall 1): Easy	Time: 1 hour
Time: 40 minutes	Distance: 1.2 miles
Distance: .4 mile	Elevation Change: 460 feet descent
Elevation Change: 80 feet	Lenses: 17mm to 50mm

Directions: From the intersection of NY 21 (Cohocton Street) and NY 53 (South Main) at the south end of Naples, follow NY 21 north through town 1.5 miles and turn right on NY 245 towards Middlesex. In 4.0 miles turn left onto Sunnyside Road and in .5 mile come to Y after crossing the West River. At the Y bear left onto West Avenue and in a little over .1 mile park in a wide spot on the right. GPS coordinates: 42° 39.709'N, 77° 20.047'W.

To reach the upper parking area for Falls 2 and 3, continue along West Avenue (heading west) for 1 mile to a Y. Bear right onto South Hill Road and climb steeply for 1.8 miles. Shortly after passing a "Special Zoning Notice" sign, park in a wide spot on the right near some wooden posts. GPS coordinates: 42° 40.397'N, 77° 20.278'W.

Significant cliffs make portions of Clark Gully inaccessible, so you must work the stream in two sections. To get to Fall 1 in the lower section, follow a wide dirt path away from the road and reach the creek in about 30 yards. Continue along an obvious footpath on the creek's right-hand side (the side you're on) for as long as possible before being forced into the creek by ledges. Ford as needed and arrive at the fall in .17 mile. In high water you'll ford numerous times as the creek meanders wildly through a straight-sided gorge. Gravel bars normally exposed in low flow will be covered in high flow, making rock hopping a challenge.

A large number of upended rocks create a dam that forms the fall's plunge pool. This dam looks uncomfortable in the viewfinder, so the best shots are from the rock dam itself. A quick look high overhead explains why this is divided into two hikes.

To get to the upper pair of falls (Falls 2 and 3), walk from the South Hill Road parking area away from the road along a path of well-trod grass. Enter the woods near a small pond on the right. Shortly after, the trail changes from an old road to a footpath and bears left to hold a ridge crest with a drop-off on the right. Around .29 mile another drop-off encroaches from the left and the trail holds the ridge spine. Water will now be audible on the left as the trail drops steeply right, bottoming out at .31 mile. Clark Gully is now visible on the left through an expansive hemlock veil. To this point (42° 40.168'N 77° 20.081'W) you've dropped 210 feet. Turn left off the path and zigzag downslope to enter the creek; then turn right and head downstream, holding the right-hand side as best you can. If you don't have a GPS handy, the trail climbs again for several dozen feet just beyond the turn. If you drop and then climb again you have gone about 30 yards too far.

When Fall 2's head comes into view, cross to the left-hand side well above and scramble down a steep slope, keeping away from the fall. This scramble is a delicate affair, especially in wet conditions, and should only be attempted if you're comfortable around heights. At .43 mile, two trees, a birch and a hemlock, partially veil the fall's face. The best shooting position

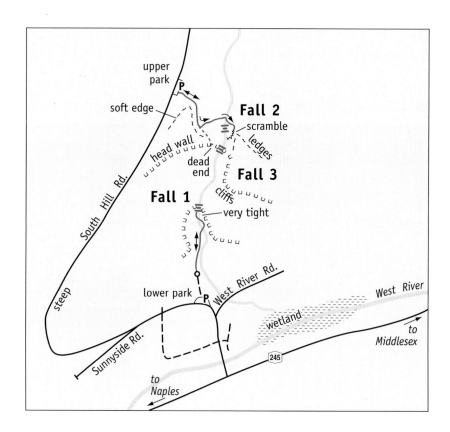

Upper Clark Gully. This is just one of those places where you need to keep the camera in the bag for a while and just kick back to enjoy the remote location. *Canon EOS 5D MkII, Tokina 20–35, Polarizer, ISO100 setting, f/16 @ 16 sec.*

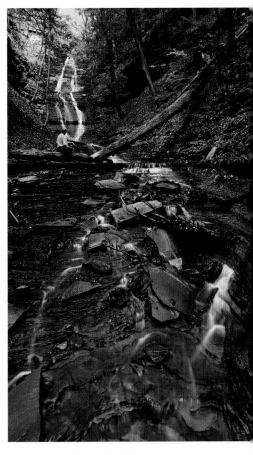

is on the right-hand bank near a mature birch or well below the fall where the creek turns sharply right.

Continue downstream around the sharp corner, clinging (quite literally) to the right-hand ledges. If there is any dry stone available you can get to the head of Fall 3, a monstrous cliffside slide. If everything in your path is wet, make absolutely no attempt to get to Fall 3. During spring runoff a slip into this fast-moving watercourse will carry you over Fall 3 and land you in the morgue. Fall 3 defines the eroded head wall of the gorge below as it cuts into South Hill. I explored left and right as far as safety would allow looking for a route down. At every turn I was ledged out and in one attempt I had an extraordinarily hard time retreating up a loose shale slope. Take my word for it: there is no safe route down.

To return to your car, reverse your route and make the steep climb back to the small pond near the parking area. Bear right of the pond into the meadow and you should see the parking area.

Hike 103 Stony Brook State Park, Steuben County

Fall 1

Type: Slide	**Height:** 12 feet
Rating: 3	**GPS:** 42° 31.100'N, 77° 41.563'W

Fall 2

Type: Cascade	**Height:** 60 feet
Rating: 5	**GPS:** 42° 31.046'N, 77° 41.604'W

Fall 3

Type: Cascade	**Height:** 30 feet
Rating: 4	**GPS:** 42° 30.957'N, 77° 41.544'W

Fall 4

Type: Cascade	**Height:** 50 feet
Rating: 4	**GPS:** 42° 30.821'N, 77° 41.499'W
Stream: Stony Brook	**Distance:** 2 miles
Difficulty: Moderate	**Elevation Change:** 340 feet
Time: 1 hour, 30 minutes	**Lenses:** 17mm to 70mm

Directions: From I-390 exit 4 at Dansville, take NY 36 south 1.6 miles to the park entrance on the left. Park in a large lot near the locker rooms. GPS coordinates: 42° 31.248'N, 77° 41.725'W. There is a second parking area called the Upper Lot located off of Oak Hill Road at GPS coordinates 42° 30.813'N, 77° 41.425'W.

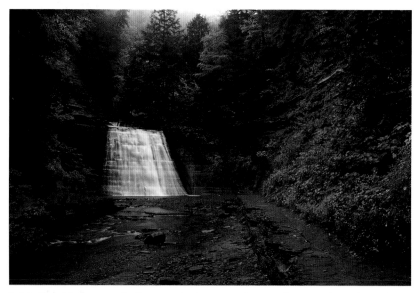

Fall 4. The wide-open creek allows you to shoot every lens you have, so please do so. *Canon EOS Digital Rebel, Tokina 20–35, Polarizer, ISO100 setting, f/14 @ 30 sec.*

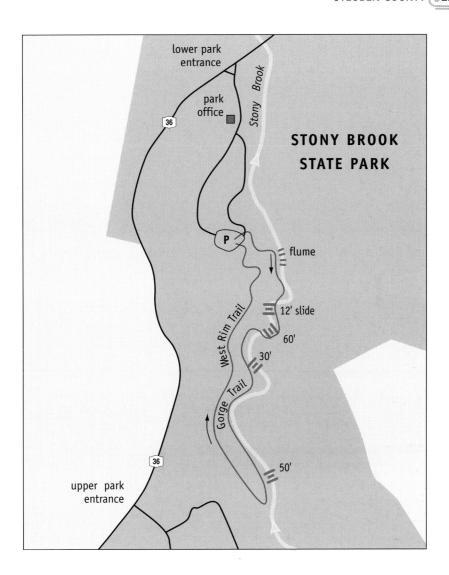

STONY BROOK STATE PARK

lower park entrance

park office

Stony Brook

36

P

flume

12' slide

60'

30'

West Rim Trail

Gorge Trail

36

upper park entrance

50'

Pick up a map and prepare to make a casual walk along the paved trails. There are numerous stairs to climb, which I've always found oddly taxing when compared to something like a rock scramble.

From the lower parking area, follow a paved service road toward the locker rooms and pass between the lockers and the playground. Bear right for the nature trail to avoid the large swimming pool and connect with the gorge trail at .12 mile. At .17 mile turn right up some stairs near a flume that heads the swimming pool area. Since it's unnecessary to provide turn-by-turn directions for a paved trail, I'll just list significant locations and shooting positions.

Find a 12-foot slide at .35 mile where you can work a side-on view from the trail. After this, cross two bridges; make note of the imposing 100-foot

cliffs and arrive at a 60-foot cascade at .45 mile. This is best photographed about halfway between the stairs ascending the falls and the second bridge crossing. There are three good positions that avoid some foreground brush but you need to have the creek completely wet, as there are large slabs of pale stone fronting the fall on the far bank.

As you crest the stairs of the 60-footer you see another cascade at .6 mile, this one 30 feet high with three ledges upstream. Shoot the entire approach, working wide and tight compositions. This fall has a wonderful background that will become a riot of color in autumn. More stairs follow before you arrive at a Y intersection where right joins with the Rim Trail and leads to the upper parking area. Bear left into the creek and work a wonderful 50-foot cascade from a gravel bar at .85 mile. The face of this last cascade is convex, making the fall look like a wedding veil; however, in low flow there is a dark stripe right down the middle that can mar an otherwise outstanding image.

Backtrack to the path and turn left to ascend your last flight of stairs, arriving at the upper parking lot at 1.0 miles. You can make your return at your leisure via the Rim Trail or the Gorge Trail. You can shorten the walk to a mile by parking a car in both lots.

Hike 104 Reynolds Gully, Livingston County

Type: Fall over cascade	**Height:** 20 feet
Rating: 3	**GPS:** 42° 40.041'N, 77° 35.322'W
Stream: Reynolds Gully	**Distance:** .6 mile
Difficulty: Moderate	**Elevation Change:** 100 feet
Time: 45 minutes	**Lenses:** 17mm to 50mm

Directions: From I-390 exit 3, take NY 15 north 6.7 miles, passing through Wayland to the village of Springwater. When NY 15 turns left, go straight and continue on NY 15A. Follow NY 15A another 2.2 miles and pull into a dirt lane on the right. The parking area is at the end of the lane. Look for a small sign stating "Public Water Supply." If you cross into Ontario County you went .3 mile too far. GPS coordinates: 42° 40.077'N, 77° 35.500'W. Obtain a free Watershed Visitor Permit at http://ci.rochester .ny.us/article.aspx?id=8589936857.

Exit the parking area on a wide path and follow it about 400 feet before dropping into the creek at an old abutment. Ford and scramble up the left-hand bank and hold it until you are forced to cross back near .25 mile. Shortly after crossing, scramble up the right-hand side of a three-foot slide. From here your upstream approach requires that you work as best you can along the left-hand edge to get around a series of ledges and slides, none of which is higher than three feet. You'll encounter an aggressive series of "No

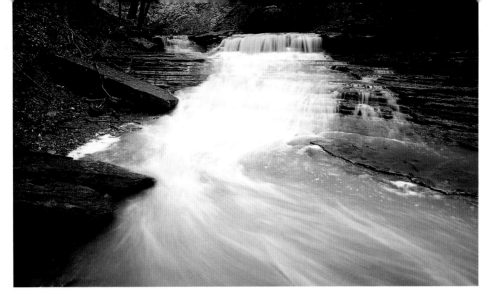

Lower Slide Reynolds Gully. Cold, swift-moving water is not what you want to slide around in. As I was shooting, heavy rain caused the creek to visibly swell and my outbound rock hop was quickly covered. Carrying a new camera, I was forced to ford through thigh-deep water to get out. Always be aware of your exit options in foul weather. *Canon EOS 5D MkII, Tokina 20–35, Polarizer, ISO100 setting, f/8 @ .4 sec.*

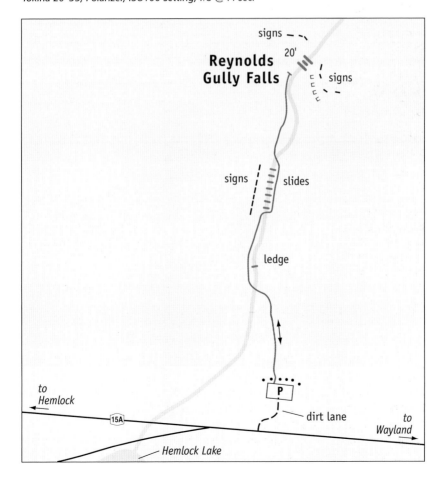

signs

Reynolds Gully Falls 20'

signs

signs | slides

ledge

to Hemlock

15A

P

dirt lane

to Wayland

Hemlock Lake

Trespassing" signs on the right-hand side, which is why you have to go to the left-hand.

Once all the signage is gone you can cross at your convenience back to the right-hand bank, at which point the fall comes into view. This attractive fall-over-cascade has several large trees fouling the right-hand side. These trees dropped in from above due to a landslide, a common occurrence in the soft shale of the Finger Lakes. You can work from either bank with ease. Even though it's simple to get around this fall and explore upstream, do not do so. Everything ahead is posted and patrolled.

Hike 105 Letchworth State Park, Livingston County

Lower Falls	
Type: Cascade	**Height:** 70 feet
Rating: 5	**GPS:** 42° 31.100'N, 77° 41.563'W
Middle Falls	
Type: Fall	**Height:** 107 feet
Rating: 5	**GPS:** 42° 31.046'N, 77° 41.604'W
Upper Falls	
Type: Cascade	**Height:** 71 feet
Rating: 5	**GPS:** 42° 30.957'N, 77° 41.544'W
Stream: Genesee River	**Lenses:** 17mm to 70mm

Directions: From I-390 exit 7, head towards Mount Morris and follow Mt. Morris/Geneseo Road (CR 408) west 2.2 miles into Mount Morris. Turn right onto North Main Street (NY 36 north). In 1.2 miles turn left onto Park Road at signs for Letchworth State Park. There is a $9 entrance fee. This approach brings you into the north end of the park. Follow the meandering Park Road 15.1 miles to a Y intersection for picnic areas and parking for Lower Falls. (Just beyond the Y is the visitor center.) If you don't stop at any viewpoints it will take more than twenty minutes to get this point.

To reach the Lower Falls, head left from the Y and go another 1.3 miles to the Lower Falls parking area near the snack shop at GPS coordinates 42° 35.279'N, 78° 2.094'W. It's noted on the park map with a little bell-like symbol with the number 8.

For the Inspiration Point view of Middle Falls, from the Y go another .5 mile along Park Road to the signed parking for Inspiration Point (Middle Falls) at GPS coordinates 42° 35.279'N, 78° 2.094'W.

For Middle Falls proper, park at the museum or Glen Iris Inn area 1.1 miles from the Y. There are several parking areas so specific GPS coordinates are not given. Your best bet is to park at the museum or the Middle/Upper Falls parking area. The Upper Falls is best accessed from the museum parking area since everybody else tries to park closer.

Everything in the park is well signed and there is normally ample parking; however, it can be very tight on weekends. During fall peak, expect to troll for parking at the Upper Falls, Glen Iris Inn, and museum parking areas.

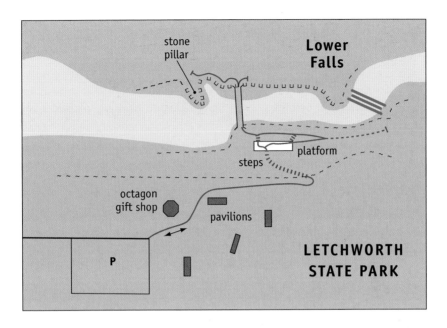

Lower Falls

Difficulty: Moderate with stairs	Distance: .8 mile
Time: 45 minutes	Elevation Change: 130 feet descent

Leave the large parking lot and walk behind the gift shop and a large pavilion, following signs for the lower falls. After a couple hundred yards, turn left and descend 127 stairs to a massive platform. As you move along the platform, examine the exposed ledges on your right. Layers of barely constituted shale several inches thick are separated by one-inch-thick layers of harder sandstone-like material. This weak layer cake of soft material is what makes descending into undeveloped gorges so dangerous, since just a little water turns the shale back to slick clay.

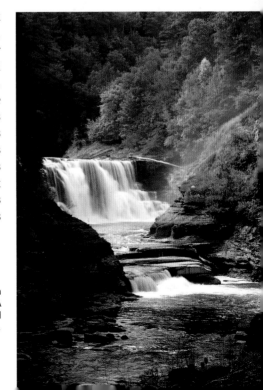

Lower Falls. The end of September brings a blush of color to the interior of Letchworth Gorge. A long lens gets over the heads of the assembled crowd. *Canon EOS Digital Rebel, Tamron 28–200, Polarizer, ISO100 setting, f/16 @ 1/8 sec.*

When you come to a T, turn left and descend stairs through a large fissure. Follow a viewing-area wall and then turn left again to an elegant bridge built by the Civilian Conservation Corps (CCC). This is your first shooting position, a medium- to long-lens shot. Wait for clouds or an overcast day since any direct sun will put one side of the gorge in shadow and the other in direct sun, overwhelming any camera. Now return to the platform and work the entire wall with every lens you have. From here the fall looks flat but in fact cuts across the river at quite an angle.

The trail continues along a bluff above the river's edge, dead-ending before the fall's head. Unfortunately, shooting from this wide grassy area is problematic because of foreground issues. There is a lower ledge that appears to have a nice shooting position, but this is absolutely not accessible. Do not attempt to descend from the trail, nor should you go any farther in an attempt to shoot the fall's head. I saw a number of people wading above this 70-foot drop, including many unsupervised children. Granted the flow was weak on this trip, but this kind of behavior is how people win Darwin Awards. Turn around, return to your car, and head for Inspiration Point.

Middle Falls

Difficulty: Easy	**Distance:** .2 mile
Time: 20 minutes	**Elevation Change:** 50 feet descent

I really like the set-ups from Inspiration Point, which provides the classic gorge image. Both Middle and Upper Falls can be seen from here and in autumn this is the best spot to work from. Tucked behind a narrow gorge section, the fall's entire width is not entirely visible; however, the shape of the intervening gorge works well with the overall composition. The best shots are with long lenses working a tight full-frame portrait, or something wider that includes a long ribbon of the fall's tailwater. Power lines that cross the gorge in front of the fall are not intrusive and can be removed in Photoshop if you feel the need to do so. The best setups are atop the small wall to the right of the right-most telescope and left of a little pond near a large tree.

To get close to Middle Falls you need to move your car to the museum and descend a road that is part of a parking loop behind the Glen Iris Inn. A footpath below the road (visible from above) has a great setup exactly halfway along the wall near a drain. You won't be able to see the fall's base and the foreground can be a tad dicey when it's all bright green, but this is the best shot here. Continuing along the wall you eventually end up at the fall's head, where a really wide lens works best, although the near side of the fall will be hidden.

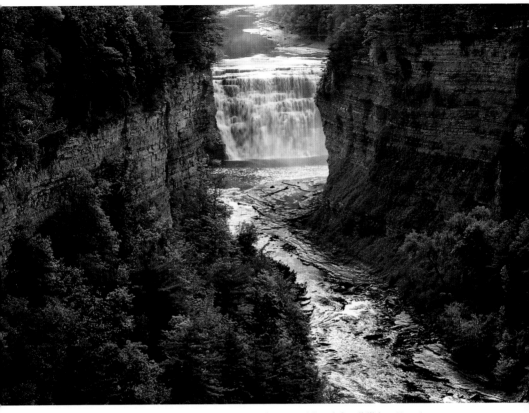

Middle Falls. Inspiration Point provides a range of compositional possibilities. Here I went wide to show the gorge in early fall color. *Canon EOS Digital Rebel, Tamron 28–200, Polarizer, ISO100 setting, f/16 @ 1/13 sec.*

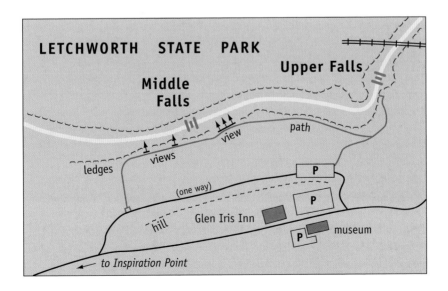

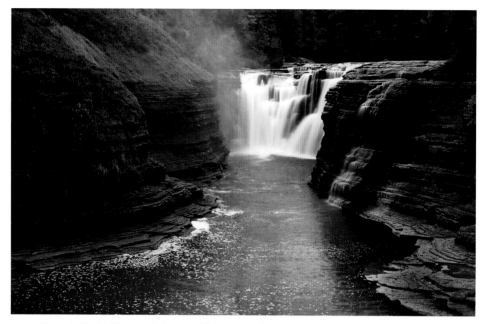

Upper Falls. A shiny new bridge-stabilizing cross frame sits between the piers. I cloned out part of it since it's major distraction. *Canon EOS Digital Rebel, Tokina 20–35, Polarizer, ISO100 setting, f/16 @ .5 sec.*

Upper Falls

Difficulty: Easy	**Distance:** .4 mile
Time: 30 minutes	**Elevation Change:** 60 feet descent

Follow the herd upstream from the Middle/Upper Falls parking area for a couple hundred yards and walk past the pay-per-use binoculars to a wide spot. This is the best view of the fall's face. From here there is no way to entirely eliminate the Norfolk and Southern Railroad bridge supports. Composing tightly will leave the white foundation piers in the upper left corner of the frame, which I think looks uncomfortable. You have to be very careful how much of the bridge is included when composing the shot. Including the bridge is fun but has the potential problem of an empty sky. In any flat light the sky above the bridge will be completely white and clash with the fall. Fall color helps; however, this is one of those times when you need some luck in the form of a cloud shadowing the falls and a nice blue sky. Late or early light will help soften the sky as well.

Even though you end up right at river level, under no circumstances should you enter the river to get a better position; it's against the law. The only people permitted in the river are those on guided rafting expeditions. Park police have been very strict about this policy since a 2005 fatality. A citation will cost you a minimum of $75.

Hike 106 Paper Mill Falls, Livingston County

Type: Cascade	**Height:** 8 feet
Rating: 4	**GPS:** 42° 52.264'N, 77° 45.681'W
Stream: Conesus Creek	**Distance:** 100 yards
Difficulty: Easy	**Elevation Change:** 10 feet
Time: 10 minutes	**Lenses:** 30mm to 100mm

Directions: From the intersection of US 20A (South Street) and NY 39 (Main Street) in the town of Geneseo, take SR 39 (Main Street) north. Main will quickly become Avon; in 6 miles, turn right onto Paper Mill Road. In .4 mile park on the left in large gravel parking lot at Paper Mill Town Park. An old road bridge will cross the creek and make both sides easily accessible. GPS coordinates: 42° 52.276'N, 77° 45.695'W.

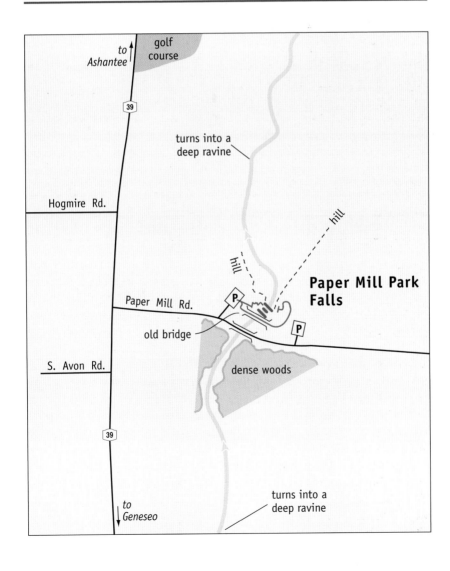

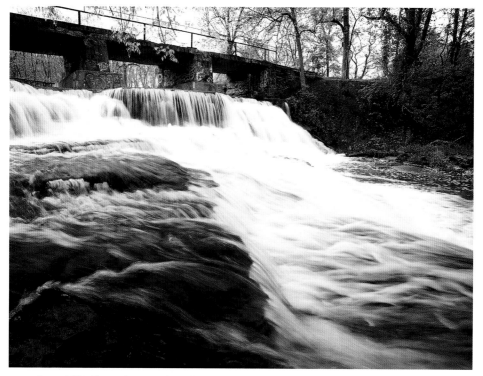

Paper Mill Falls. You have no choice but to include the graffiti-tagged bridge piers. To increase them as a compositional element, move left from where I've shot; to minimize the graffiti, move right. *Canon EOS 5D MkII, Tokina 20–35, Polarizer, ISO100 setting, f/8 @ ¹/₁₃ sec.*

I liked shooting from the creek's right-hand side (the far side from the parking area). Cross the old bridge and enter the creek to shoot the fall. Shooting from the tailwater is very difficult since the old road bridge's supports are heavily tagged with graffiti. At first I found this frustrating and almost eliminated this little fall from the guide. As I looked through my viewfinder, however, I found the tags to be very well done and quite artistic and began shooting them with a long lens to create colorful graphic designs. The best position for a clean shot is on the fall's right-hand side at a shelf midway up the cascade. From here you can eliminate all manmade distractions and isolate the stream flow.

About now your GPS is showing a fall called Triphammer sitting about .7 mile upstream. Yes, it's a monster, but it's also on posted private land and inaccessible by both creek and other approaches. There are several other big falls along NY 39 north and south of Geneseo and unfortunately all are on posted land.

Hike 107 Genesee River, Monroe County

Lower Falls

Type: Cascade	Height: 78 feet
Rating: 5	GPS: 43° 10.734'N, 77° 37.700'W

Middle Falls

Type: Slide	Height: 20 feet
Rating: 2	GPS: 43° 10.605'N, 77° 37.684'W

High Falls

Type: Fall over cascade	Height: 96 feet
Rating: 5	GPS: 43° 9.782'N, 77° 36.910'W
Stream: Genesee River	Lenses: 50mm to 150mm

The three large falls of the lower Genesee River are a combination of short walks and short drives. When shooting in this urban environment I would recommend not flashing a lot of expensive camera gear, especially in the area of the Lower Falls.

Lower and Middle Falls

Difficulty: Easy	Distance: .6 mile
Time: 30 minutes	Elevation Change: 80 feet

Directions: From any point on I-390 in Rochester, make your way to exit 22 and take Lexington Avenue east toward downtown. In 2.6 miles the road reaches a T at Lake Avenue. Turn left (north) and go one block (.1 mile); turn right (east) onto Driving Park and make an immediate left into a large parking lot at Maplewood Park. Do not park on the south side of Driving Park in the YMCA lot; you'll get towed or ticketed. GPS coordinates: 43° 10.925'N, 77° 37.822'W.

To view the fall's head, bear left of a large yellow building and look for a flight of stairs descending toward the river. If the access gate to the stairs is closed, head toward Driving Park Avenue and find a paved path that switchbacks down to the base of the stairs. When you descend a second set of stairs you will be able to see the Lower Falls veiled through the trees. Keep the river on your left, head upstream, and pass below the large Driving Park Bridge at .13 mile. You get a wonderful view of the geology underlying Rochester across the gorge. The exposed section of the gorge shows a large portion of the Clinton group of Rochester shales, dating to the mid-Silurian period about 410 million years ago. These redbeds are interspersed with layers ranging in color from pale tan to light green to purplish; when wet, they exhibit saturated colors that are almost otherworldly. You'll also note large buildings across the

gorge; below these are big tan cans jutting from the gorge walls. These are huge cable tendons imbedded in the cliff to keep the gorge walls from collapsing out from under these structures. It's quite a bit of engineering.

At .17 mile you arrive at the beginning of a large view area. Near the falls' side is a large structure in the gorge and huge water tank above. This is a hydroelectric plant and its surge tank. Keeping either out of frame will be very difficult. Continue along, bearing left at every path junction, and arrive at the best view at .31 mile near a sculpture titled *Remembering and Forgetting*. You can stand on some large rocks or work a short distance down a path through some foreground brush.

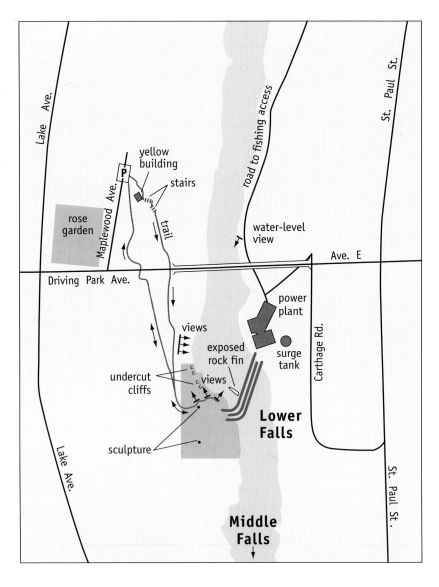

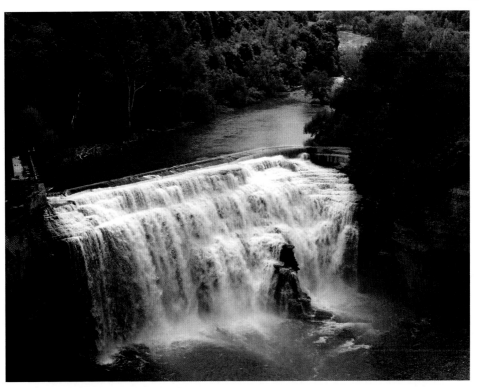

Lower Falls. There were some odd people on the bridge who spooked me, so I hand-held at a high ISO, shot through the fence, and then walked quickly back to my car. This image is heavily cropped from the original shot. *Canon EOS Digital Rebel, Tokina 20–35, Polarizer, ISO1600 setting, f/8 @ 1/640 sec.*

A short distance upstream is the Middle Falls, but I wouldn't waste any time with them since they've long been dammed and turned into the head-stock facility for the power plant at Lower Falls.

Return to the Maple Park parking area by following the paved path back the way you came, only now bear left and uphill toward Driving Park Avenue. When you pop out onto the street turn right and amble across the bridge, shooting the falls as you go. The black cyclone fence lining the bridge has smaller-than-normal holes that you can't shoot through, so hold the tripod high overhead and shoot over the fence. It will take some practice and you won't be able to take long exposures this way. Return to your car and prepare to head for High Falls.

There is a river-level fishing access from Seth Green Drive. A small parking lot is near Seth Green about 100 yards from the intersection with St. Paul. You can follow the power plant access road or a trail down to the river. Either way, you need to get well out onto a gravel bar near the Driving Park Bridge. In low flow you'll need waders and steady feet; in high flow there's no shot since you're confined to the river bank.

High Falls

Difficulty: Easy	Distance: .3 mile
Time: 30 minutes	Elevation Change: None

Directions: Exit the parking lot for Lower Falls, carefully turn left onto Driving Park Avenue, and cross the river. Just after crossing, turn right (south) onto St. Paul Street and follow it 1.4 miles to Ward Street. After you cross Bausch Street you'll start passing the Genesee brewery on the right. When the traffic light at Ward Street comes into view, look for a public parking area on the right opposite Ward. Make a quick right into this lot (which holds maybe six cars). GPS coordinates: 43° 9.795'N, 77° 36.763'W.

Exit the lot walking toward the river and turn right, going behind the Genesee plant (there will likely be several homeless people milling around) and then left onto a footbridge over the river. Shoot every few steps as you walk across the bridge. The bridge is a popular lunch spot and if you feel like a nosh try the Triphammer Grill across the river; have some locally brewed Nutbrown Ale. The city skyline and several bridges upstream must be made part of the image since they're impossible to eliminate. Normally we prefer overcast to shoot falls, but with the need to include the skyline here you'll want a cobalt blue sky day or twilight when the city lights will render nicely. Return to your car.

Other online and print guides list several other falls, such as Red Falls or Zoo Falls, dropping from the gorge walls into the Genesee. I've carefully sur-

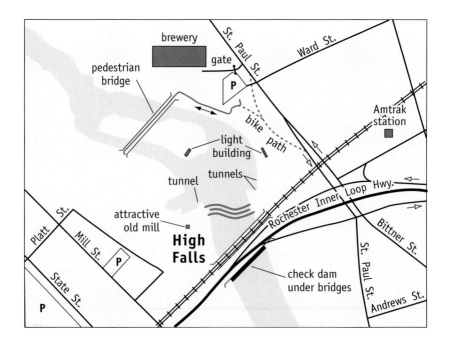

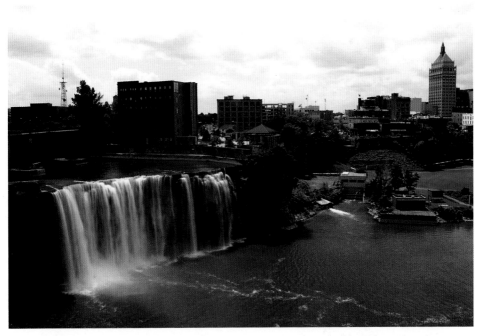

High Falls. I struggled quite a bit getting an image I was pleased with. Perhaps the urban nature of the location threw me off my game. If you can manage it, come here at twilight and work a nice evening sky into the scene. *Canon EOS Digital Rebel, Tokina 20–35, Polarizer, ISO100 setting, f/22 @ 1/6 sec.*

veyed them all and even in high flow they don't warrant the time necessary to shoot them. In fact, three of them are storm sewers that dump into existing falls and are thus trash-filled, along with having an interesting odor that's difficult to overcome.

Hike 108 Warsaw Falls, Wyoming County

Type: Cascade	Height: 85 feet
Rating: 5	GPS: 42° 43.947'N, 78° 9.134'W
Stream: Stony Creek	Distance: 1.6 miles
Difficulty: Easy	Elevation Change: 140 feet
Time: 40 minutes	Lenses: 17mm to 50mm

Directions: From the intersection of US 20A (West Buffalo Street) and NY 19 (Main Street) in the center of Warsaw, take US 20A west .2 mile and turn left onto Liberty Street opposite a school. In .5 mile turn right onto Jefferson (after passing a park) and park on the left at a dead end opposite a white house. GPS coordinates: 42° 44.031'N, 78° 8.453'W.

This popular swimming spot is a delightful creek walk and is a great hike for kids. I saw a number of mothers with their kids having a grand time in some of the deeper pools. If the stream is ankle deep when you first get to it you can just hop in and head upstream. If it's running deeper, say enough to swamp a pair of boots, a fording approach is in order since fighting the stream's flow for .8 mile gets old in a hurry.

Walk away from the road, passing behind a white house on the left. The path is a wide ATV-like trail and it sweeps right around a hill that funnels you into the creek. You can hop in or follow a drier route by turning right to head upstream on the creek's left-hand side (the side you're on). You'll arrive at a nice eight-foot slide at .12 mile.

Ascend the fall's left-hand side (your right) and follow a footpath in a side channel to the right where the creek sweeps to your left. This path, with a creek crossing at .17 mile, follows a roughly straight line up the steep-sided glen as the creek meanders to and fro. In low water the ford is simple; in high water it can run more than calf-deep, so take care.

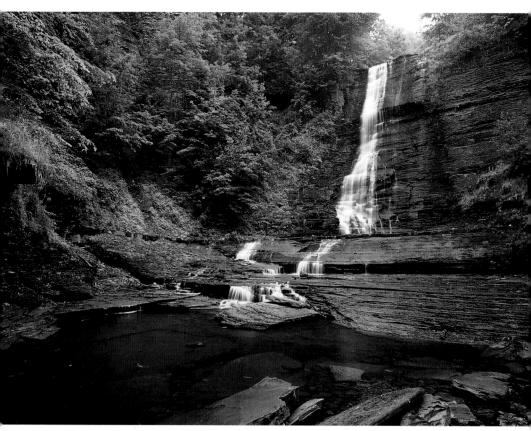

Warsaw Falls. You can imagine the color the trees on the left will take on come fall. Don't forget to shoot the creek as you approach. It's a wonderful location. *Canon EOS 5D MkII, Tokina 20–35, Polarizer, ISO100 setting, f/16 @ 4 sec.*

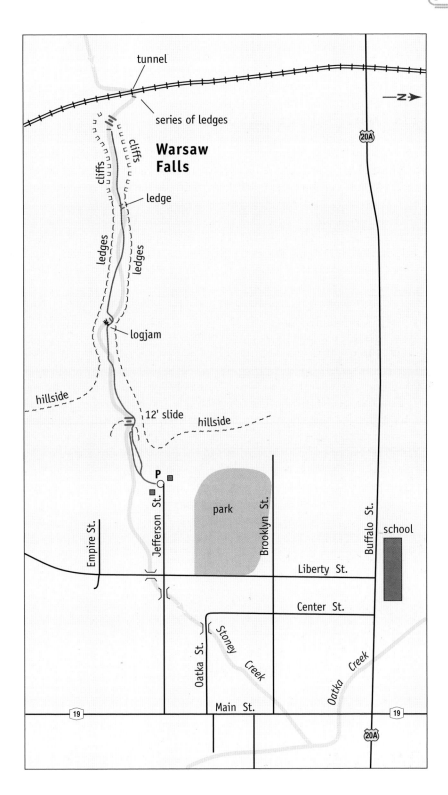

tunnel

series of ledges

cliffs

cliffs

Warsaw Falls

ledge

ledges

ledges

logjam

hillside

12' slide

hillside

P

park

Empire St.

Jefferson St.

Brooklyn St.

Buffalo St.

school

Liberty St.

Center St.

Oatka St.

Stoney Creek

Oatka Creek

Main St.

19

19

20A

20A

Just upstream I encountered a huge logjam that was a little dicey to get around. High banks on both sides had foot traffic scars that helped guide my way, but they were a challenge to climb. Going over the jam would have been easier but I had no mad desire to swamp my boots so early in the hike. (I returned with water shoes and it was much easier). The third crossing is at .26 mile and it has the potential for some deep hidden holes.

Now on the right-hand side, follow a well-defined footpath for as long as possible until forced to ford yet again at .38 mile. Take the higher path on the left-hand bank and drop into the creek again 50 yards later. Haul up and over a nice ledge at .44 mile. If you look closely at the creek's shale bottom you'll see oval mounds imbedded in the rock. These are solution deposits formed when voids in the underlying strata were filled by mineral-rich water. You'll notice them as sudden changes in pattern where parallel ripple marks are upset by round shapes.

The creek has climbed steadily throughout the hike, and with ledges creeping ever closer to become cliffs, your fording is over. From this last ledge to the falls it's a straight shot up the creek, which has stopped meandering. The driest approach is up the left-hand side; at .7 mile the 85-foot fall comes into view. Start shooting from here.

Tucked into a 90-degree turn, the cascade presents many different views as you move along. Dropping from the right-hand side of a wide, pale-gray cliff, the water wets maybe a third of the fall's face. This can be a problem since that leaves a large expanse of bright rock to deal with. Trees adjacent to the right-hand side crowd close to the watercourse and will make lovely fall colors when they go gold in autumn. Several large rock slabs make nice perches to work from. However, don't forget to look up to see where they came from. In this shale-based geology you should always look up to check for loose material. A railroad crosses just upstream and every twenty minutes a loud horn will sound, so don't be surprised.

Hike 109 Crow Creek, Wyoming County

Upper

Type: Cascade	Height: 8 feet
Rating: 4	GPS: 42° 48.963'N, 78° 15.211'W

Middle

Type: Cascade	Height: 54 feet
Rating: 5	GPS: 42° 48.975'N, 78° 15.226'W

Lower

Type: Cascade	Height: 11 feet
Rating: 4	GPS: 42° 49.024'N, 78° 15.225'W
Stream: Crow Creek	Difficulty: Difficult, steep scrambles
Time: 40 minutes	Elevation Change: 80 feet down to Lower Falls
Distance: .4 mile	Lenses: 20mm to 100mm plus macro

Directions: From the center of Attica and the intersection of NY 98 (High Street) and NY 238 (Main Street) near the railroad bridge, head east on NY 238 one block and turn right (south) onto Exchange Street. Follow Exchange south out of town 3.5 miles, passing the imposing edifice of Attica Prison in 1.3 miles; turn left onto Cascade Road. In .5 mile, park at a wide spot on the left near the end of a guardrail where the road makes an S-curve. There should be a large blue trash barrel chained to a metal pole marking the parking area. If you cross a creek there will be another wide spot next to the guardrail on the left. GPS coordinates: 42° 48.974'N, 78° 15.279'W.

This short hike, with its steep scramble, provided a painful reminder that western New York's shale-based geology is treacherous in the rain. The short switchback down to the middle fall's head is no big deal. The scramble into the deeper ravine below the lower fall ended up requiring a couple months of physical therapy.

From the parking area, walk down the wide trail a few feet to a Y and follow a switchback down and right into the creek at the middle fall's head. Walk upstream to the upper fall's base. This 8-foot cascade sits a few yards below the road bridge carrying Cascade Road over Crow Creek. You'll need to move around some and change tripod height to eliminate the concrete abutments from view.

Return to the Y and continue downstream on the trail another 60 yards and look for a good spot to scramble down. This descent location will place you below the lower drop. You may find knotted ropes tied to trees to assist your descent.

With a full pack of gear and tripod I opted to free descend using a network of roots. Having just gotten bifocals, I lost sight of my feet, hooked a toe on a root, and fell. Thus began a harrowing slide down the wet clay

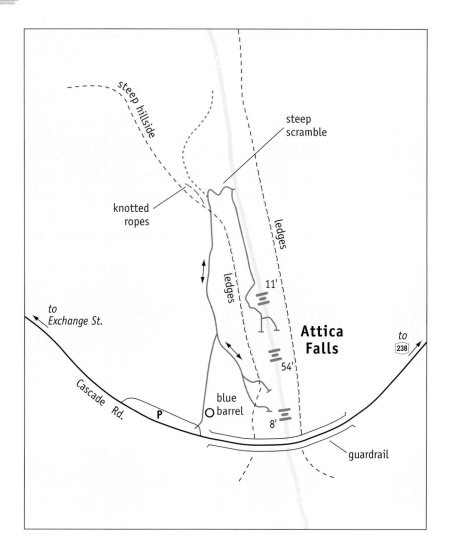

steep scramble

knotted ropes

steep hillside

ledges

ledges

11'

to
Exchange St.

**Attica
Falls**

to
238

54'

Cascade Rd.

P

blue
barrel

8'

guardrail

slope. This kind of thing has happened before without any consequence other than great embarrassment. This time, however, I landed on my right elbow, which drove my shoulder into my ear. Over the next several days my shoulder became rather sore and in a couple months I couldn't raise my arm to write on a blackboard. It turned out I had mangled the bursa and my shoulder joint had frozen. I got that taken care of just in time to start wrestling season, but quite frankly it just hasn't been the same since. It just goes to show that even minor things can morph into big things if you aren't careful. Please take your time descending this steep ravine.

Once you are safely in the creek, turn right and begin shooting as soon as you get a clear view of the lower and middle drops together. This is a wonderful spot for "the one lens drill." Using your favorite focal length, shoot a couple frames, walk forward a few feet, shoot again, and repeat until you're

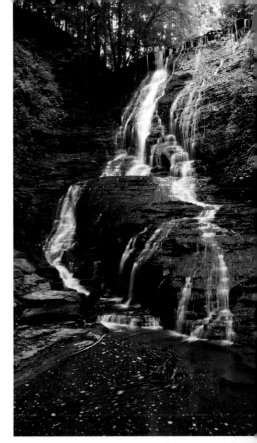

Middle Cascade. Extensive gardening was needed to clean debris from the plunge pool before shooting. You'll need to carefully check your viewfinder when shooting any portion of the creek. *Canon EOS Digital Rebel, Tokina 20–35, Polarizer, ISO1600 setting, f/22 @ 1.3 sec.*

at the foot of the large middle drop. Don't forget to shoot horizontals and verticals as you move along. Getting over the lower drop is quite easy if you stick to the soil edge on the right.

When you're done, return to your descent point and make the difficult scramble back to the trail. I had to use my tripod like an ice axe to keep my footing as I shifted my weight while climbing. I'd also recommend you explore the town of Attica, as there are some wonderful houses and trees to shoot. There are a couple more falls downstream of Attica Reservoir (closer to town) but they were heavily posted when I visited.

Hike 110 Clarendon Falls, Orleans County

Type: Cascade	**Height:** 22 feet
Rating: 3	**GPS:** 43° 11.503'N, 78° 3.956'W
Stream: Mill Creek	**Distance:** 100 yards
Difficulty: Easy	**Elevation Change:** None
Time: 5 minutes	**Lenses:** 20mm to 70mm

Directions: From the center of Holley at the intersection of NY 31 (West Albion/Wright Street) and NY 237 (Main Street), take NY 237 south out of town 3.2 miles to the town of Clarendon; bear left as you enter the town to keep with NY 237. Park on the right in Clarendon Veterans Park. GPS coordinates: 43° 11.520'N, 78° 3.942'W.

Like its sister to the north (Hike 111), this nice little fall is located in a well-kept town park. The fall is visible from the parking area. Head across the wide lawn toward the fall and set up in the tailwater on the fall's right-hand side. This delightful fall is also known as Farwell's Mill Fall, named after the first white settler in the area. He built a sawmill in 1811 and then a gristmill in 1813. The white house above has no relationship to the mills.

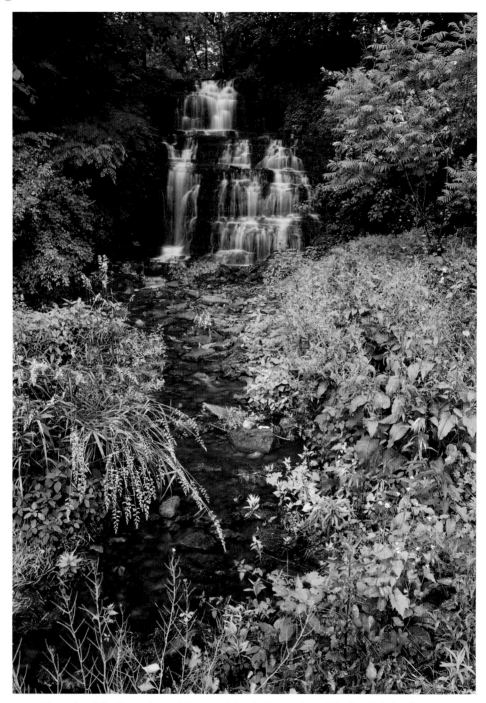

Clarendon Falls. You only need to move thirty feet to go from this view to being face-to-face with the pleasing cascade. *Canon EOS 5D MkII, Tokina 20–35, Polarizer, ISO100 setting, f/25 @ 2 sec.*

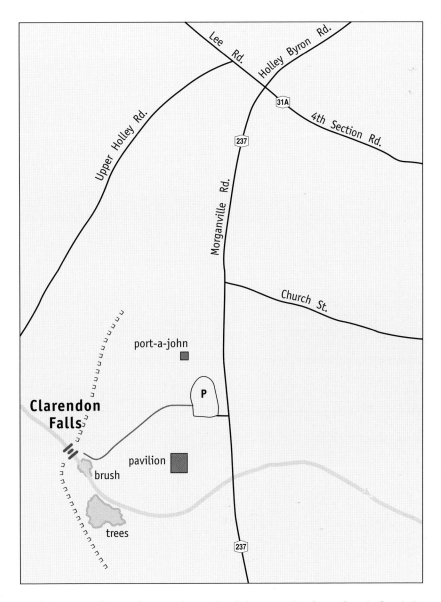

This seasonal cascade spends much of the year dry, but when I shot it in June there had been several days of good soaking rains. There's a pavilion nearby so pack a lunch and sit for a spell. The fall drops over a long scarp face that parallels NY 237 for several miles and is the same basic feature that Holley Falls drops over. Since it faces east you may be able to get a unique image of the fall illuminated by the rising full moon. A typical full moon exposure for ISO 100 would be about 32 minutes at f8 or 128 minutes for f16. Since the park is open 6 A.M. to 10 P.M. it will take a little planning to keep such a shot legal.

Hike 111 Holley Canal Falls, Orleans County

Type: Fall	**Height:** 25 feet
Rating: 4	**GPS:** 43° 13.515'N, 78° 1.148'W
Stream: Tributary to E. Branch of Sandy Creek	**Distance:** 50 yards
Difficulty: Easy	**Elevation Change:** None
Time: 10 minutes	**Lenses:** 28mm to 70mm

Directions: From the center of Holley at the intersection of NY 31 (West Albion/Wright Street) and NY 237 (Main Street), take NY 31 (Wright Street) southeast away from Albion Street. Turn left onto the third street, which is Frisbee Terrace, and follow it downhill past the food market. Bear right past a green water company building and follow a small sign for a park. The road ends in about 100 yards near the falls. GPS coordinates: 43° 13.526'N, 78° 1.182'W.

This is a great little public park with a nice picnic pavilion, ample parking, and well-kept surroundings. On any spring day you'll see parents teaching their kids to fish in the small pond at the fall's base, kids scampering about hither and yon, and the occasional young couple. Walk over to the falls, approaching it on your left, and find a nice spot. Work both sides of the pond and watch this delightful fall change character as you move around. If it's going to be a blue-sky day, get here before 9:00 A.M. while the fall is in shadow. The fall runs with power all year long since it's fed by the canal. Fall color is particularly nice. Enjoy!

Holley Canal Falls. There will be people fishing from either bank close to the fall. Be patient, have a snack, and let them do their thing. *Canon EOS Digital Rebel, Tokina 20–35, Polarizer, ISO100 setting, f/16 @ 1/4 sec.*

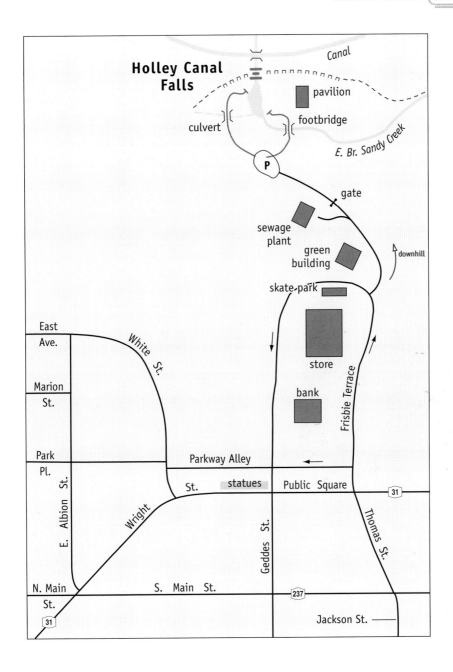

Holley Canal Falls

Canal

pavilion

culvert

footbridge

E. Br. Sandy Creek

P

gate

sewage plant

green building

downhill

skate park

store

bank

Frisbie Terrace

East Ave.

White St.

Marion St.

Park Pl.

Parkway Alley

E. Albion St.

St.

statues

Public Square

31

Wright

Geddes St.

Thomas St.

N. Main St.

S. Main St.

237

Jackson St.

31

Hike 112 Waterport Falls, Orleans County

Type: Slide	**Height:** 48 feet
Rating: 4	**GPS:** 43° 19.662'N, 78° 14.203'W
Stream: Oak Orchard Creek, Waterport Pond	**Distance:** 1.2 miles
Difficulty: Easy	**Elevation Change:** 80 feet
Time: 40 minutes	**Lenses:** 28mm to 70mm

Directions: From the intersection of NY 104 (Ridge Road West) and NY 279 (Gaines-Waterport Road) in the village of Gaines, take SR 279 north toward Waterport. In 2.3 miles NY 279 curves left and Park Avenue, a smaller road, heads straight. Bear right and take Park Avenue north .3 mile. As soon as you pass a power substation on the left, look for a DEC-signed parking area for Oak Orchard Fishing Access. Turn left and park in the huge stone parking area. GPS coordinates: 43° 19.585'N, 78° 14.057'W.

This fall is the power plant spillway. Since the plant consumes all the water for most of the year, this large fall rarely runs. I've only seen two pictures of it at full flow and it's spectacular, but I've never seen it running myself even though I went during a very wet period when they were re-releasing water from other dams in the region. I hope you get to see it run. To check if the falls is running, head to the end of the huge parking lot, hop

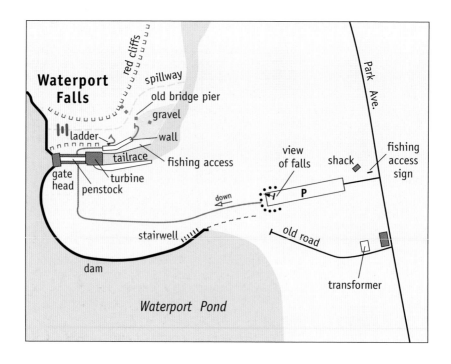

one of the bigger boulders, and look at the red-brown gash to the right of the plant. If the falls are running you will hear it and see it from here. If it's not, go find something else to do.

If the falls are running, follow the wide gravel road to the power plant, which you will approach on the right (the dam's side of the plant). Separating the plant's surge basin channel and the spillway channel is a massive concrete pier; that's where you want to be. Head for the back of the plant closest to the hill and turn right to walk behind it, and then right again to get to the pier. Close to the plant, but on the spillway side, look for an iron ladder descending to the spillway. If the water level is low enough that you can see rocks and a route along a gravel bar facing the fall, then climb down and work to the gravel bar. Bear in mind that the ladder ends near a deep pool. Slip, drop your gear, or stumble, and you'll be having a very bad day. If the water level in the spillway channel affords no safe access to the gravel bar, head to the end of the pier and work from there.

Hike 113 Medina Falls, Orleans County

Type: Fall	Height: 40 feet
Rating: 5	GPS: 43° 13.322'N, 78° 22.982'W
Stream: Oak Orchard Creek	Distance: .4 mile
Difficulty: Easy	Elevation Change: 60 feet
Time: 20 minutes	Lenses: 28mm to 70mm

Directions: From the center of Medina at the intersection of NY 63 (Center Street) and NY 31 (Main Street), take NY 31 east toward the canal .3 mile and turn left onto State Street. Ahead of you is an imposing steel truss bridge over the canal; turn left onto Horan, cross the wide canal, and then make an immediate left onto Laurel, a small side street. There's a small gravel parking area with space for two cars within sight of an information kiosk next to the canal. Warning: There's no parking bumper, so if your brake slips your car will roll into the canal. Park facing the bushes. GPS coordinates: 43° 13.370'N, 78° 22.916'W. Alternate parking is up the canal. Turn right off the bridge onto Horan and go about .2 mile to a large parking area on the right. GPS coordinates: 43° 13.535'N, 78° 22.817'W.

Walk away from the small information kiosk near the end of the Horan Street Bridge on a wide concrete path, keeping the canal on your left. The falls are about .1 mile from the kiosk. Looking ahead you'll see the canal walls standing well above grade. The large canal passes over Oak Orchard Creek and the canal drains into the creek upstream of the falls. For this reason the falls thunder all year long. The fall soon comes into view below on the right. Look for a rickety makeshift ladder lashed to the canal handrail;

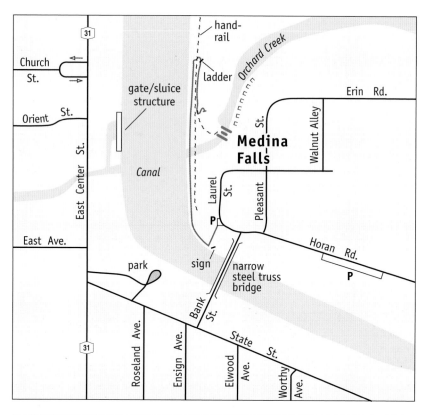

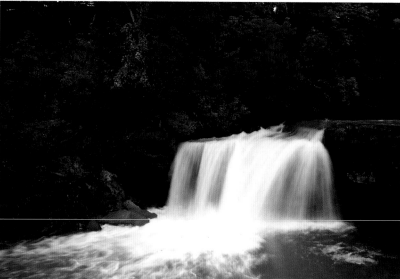

Medina Falls. The curve of the cliff allows for a number of possibilities. Here I've emphasized early fall color by shifting the waterfall off-center. *Canon EOS Digital Rebel, Tokina 20–35, Polarizer, ISO100 setting, f/16 @ .4 sec.*

this is your way down. Ever so carefully ferry your gear down and then climb the few feet yourself. Try not to tumble down the steep mound at the ladder's base and bear right on a prominent footpath. In a few dozen yards you come to a rocky shooting perch with a perfect view of the falls. You can work from lower down but spray will be an issue.

A note of caution: The grass around the shooting perch can be quite slippery. A stumble will send you quite a ways down onto rocks you can't see from above. This is the kind of thing that could ruin your day. In dry weather a white concrete retaining wall that channels the flow over the fall will render as a blown-out highlight. If that's the case you need to crop this out as best you can or shoot what's called a high dynamic range series of frames, merging them in Photoshop. If it's raining, don't worry: compose wide and blast away, although if you go too wide, foreground brush will tarnish the image's lower right corner.

Hike 114 Royalton Fall, Niagara County

Type: Slide	**Height:** 14 feet
Rating: 3	**GPS:** 42° 10.897'N, 78° 35.192'W
Stream: East Branch Eighteen Mile Creek	**Distance:** 1.9 miles
Difficulty: Easy	**Elevation Change:** 60 feet
Time: 50 minutes	**Lenses:** 28mm to 70mm

Directions: From the center of Lockport (which is northeast of Buffalo), take NY 31 (Walnut Street) east out of town. In 3.3 miles you will come to a Y where NY 31 (Rochester Road) bears left and NY 77 (Chestnut Ridge Road) bears right; follow NY 77. In 2.3 miles turn left onto Mill Road and then in 1.4 miles go left at a T onto Gasport Road. The park entrance will be on the left in .3 mile. GPS coordinates: 43° 11.179'N, 78° 34.630'W.

The full name of the park is the Victor A. Fitchlee Royalton Ravine Gasport Conservation Education Park—now that's a mouthful. This 146-acre facility has a couple picnic shelters and is a popular family gathering spot. It's a nice walk, especially for kids, but unfortunately the fall is quite seasonal and runs with power only for a short period in the early spring.

Leave the parking area and follow a pole line away from the road that heads for the woods in the distance. You'll pass a large pond on the left and enter the woods on a wide, groomed path with the occasional orange blaze. As the trail swings left, look for a side trail right at .2 mile and turn right. Shortly after you will come to a Y where left is heavily used and right is a grassy path; bear left downhill on a flight of wood stairs. When you bottom

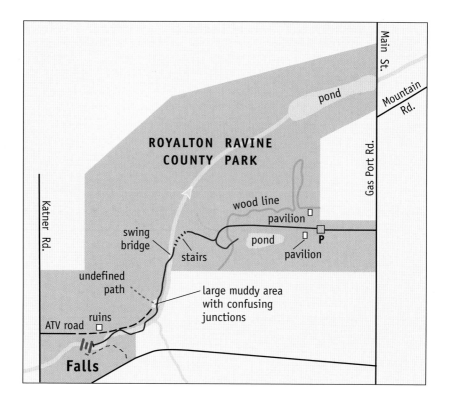

out you come to another Y where right drops into the creek and left does not; bear left and stick to a muddy, root-infested trail above the creek.

A cable bridge is found at .35 mile. Cross it and turn left to follow the creek on a blue blaze. At .47 mile the foot trail opens up into a large muddy area eroded by heavy ATV usage. If you continue on the trail it eventually widens to a road and takes you easily to the fall's head with no way down. Instead turn left and head for the creek; then turn right to hold the left-hand bank (the side you're on). The ravine walls run fairly straight while the creek meanders within it, creating a series of fords. As you head out, look for an illegal ATV trail on the wide bank and use it. The ATV trail crosses the creek three times and provides the best access. You'll arrive at .88 mile.

A boulder choke creates the fall's plunge pool and large amounts of gravel effectively weld the mass together. Some overhanging trees mean you'll shoot from the creek's right-hand side near the tailwater outlet. Don't forget to bring a trash bag to remove all the beer cans you'll find. ATV riding is apparently thirsty work.

Hike 115 Indian Falls, Genesee County

Type: Cascades	**Height:** 22 feet
Rating: 4	**GPS:** 43° 1.582'N, 78° 23.978'W
Stream: Tonawanda Creek	**Distance:** 50 yards
Difficulty: Easy	**Elevation Change:** None
Time: 10 minutes	**Lenses:** 28mm to 100mm

Directions: From I-90 exit 48A for NY 77, turn left onto NY 77 North toward Indian Falls. In 1.7 miles turn left onto Gilmore Road. Just after the turn, park on the right in the large parking lot for the Indian Falls Log Cabin Restaurant. GPS coordinates: 43° 1.591'N, 78° 23.967'W.

Indian Falls is a big fall but a very tough shoot; in fact I never did get anything I liked from my three visits. Restricted by foreground brush and the restaurant's footprint, the best shooting position is not accessible since it's on the restaurant's back deck. If you're here during off hours, respect the owner's property rights and don't step onto the deck. If they're open, ask in advance before setting up. They get many such requests and it's appropriate to order lunch or dinner (both are quite good). Several trees across the creek become a vibrant red in early fall and contrast well with other trees that are still green. You might see bathers in the creek; recognize that the whole creekshed is posted land so keep to the high banks on the parking-lot side.

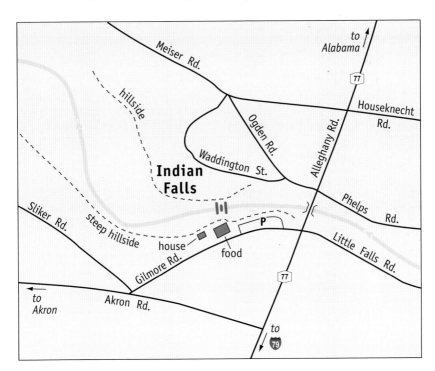

Hike 116 Akron Falls County Park, Erie County

Lower Akron Falls

Type: Fall	Height: 35 feet
Rating: 4	GPS: 43° 0.945'N, 78° 29.056'W

Upper Akron Falls

Type: Fall	Height: 15 feet
Rating: 0	GPS: 43° 0.945'N, 78° 29.050'W
Stream: Murder Creek	Distance: 150 yards
Difficulty: Easy	Elevation Change: 50 foot descent
Time: 15 minutes	Lenses: 28mm to 50mm

Directions: From I-90 exit 48A for NY 77, turn right onto NY 77 South toward Brick Corners. Go .7 mile and then turn right onto NY 5 (Main Road); if you pass Pembroke High School you went too far. Take NY 5 west 3.7 miles and then turn right onto Crittenden Road (CR 8). Take Crittenden north .9 mile and turn left onto Skyline Drive. Then bear right into the park and park next to the bathrooms (Comfort Station 4 on the park map). GPS coordinates: 43° 0.909'N, 78° 29.102'W.

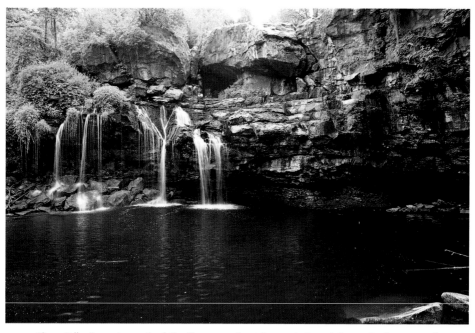

Akron Falls. I'm not sure the fall will ever run from the central precipice again. A stone wall above the fall gave way some time ago and now water flows through a series of fractures, dropping over the ledges you see here. This is unfortunate because old photos of the fall are incredible. Perhaps at some point the county will make a repair and you'll get lucky. *Canon EOS 5D MkII, Tokina 20–35, Polarizer, ISO100 setting, f/8 @ 1/6 sec.*

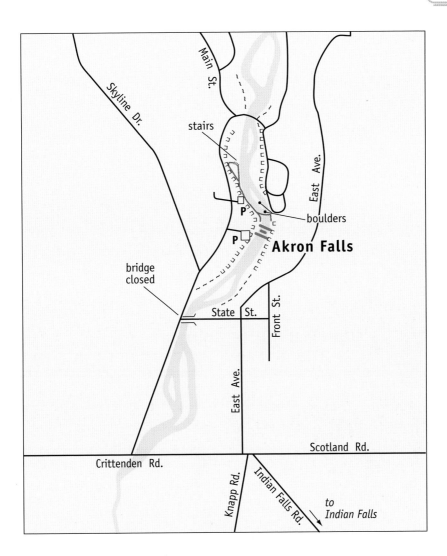

Oh how frustrating this location is! Three times I came here, twice during epic rainfall, and never was the fall running. The creek wasn't just dry; it was bone dry with no evidence of having seen water in months. Even a creek with standing water will have living algae blooms in the shallows. Not here: the dried algae mats were a stinky brown mass covered in a fog of flies. This may not sound like an endorsement; however, based on images I've seen on Panoramio.com, when the falls run it is epic.

Head downhill a few yards from the parking area to a staircase that drops right toward the creek; follow the paved path down. When you get to a Y bear right. The trail dead-ends at a viewpoint. To get to the fall's tailwater, bear left from the Y and quickly arrive at the creek. Turn right and head

upstream. Massive Silurian sandstone boulders fill the stream in stark contrast to the limestone bedding the creek above. The primary drainage channel is to your left and in high flow this hits an intermediate platform, fanning to twice the starting width.

I tried unsuccessfully to get to the upper drop, a short distance upstream of the lower drop. There's a mowed path on the north side of the State Street Bridge (about 100 yards before the park entrance). The path braids some and eventually dead-ends at a wall of sticker bushes. There was a path to the upper drop at some point, but no longer. I recommend that you don't bother.

A note of caution: There is ample signage warning people to stay out of the creek. If you do work from the tailwater area you may be subject to fines, although I would doubt that would happen. In speaking with a maintenance person he indicated that the problem was swimmers and drunks.

Hike 117 Glen Park, Erie County

Glen Falls

Type: Cascade	Height: 30 feet
Rating: 4+	GPS: 42° 57.837′N, 78° 44.660′W
Stream: Ellicott Creek	Distance: 200 yards
Difficulty: Easy	Elevation Change: 20 feet
Time: 20 minutes	Lenses: 50mm to 100mm

Directions: From the junction of I-90 and 290 near the Buffalo International Airport, take I-290 north to exit 7B for NY 5 (Williamsville) and head east on NY 5 for .9 mile. Make a left onto narrow Rock Street; a firehouse marks the turn. In two blocks you will come a T; turn right onto Glen Avenue, cross Ellicott Creek, and park on the left in a large parking area. GPS coordinates: 42° 57.966′N, 78° 44.658′W.

This town park is popular with wedding photographers, and with good reason: it's a gorgeous spot. From the parking area adjacent to the bathrooms, cross Glen Avenue and wander over to the handicapped-accessible view area, which provides a nice view of the fall. From here you'll have to carefully frame the shot to keep the NY 5 bridge and adjacent steel fencing out of the way. Head up a gravel path adjacent to a large retaining wall holding the creek's left side. Good shooting is possible from any spot on the wide wall and from the fence as well. The wall is about six feet above the stream bed; with the creek so channelized the water below will be moving quite

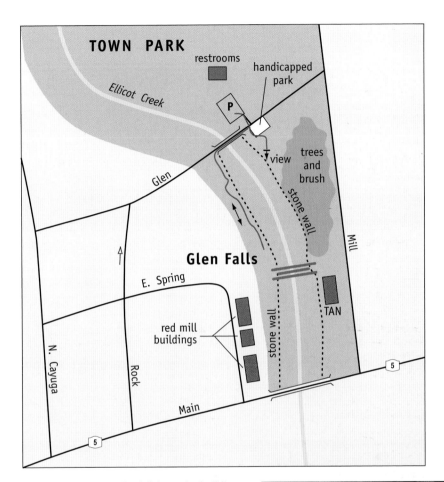

TOWN PARK

restrooms

handicapped park

Ellicot Creek

P

Glen

view

trees and brush

stone wall

Mill

Glen Falls

E. Spring

red mill buildings

stone wall

TAN

N. Cayuga

Rock

Main

5

5

Glen Falls. To isolate the fall from the buildings, work from downstream with a long lens and shoot horizontals and verticals. As you move right and up the wall, a tan building on the upper left will become very prominent. *Canon EOS Digital Rebel, Tokina 20–35, Polarizer, ISO1600 setting, f/29 @ 1/40 sec.*

swiftly. As you get closer to the fall, a tan building above on the left becomes much more prominent. If you have an opportunity to work from the creek, which is open to fishing, the building will not be an issue but the bridge will. All in all this is a nice spot and a nearby bagel shop just makes it so much better.

Hike 118 Niagara Falls, Niagara County

American Falls

Type: Fall	Height: 183 feet
Rating: 5+	GPS: 43° 5.120′N, 79° 4.136′W

Bridal Veil Falls

Type: Fall	Height: 181 feet
Rating: 5+	GPS: 43° 5.020′N, 79° 4.219′W

Horse Shoe Falls

Type: Fall	Height: 173 feet
Rating: 5+	GPS: 43° 4.637′N, 79° 4.486′W
Stream: Niagara River	Distance: Variable
Difficulty: Easy	Elevation Change: Variable
Time: All day	Lenses: 28mm to 110mm

Directions: Find your way to I-190 north, following signs for Niagara Falls. Cross Grand Island; as you descend from the North Grand Island Bridge, pay very close attention to the road signage. Get off at exit 21 for NY 384 and Robert Moses Parkway. As you come down the ramp, continue bearing right around the cloverleaf, passing under the bridge and now running parallel with the Niagara River on the left; merge carefully on the Moses Parkway. Stay on the Parkway for about 4 miles, passing by the exit for Rainbow Boulevard, until it ends at the fall's main parking lot. Pay the $10 entrance fee to park. GPS coordinates: 43° 5.226′N, 79° 3.946′W. This lot can fill quickly. There's additional parking at Rainbow Center, which is bordered by Niagara Street and Rainbow Boulevard. There's also on-street parking on the Moses Parkway as you pass under the NY 384 exit. There are two large lots on Goat Island as well. Just take your time on a crowded day; everybody else will be trying to navigate in an unfamiliar town just like you are.

Henry James said of Niagara Falls, "I have seen the falls in rapture and amazement." I would agree. The best source for information about getting to and finding parking for the falls is on the Web; consult the state park's site at www.niagarafallsstatepark.com. I also recommend investing in the Discovery Pass, which gets you into several attractions; however, the Cave of the Winds and Maid of the Mist are separate from the park.

Expect large crowds. As many as 12 million people visit the falls each year and everybody wants that postcard shot from close to the rail just as you do. The best shooting position is from Canada, which I didn't do. You need a passport or special federal ID to get into and out of Canada now. I didn't get a passport so I shot from the U.S. side. My wife and I came here for our anniversary in 1992 and I do remember how crowded it was on the Canadian side.

When I came back to work on this project I timed it so I was here mid-week while New York schools were still in session, so there were fewer people. What I found were crowds of polite, pleasant, happy people doing their own thing. What I had forgotten though was the raw power of the falls. Grab any bit of handrail at American Falls or sit on the ground and you can feel it vibrate. It's pretty amazing, but that's not surprising: in summer 100,000 cubic feet per second goes over the falls.

I walked everywhere. I wandered from the main lot up to the Geology Museum, over to Terrapin Point, to the south point of Goat Island, and everywhere else in between. I walked about seven miles and spent roughly four hours doing it, including stopping at every view and reading every sign. If you have a good set of legs, walk the gorge trail under the Friendship Bridges and beyond. You may want to drive up to Whirlpool Park and you should definitely visit Joseph B. Davis State Park at the edge of the Niagara Escarpment. Also, bring a good geology guide along. I'm fond of Van Diver's book, but I encourage you to find materials more specific to the Niagara gorge's geology. Niagara is one of the places that provided the first, best estimates at how old the Earth could be—the migration of the falls from the escarpment was calculated to have taken about 12,000 years.

Rocks Below American Falls. The most powerful tool for dealing with poor light and conditions is creativity. By going with a long lens and isolating the rocks through spray you can create a unique view. Thinking graphically can save the day when conditions aren't perfect. *Canon EOS 5D MkII, Tamron 28–200, Polarizer, ISO100 setting, f/5.6 @ 1/13 sec.*

Niagara Falls. Don't miss the illumination, which gets better as the night wears on. *Canon EOS 5D MkII, Tamron 28–200, Polarizer, ISO100 setting, f/8 @ 15 sec.*

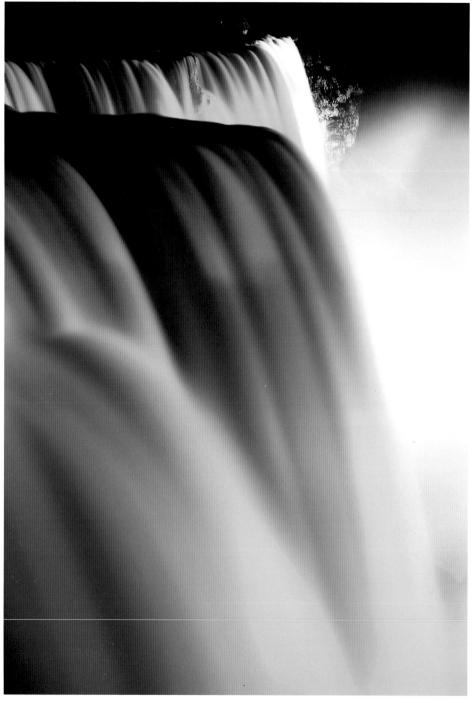

American Falls. From the American side, work graphic compositions with a long lens. The colors change about every ten minutes.

The falls are exceptionally hard to shoot during daylight from the American side. You can get nice keepsakes, albeit nothing that would make an editor swoon. The absolute best shooting is at night. The illumination runs from 9:00 P.M. to midnight from May 1 to August 13. Times vary the rest of the year based on local sunset. The colors become more saturated as the night wears on so stay late.

A good spot is as you approach the Observation Tower (a paid attraction). Bear left and set up along the handrail among the several telescopes. From here you can see all the falls in profile and shoot fun graphic patterns. If the Observation Tower is open at night (which it was supposed to be when I went), get there early and stake out a good spot. It will cost a couple dollars but it's worth it.

In short, take your time and do everything: visit the power plants, go to Canada and ride the Spanish Aero Car, visit the Ripley's Museum. For me Niagara isn't about the camera, it's about being a tourist. Have fun, go play, and bring the family.

Hike 119 Eternal Flame Falls, Erie County

Type: Cascade	**Height:** 22 feet
Rating: 2–3	**GPS:** 42° 42.088'N, 78° 45.146'W
Stream: Shale Creek	**Distance:** 2.0 miles
Difficulty: Easy	**Elevation Change:** 110 feet descent
Time: 1 hour	**Lenses:** 50mm to 100mm

Directions: From US 219 south of Buffalo, exit onto NY 391 (Boston State Road) South for Hamburg and Boston. In .75 mile turn left onto NY 277 (Herman Hill Road). This wide road changes names to Boston Ridge Road after you cross South Abbot Road. Stay on NY 277 as it climbs the ridge for about 1.6 miles and make a hard left onto Seufert Road, which joins NY 227 at an acute angle. Pass a house on the right and in 50 yards park in a wide area on the right. There will be an extensive array of "No Parking" signs on the left. GPS coordinates: 42° 42.008'N, 78° 45.158'W.

Eternal Flame Falls takes its name from a little flame created by gas seeping through the shale lamina of the fall's face. A small niche has been carved into the fall's lower left-hand side (your right) so water will cascade over the flame. Blue haze fills the small ravine and the odor of rotten eggs overtakes the pleasant smell of the pines flanking the fall. Shale Creek has a very small drainage basin and is quite seasonal. The creek is fed from a pond near Ward and Chestnut Ridge roads; if the pond is not overflowing the fall runs quite weakly.

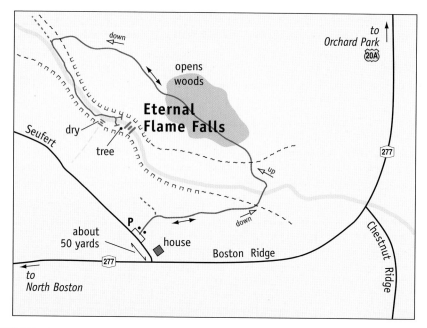

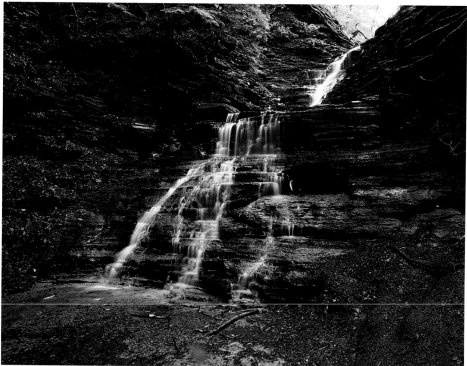

Eternal Flame Falls. The flame will glow dull orange and lick up the niche's left side no matter what the weather. Move a couple feet left to get the flame out of view. *Canon EOS 5D MkII, Tokina 20–35, Polarizer, ISO100 setting, f/16 @ 20 sec.*

Begin your short hike by heading down a wide gravel road. In a few yards the road swings right and a blue-blazed foot trail breaks left into the trees. Stick with the road and head right. A little farther on you will arrive at an information kiosk. To reach the fall, follow the blue rectangular blazes. At .1 mile you will cross the run, which during my first visit in August was barely a trickle. If water doesn't at least run over your boot toes the fall won't be photographable.

After climbing out of the run you enter a hemlock grove at .14 mile. Here the trail becomes braided in the open sandy forest. Keep to the left in the grove and look for blazes about 10 feet off the ground—an indication of the amount of snow the area receives. At .25 mile the trail bears left and drops into a small glen. As you bottom out, look for a trail left that drops into the creek. There is one blue blaze but an orange one nearby is easier to spot. If you miss this that's okay; just hop into the creek and turn left to head upstream. You'll arrive the fall at .52 mile.

The color, pitch, and loamy soils surrounding the fall remind me of many falls in my home state of Pennsylvania. Sitting low to your right is the dull orange glow of the eternal flame; to hide it, set up to the left, and to make it prominent, set up right. If the flame is out, bring a lighter and paper to reignite it. Take great care since gas will hang near the niche. It's best to keep your hand out of the niche lest you lose your arm hair.

Hike 120 Franklin Gulf, Erie County

Type: Cascades	**Height:** 24 feet
Rating: 3	**GPS:** 42° 36.386'N, 78° 54.400'W
Stream: Tributary of Franklin Gulf	**Distance:** 2.0 miles
Difficulty: Moderate	**Elevation Change:** 440 feet
Time: 1 hour	**Lenses:** 50mm to 100mm

Directions: From the intersection of US 62 and NY 249 in the town of North Collins, take US 62 (North Gowanda Street) north .2 mile and turn right onto School Street (passing the high school on the right). Follow School Street east 2.1 miles to the intersection with multi-signed Larkin Road, Rodger Road, and Ketchum Road. Turn left to head north onto Larkin Road. In .7 mile park on the left where Larkin Road makes a slight jog to the left and then back to the right. GPS coordinates: 42° 36.528'N, 78° 54.111'W.

There are actually four falls in the park, but three are just a few feet high and not worth noting as real falls. What makes Franklin Gulf so special and worth your time is the delightfully photogenic stream that descends about 100 feet to join Franklin Gulf and then Sister Creek. This county park

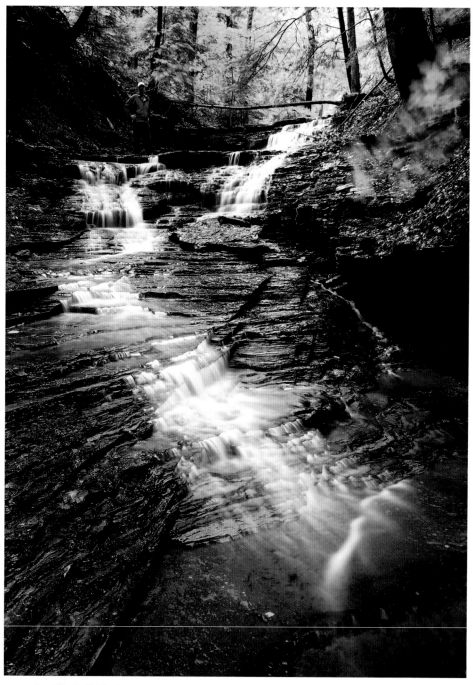

Franklin Gulf. I had never seen any photographs of Franklin Gulf, so my expeditions were designed to shoot as much as I could. This is one of more than one hundred images of just this 50-yard section. Fill every memory card you have—it's that nice a location. *Canon EOS 5D MkII, Tokina 20–35, Polarizer, ISO100 setting, f/18 @ 30 sec.*

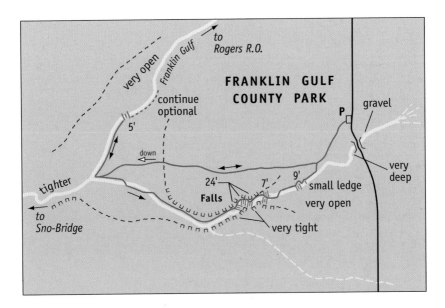

doesn't appear on Erie County's Web site because technically it's undeveloped. There are several blazed trails and two substantial snowmobile bridges that were built by local snowmobile enthusiasts. If you get here in winter, bring snowshoes and plan on having a grand time.

From the parking area, walk up Larkin Road a few feet and cross to the far side to where a culvert carries the unnamed stream under the road; hop into the creek. Unless there's enough water to cover your boot toes, neither creek you'll be exploring will have enough water to make it photogenic. Normally that would be a dealbreaker for me but this place is great fun even when relatively dry. Head back to the parking area and follow a red-blazed trail into the woods .7 mile to where it joins the confluence of two creeks. The creek to your left has the 24-foot drop and is the one you checked out earlier. To your right is Franklin Gulf.

Turn right (upstream) into Franklin Gulf and keep to the shallows, arriving at a little five-foot slide at .9 mile. I include this little side excursion to get you comfortable with working the creek and its slippery, flat bottom. Return to the confluence at 1.1 miles. Sitting .2 mile downstream from here is a large bridge with a small three-footer nearby, but don't bother with that. Instead head upstream along the other channel to your left.

You'll arrive at a series of three drops, totaling around 24 feet, at 1.5 miles (about ten minutes up from the confluence). The creek is rather narrow here and the ravine sides quite steep. I was able to scramble up the creek's left-hand side (your right) using every exposed root I could find.

The creek widens considerably above the fall and remains wide until you hit a nine-foot cascade at 1.6 miles. This fall is divided by an island and has a smaller twin on your left. To get around this drop, go straight up the

island's center. No other drops are found from here to the road. If you stick with the creek the channel will narrow within earshot of the road but its depth will make it impassable. Turn left to exit the creek. With your back to the water, bushwhack a dozen-plus yards to the red trail. You'll be between 50 and 100 yards from the road. Now turn right and return to the parking area at 2.1 miles.

A number of "gulfs" flow west off the plateau into Sister Creek, several of which have interesting names such as Hyssey Gulf and Branch Gulf. All are on private land and heavily posted. Regardless of what intriguing features you see on maps of the North Collins area, Franklin Gulf is the only public facility in the vicinity.

Hike 121 Walnut Creek Falls, Chautauqua County

Type: Cascade	**Height:** 25 feet
Rating: 4	**GPS:** 42° 28.167'N, 79° 10.906'W
Stream: Walnut Creek	**Distance:** 50 feet
Difficulty: Easy	**Elevation Change:** 280 feet descent
Time: 10 minutes	**Lenses:** 50mm to 100mm

Directions: From I-90 exit 59 for Dunkirk and Fredonia, take NY 60 south (Bennet Road) towards Fredonia. Follow it .6 mile and turn left onto US 20 East for Cook Corners and Sheridan. In 2.1 miles turn right onto NY 39 (Fredonia Road). Follow the ramrod-straight NY 39 east 4.8 miles to Forestville and turn left onto Walnut Street. If you cross a large bridge over Walnut Creek you went 50 yards too far. Park opposite house number 6 on the right near a blue gas-line marker. GPS coordinates: 42° 28.164'N, 79° 10.910'W.

Walk along Walnut Street until you find the best view and shoot away. Situated at a jog in the creek, the fall sits at about a 45-degree angle to the road, providing a clear view. Roadside falls typically have some kind of view restriction but this one is pretty clear. I'm sure there's a way into the tailwater area; I'm also sure it's heavily posted, so it's best to just work from the road. The 25-foot drop is shaped like a large Y where the creek divides above and merges at the plunge pool. In summer's heat most of the flow will be to your right, so set up as far left as possible. In spring runoff the full veil will be filled, with the lion's share coming from your right. The fall's middle tier allows the water to slide across the fall's face and fill it. If the creek above is less than full, the uppermost stone slab will have a pale mud patina that will render as a bright highlight. Take care with your exposure and hope for rain to wet the entire area. Also, trees on the right will be on the dark side in the morning and bright in the afternoon.

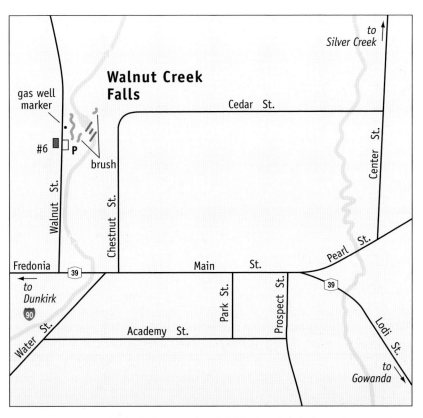

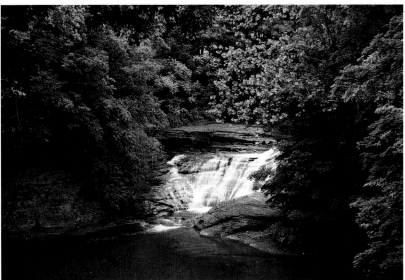

Walnut Creek Falls. A gravel bar fills the foreground; for this shot I cropped it out. This feature, open to the sky, will be a couple stops brighter than anything else in the scene and thus a distraction to the viewer. *Canon EOS 5D MkII, Tamron 28–200, Polarizer, ISO100 setting, f/16 @ .6 sec.*

Hike 122 Arkwright Falls, Chautauqua County

Type: Cascade	**Height:** 12 feet
Rating: 3	**GPS:** 42° 23.537′N, 79° 16.119′W
Stream: Canadaway Creek	**Distance:** 3 miles
Difficulty: Easy	**Elevation Change:** 280 feet descent
Time: 1 hour, 30 minutes	**Lenses:** 28mm to 100mm plus macro

Directions: From I-90 exit 59 for Dunkirk and Fredonia, turn left onto NY 60 South (Bennet Road) and go 3.2 miles. Turn left onto NY 83. In 1.6 miles turn right onto gravel Miller Road at a small cemetery in the village of Cowdens Corner. Take Miller .5 mile and turn left onto gravel Ball Road. (You'll pass Brainard Road just before the turn.) Park at a wide spot on the right in .5 mile, just as the road crests a small hill. Ball Road is not maintained in winter and is officially closed from November 3 to April 1. All roads are improved gravel and okay for small passenger cars. GPS coordinates: 42° 24.106′N, 79° 16.210′W.

Canadaway Creek and Arkwright Falls inhabit the upper section of Ball Gulf, a deeply incised glen within soft brown shale. From the parking area, head away from the road and follow a wide path or ATV trail. After starting level, the trail begins to descend and twist at .22 mile. Descend steeply and come parallel with Canadaway Creek near an illegal campsite and party spot at .53 mile. At 1.02 miles the trail joins a woods road that heads uphill at a small pond with several springs piped into it. Turn left onto the road and in a few yards come to the creek. Now turn left and head upstream.

Keep to the creek's right-hand side, following various foot and ATV trails to keep dry as long possible. Unfortunately, cliffs encroach from both sides at 1.25 miles and you're forced into the creek. Just beyond this point a side drainage joins from the left. There's a nice drop in here so turn left and ever so carefully navigate your way over a nasty logjam spanning a four-foot ledge. The tangled mass hangs above a deep pool and the footing is rather bouncy. A slip here and you're wet and tangled in logs (and probably bashing your head as well). Not more than 50 feet farther is a 15-foot horsetail dropping into a narrow tub. This side stream is quite seasonal. You'll know it's running when you hear the fall before entering, plus there will be quite a bit of water exiting under the logjam.

Return to the main channel and continue upstream 1.6 miles to Arkwright Falls. This is quite a party spot as evidenced by all the detritus. Just prior to the fall you'll find a knotted rope used to scale the ledges above the fall and leading to a rope swing. All the land upstream is heavily posted.

Choking the fall's primary flow channel is an old hemlock trunk that you'll have to take time to wet down; otherwise it will be a highlight slash-

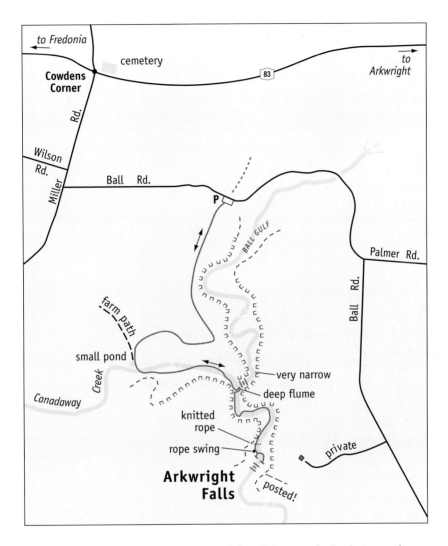

ing through the image. A seep to your left will keep rocks in that area damp. Rocks closer to the fall itself will be dry, which means setting a polarizer properly is a must. It's best to darken the left-side rocks about 80 percent to balance the image. A thin rope hangs over the fall but it sways gently in any breeze so it will disappear during any long exposure. Reverse your route and head back to the car. When you get to the pond don't forget to turn right onto the foot trail as the woods road crosses private land.

About the Author

© Lawanna Folse

Scott E. Brown is an engineering professional and high school
teacher. He is an avid photographer and the author of *Penn-
sylvania Waterfalls* and *Pennsylvania Mountain Vistas*. He has
also had several articles and photo essays published in *Pennsyl-
vania Magazine* and *Nature Photographer*, and his photos have
appeared in *Blue Ridge Country*, *Country*, *Country Extra*, and the
book *American Vision*. He is an associate of the Great American
Photography Workshops, Inc., a nationally known tourism and
workshop company, and is a member of the North American
Nature Photographers Association. He is married and lives in
Horsham, Pennsylvania.